NATURE ANATOMY

THE CURIOUS
PARTS & PIECES
OF THE
NATURAL WORLD

JULIA ROTHMAN
WITH HELP FROM JOHN NIEKRASZ

The mission of Storey Publishing is to serve our customers by
publishing practical information that encourages
personal independence in harmony with the environment.

Text and illustrations © 2015 by Julia Rothman

All rights reserved. No part of this book may be reproduced without written permission from the publisher, except by a reviewer who may quote brief passages or reproduce illustrations in a review with appropriate credits; nor may any part of this book be reproduced, stored in a retrieval system, or transmitted in any form or by any means — electronic, mechanical, photocopying, recording, or other — without written permission from the publisher.

The information in this book is true and complete to the best of our knowledge. All recommendations are made without guarantee on the part of the author or Storey Publishing. The author and publisher disclaim any liability in connection with the use of this information.

Storey books are available at special discounts when purchased in bulk for premiums and sales promotions as well as for fund-raising or educational use. Special editions or book excerpts can also be created to specification. For details, please call 800-827-8673, or send an email to sales@storey.com.

Storey Publishing
210 MASS MoCA Way
North Adams, MA 01247
www.storey.com

Printed in China by R.R. Donnelley
20 19 18 17 16 15 14 13

Library of Congress Cataloging-in-Publication Data

Rothman, Julia.
 Nature anatomy / by Julia Rothman, with John Niekrasz.
 pages cm
 ISBN 978-1-61212-231-1 (paper w/ flaps : alk. paper)
 ISBN 978-1-61212-232-8 (ebook)
 1. Earth sciences–Study and teaching (Middle school)–Pictorial works. I. Niekrasz, John. II. Title.
QE28.R64 2015
508–dc23

2014033664

for my sister, Jess,
who reminds me there's
a whole world outside
the city

CONTENTS

INTRODUCTION..6

CHAPTER 1
Common Ground ... 11
Really Moving • Layers of the Earth • Minerals • The Rock Cycle • Fossils • Landforms • Mountains • North American Landscapes • Field Succession • Loose Landscape Painting

CHAPTER 2
What's Up? .. 41
Up in the Atmosphere • Predicting Weather • The Water Cycle • Storms • Why Are All Snowflakes Different? • Rainbows • Sunsets • Phases of the Moon • Constellations

CHAPTER 3
Come Close ..61
Anatomy of a Flower • Anatomy of a Bee • Anatomy of a Butterfly • Metamorphosis • Plants That Attract Butterflies • Beautiful Butterflies • Colorful Moths • Sedges, Rushes, Grasses • Grazing Edibles • Incredible Insects and Bugs Abounding • Spectacular Spiders • Anatomy of an Ant

CHAPTER 4
Take a Hike ..97
Anatomy of a Deciduous Tree • Anatomy of a Trunk • Leaf Identification • North American Trees • Beautiful Bark • Some Flowers, Cones, Seeds, and Fruits

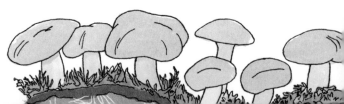

of Trees • Printing Patterns • Anatomy of a Fern • Pretty, Pretty Lichen • Mysterious Mosses • Waterbears • Mycelium • Anatomy of a Mushroom • Marvelous Mushrooms • Rotting Log • Foraging in the Forest

CHAPTER 5
Creature Feature .. 131

Animals in the Neighborhood • Anatomy of a Bat • Common North American Bats • Tree Squirrels • Ground Squirrels • The Lyme Bacteria Cycle • Grizzly Bear vs. Black Bear • The Animal Underground • Snakes • Lizards • Wild Cats • Wild Dogs • Animals with Antlers . . . and Horns • Aquatic Mammals • Outstanding Adaptations • Marine Mammals

CHAPTER 6
A Little Bird Told Me 161

Anatomy of a Bird • A Bevy of Birds • Kinds of Feathers • Birdcalls • A Variety of Nests • Extraordinary Eggs • Intriguing Bird Behavior • Birds of Prey • Owls • Big Birds • A Variety of Beaks • Water Birds

CHAPTER 7
Head above Water .. 189

Water Bodies • Ecosystem of a Pond • A Few Freshwater Fish • Life Cycle of a Salmon • Water Bugs • Toad vs. Frog • Life Cycle of a Frog • Tidal Zone Ecosystem • Fantastic Saltwater Fish • Anatomy of a Jellyfish • On the Sand • Seashells by the Seashore • Some Seaweed • Harvesting, Processing, and Eating Seaweed

A Note about Conservation .. 218

Bibliography ... 220

INTRODUCTION

A couple of years ago, after finishing my last book, *Farm Anatomy*, and learning so many incredible things about growing and preserving food, identifying animals, and the way harvesting works, my hunger for more "green" knowledge grew. I wanted to continue my journey as a city dweller studying the natural world.

I grew up on City Island in the Bronx, in New York City, on a block that ends with a beach, as most of the streets on the island do. Collecting and categorizing shells, studying horseshoe crabs' undersides, and swallowing salt water were part of my childhood, even though we could see iconic skyscrapers glowing across the water. My sister and I spent summers at camp, hiking in the woods in upstate New York, and sleeping in tents outfitted with lots of bug spray to satisfy my over-protective mother.

I really loved nature as a kid and looked forward to outdoor adventures at every opportunity, whether it was a family vacation to Maine or a weekend trip to a neighbor's log cabin. But as I got older, I became a city girl at heart. My teenage years were spent sneaking out to nightclubs downtown and hanging out on the sidewalks of the Lower East Side. That child who loved collecting live bugs and growing crystals (encouraged by my dad, a science teacher) was replaced by a rebellious adolescent who wore black and white checkered stockings with denim skirts and chased skateboarders in Union Square.

While I live in the middle of the city, in Park Slope, Brooklyn, I am only a few buildings away from the entrance to Prospect Park, which I visit on a daily basis, most often for a dog walk or a long run. While it seems a far leap to call these tiny

journeys "nature walks." I cherish being surrounded by greenery for just a small period of time each day. It keeps me sane to be able to smell some grass after being squished like a sardine in a subway car. I really look around the park, wanting to know more. What is that tree with the beautiful leaves called? When will those flowers I saw last year show up again? Are those really bats flitting above our heads? How funny to see so many dragonflies attached, making love!

My curiosity continues to grow, and that's how the idea for this book took shape. I am glad my work has taken me back to a nostalgic place where I can begin to appreciate the things I was intrigued with as a kid.

It's about as fair to call this a "nature book" as it is to call my little walks "nature hikes." There is no way to include even a small portion of the enormous world around us in a book of any size. Where does it end? There is an infinite amount to learn about, from the constellations to the core of the earth. I guess I think of this project as MY nature book. It's the information I was interested in learning about, the things I wanted

to draw and paint. While it is only a teeny scratch on the surface, it gave me a chance to become acquainted with plants, animals, trees, grasses, bugs, precipitation, land masses, and bodies of water that I wanted to be able to name when I walked by.

My friend John has always been an influential green voice, telling me about what he cooks from his plentiful gardens, how he saved some infested fruit trees in a neighbor's yard, and how he finds ingredients in his backyard. For this project, I asked John to literally guide me on my path and show me some cool stuff I might not have found myself.

As we walked through Prospect Park one afternoon, John picked some leaves and encouraged me to eat them. I was a bit worried about what dog may have relieved himself on the plant but eventually obliged, chewing while he laughed at my reaction to the flavor. We walked through the park picking and tasting and critiquing the bitterness, sweetness, and texture of all of the edibles right under our noses. I had no idea I could make such a colorful salad from my Brooklyn park. And if this park could give us this much, I could only imagine what we could forage from actual deep woods.

If it weren't for John, this book wouldn't have become what it is, as he was my teacher and I was his student. He wrote and edited and helped me formulate ideas for the project, and I followed his lead. And while I ultimately decided what I wanted this book to be, you can find his voice on every page.

This book is now an object, a finished piece of work that we are both proud to hold in our hands. But I won't stop drawing flowers or looking up birds that I see in the park in my Sibley guide. John will continue telling me about his vegetable garden plans for next year and about the trips he takes to visit specific natural phenomena. It's a continuous lifelong project for us to appreciate our surroundings, whatever they may be, and this book is just a tiny piece of evidence of that. I hope our book inspires you to be curious about your own backyard, too, whether it's rolling hills or a flower box on a fire escape.

Julia Rothman

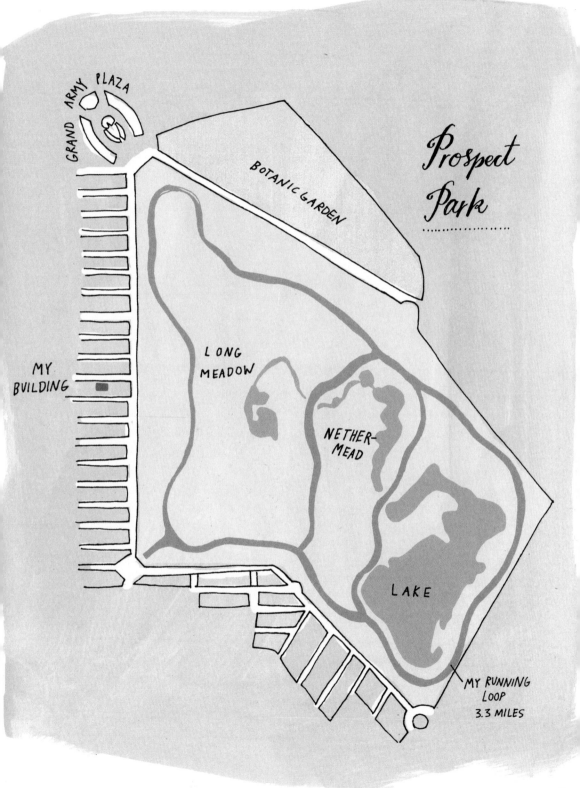

REALLY MOVING

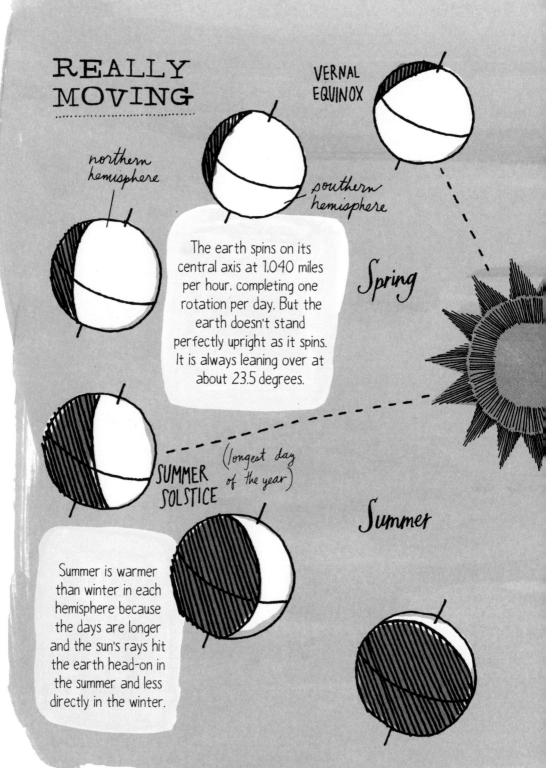

northern hemisphere

southern hemisphere

VERNAL EQUINOX

Spring

The earth spins on its central axis at 1,040 miles per hour, completing one rotation per day. But the earth doesn't stand perfectly upright as it spins. It is always leaning over at about 23.5 degrees.

SUMMER SOLSTICE (longest day of the year)

Summer

Summer is warmer than winter in each hemisphere because the days are longer and the sun's rays hit the earth head-on in the summer and less directly in the winter.

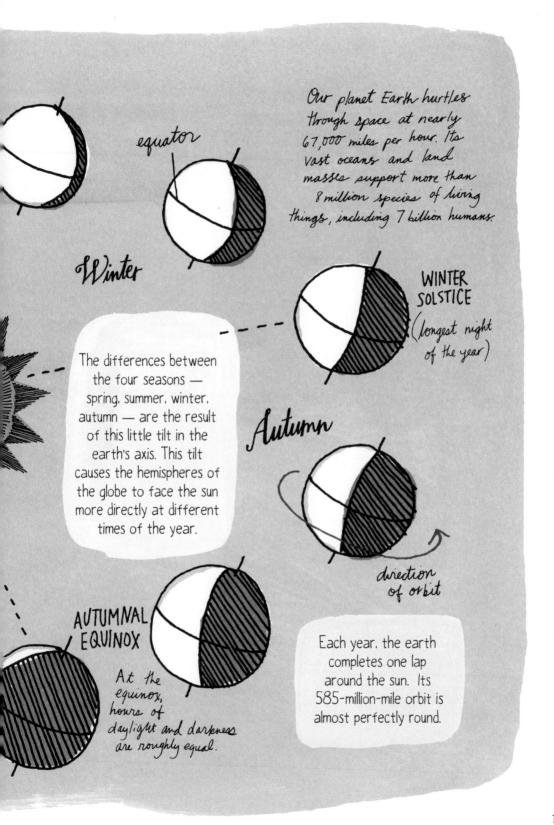

equator

Our planet Earth hurtles through space at nearly 67,000 miles per hour. Its vast oceans and land masses support more than 8 million species of living things, including 7 billion humans.

Winter

WINTER SOLSTICE (longest night of the year)

The differences between the four seasons — spring, summer, winter, autumn — are the result of this little tilt in the earth's axis. This tilt causes the hemispheres of the globe to face the sun more directly at different times of the year.

Autumn

direction of orbit

AUTUMNAL EQUINOX

At the equinox, hours of daylight and darkness are roughly equal.

Each year, the earth completes one lap around the sun. Its 585-million-mile orbit is almost perfectly round.

Layers of the Earth

Planet Earth was formed 4.54 billion years ago. Most of what we know about the structure of Earth comes from studying the seismic waves that pass through the planet during earthquakes. Earth is distinctly layered and each layer has its own unique characteristics.

CRUST

The earth's crust is between 3 and 44 miles thick, being thickest where there are land masses and thinnest beneath the oceans. It makes up less than 1% of the planet's total volume.

MANTLE

This layer of iron- and magnesium-rich silicate rock is hot enough (between 930° and 7,200°F) that it flows very slowly, causing earthquakes as the surface plates shift atop it. The mantle composes 84% of earth's volume.

OUTER + CENTRAL CORE

The core has two parts: The outer core is primarily molten iron. The central core – an alloy of iron and nickel – is under so much pressure that it has crystallized into a solid even though it is hotter than the surface of the sun.

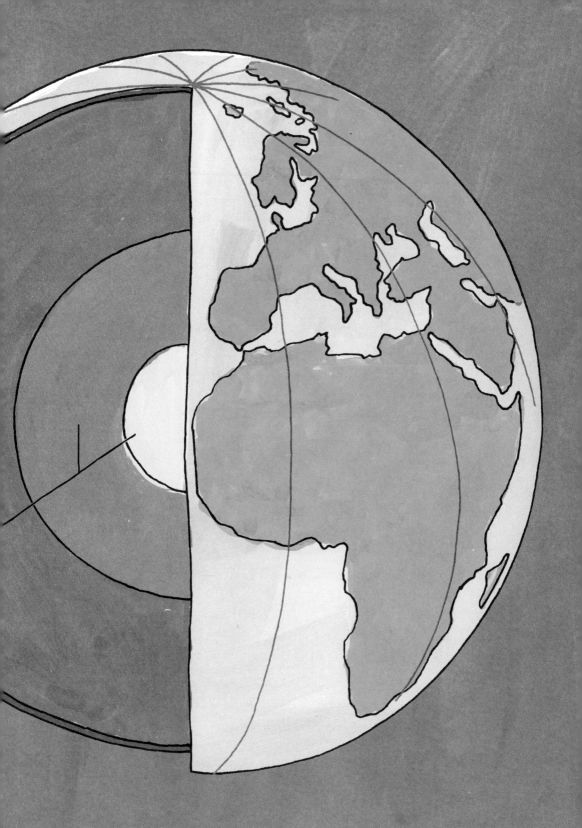

Minerals

Minerals are naturally occurring solid substances consisting of inorganic materials. There are more than 4,000 identified minerals, with more being discovered every year.

RHODOCHROSITE

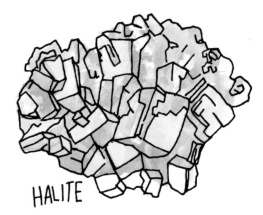
HALITE

TURQUOISE
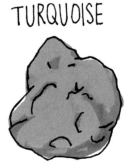

ICE

Liquid water is not a mineral, but naturally formed ice is one of the most common minerals on Earth.

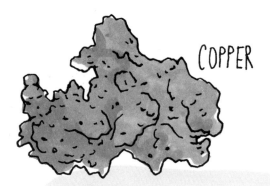
COPPER

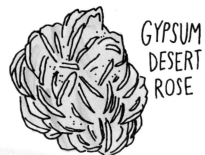
GYPSUM DESERT ROSE

Minerals form through crystallization:
- through evaporation of a solution (like salt water evaporating into salt)
- through cooling (natural water freezing, magma solidifying)
- through changes in surrounding pressure and temperature (often found at faults and other tectonically active zones)

JEREMEJEVITE

QUARTZ

HEMATITE

AZURITE - MALACHITE

The Rock Cycle

Dynamic transitions take place among different types of rocks over long periods of time.

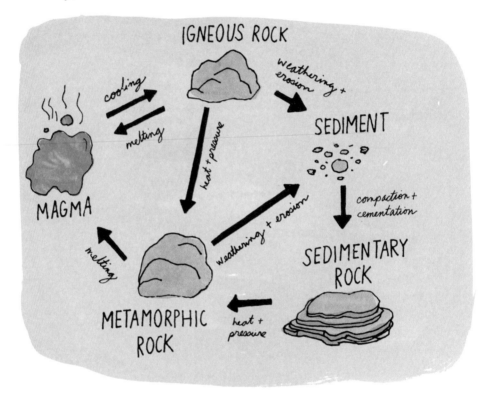

Rocks are altered or destroyed by natural forces: heat, pressure, friction, and weathering.

Based on how they are formed, rocks are classified into types:

Igneous

Magma is molten rock beneath the surface of the earth. When magma cools and solidifies at or near the surface, it creates igneous rock.

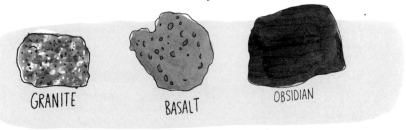

GRANITE — BASALT — OBSIDIAN

Sedimentary

As bits of minerals settle into layers over thousands of years, the weight of water and the layers of sediment above press down and cement the minerals into sedimentary rock.

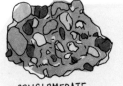

CONGLOMERATE — MUDSTONE — LIMESTONE

Metamorphic

When sedimentary or igneous rocks are subjected to extreme pressure and heat, their mineral structures transform, resulting in metamorphic rock.

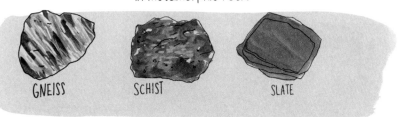

GNEISS — SCHIST — SLATE

Fossils

The chances of an organism's being preserved as a fossil are very small. For a fossil to form, the organism must be covered in sediment shortly after its death. Then, water with high mineral content enters the small pores and cavities of the organism. With time and pressure, the minerals in the water are deposited into the structure of the organism and solidify, leaving behind a three-dimensional fossil.

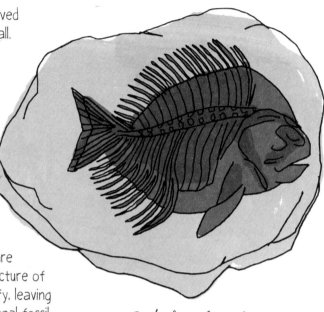

Perch from Green River Formation of southwest Wyoming

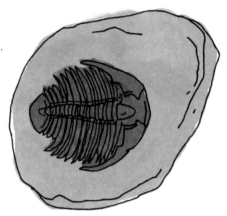

Trilobite from Marjum Formation in Millard County, Utah

Not all parts of a creature become fossilized. Soft parts of the anatomy, like skin and internal organs, often decompose before fossilization.

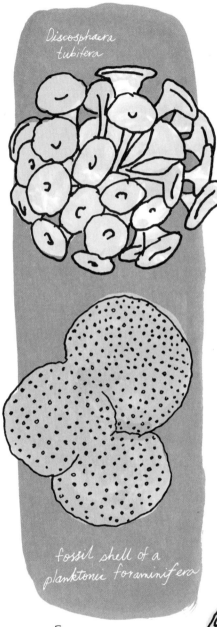

Discosphaera tubifera

fossil shell of a planktonic foraminifera

[MAGNIFIED MILLIONS OF TIMES!]

Microfossils

The fossils displayed in museums are macrofossils, that is, larger than 1 millimeter and visible to the naked eye. Vastly more numerous are microfossils, the tiny preserved remains of bacteria, diatoms, fungi, protists, invertebrate shells or skeletons, pollen, and bits of bones and teeth of vertebrates. Microfossils usually occur in large numbers in all kinds of sedimentary rocks.

The Egyptian pyramids were built with sedimentary rocks made up of shells of foraminifera, a major microfossil group.

radiolaria

🌿 LANDFORMS 🌿

Canyon

a deep river valley with very steep sides, carved into the land by rivers over long periods of time

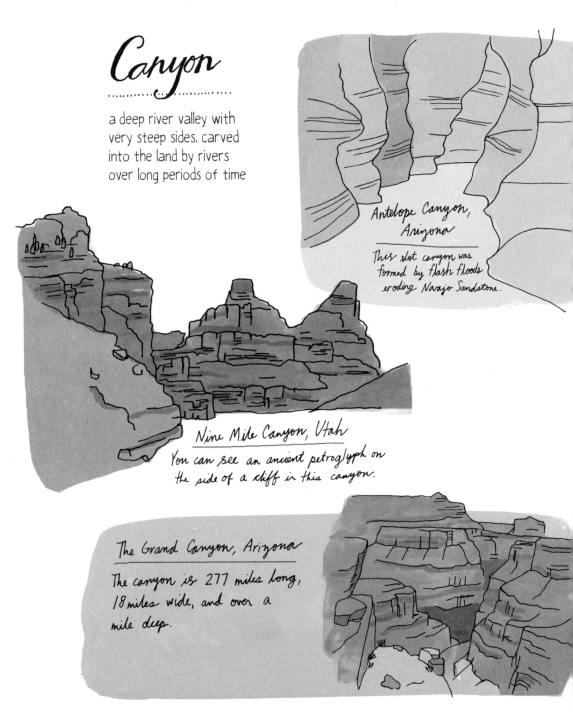

Antelope Canyon, Arizona

This slot canyon was formed by flash floods eroding Navajo Sandstone.

Nine Mile Canyon, Utah

You can see an ancient petroglyph on the side of a cliff in this canyon.

The Grand Canyon, Arizona

The canyon is 277 miles long, 18 miles wide, and over a mile deep.

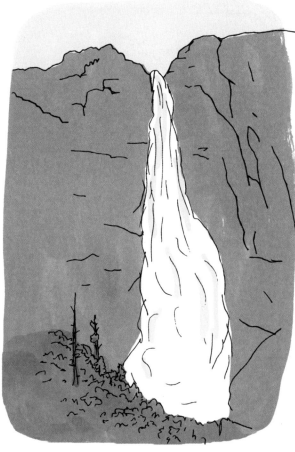

Cataract

a large and powerful waterfall

Yosemite Falls, California

This is the highest waterfall in North America.

Niagara Falls, border of Ontario, Canada, and New York

It has the highest flow rate of any waterfall in the world.

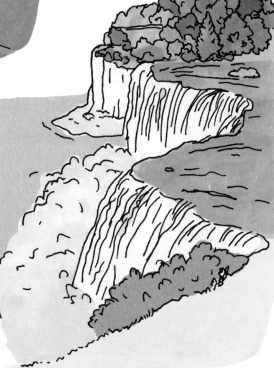

Delta

a low, triangular formation at the mouth of a river where silt, sand, and small rocks are deposited where the river meets a larger body of water

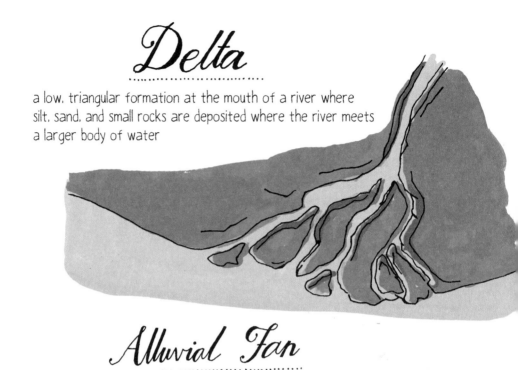

Alluvial Fan

made of large amounts of sediment deposited by streams and rivers in a fan shape, most frequently where a canyon drains from mountains and spreads out over a flat plain

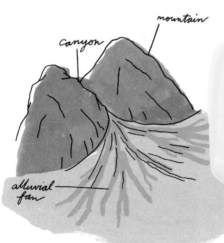

On July 15, 1982, Lawn Lake Dam in Rocky Mountain National Park, Colorado, failed. Thirty million cubic feet of water carried tons of debris to an alluvial fan that is still prominent decades later.

Archipelago
a cluster or chain of islands found in a sea or ocean

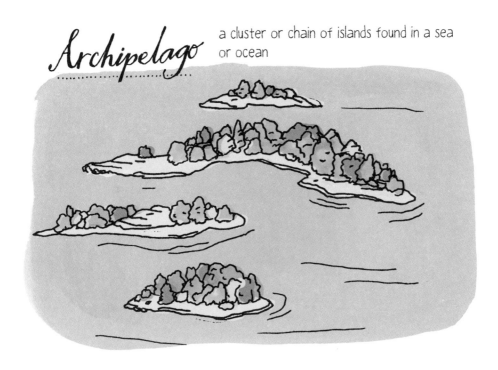

Isthmus
a narrow bridge of land connecting two larger land masses across a body of water

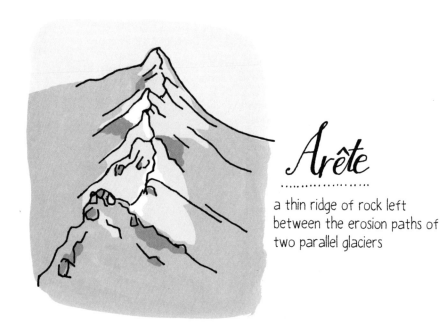

Arête
a thin ridge of rock left between the erosion paths of two parallel glaciers

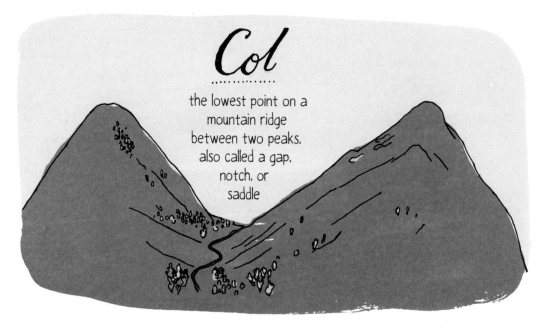

Col
the lowest point on a mountain ridge between two peaks, also called a gap, notch, or saddle

Plateau

a massive area of flat terrain that is higher than the surrounding area

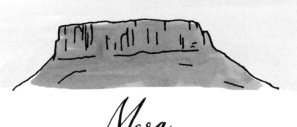

Mesa

a smaller area of elevated arid land with a flat top and sides that are usually steep cliffs

Butte

an even smaller area of raised land with steep sides. Most buttes were once larger mesas.

🌿 MOUNTAINS 🌿

Mountains are formed over long periods of time by plate tectonics, the process by which large pieces of the earth's crust shift, collide, crumple, and slide. With their varying climate zones, altitude, and steepness, mountains are home to unique flora and fauna.

There are three primary types of mountain: fold, block, and volcanic.

Fold Mountains

As the earth's plates collide or ride one over another, the crust tends to buckle and fold upward. Most of the Appalachian and Rocky Mountain ranges are associated with this type of movement.

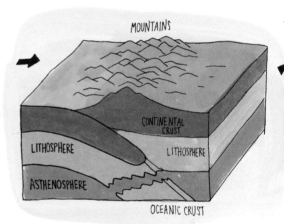

Block Mountains

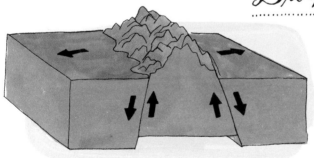

Block, or fault-block, mountains, are distinguished by enormous sheer rock faces like those found in the Sierra Nevada range in California. Block mountains form when tectonic pressure forces a huge rock mass to break apart. This line of separation is called a fault. The rocks rise on one side of the fault and sink down on the other side, creating dramatic cliffs.

Volcanic Mountains

Volcanic mountains form where two plates of the earth's crust move together or apart, rather than sliding past each other. The magma that volcanic mountains emit often comes from crust material that melts as it is pushed down into the hot mantle below an advancing tectonic plate.

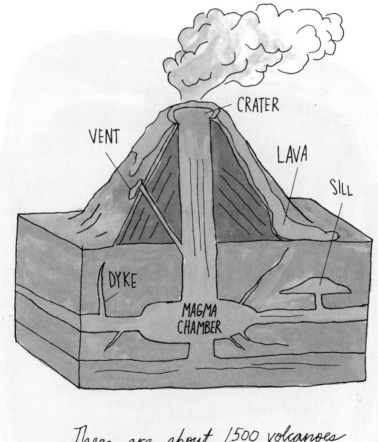

There are about 1,500 volcanoes that are known to have been active in the last 10,000 years.

NORTH AMERICAN LANDSCAPES

Deserts

Although deserts typically receive less than 10 inches of rain per year, the harsh dry terrain is often rich with life.

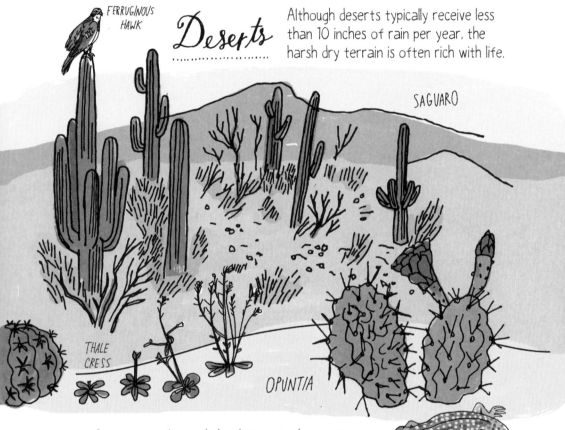

Desert animals avoid the desiccating heat of day by sleeping in the shade or burrowing underground. Some even remain in a state of dormancy during very dry spells.

Desert plants can store water for long periods and often have protective spines or needles to keep thirsty animals at bay. Some species germinate and bloom as if in fast-forward, living out their entire lives in the few short weeks after a rare rainfall.

Grasslands

Wide-open treeless areas dominated by grasses, sedges, and rushes occur naturally in most regions of the earth. Grasslands have the deepest soil base of any landscape. Rich soils in an undisturbed grassland can extend as deep as 20 feet.

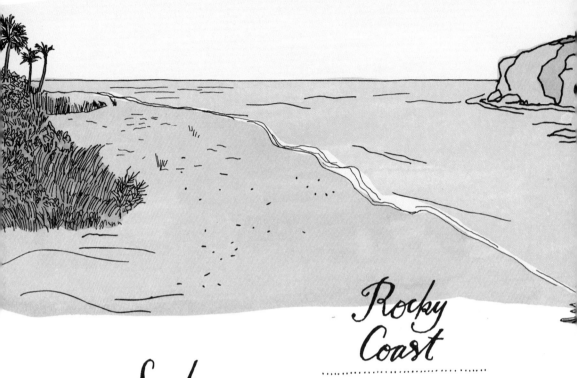

Sandy Shore

Where land meets the open ocean, the eternal beating of waves breaks down rocks and shells into fine sand. Wind and waves constantly move and reshape the shoreline. Salt-tolerant beach grasses, rushes, heathers, and roses hold the dunes and sandy shoreline together.

Rocky Coast

Along the rugged shorelines of inlets, islands, and promontories, the sea's power carves arches and caves into the rocky cliffs. Well above the surface, seabirds nest on protected crags, wind-dwarfed conifers cling to the rocks, and blue-green algae and lichens live amidst the ocean spray. In areas submerged for part of the day, tawny rockweeds and mussels thrive. Limpets, barnacles, and kelp extend from just below the surface out to sea.

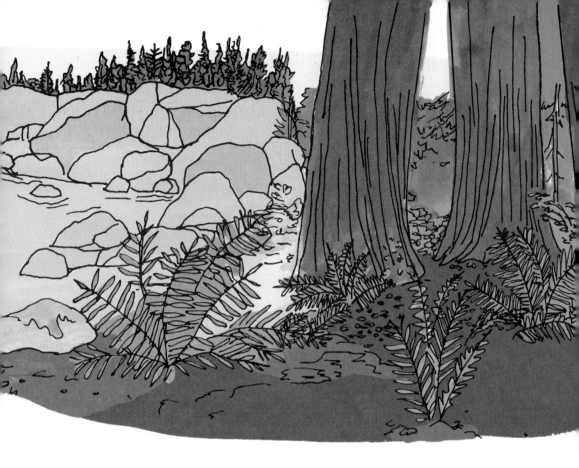

Moist Coastal Forest

Large ferns, thick blankets of moss, and massive trees give the moist coastal forest the impression of a timeless land. Rain and fog provide consistent moisture, and the mild oceanic climate allows plants to reach great size since they can grow much of the year.

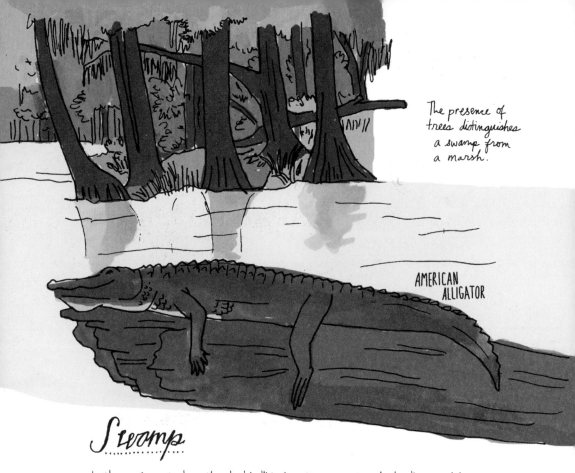

The presence of trees distinguishes a swamp from a marsh.

AMERICAN ALLIGATOR

Swamp

In these forested wetlands, birdlife is often spectacularly diverse. Many amphibians, fish, and mammals also thrive in these lush environments. Duckweed and water lilies spread across the surface of the slow-moving water. Alligators, turtles, and venomous cottonmouth snakes can be found basking in warm southern swamps.

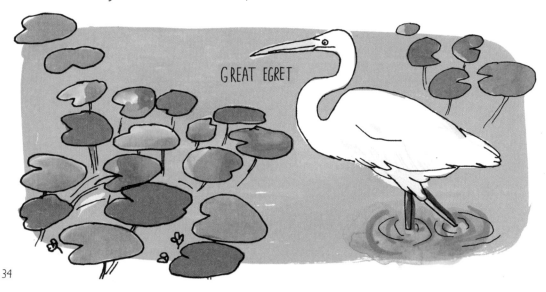

GREAT EGRET

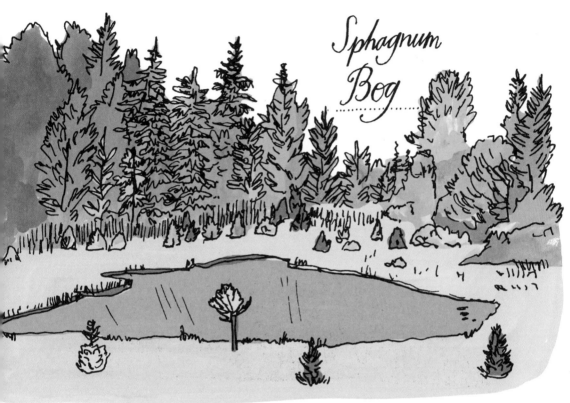

Sphagnum Bog

Most bogs transition from open water to forested land over many years.

Sphagnum mosses are northern wetland plants that help create unique bog habitats in glacial depressions. The mosses decay extremely slowly, accumulating into thick layers of peat. Sedges, orchids, labrador tea, and even carnivorous plants are found in the cold microclimate of the sphagnum bog. Wetlands deplete available oxygen and peat acidifies its surroundings, so fish and many other aquatic organisms are generally scarce.

Bog lemmings have bright green droppings!

Field Succession

If a piece of land previously used for agriculture or logging is left alone, it slowly begins to revert to its wild state. Succession is the process by which a field transitions to woodland.

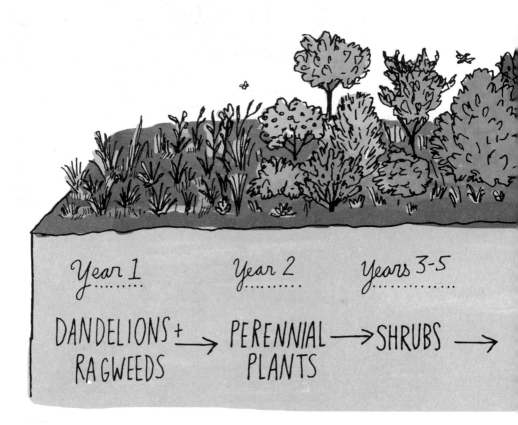

Year 1: DANDELIONS + RAGWEEDS → Year 2: PERENNIAL PLANTS → Years 3-5: SHRUBS →

In temperate zones, early species include hardy, sun-tolerant plants like dandelions, ragweed, and lamb's-quarters. Gradually, plants such as thistles, Queen Anne's lace, and milkweed take hold.

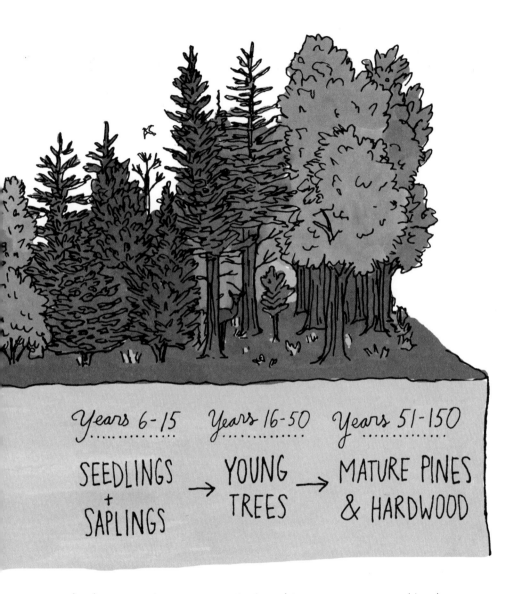

As the vegetation matures, animals and insects are attracted by the increased cover and forage. Woodchucks, cottontail rabbits, foxes, and deer can be found, as well as butterflies, sparrows, meadowlark, and quail. Birds and squirrels deposit the seeds of trees such as black cherry, oak, mulberry, and staghorn sumac.

Loose Landscape Painting

TOOLS

- Pigment of your choice: watercolor, gouache (my favorite — it's what this book was painted with), crayon, colored pencil
- Thick paper or small canvas
- Medium to large paintbrush

INSTRUCTIONS

Find an intriguing landscape and sit in a quiet, comfortable spot with an ideal view of your subject. Squint your eyes to see the scene out of focus. Look at the area as chunks of color without any close details.

Block in the color in large strokes. Think about using colors that complement each other even if they aren't exactly accurate. Keep adding color shapes until the entire page is full. Try not to leave white paper. If you want to have white, paint it rather than leaving the paper blank.

TIPS

Hold your paintbrush near the tip, not the brush, so it's a bit looser in your hand and harder to control. Do lots of paintings of the same scene, switching the colors slightly to see how much it changes the image.

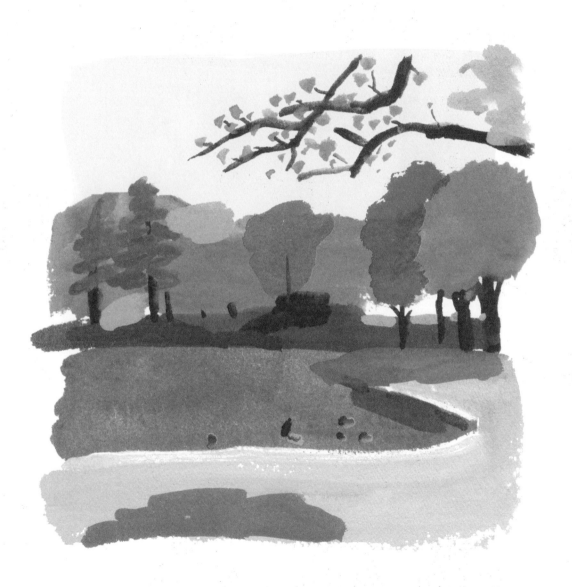

UP IN THE ATMOSPHERE

The atmosphere encompasses all of the layers of gaseous masses that surround the earth.

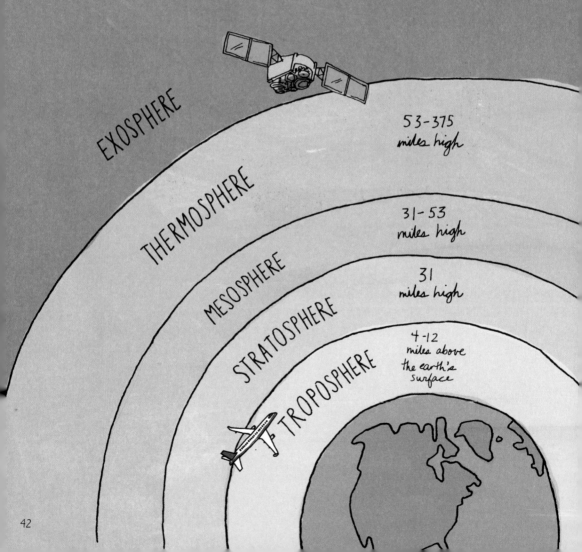

EXOSPHERE — 53-375 miles high

THERMOSPHERE — 31-53 miles high

MESOSPHERE — 31 miles high

STRATOSPHERE — 4-12 miles above the earth's surface

TROPOSPHERE

The TROPOSPHERE is the lowest atmospheric level and almost all weather occurs in this region. The troposphere begins at the earth's surface and extends from 4 to 12 miles high.

The STRATOSPHERE holds 19 percent of the atmosphere's gases but very little water vapor.

The gases, including oxygen molecules, continue to become less dense as one ascends the MESOSPHERE.

The THERMOSPHERE is also known as the upper atmosphere. Ultraviolet and x-ray radiation from the sun gets absorbed by the molecules in this layer, which results in a temperature increase.

In the EXOSPHERE, atoms and molecules escape into space and satellites orbit the earth.

Predicting Weather

Here are some ways to predict weather so you're not caught off guard on a hike:

CLOUD FORMATION
Certain types of clouds are good indicators of precipitation or storms.

MORNING DEW
Heavy dew means there aren't strong winds to dry it off. That usually forecasts fair weather.

FLIGHT PATTERNS
Birds fly lower to the ground when a storm is coming because the air pressure hurts their ears.

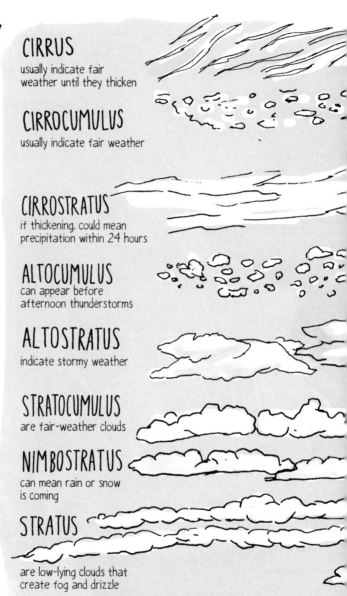

CIRRUS
usually indicate fair weather until they thicken

CIRROCUMULUS
usually indicate fair weather

CIRROSTRATUS
if thickening, could mean precipitation within 24 hours

ALTOCUMULUS
can appear before afternoon thunderstorms

ALTOSTRATUS
indicate stormy weather

STRATOCUMULUS
are fair-weather clouds

NIMBOSTRATUS
can mean rain or snow is coming

STRATUS
are low-lying clouds that create fog and drizzle

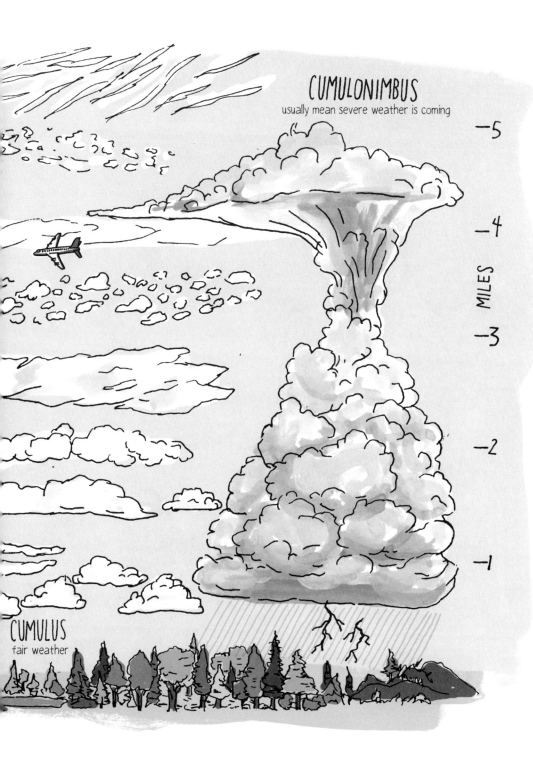

The Water Cycle

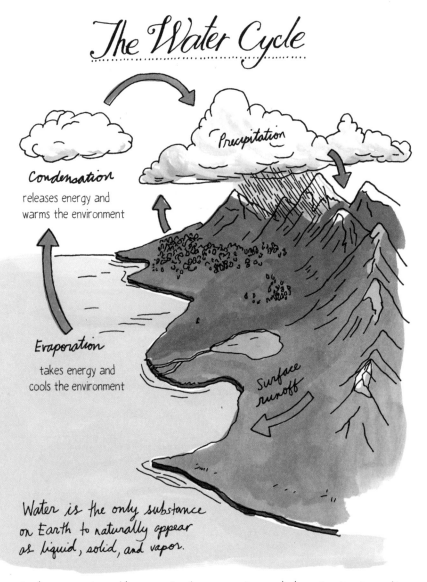

In the natural world, water is always moving and changing its form. It travels from streams to rivers to oceans, from lakes and oceans to the atmosphere, and from the atmosphere back to land. This cycle slowly purifies water and replenishes the land with fresh water.

Fog vs. Mist

Fog is a stratus cloud formation located close to the surface of the earth. Mist is made of tiny water droplets suspended in the air. Both can form when there is a significant temperature difference between the air and the ground. Bodies of water or moist ground in the immediate area provide the water vapor that becomes mist or fog.

The main difference is that fog reduces visibility to less than 1 kilometer; you can see farther in mist.

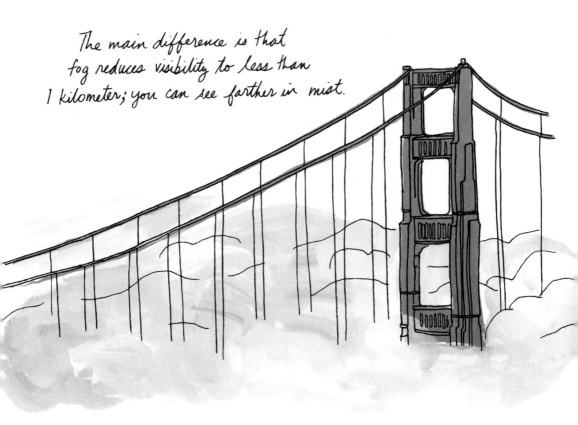

STORMS

Thunderstorm

Storms develop when masses of very cold air collide with masses of very warm air. As the warm air rises, surface air pressure drops, creating a vacuum effect. Cold air rushes in, forcing more warm air upward in a turbulent cycle that can produce strong winds, rain, and hail.

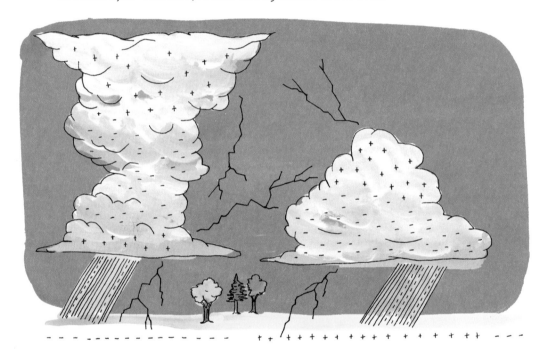

Lightning

The air is full of ions (atoms or molecules with an electrical charge). In a thundercloud, positive ions are grouped near the top of the cloud and negative ones at the bottom. When the difference in voltage becomes great enough, a bolt of lightning balances out the charge. Lightning can bridge the top and bottom of a cloud or strike from the cloud to the ground. Claps of thunder result from sound waves created by the lightning.

Tornado

The collision of hot and cold air can produce mammoth rotating thunderstorms called supercells. A tornado is a violently rotating column of air that stretches between the cumulonimbus clouds of a supercell and the ground.

Tornadoes are classified by wind speed and destructive power on the Enhanced Fujita Scale between EF0 and EF5.

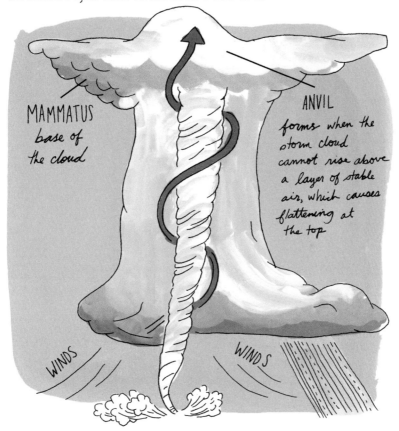

Tornado Alley in the central United States has the highest occurrence of tornadoes in the world.

WHY ARE ALL SNOWFLAKES DIFFERENT?

A snowflake's shape is determined by temperature and humidity. At low temperatures inside a cloud, water vapor crystallizes directly into solid ice through a process called deposition. These tiny ice crystals keep growing until they are heavy enough to fall from the cloud as snowflakes.

As a crystal grows, the molecules do not stack together with perfect regularity. Each falling snowflake travels a unique path through many different microclimates, resulting in a different shaped arrangement of crystals.

CAPPED COLUMN

BULLET ROSETTES

NEEDLE CLUSTERS

HOLLOWED COLUMNS

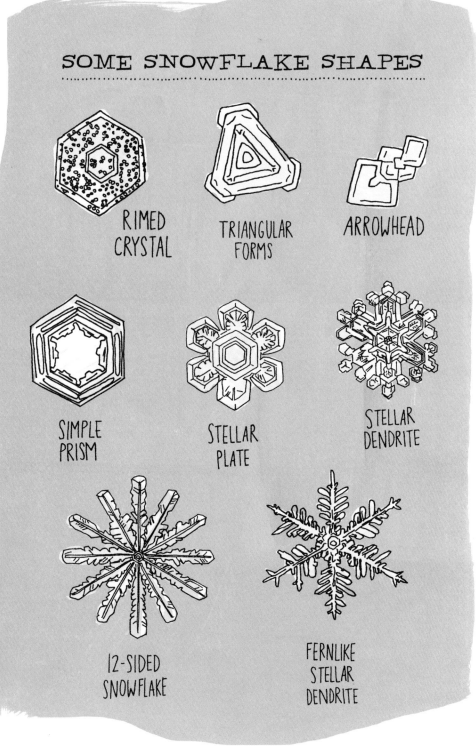

RAINBOWS

The familiar multicolored arc of a rainbow is one of nature's most striking phenomena. Rainbows are formed by light refracting and reflecting through tiny water droplets in the air. Light from the sun may look white or yellow, but it is actually a combination of many colors.

A rainbow always appears directly opposite the sun, but the observer's location determines its apparent position.

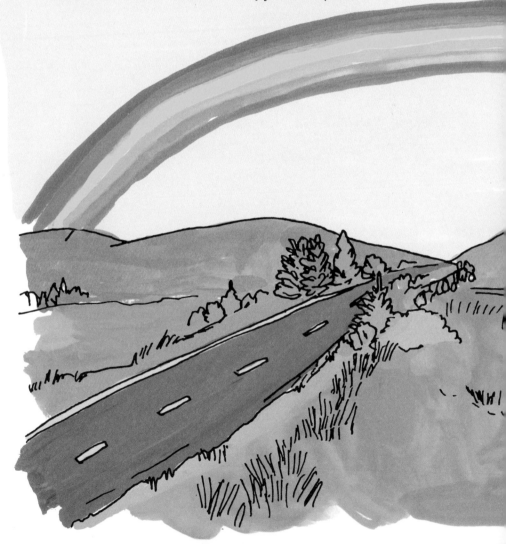

SUNSETS

Sunlight is made up of many different wavelengths and colors of light. When sunlight strikes particles in the atmosphere (such as water and air molecules, dust, pollen, or pollution), certain wavelengths are deflected and refracted more than others.

Because of the indirect angle of the sunlight striking the earth at sunset, the light has to travel through more atmospheric particles, so more of it is scattered. Blue and green wavelengths are largely filtered out, leaving the longer-wavelength orange and red hues.

The colors of sunsets are often more dramatic than sunrise colors because evening air is warmer and holds more particles aloft than morning air.

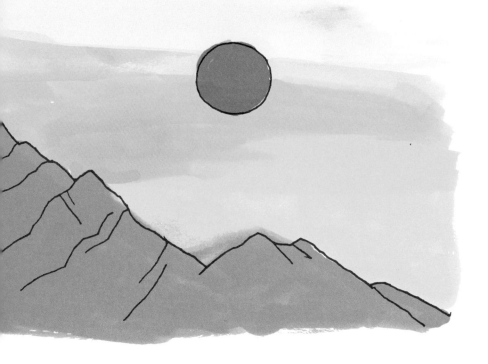

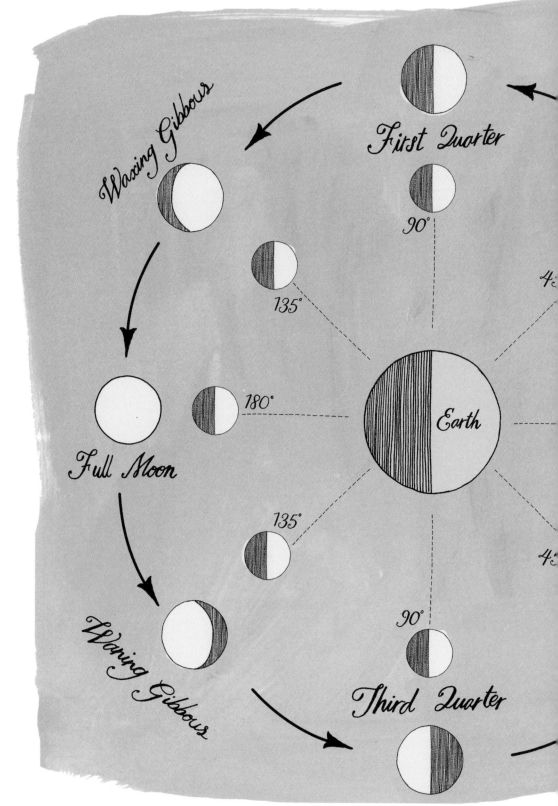

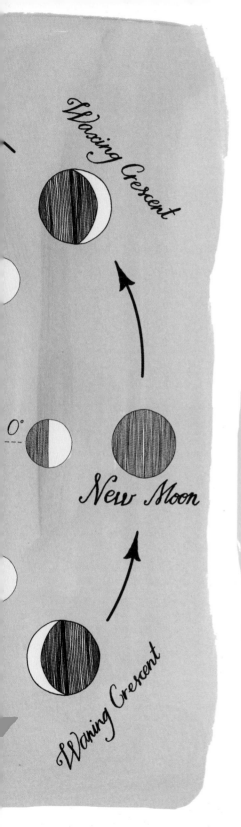

Phases of the Moon

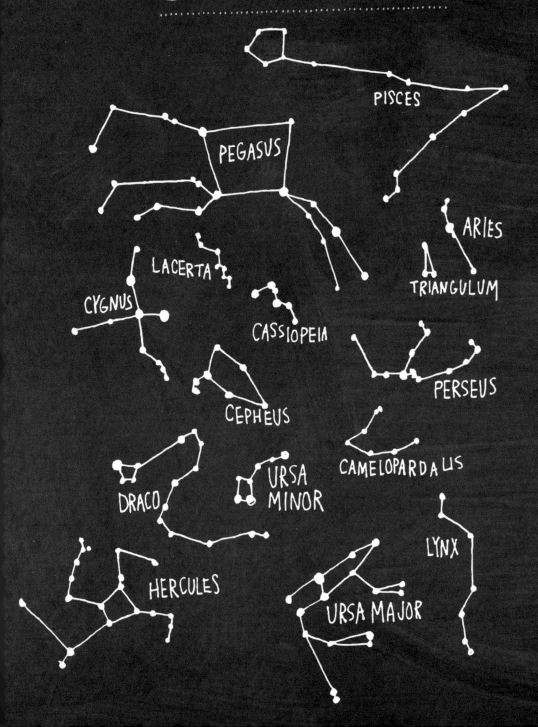

For thousands of years, humans have sought and found meaning in the patterns of the stars. Constellations, or asterisms, are images formed by groups of prominent stars in the night sky. Though the stars of a single constellation appear to be close to each other, they may in fact be many light years apart.

The images and meanings ascribed to constellations have varied between cultures and eras, but the International Astronomical Union currently recognizes 88 constellations in the northern and southern skies. Many constellation names we use today are Latin and from the time of the Roman empire, though the particular meanings and images are often much older than that.

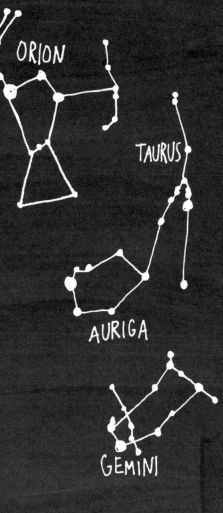

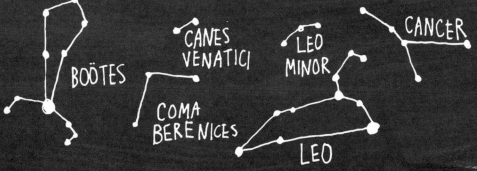

ANATOMY OF A FLOWER

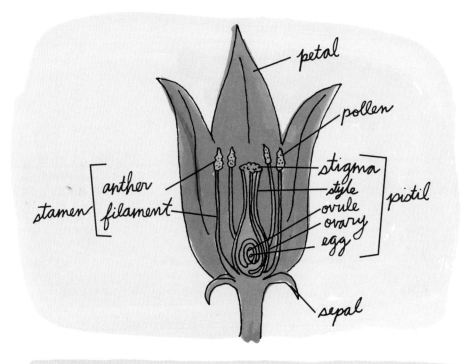

anther - male reproductive cell that contains pollen
filament - supports the anther
sepal - modified leaf beneath the flower
stamen - includes the male parts of the flower
pistil - includes the female parts of the flower
ovary - female reproductive organ
ovule - reproductive cell; forms the seed when fertilized with pollen
stigma - structure atop the ovary that receives pollen
style - stalk that connects the stigma and the ovary

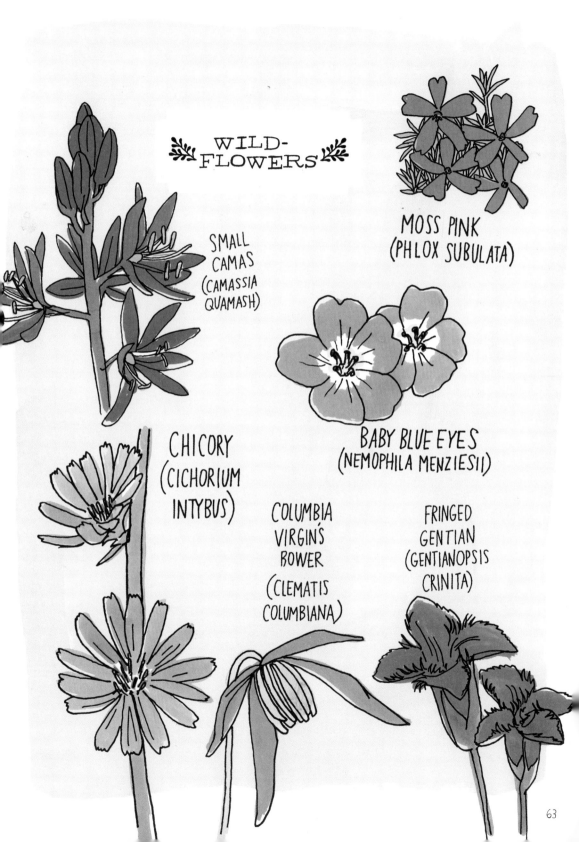

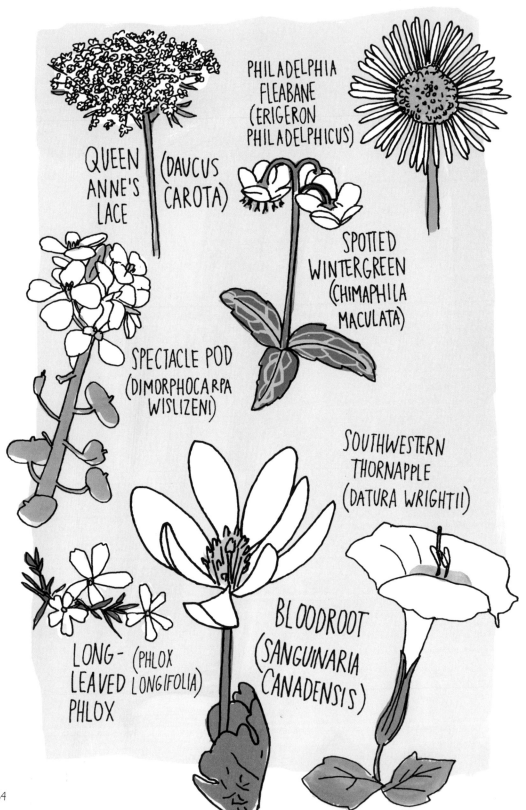

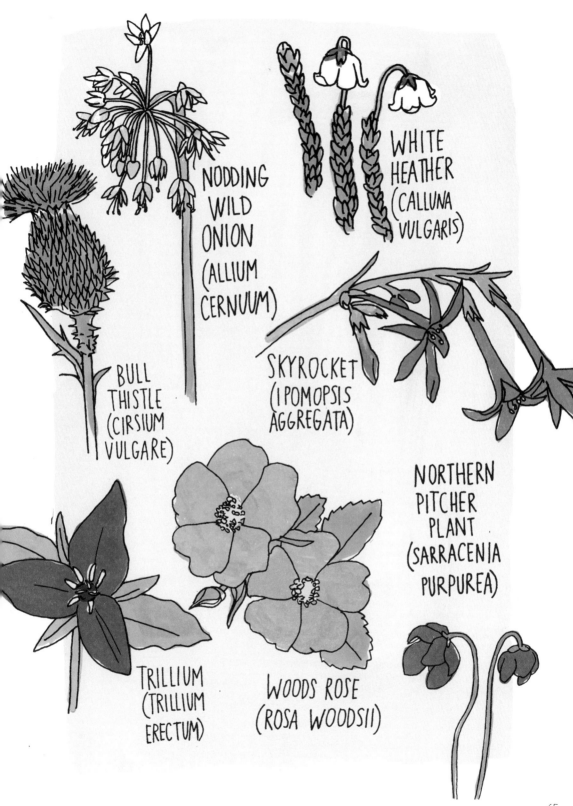

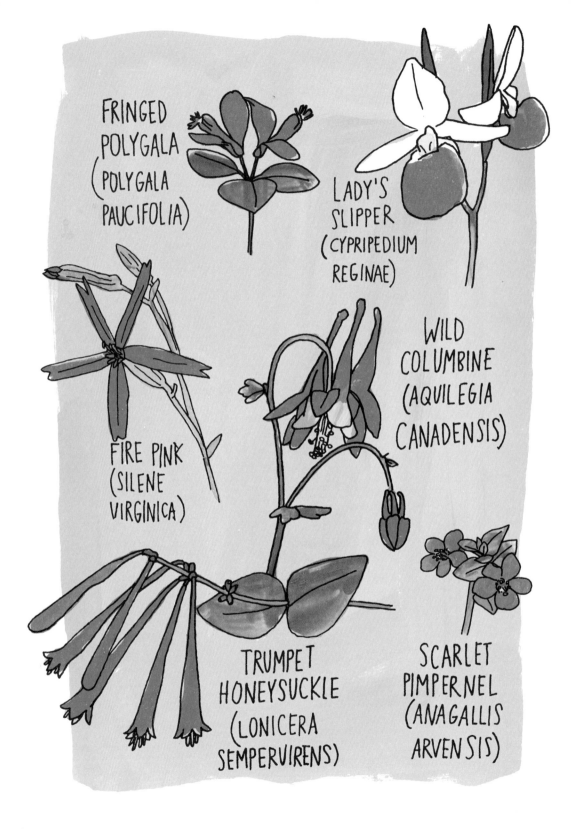

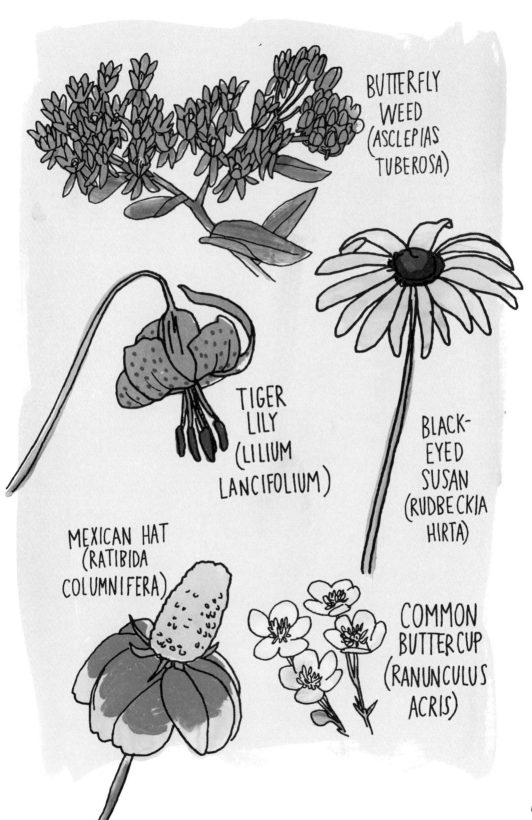

COMMON NECTAR SOURCES

- DANDELION
- YELLOW SWEET CLOVER
- WHITE DUTCH CLOVER
- GOLDENROD

HONEY

North America has some 4,000 species of native bees, but our familiar honey bee came over from Europe with the settlers.

LEAF CUTTER

BUMBLE

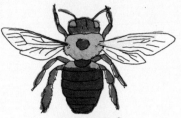

CARPENTER

SWEAT

MASON

ANATOMY OF A BEE

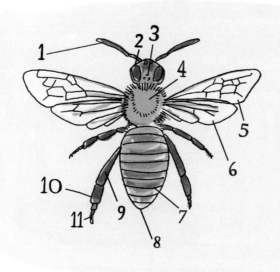

1. **antenna** - contains thousands of tiny sensors that detect smell
2. **compound eye** - for general distance sight
3. **ocellus** - three simple eyes used for low light conditions in the hive
4. **thorax** - segment between head and abdomen where wings attach
5. **forewing**
6. **hindwing** — 2-part wings hook together in flight but separate at rest
7. **abdomen** - contains all the organs, wax glands, and stinger
8. **stinger** - only present on worker and queen bees
9. **femur**
10. **tibia**
11. **tarsal claw** — three pairs of legs with six segments each; used for walking and packing pollen

BUTTERFLY FAMILIES OF NORTH AMERICA

TRUE BUTTERFLIES

- **swallowtails** (FAMILY PAPILIONIDAE)
 medium to large, tail-like appendages on hindwings, colorful

- **brush-footed** (FAMILY NYMPHALIDAE)
 largest family, two shorter legs used for tasting food

- **whites + sulphurs** (FAMILY PIERIDAE)
 mostly white or yellow wings with black or orange marks

- **gossamer-winged** (FAMILY LYCAENIDAE)
 sheer wings, smaller sized, includes hairstreaks, blues and copper

- **metalmarks** (FAMILY RIODINIDAE)
 small to medium, mostly tropical, metallic marks

- **skippers** (FAMILY HESPERIIDAE)
 wide thoraxes, small wings, hooked antennae, brown and gray with white and orange marks

ANATOMY OF A BUTTERFLY

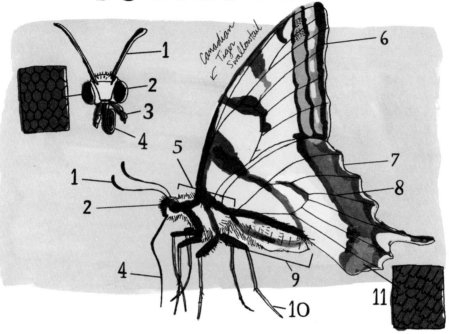

1. **antenna** - used as a form of radar and pheromone detection
2. **compound eye** - has up to 1,700 individual ommatidia (light receptors and lenses)
3. **palpus** - shields the eye from dust, covered in scent-detecting sensors
4. **proboscis** - like a long straw for feeding and drinking
5. **thorax** - three body segments that contain the flight muscles
6. **forewing** ⎫
7. **hindwing** ⎬ - two pairs of overlapping wings that flap and sometimes glide
8. **wing veins** - vary between each genus of butterfly, used in classification
9. **abdomen** - contains the digestive system, respiratory equipment, heart, and sex organs
10. **legs** - butterflies have three pairs except in the Nymphalidae family
11. **scales** - wings are covered in tiny dust-like colored scales

Metamorphosis

The life cycle of a butterfly has four stages: 1. egg, 2. larva (caterpillar), 3. pupa (chrysalis), 4. adult (butterfly).

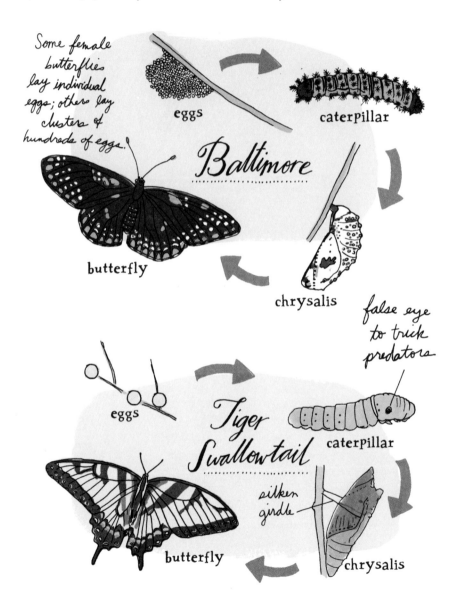

Some female butterflies lay individual eggs; others lay clusters of hundreds of eggs.

Baltimore: eggs → caterpillar → chrysalis → butterfly

false eye to trick predators

Tiger Swallowtail: eggs → caterpillar → chrysalis (silken girdle) → butterfly

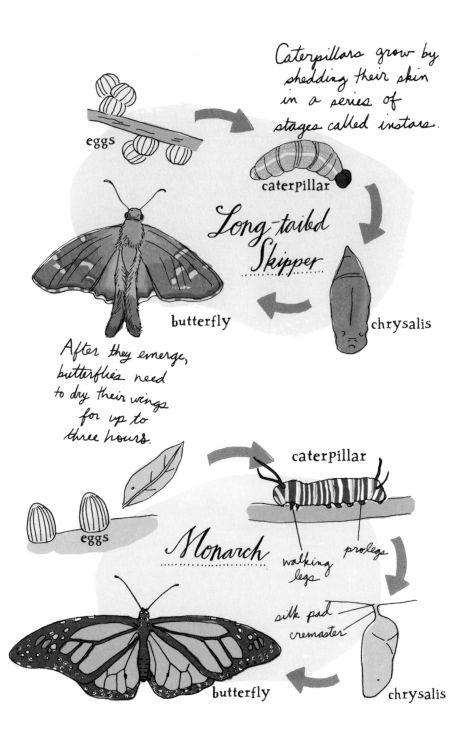

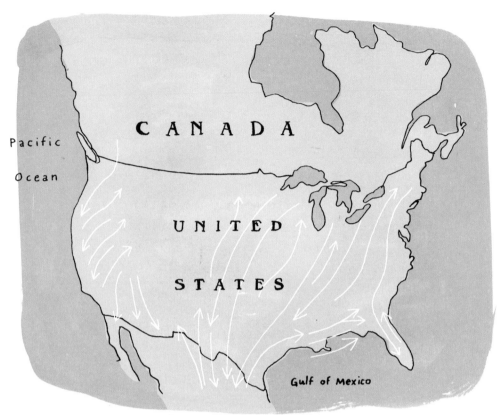

Monarch Migration

Monarchs travel south in the winter and north in the summer, just like birds. Because of the butterflies' short lifespan, each migration consists of an entirely new generation.

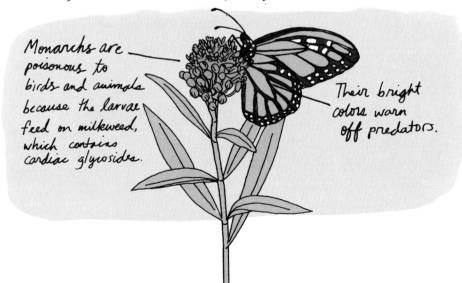

Monarchs are poisonous to birds and animals because the larvae feed on milkweed, which contains cardiac glycosides.

Their bright colors warn off predators.

🦋 PLANTS THAT 🦋 ATTRACT BUTTERFLIES

Anise Hyssop
attracts Red Admiral, Monarch, Painted Lady, Buckeye, Milbert's Tortoiseshell, Pipevine Swallowtail, Sulphur

Butterfly Bush
attracts Monarch, Buckeye, Black Swallowtail, Pipevine Swallowtail, Snout Butterfly, Great Spangled Fritillary, Pearl Crescent, Red Admiral, Painted Lady, Common Checkered Skipper, Nymphalidae

New Jersey Tea
attracts Spring Azure, Coral Hairstreak, Striped Hairstreak, Edward's Hairstreak, Acadian Hairstreak

Cut-Leaf Coneflower
attracts Great Spangled Fritillary, Pearl Crescent, Viceroy, Monarch, Blues

Pink Turtlehead
attracts Silver-Spotted Skippers, Spicebush Swallowtail, Tiger Swallowtail

BEAUTIFUL BUTTERFLIES

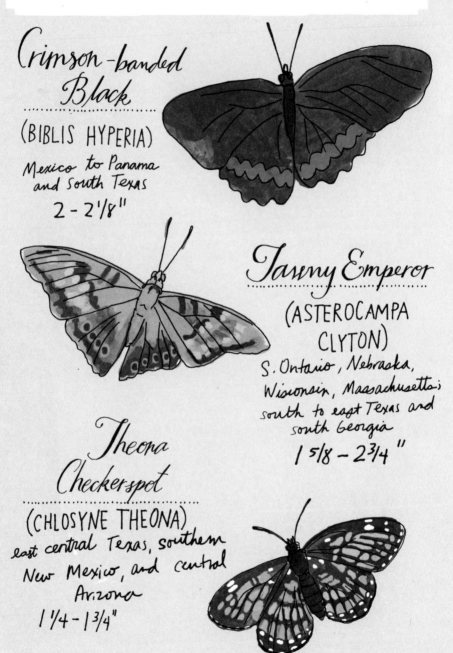

Crimson-banded Black
(BIBLIS HYPERIA)
Mexico to Panama and south Texas
2 - 2 1/8"

Tawny Emperor
(ASTEROCAMPA CLYTON)
S. Ontario, Nebraska, Wisconsin, Massachusetts; south to east Texas and south Georgia
1 5/8 - 2 3/4"

Theona Checkerspot
(CHLOSYNE THEONA)
east central Texas, southern New Mexico, and central Arizona
1 1/4 - 1 3/4"

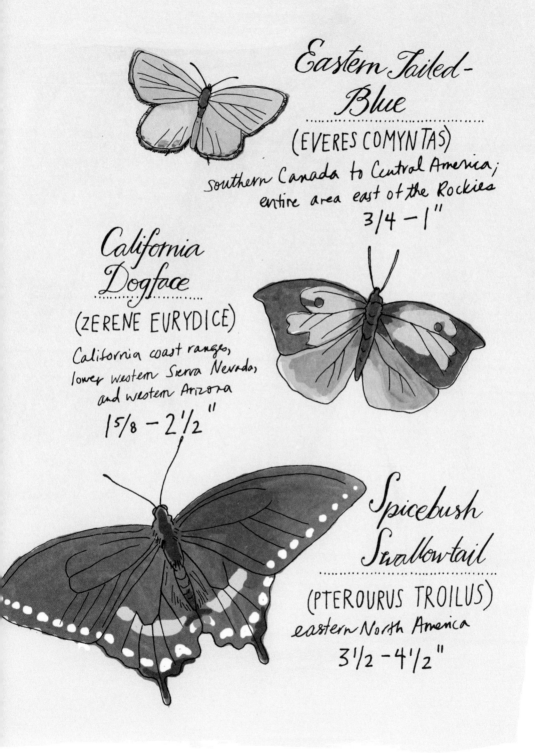

Eastern Tailed-Blue
(EVERES COMYNTAS)
southern Canada to Central America;
entire area east of the Rockies
3/4 – 1"

California Dogface
(ZERENE EURYDICE)
California coast ranges,
lower western Sierra Nevada,
and western Arizona
1 5/8 – 2 1/2"

Spicebush Swallowtail
(PTEROURUS TROILUS)
eastern North America
3 1/2 – 4 1/2"

Zebra Longwing

(HELICONIUS CHARITONIUS)

South America through Central America, southern Texas, peninsular Florida, sometimes New Mexico, Nebraska + South Carolina

3 - 3 3/8"

Malachite

(SIPROETA STELENES)

Central America, Mexico to southern Florida and south Texas

3 1/3 - 3 7/8"

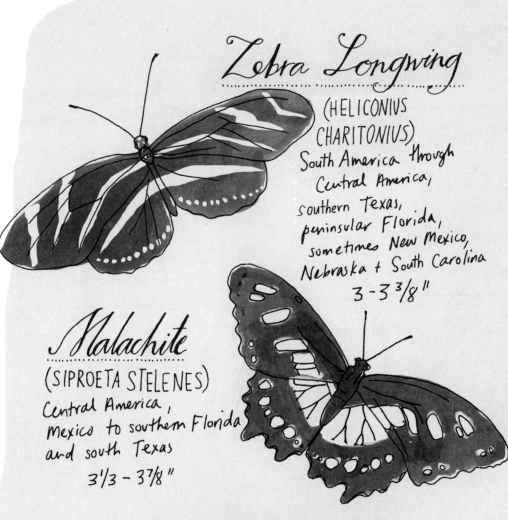

White Checkered Skipper

(PYRGUS ALBESCENS)

southern California, southern Arizona, southern New Mexico, west + south Texas, Florida, Mexico

1 - 1 1/2"

Buckeye
(JUNONIA COENIA)

southern Manitoba, Ontario, Quebec, Nova Scotia - all over US except northwest

1 3/4 - 2 3/4"

Ruddy Daggerwing

Brazil through Central America; Mexico to south Florida. Rarely in Arizona, Colorado, Nebraska, Kansas, south Texas

(MARPESIA PETREUS)

2 5/8 - 2 7/8"

Sara Orangetip
(ANTHOCHARIS SARA)

Alaska coast south to Baja, CA - west of Pacific Divide

1 - 1 1/2"

🌿 COLORFUL MOTHS 🌿

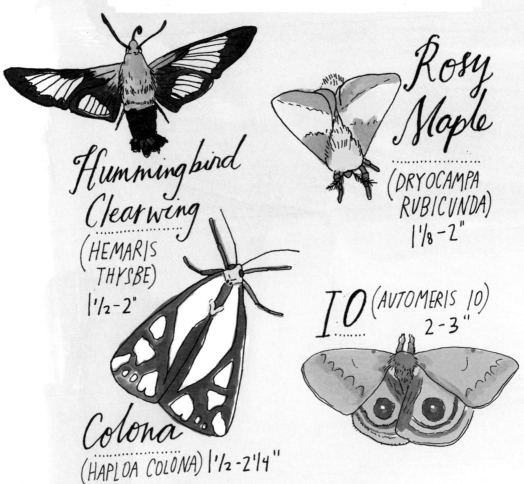

Hummingbird Clearwing (HEMARIS THYSBE) 1½-2"

Rosy Maple (DRYOCAMPA RUBICUNDA) 1⅛-2"

Colona (HAPLOA COLONA) 1½-2¼"

IO (AUTOMERIS IO) 2-3"

BUTTERFLY
- active during the day
- uses sight to find mate
- can't hear
- uses sun for warmth
- makes hanging chrysalis

VS.

MOTH
- nocturnal
- uses smell to find mate
- has ears
- flies for warmth
- makes a cocoon

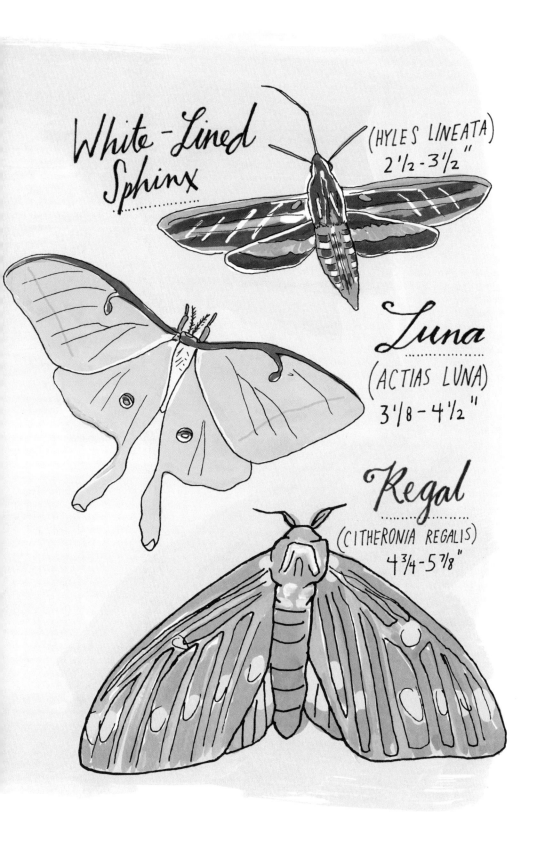

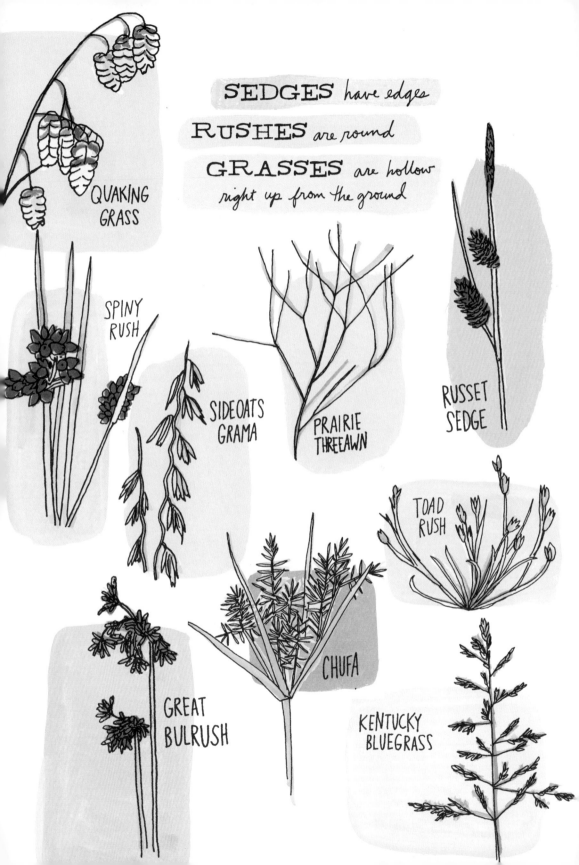

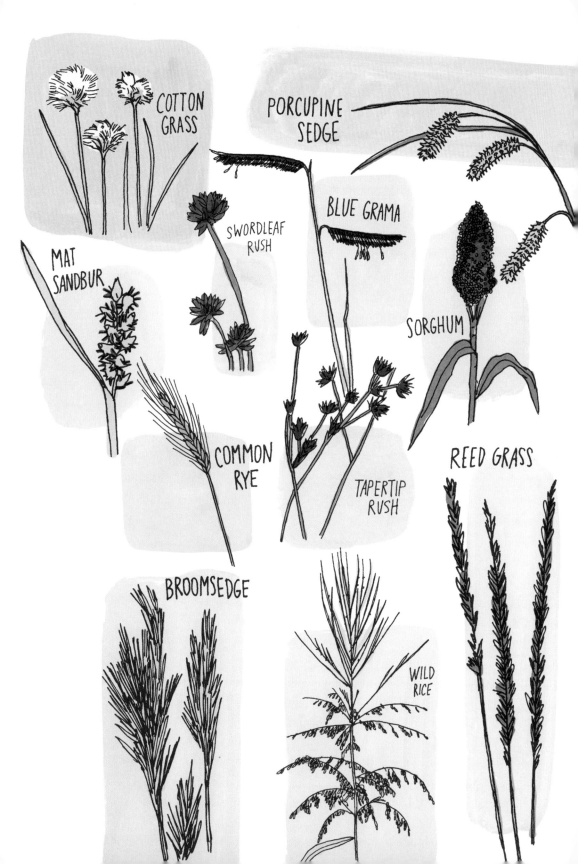

GRAZING EDIBLES

Young Chicory

Early spring shoots are good raw and the roots can be roasted for a coffee substitute.

Miner's Lettuce

The nutritious, succulent leaves are delicious in raw salads.

Violet

Young leaves are tasty and the pretty flowers can be candied or eaten raw.

Young Dandelion

Use small leaves from the center of the whorl and serve raw or lightly steamed.

Lamb's-Quarters

Packed with nutrients. Use this prolific wild plant just like spinach.

Red Clover

High in protein, the leaves are good as a cooked green and the flowers make a nice tea.

Mullein

Tea from the flowers and leaves is good for coughs and other lung problems.

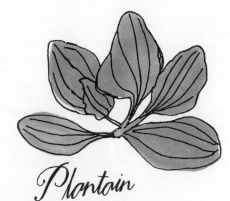

Plantain

Blanch the young leaves. Seeds can be ground into a nutritious meal and added to breads.

Yarrow

Flowers make an aromatic tea. Leaves can be used in place of hops for beer making.

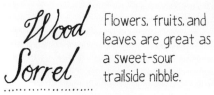

Wood Sorrel

Flowers, fruits, and leaves are great as a sweet-sour trailside nibble.

FIVE RULES FOR GRAZING WILD EDIBLES

1. MID-SPRING IS THE BEST SEASON FOR FINDING DELICIOUS, NUTRIENT-RICH WILD GREENS.

2. PICK ONLY A SMALL PERCENTAGE OF ANY PATCH OF PLANTS SO YOU CAN COME BACK EVERY YEAR.

3. STICK TO AREAS WHERE THE SOIL HASN'T BEEN CONTAMINATED BY PRIOR INDUSTRIAL OR COMMERCIAL USE.

4. CHECK LOCAL REGULATIONS ABOUT FORAGING AND ASK PROPERTY OWNERS FOR PERMISSION.

And most important:

5. SOME POISONOUS SPECIES RESEMBLE EDIBLE ONES, SO <u>NEVER</u> EAT ANYTHING THAT YOU CAN'T IDENTIFY WITH 100% ACCURACY.

Jenny Kendler's Gorgonzola-Stuffed Daylily Buds

- DAYLILY BUDS (CHOOSE <u>UNOPENED</u> BUT MATURE BUDS, 2½–3½" LONG)
- OLIVE OIL
- GORGONZOLA CHEESE, OR A BLUE CHEESE OF YOUR CHOICE (CHOOSE A LOCAL CHEESE IF POSSIBLE)
- FRESH CRACKED PEPPER

Preheat oven/toaster oven to 400°F. Arrange buds on a baking sheet that has been lightly coated with olive oil. Gently open each daylily bud and stuff with cheese, closing the petals back up as best as possible. Brush the stuffed lilies with a touch more olive oil, cracking fresh pepper generously over the tops. Bake until cheese begins to brown and bubble out. Serve hot, and enjoy this elegant, wild-harvested treat with friends.

🌿 INCREDIBLE INSECTS 🌿
AND BUGS ABOUNDING

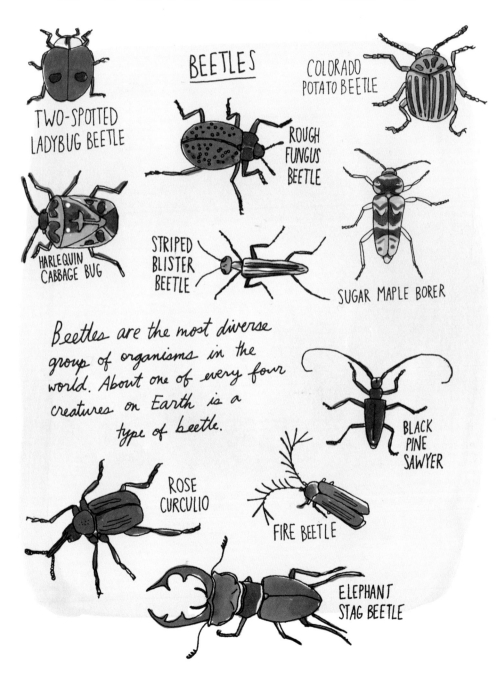

BEETLES

- TWO-SPOTTED LADYBUG BEETLE
- ROUGH FUNGUS BEETLE
- COLORADO POTATO BEETLE
- HARLEQUIN CABBAGE BUG
- STRIPED BLISTER BEETLE
- SUGAR MAPLE BORER
- BLACK PINE SAWYER
- ROSE CURCULIO
- FIRE BEETLE
- ELEPHANT STAG BEETLE

Beetles are the most diverse group of organisms in the world. About one of every four creatures on Earth is a type of beetle.

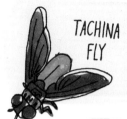

TACHINA FLY — The larvae are parasitoids that develop inside the body of other insects, eventually killing their hosts.

ALUTACEA BIRD GRASSHOPPER — It can jump up to 20 times the length of its body — the equivalent of a 6-foot-tall man jumping 120 feet.

SCARLET-AND-GREEN LEAFHOPPER — They are covered with tiny hairs and secrete a liquid over their bodies that acts as a water repellent and contains pheromones.

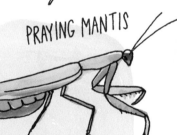

PRAYING MANTIS — The female mantis sometimes bites the head off her mate during copulation.

TRUE KATYDID — Katydids get their name from how their song sounds: "Katy did Katy didn't." Katydids lay their eggs in the fall on plants or in the soil, but they don't hatch until spring.

17-YEAR CICADA

Some species of cicadas live underground, feeding on tree roots and emerging in great numbers in 13-17 year cycles. The famously loud mating call made by large groups of males can go over 120 decibels (breaking local noise laws in some areas) and is thought to repel predatory birds.

GIANT DESERT SCORPION

The largest scorpion in North America — attaining a growth of 5.5 inches in length — feeds on lizards and snakes.

PHANTOM CRANE FLY

They seem to disappear when they fly out of any source of light, leaving only their white spots visible.

THORN-MIMIC TREEHOPPER

It camouflages itself as a thorn when sitting on a stem.

SNOW FLEA

This type of springtail has a unique jumping organ that folds beneath the abdomen and can fling the insect 4 inches into the air.

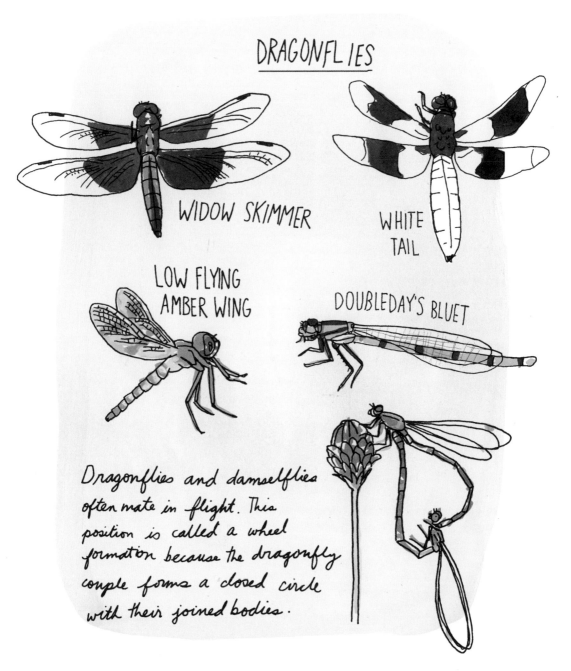

SPECTACULAR SPIDERS

Spiders have been around for at least 500 times longer than humans. They belong to the class Arachnida along with scorpions, ticks, and mites. Unlike insects, spiders have only two major body sections and no antennae.

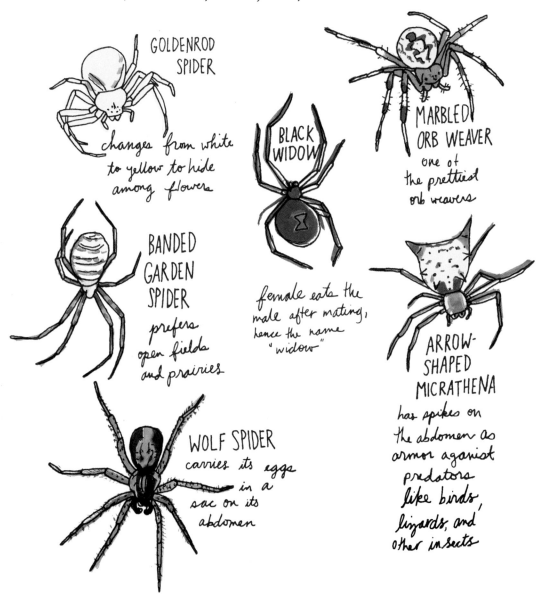

GOLDENROD SPIDER — changes from white to yellow to hide among flowers

BLACK WIDOW — female eats the male after mating, hence the name "widow"

MARBLED ORB WEAVER — one of the prettiest orb weavers

BANDED GARDEN SPIDER — prefers open fields and prairies

ARROW-SHAPED MICRATHENA — has spikes on the abdomen as armor against predators like birds, lizards, and other insects

WOLF SPIDER — carries its eggs in a sac on its abdomen

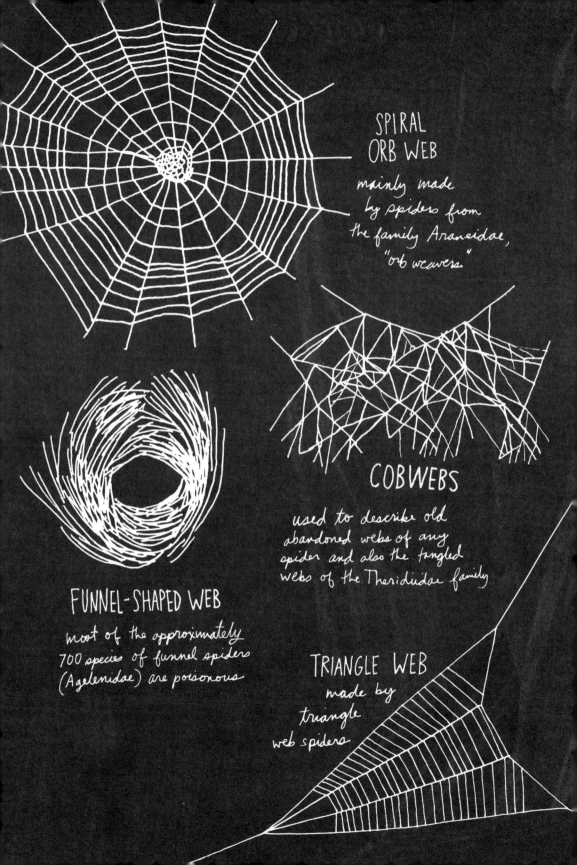

ANATOMY OF AN ANT

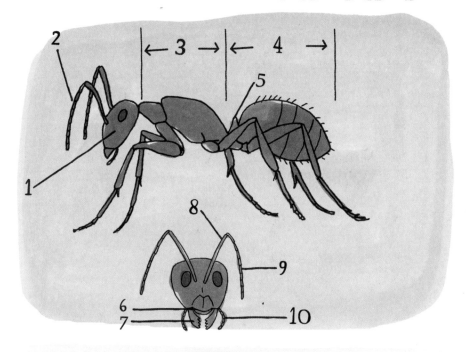

1. **head** - contains the mouth, mandibles, eyes, and antenna
2. **antenna** - used to smell, recognize nest mates, and detect enemies
3. **thorax** - middle region where the three pairs of legs are connected
4. **abdomen or gaster** - contains the vital organs and reproductive parts
5. **petiole** - connects the thorax to the abdomen
6. **labrum** - floor of the mouth
7. **mandible** - used for digging, carrying, and collecting food and building nests
8. **shaft** - base of the antenna
9. **lash** - segmented top of the antenna used for smell
10. **labial palp** - serves the function of a lower lip

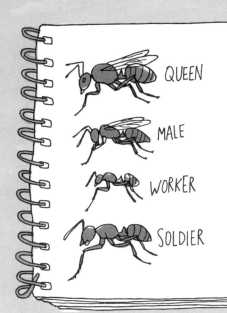

Ants have successfully colonized almost every landmass on earth. They evolved from wasp-like creatures about 120 million years ago and their social structures still resemble those of bee colonies.

ANTS TAKE HONEYDEW FROM APHIDS

At first glance, ants seem to treat their dead in the same way as humans - the carcass is untouched for two days before it is moved because the ants don't recognize the ant as dead until it starts emitting a chemical called oleic acid. Once they pick up that scent, the decaying ant, which now smells foreign, is carted off to the dump pile. The entomologist Edward O. Wilson found that if you put oleic acid on a live ant, the other ants will think it's dead and carry it away.

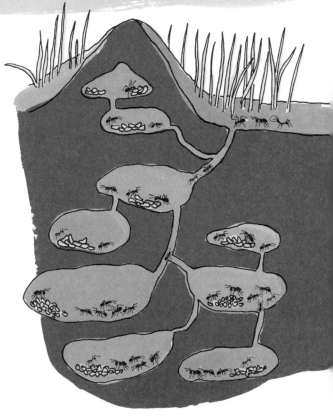

Tree Shapes

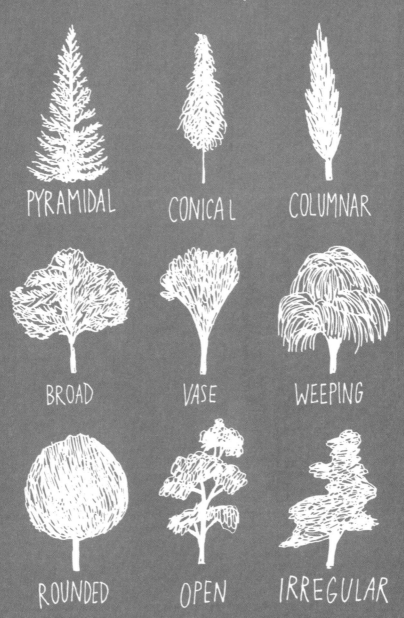

ANATOMY OF A DECIDUOUS TREE

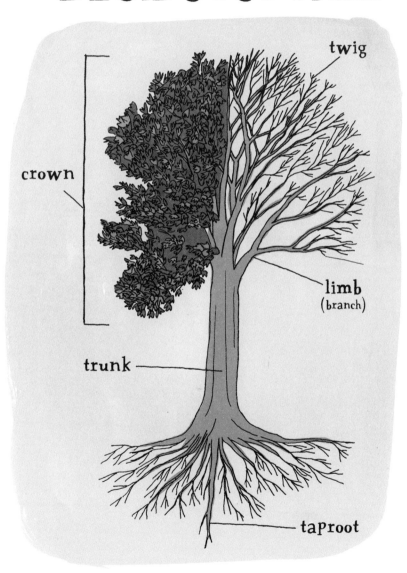

ANATOMY OF A TRUNK

SAPWOOD transports nutrients and water from the roots. This movement of substances is called translocation.

HEARTWOOD is composed of inactive cells, providing structural support at the center of the tree.

CAMBIUM is the actively growing layer where cells multiply quickly, forming either wood or bark.

INNER BARK carries food made in the leaves to the cambium and storage cells.

OUTER BARK has a protective layer of inactive cells.

Dendrochronology

(DETERMINING THE AGE OF A TREE BY COUNTING THE GROWTH RINGS IN A CROSS-SECTION OF ITS TRUNK)

New growth appears as rings in cross-sections of a tree's cambium layer, where one ring usually marks the passage of one year. Trees growing in temperate zones with distinct summers and winters develop the clearest rings. A long, wet growing season will result in trees having wider rings. Dry years create very thin rings.

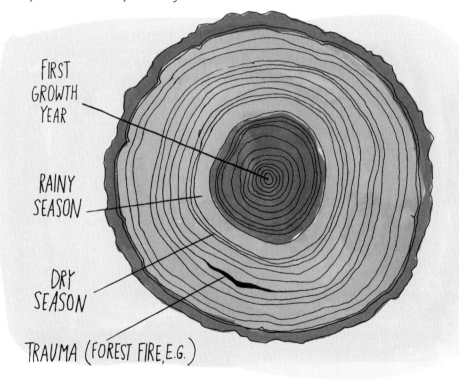

- FIRST GROWTH YEAR
- RAINY SEASON
- DRY SEASON
- TRAUMA (FOREST FIRE, E.G.)

The oldest living tree recorded is named "The Hatch Tree." It was cored to reveal 5,063 rings. It's a Great Basin bristlecone pine located in the White Mountains of California.

LEAF IDENTIFICATION

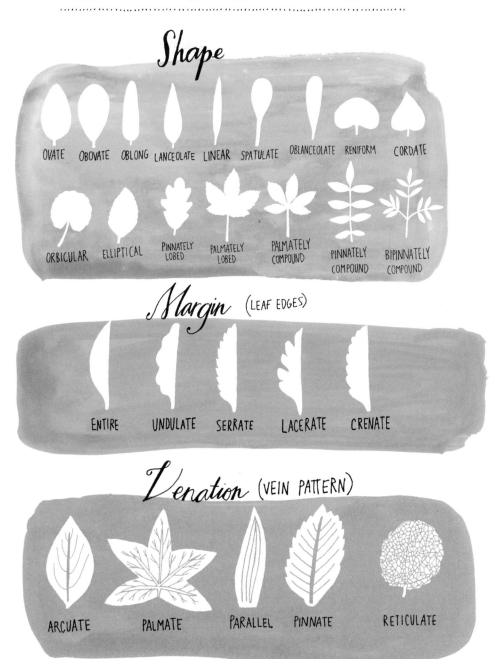

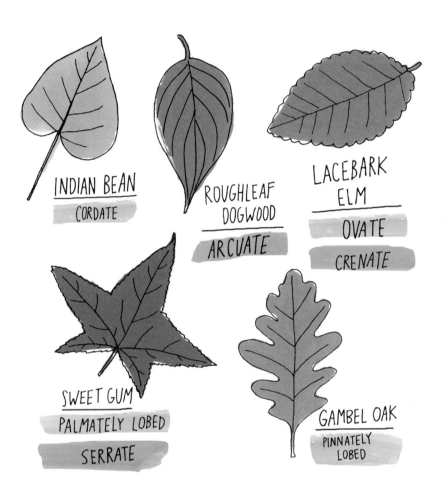

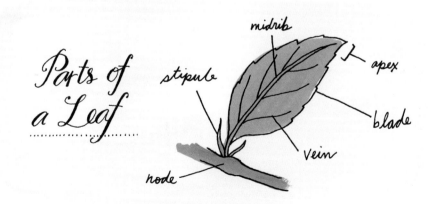

Parts of a Leaf

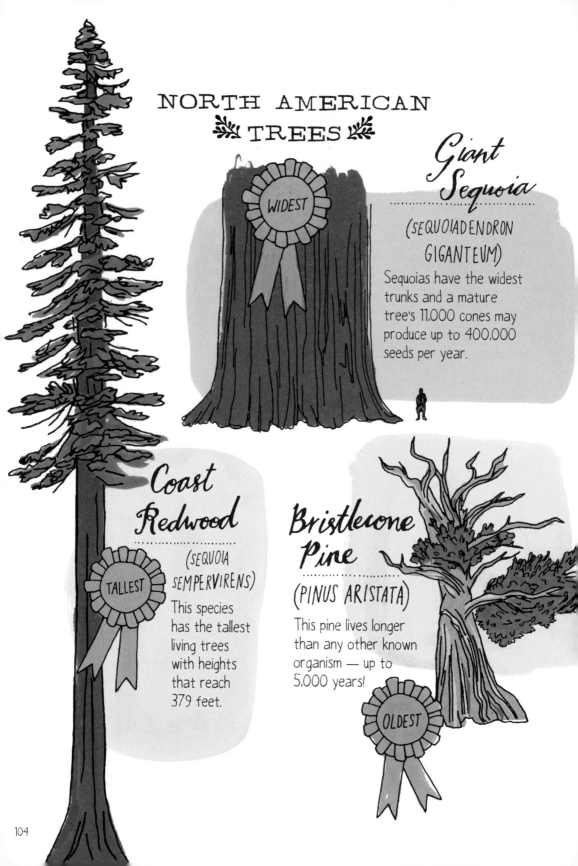

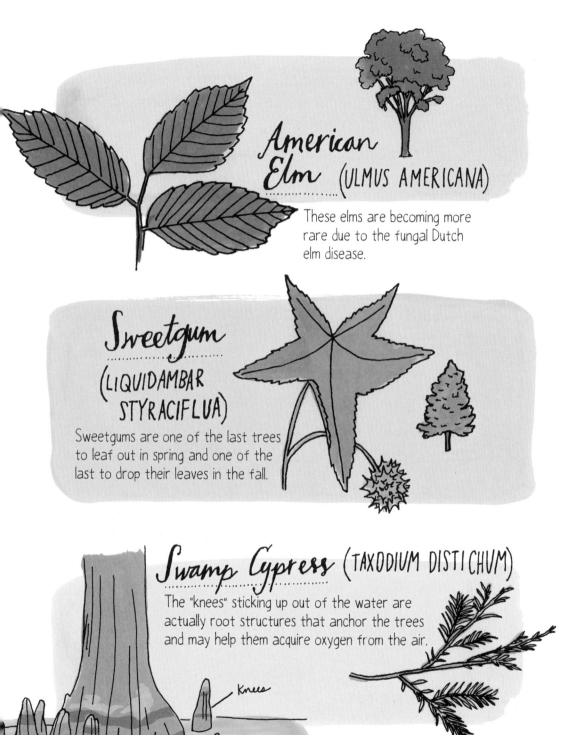

American Elm (ULMUS AMERICANA)

These elms are becoming more rare due to the fungal Dutch elm disease.

Sweetgum (LIQUIDAMBAR STYRACIFLUA)

Sweetgums are one of the last trees to leaf out in spring and one of the last to drop their leaves in the fall.

Swamp Cypress (TAXODIUM DISTICHUM)

The "knees" sticking up out of the water are actually root structures that anchor the trees and may help them acquire oxygen from the air.

knees

Southern Live Oak
(QUERCUS VIRGINIANA)

This is one of the few oaks regularly wider than it is tall.

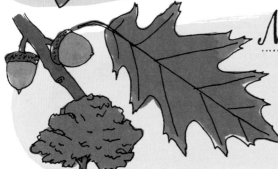

Northern Red Oak
(QUERCUS RUBRA)

Individual trees can live up to 500 years in optimal conditions.

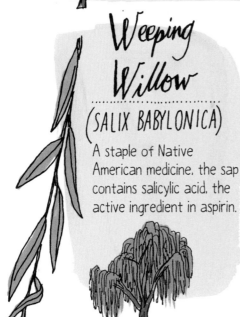

Weeping Willow
(SALIX BABYLONICA)

A staple of Native American medicine, the sap contains salicylic acid, the active ingredient in aspirin.

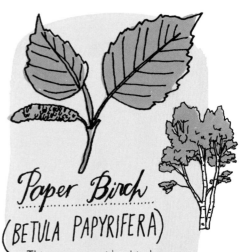

Paper Birch
(BETULA PAPYRIFERA)

This tree provides birch syrup, a sweetener made by boiling down the sap.

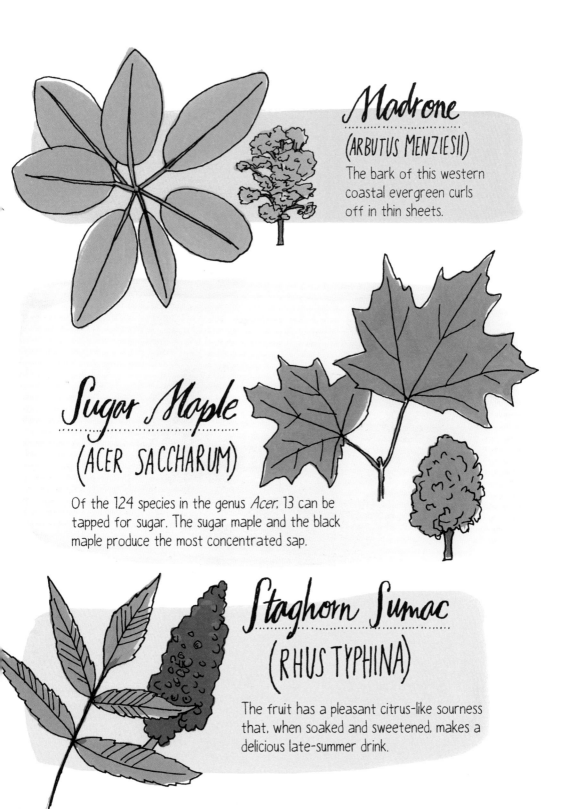

Madrone
(ARBUTUS MENZIESII)
The bark of this western coastal evergreen curls off in thin sheets.

Sugar Maple
(ACER SACCHARUM)
Of the 124 species in the genus *Acer*, 13 can be tapped for sugar. The sugar maple and the black maple produce the most concentrated sap.

Staghorn Sumac
(RHUS TYPHINA)
The fruit has a pleasant citrus-like sourness that, when soaked and sweetened, makes a delicious late-summer drink.

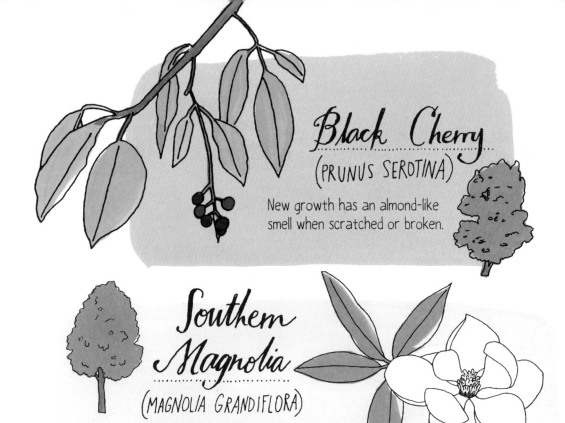

Black Cherry
(PRUNUS SEROTINA)
New growth has an almond-like smell when scratched or broken.

Southern Magnolia
(MAGNOLIA GRANDIFLORA)
The fragrant white flowers can be as big as 12 inches in diameter.

Ginkgo
(GINKGO BILOBA)
The ginkgo is truly unique in that it is the only species of its kind.

Ponderosa Pine
(PINUS PONDEROSA)
This pine tree has evolved to survive brush fires. Bark from furrows in the trunk is said to smell like vanilla.

Black Walnut
(JUGLANS NIGRA)
Black walnut drupes can be used to make yellow and brown dye.

Tamarack
(LARIX LARICINA)
Though it has needles and looks like an evergreen, this tree sheds its yellowing needles in the autumn.

Cliffrose
(COWANIA MEXICANA)
The seeds have long hairs that act like tiny parachutes, aiding in dispersal. On the ground, the wind turns the curved hair into a drill to drive the seed into the soil.

Pacific Yew
(TAXUS BREVIFOLIA)
The chemotherapy drug Taxol is derived from this species.

Eastern Cottonwood
(POPULUS DELTOIDES)

These are one of the largest hardwood trees in North America and typically live to be 70-100 years old.

Northern Catalpa
(CATALPA SPECIOSA)

A midwestern native, this medium-sized tree is often planted ornamentally.

Red Mangrove
(RHIZOPHORA MANGLE)

These trees thrive in coastlines and salty swamps where other species can't survive. Their seeds become fully formed mature plants before dropping off the tree.

Black Locust
(ROBINIA PSEUDOACACIA)

Paired leaflets form 6- to 12-inch-long leaves that close up at night.

American Holly
(ILEX OPACA)

Only female trees produce the famous berries used in holiday decoration.

Fireberry Hawthorn
(CRATAEGUS CHRYSOCARPA)

Its shrubby growth provides shelter for small birds. The fruit can be dried, or used for pies or jams.

Faxon Yucca
(YUCCA FAXONIANA)

This desert dweller has spiked leaves up to 4½ feet long and a flower head of creamy blossoms as long as two feet.

🌿 BEAUTIFUL BARK 🌿

Shagbark Hickory
(CARYA OVATA)

Flowering Dogwood
(CORNUS FLORIDA)

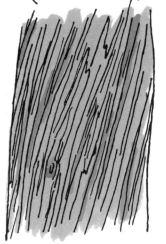

Northern White Cedar
(THUJA OCCIDENTALIS)

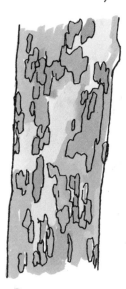

Sycamore
(PLATANUS OCCIDENTALIS)

Hercules' Club
(ZANTHOXYLUM CLAVA-HERCULIS)

White Poplar
(POPULUS ALBA)

Winged Elm
(ULMUS ALATA)

Hackberry
(CELTIS OCCIDENTALIS)

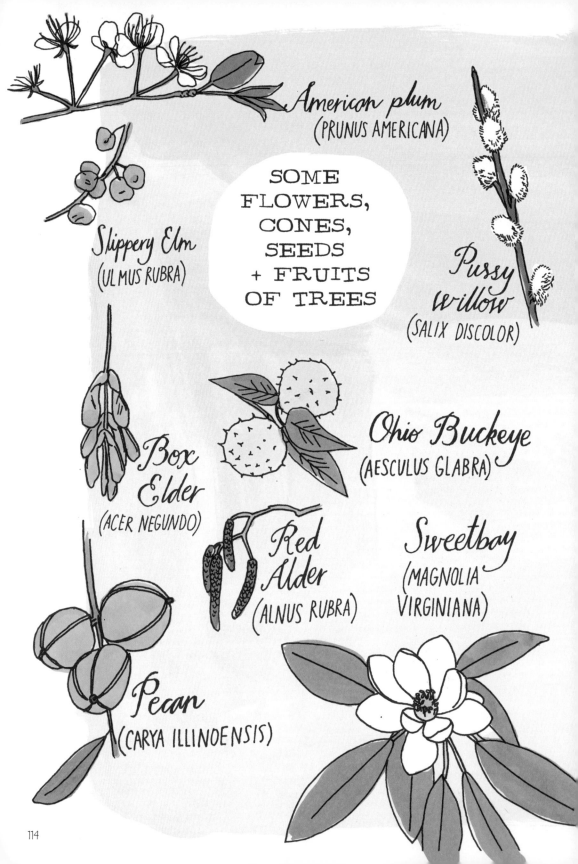

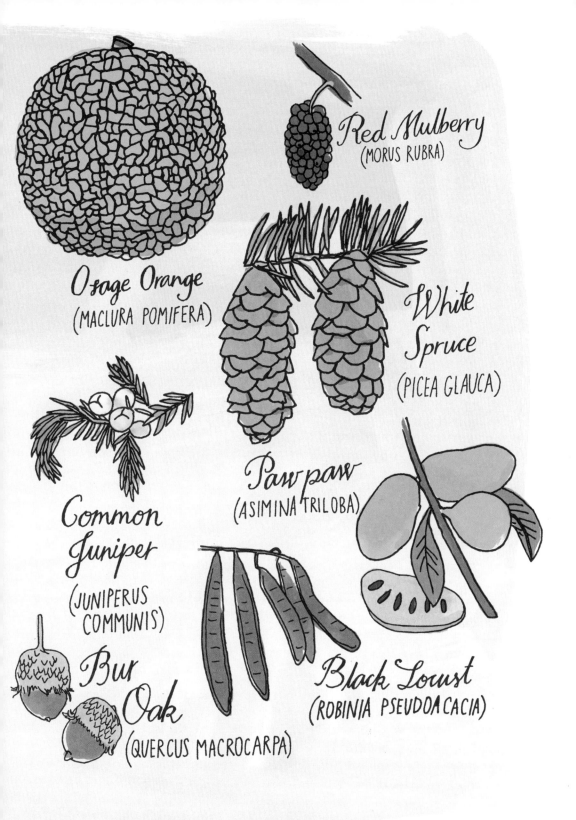

Printing Patterns

TOOLS

- Brayer
- Printing ink
- Palette
- Paper or fabric to print on
- Scratch paper

INSTRUCTIONS

Collect interesting leaves, twigs, plants, flowers. Make sure not to pick endangered species or take too much of one plant.

Pour some ink on your palette, then roll the roller back and forth through the ink until it's evenly covered. It should make a sticky noise.

Place your leaf on a piece of scratch paper and directly roll over it with the brayer. Cover the entire surface as evenly as you can.

Press the ink-covered object onto the paper or fabric, pressing down on the entire surface to ensure it transfers. Peel it back slowly to reveal your print.

TIPS

Experiment with pressure. Sometimes it's nicer to have a very faint print than a mushy thick one. Try pressing the paper on to the inked objects instead and see if the result differs.

Play with the design: use lots of objects in the same color or one object in several different colors, or create a repeating pattern.

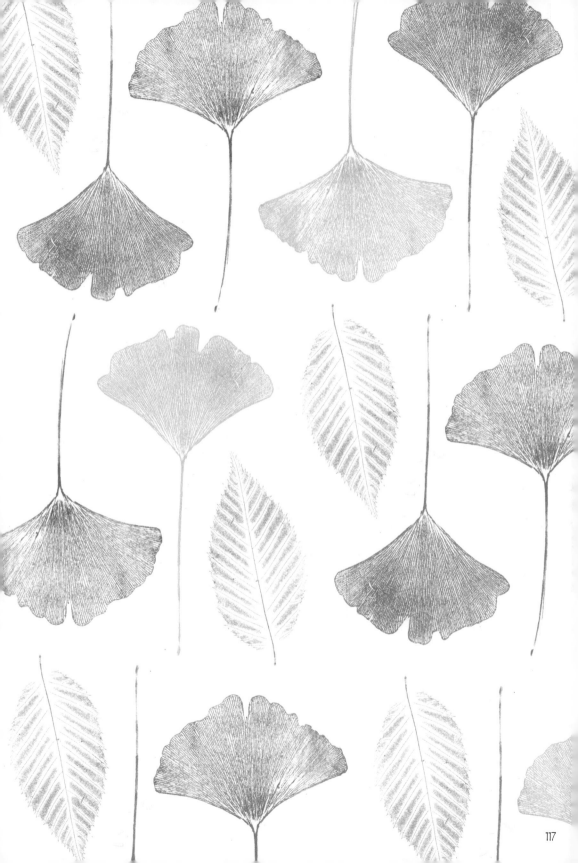

ANATOMY OF A FERN

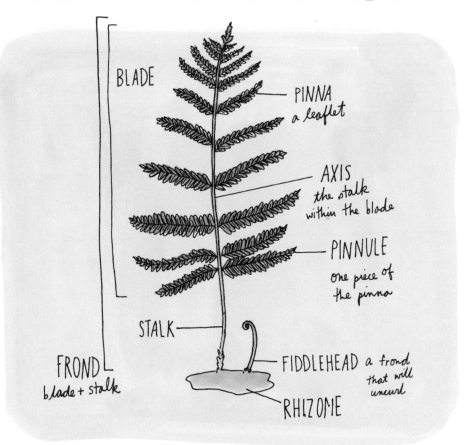

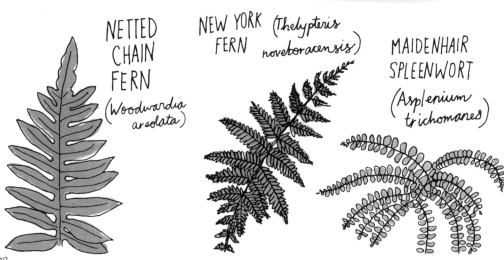

🌿 PRETTY, PRETTY LICHEN 🌿

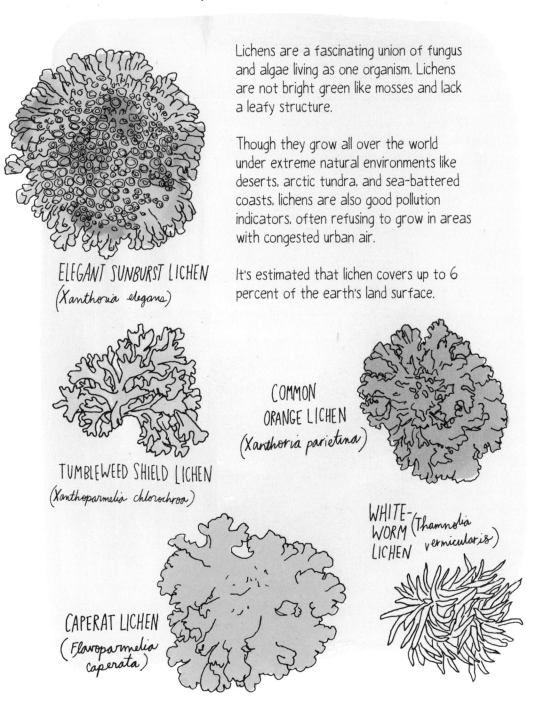

Lichens are a fascinating union of fungus and algae living as one organism. Lichens are not bright green like mosses and lack a leafy structure.

Though they grow all over the world under extreme natural environments like deserts, arctic tundra, and sea-battered coasts, lichens are also good pollution indicators, often refusing to grow in areas with congested urban air.

It's estimated that lichen covers up to 6 percent of the earth's land surface.

ELEGANT SUNBURST LICHEN (Xanthoria elegans)

TUMBLEWEED SHIELD LICHEN (Xanthoparmelia chlorochroa)

COMMON ORANGE LICHEN (Xanthoria parietina)

CAPERAT LICHEN (Flavoparmelia caperata)

WHITE-WORM LICHEN (Thamnolia vermicularis)

🌿 MYSTERIOUS MOSSES 🌿

Mosses are small, spore-producing plants with simple leaves and no flowers or seeds. They don't even have proper roots to collect moisture and nutrients. Mosses grow in clumps in shady and moist locations. You can often find them on the north-facing sides of trees.

Tiny insects like mites and springtails are drawn to the scent of moss and help spread its spores.

Tons of sphagnum moss were used in World War I to treat wounds as surgical dressing. Sphagnum can absorb up to 20 times its dry weight in moisture.

STAR MOSS
(*Atrichum angustatum*)

TREE MOSS
(*Climacium americanum*)

SPOON-LEAVED MOSS
(*Bryoandersonia illecebra*)

PINCUSHION MOSS
(*Leucobryum glaucum*)

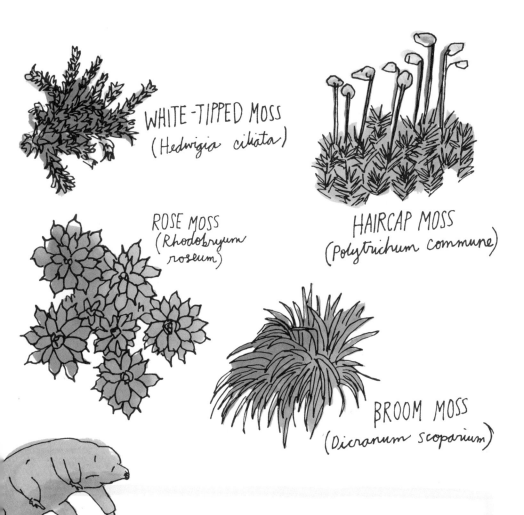

WATERBEARS

Waterbears (also called tardigrades) are eight-legged micro-animals that often live and feed on mosses and lichens. Waterbears may be the most adaptable animals in the world. They can live within a temperature range of -300°F to 300°F, can be dried out to three percent water, survive 6,000 atmospheres of pressure, withstand radiation bombardment at levels that would kill any other animal, and survive the harsh environment of outer space. Plus they're kind of cute!

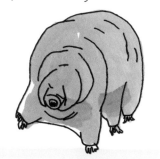

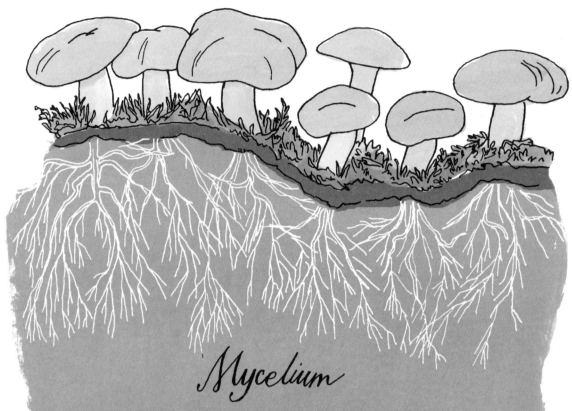

Mycelium

Fungi absorb nutrients through vast underground networks of white branching threads called mycelium. Though hidden in the soil and sometimes mistaken for roots, mycelium is actually the proper body of a fungus. Mushrooms are the fruit, appearing only when conditions for spreading their spores are just right.

Mycelium plays a vital role in the decomposition of plant material but also can form a symbiotic relationship, called mycorrhiza, with the roots of a plant. Most plants depend on mycorrhiza to absorb phosphorus and other nutrients. In exchange, fungi gain constant access to the plants' carbohydrates.

A patch of mycelium in eastern Oregon estimated to be the size of 1,665 football fields and 2,200 years old, is a contender for the title of world's largest and oldest organism.

ANATOMY OF A MUSHROOM

- cap
- gills
- annulus (ring)
- stipe (stem)
- volva

Life Cycle of a Mushroom

- spores
- spore germination
- mycelium
- pinhead
- primordium
- fruiting body

🌿 MARVELOUS 🌿 MUSHROOMS

SLIPPERY JACK
(Suillus luteus)

Instead of gills, these mushrooms have spore-dispersing tubes on their undersides.

FLY AGARIC
(Amanita muscaria)

Luckily, this is one of the most easily recognizable fungi because it's fatally poisonous if eaten.

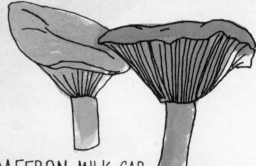

SAFFRON MILK CAP
(Lactarius deliciosus)

This orange edible becomes a dull green when bruised or old.

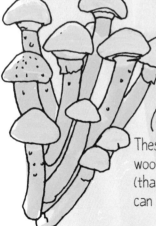

HONEY MUSHROOMS
(Armillaria mellea)

These grow in clusters on decaying wood. Its mycelia are bioluminescent (that is, they glow in the dark) and can be harmful to living trees.

OYSTER MUSHROOM
(Pleurotus ostreatus)

This choice edible mushroom grows in clusters, attached to trees like ears.

VIOLET CORT
(*Cortinarius violaceus*)

Edible, but not choice, this one is more admired for its beautiful color.

RAVENEL'S STINKHORN
(*Phallus ravenelii*)

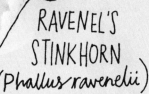

It emits a slime that smells of rotting meat to attract flies and beetles for spore dispersal.

SHAGGY CHANTERELLE
(*Gomphus floccosus*)

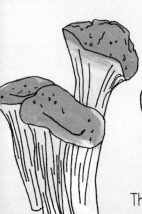

This one can be toxic.

WITCH'S BUTTER
(*Tremella mesenterica*)

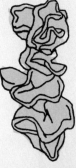

Edible but not very appealing, it can appear greasy and slimy and is sometimes called "yellow brain."

HEN OF THE WOODS
(*Grifola frondosa*)

This tasty species grows in clumps at the base of oaks. Also called maitake.

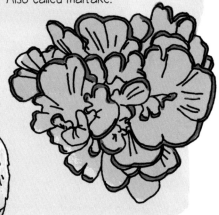

INKY CAP
(*Coprinopsis atramentaria*)

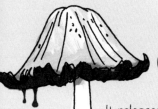

It releases a liquid that can be used as ink. Edible but causes acute sensitivity to alcohol.

ROTTING LOG

A dead tree on the forest floor may not look like much, but the decomposing wood hosts a party of plant and animal life. Many kinds of insect larvae burrow into decaying wood to take shelter from the winter. Snails and slugs delight in the debris and fungi growing from rotting logs. Earthworms digest vast quantities of rotting organic matter, leaving behind nutrient-rich casts. Moist decomposing wood is a perfect nutrient nursery from which lichens, mosses, flowers, and even other trees can set root and thrive.

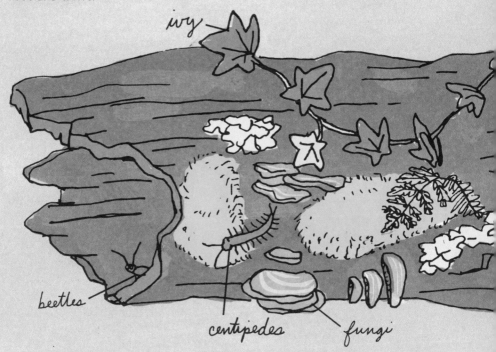

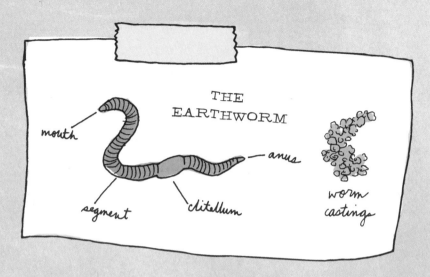
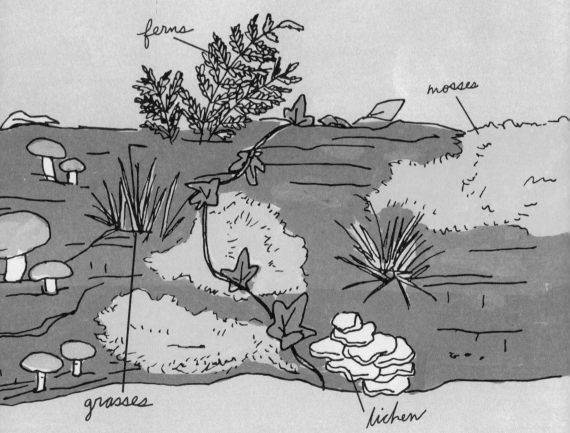

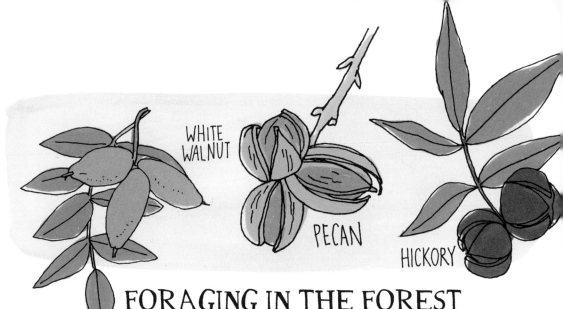

FORAGING IN THE FOREST

The ancient practice of foraging in the forest for nuts, berries, and mushrooms is enjoying a resurgence, and fiddlehead ferns and wild ramps can now be found in many farmers' markets. Other forest edibles include acorns, balsam and spruce (inner bark), dogwood (berries), and chokeberry.

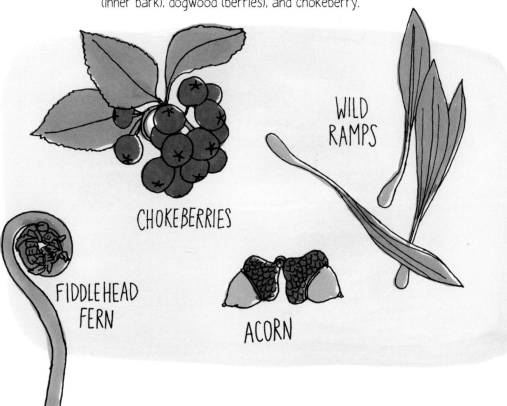

Dry-Sautéed Bolete with Yellow Wood Sorrel and Thyme

1 POUND FRESH KING BOLETE MUSHROOMS

2 TABLESPOONS BUTTER

1 OUNCE WHITE WINE

1 SPRIG CHOPPED THYME

LEAVES AND FLOWERS OF WILD YELLOW WOOD SORREL

SALT AND PEPPER

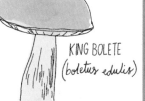

KING BOLETE (boletus edulis)

Fresh mushrooms can become mushy when cooked. Dry-sauteeing leaves them beautifully browned and brings out their natural flavor and texture. It couldn't be simpler:

Gently clean dirt from the fungi with a soft pastry brush. Do not wash them unless absolutely necessary, and then only in a bit of cold water or with a damp cloth.

Slice the mushrooms 1/3" thick and place the pieces flat on a completely dry frying pan at medium-high heat. Stir occasionally to avoid sticking. Once the mushrooms are browned and most of the juices have evaporated, add the butter, wine, and thyme to the pan. Stir and cook for another couple of minutes as the mushrooms absorb the liquid.

Remove from heat and top with tangy flowers and leaves of yellow wood sorrel (there's probably some growing in your yard!). Salt and pepper to taste. Serve atop risotto or pasta.

ANIMALS IN THE NEIGHBORHOOD

Woodchuck

Woodchucks (or groundhogs) can climb trees if they need to escape.

Raccoon

Raccoons have 5 fingers but no thumbs on their highly sensitive paws. They are excellent swimmers.

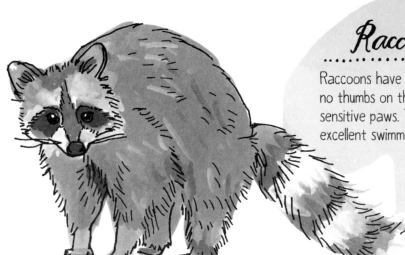

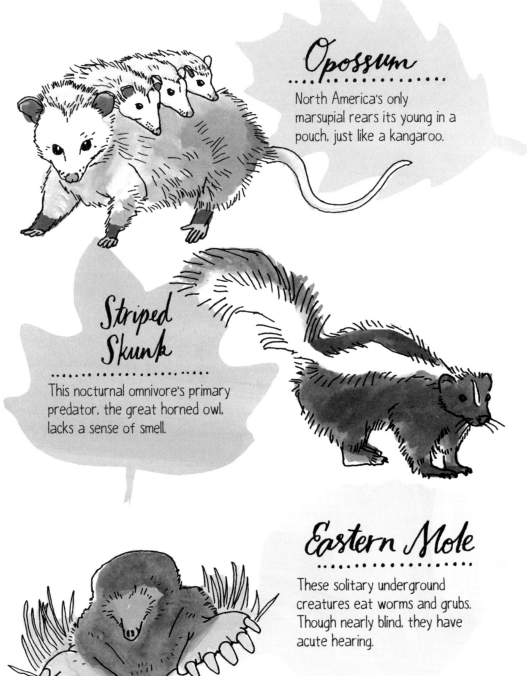

Opossum

North America's only marsupial rears its young in a pouch, just like a kangaroo.

Striped Skunk

This nocturnal omnivore's primary predator, the great horned owl, lacks a sense of smell.

Eastern Mole

These solitary underground creatures eat worms and grubs. Though nearly blind, they have acute hearing.

ANATOMY OF A BAT

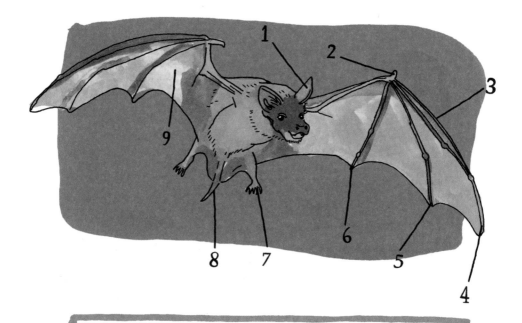

1. ear
2. thumb
3. second finger
4. third finger
5. fourth finger
6. fifth finger
7. foot
8. tail
9. membrane

Bats are the only mammals capable of true flight.

COMMON NORTH AMERICAN BATS

Twenty percent of all classified mammals are bats, with over 1,000 species identified. Insect-eating bats emit ultrasonic sounds to pinpoint with astonishing accuracy the location of their prey. Most larger bats consume fruit, helping to disperse seeds and pollen. There are three species of vampire bats that feed on the blood of animals, but they are rare.

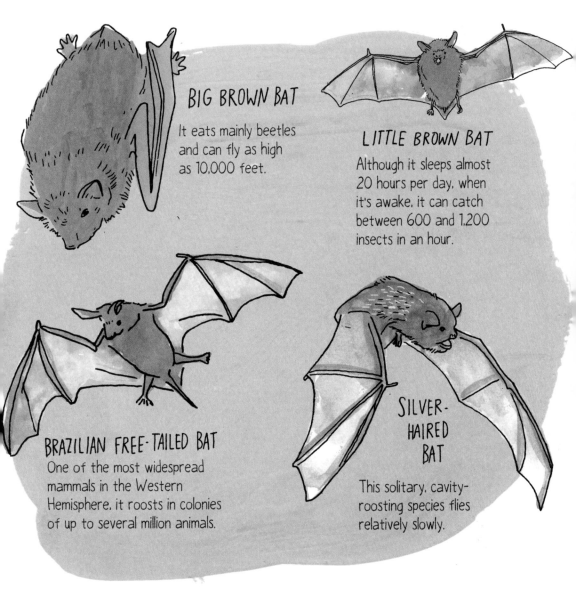

BIG BROWN BAT
It eats mainly beetles and can fly as high as 10,000 feet.

LITTLE BROWN BAT
Although it sleeps almost 20 hours per day, when it's awake, it can catch between 600 and 1,200 insects in an hour.

BRAZILIAN FREE-TAILED BAT
One of the most widespread mammals in the Western Hemisphere, it roosts in colonies of up to several million animals.

SILVER-HAIRED BAT
This solitary, cavity-roosting species flies relatively slowly.

🌿 TREE SQUIRRELS 🌿

These squirrels are one of the very few mammals that can descend a tree headfirst.

Eastern Gray Squirrel

American Red Squirrel

Though their primary diet is pine and spruce cones, they also eat mushrooms, buds and flowers, and even bird eggs.

Not true fliers, these nocturnal squirrels glide downward between trees, gaining lift from flaps of skin on their sides. Most "flights" are 30 feet or less, but some flying squirrels have been observed gliding nearly 300 feet!

Northern Flying Squirrel

🌿 GROUND SQUIRRELS 🌿

Yellow-Bellied Marmot

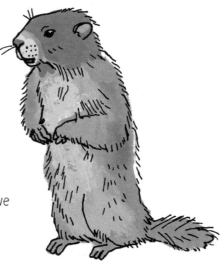

Rather than dig burrows, marmots live in rocky piles in mountainous areas.

Prairie dogs and marmots post sentinels by their burrows to spot predators. Warning calls and whistles identify whether a snake or a hawk is approaching.

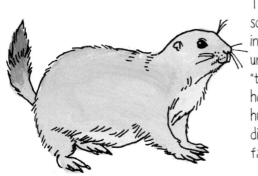

These extremely social animals live in elaborate underground "towns" that may house several hundred individuals divided into small family groups.

Black-Tailed Prairie Dog

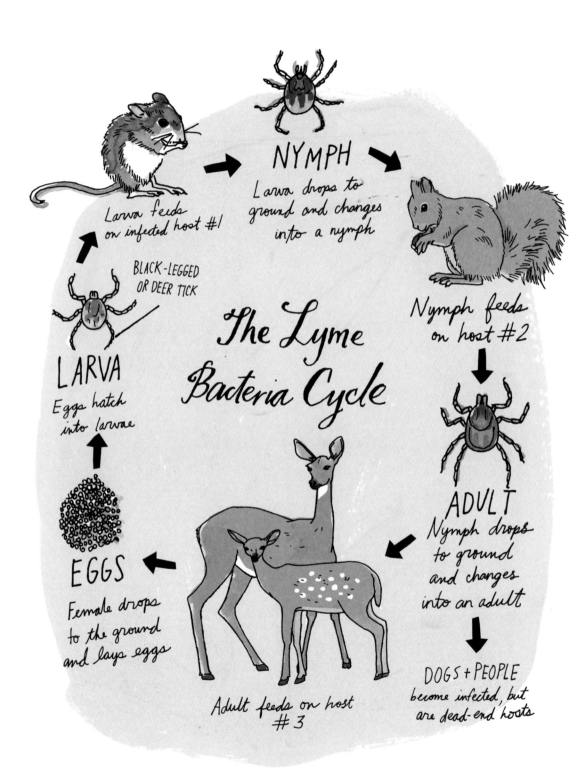

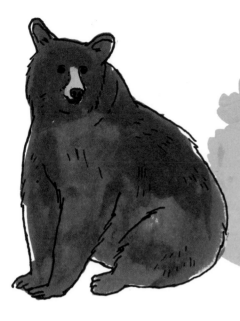

Black Bear

- weighs between 100 and 600 pounds
- upright ears
- flat shoulder
- rump higher than shoulder
- rounded (convex) profile

VS.

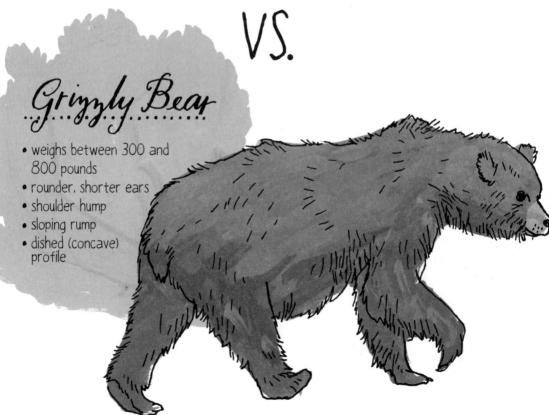

Grizzly Bear

- weighs between 300 and 800 pounds
- rounder, shorter ears
- shoulder hump
- sloping rump
- dished (concave) profile

❧ THE ANIMAL UNDERGROUND ❧

Bushy-Tailed Woodrat
With a fondness for shiny objects, these woodrats sometimes pick up a bottle cap, coin, or bit of foil over food.

Plains Pocket Gopher
This subterranean dweller has large cheek pouches for carrying food and long teeth that are visible even when its mouth is closed.

Badger
Badgers are such strong burrowers that they can dig themselves into underground hiding within moments of any threat.

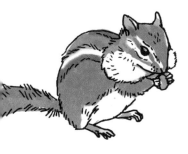

Chipmunks pack food into their expandable cheek pouches and carry it back to their lairs. They dig extensive burrows with "rooms" separated by function: bedroom, pantry, latrine, nursery.

Eastern Chipmunk

This is the smallest and also the most widespread North American chipmunk. They don't hibernate but go into a state of torpor, or decreased physiological activity, for extended periods of time.

Least Chipmunk

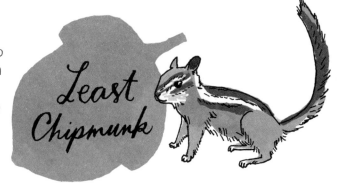

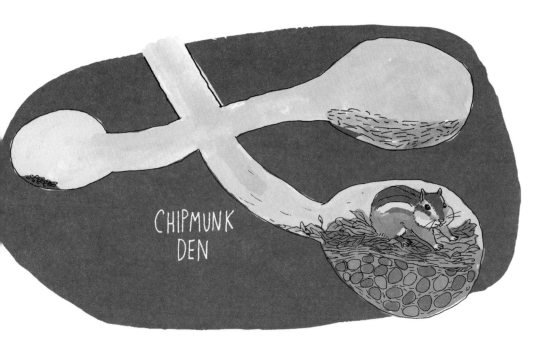

CHIPMUNK DEN

SNAKES

GARTER

COTTONMOUTH

COPPERHEAD

MUD SNAKE

SCARLET SNAKE

WESTERN RATTLESNAKE

■ = venomous

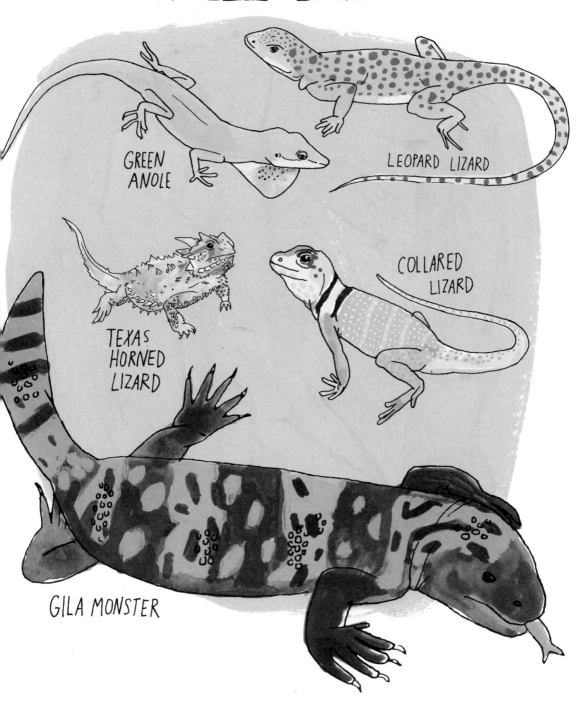

🌿 WILD CATS 🌿

Mountain Lion

More closely related to the domestic cat than the lion, the mountain lion's range extends from northern Canada to southern South America.

Lynx

In the snowy north, a lynx's paw may be larger than a human's hand.

Bobcat

Named for its stubby tail, the bobcat is smaller than its northern lynx cousin and lacks the distinctive ear tufts.

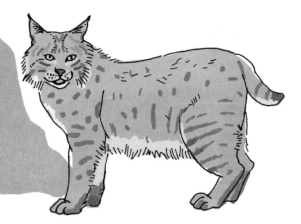

WILD DOGS

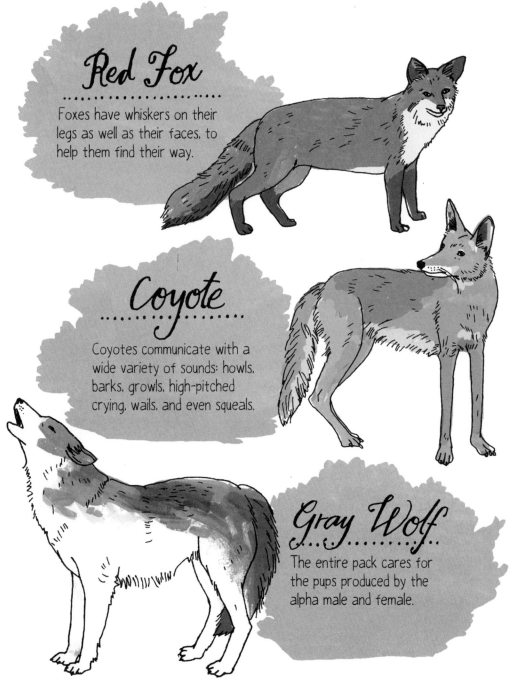

Red Fox
Foxes have whiskers on their legs as well as their faces, to help them find their way.

Coyote
Coyotes communicate with a wide variety of sounds: howls, barks, growls, high-pitched crying, wails, and even squeals.

Gray Wolf
The entire pack cares for the pups produced by the alpha male and female.

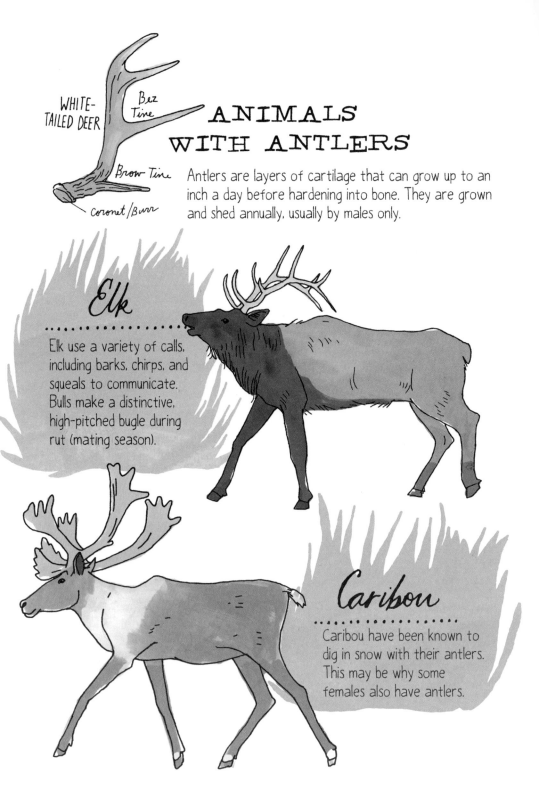

ANIMALS WITH ANTLERS

WHITE-TAILED DEER — Bez Tine, Brow Tine, Coronet/Burr

Antlers are layers of cartilage that can grow up to an inch a day before hardening into bone. They are grown and shed annually, usually by males only.

Elk

Elk use a variety of calls, including barks, chirps, and squeals to communicate. Bulls make a distinctive, high-pitched bugle during rut (mating season).

Caribou

Caribou have been known to dig in snow with their antlers. This may be why some females also have antlers.

...AND HORNS

Horns are permanent appendages with a bony core covered by keratin. They are typically grown by both males and females and have rings that show the animal's age.

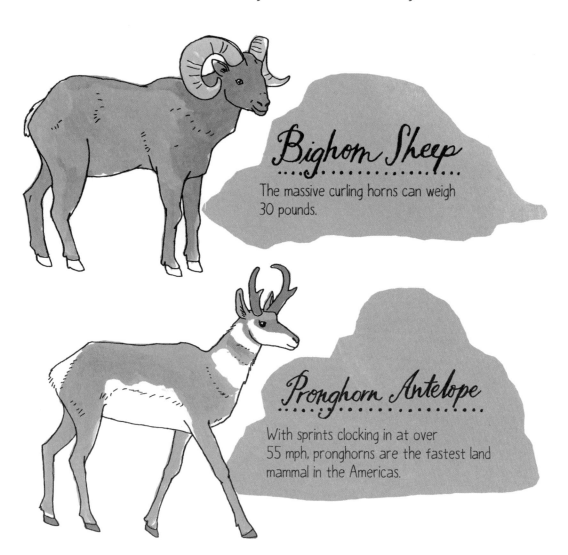

Bighorn Sheep
The massive curling horns can weigh 30 pounds.

Pronghorn Antelope
With sprints clocking in at over 55 mph, pronghorns are the fastest land mammal in the Americas.

AQUATIC MAMMALS

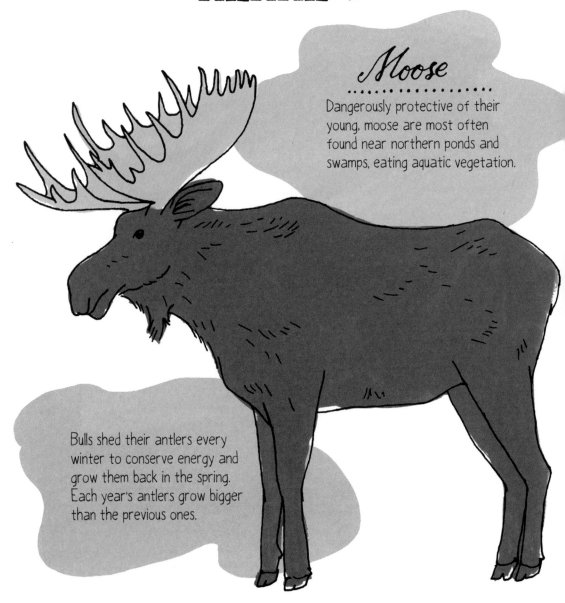

Moose

Dangerously protective of their young, moose are most often found near northern ponds and swamps, eating aquatic vegetation.

Bulls shed their antlers every winter to conserve energy and grow them back in the spring. Each year's antlers grow bigger than the previous ones.

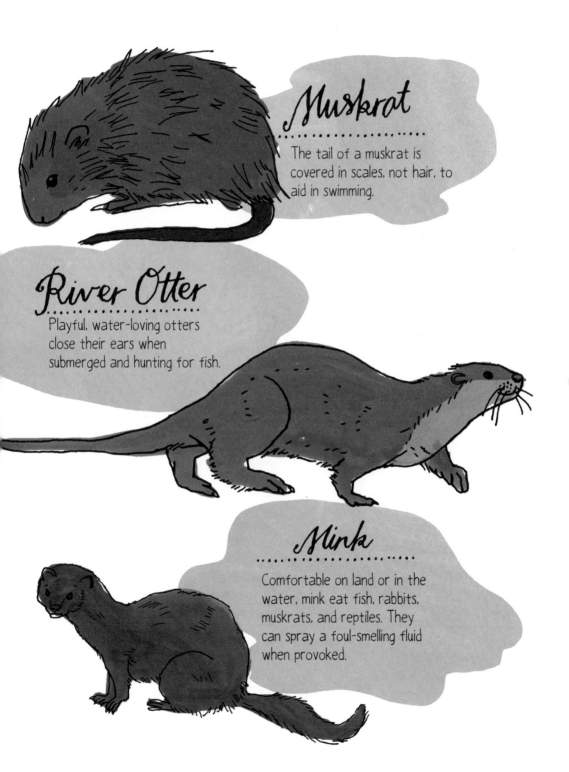

Muskrat

The tail of a muskrat is covered in scales, not hair, to aid in swimming.

River Otter

Playful, water-loving otters close their ears when submerged and hunting for fish.

Mink

Comfortable on land or in the water, mink eat fish, rabbits, muskrats, and reptiles. They can spray a foul-smelling fluid when provoked.

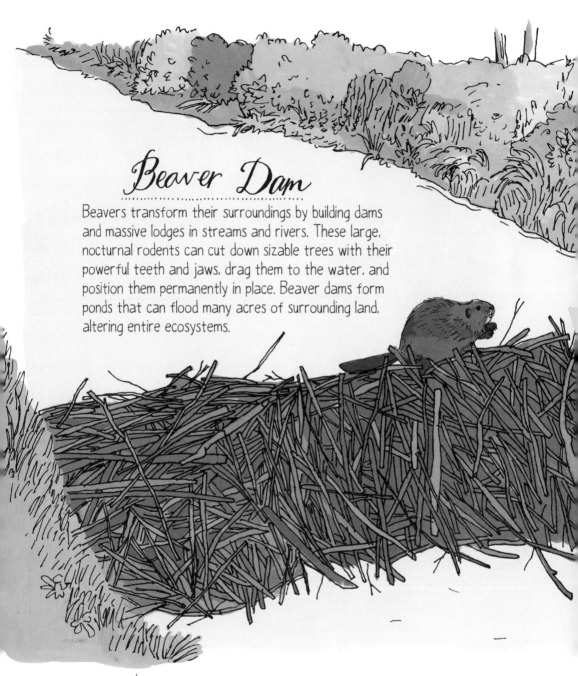

Beaver Dam

Beavers transform their surroundings by building dams and massive lodges in streams and rivers. These large, nocturnal rodents can cut down sizable trees with their powerful teeth and jaws, drag them to the water, and position them permanently in place. Beaver dams form ponds that can flood many acres of surrounding land, altering entire ecosystems.

Beavers are second only to humans in the impact they have on the natural environment.

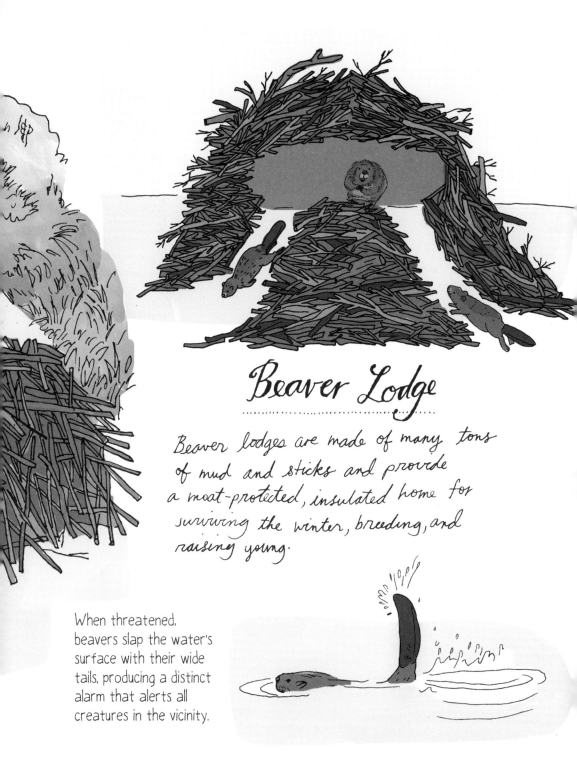

Beaver Lodge

Beaver lodges are made of many tons of mud and sticks and provide a moat-protected, insulated home for surviving the winter, breeding, and raising young.

When threatened, beavers slap the water's surface with their wide tails, producing a distinct alarm that alerts all creatures in the vicinity.

SALAMANDERS

"Salamander" is the name for a group of amphibians that have tails as adults, including newts and sirens. Most adult salamanders have neither lungs nor gills. They breathe through their skins and permeable membranes in their mouths.

HELLBENDER
wrinkly skin provides more surface area for absorbing oxygen from the water

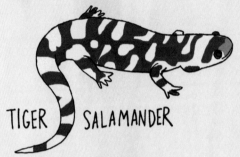

TIGER SALAMANDER
is striped like a tiger and has two protruding tubercles on the soles of its feet

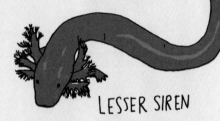

LESSER SIREN
has visible gills its entire life

SLIMY SALAMANDER
excretes a foul-tasting liquid to deter predators

RED SALAMANDER
the brilliant red of their youth fades as they age

EASTERN NEWT
can regenerate lost or damaged limbs, eyes, jaws, and some internal organs

TURTLES

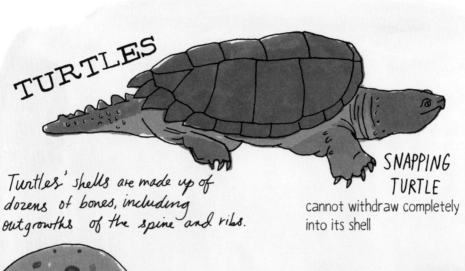

Turtles' shells are made up of dozens of bones, including outgrowths of the spine and ribs.

SNAPPING TURTLE cannot withdraw completely into its shell

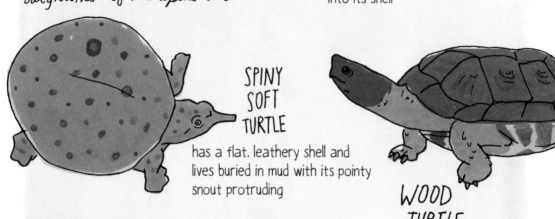

SPINY SOFT TURTLE has a flat, leathery shell and lives buried in mud with its pointy snout protruding

WOOD TURTLE feeds on mollusks, small animals, and plants

DIAMONDBACK TERRAPIN females sometimes twice the size of males

PAINTED TURTLE social and gregarious, often seen basking on logs together, sometimes on top of each other

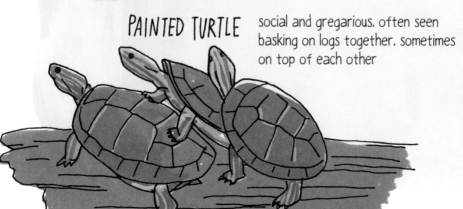

OUTSTANDING ADAPTATIONS

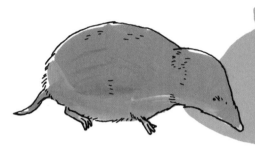

Short-tailed Shrew
Shrews are among the smallest mammals in the world. This species has venomous saliva for protection and for subduing prey.

Snowshoe Hare
This seasonal chameleon has a stark white winter coat and a brown summer coat. Its name comes from the pads of matted hair on its feet for warmth and mobility on snow.

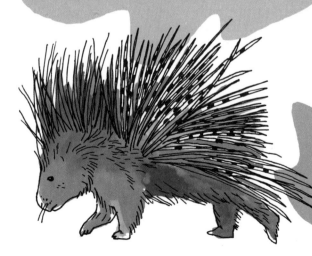

Porcupine
The porcupine's 30,000 sharp quills are actually modified hairs with barbed tips.

Wolverine

The largest member of the weasel family, the wolverine is strong enough to take down animals much larger than itself. Native to the far north, they can comfortably travel long distances on rough, snow-covered terrain.

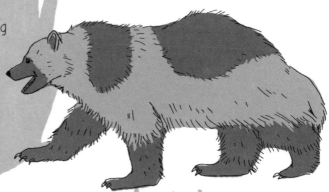

Bison

When under attack, bison form a circle around vulnerable calves, presenting their formidable horns and well-protected shoulders to predators.

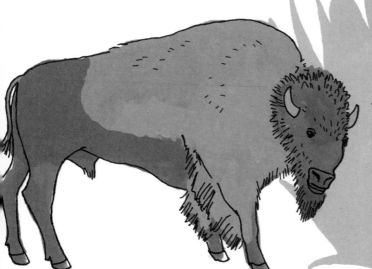

MARINE MAMMALS

Northern Elephant Seal

Excellent deep-sea divers, they can remain underwater for up to 2 hours. Males grow to 20 feet long and are fiercely protective of their harems. They roar and bellow through their long noses during the mating season.

Northern Fur Seal

Dense, luxurious fur keeps these seals insulated in the cold north. Males fight for breeding grounds, and once they've won a space they stay put, fasting through the entire breeding season.

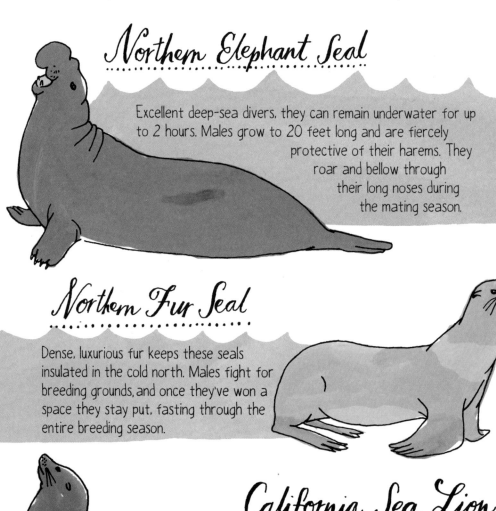

California Sea Lion

These playful swimmers can be seen leaping from the water and riding waves like surfers. They feed at night on fish and mollusks.

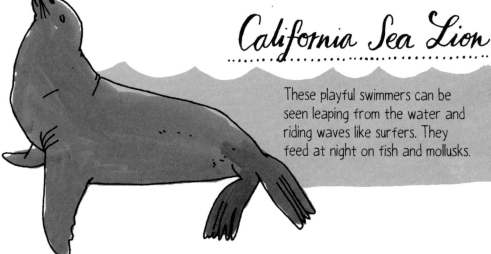

Manatee

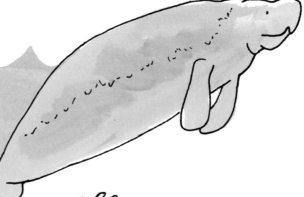

Fond of the warm water flowing out of power plants, these slow-moving mammals graze on sea-bottom plants with their nimble, prehensile lips.

Harbor Seal

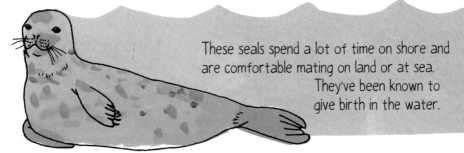

These seals spend a lot of time on shore and are comfortable mating on land or at sea. They've been known to give birth in the water.

Sea Otter

The smallest marine mammal spends almost all of its time in the water. To crack mollusks open, an otter floats on its back and smashes shells against rocks it holds on its belly.

Bottlenose Dolphin

These social creatures use echolocation to hunt. They communicate with body language and clicks and squeaks from their mouths and blowholes. They are known for their intelligence and willingness to interact with humans and recent research suggests that dolphins transmit cultural knowledge across generations.

Orca

Master pack hunters, orcas corral fish into tight coves where they are easy to catch. They hunt whales many times their size by chasing them down and taking bites until the whale succumbs.

Harbor Porpoise

Elaborate courtship displays between males and females may involve intense vocalizations and playful touching.

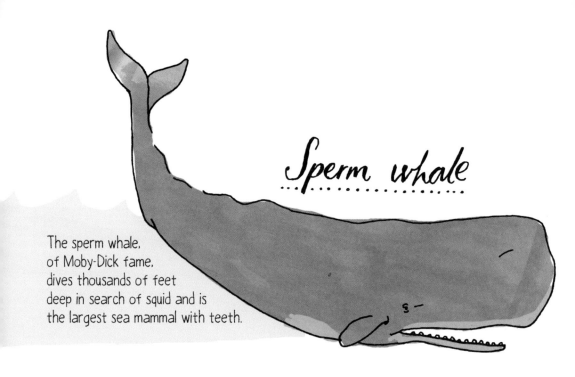

Sperm whale

The sperm whale, of Moby-Dick fame, dives thousands of feet deep in search of squid and is the largest sea mammal with teeth.

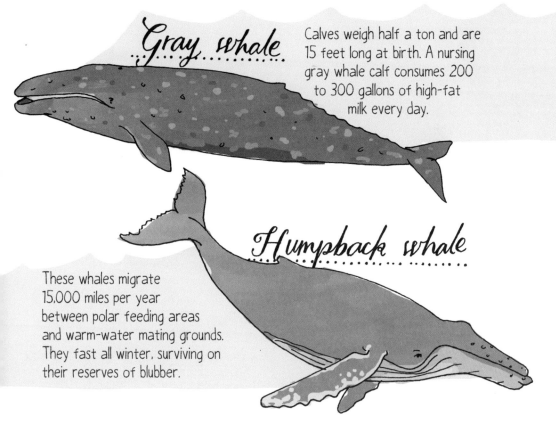

Gray whale

Calves weigh half a ton and are 15 feet long at birth. A nursing gray whale calf consumes 200 to 300 gallons of high-fat milk every day.

Humpback whale

These whales migrate 15,000 miles per year between polar feeding areas and warm-water mating grounds. They fast all winter, surviving on their reserves of blubber.

Chapter 6
A Little Bird Told Me

ANATOMY OF A BIRD

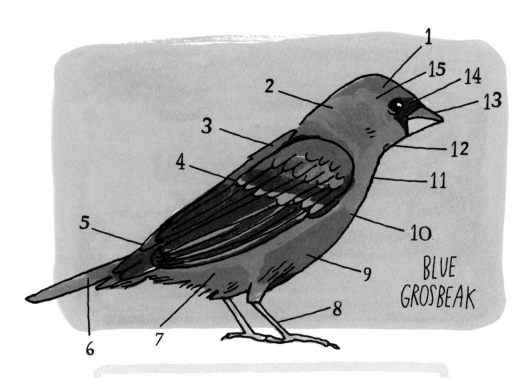

BLUE GROSBEAK

1. crown
2. nape
3. back
4. wing bar
5. rump
6. tail
7. flank
8. tarsus
9. side
10. breast
11. throat
12. chin
13. bill
14. lore (area between eye and bill)
15. ear patch

A BEVY OF BIRDS

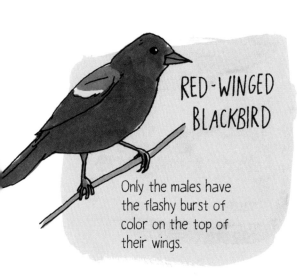

RED-WINGED BLACKBIRD

Only the males have the flashy burst of color on the top of their wings.

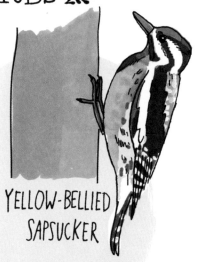

YELLOW-BELLIED SAPSUCKER

One-fifth of their diet comes from the sap collected from drilling tiny holes in trees.

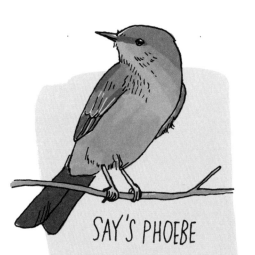

SAY'S PHOEBE

Look for their cup-shaped nests attached to bridges, canyon walls, and wells.

VERDIN

These desert dwellers build round nests covered with thorns.

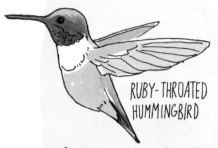

RUBY-THROATED HUMMINGBIRD

During its winter migrations to Central America, it may fly over the entire Gulf of Mexico nonstop.

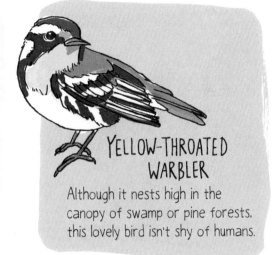

YELLOW-THROATED WARBLER

Although it nests high in the canopy of swamp or pine forests, this lovely bird isn't shy of humans.

SCARLET TANAGER

They provide an important service to the oaks they call home by eating damaging caterpillars and beetles.

CANADA WARBLER

This small songbird nests near the ground in decaying logs.

MOUNTAIN CHICKADEE

Mated pairs of chickadees may join forest flocks containing several different species of small birds.

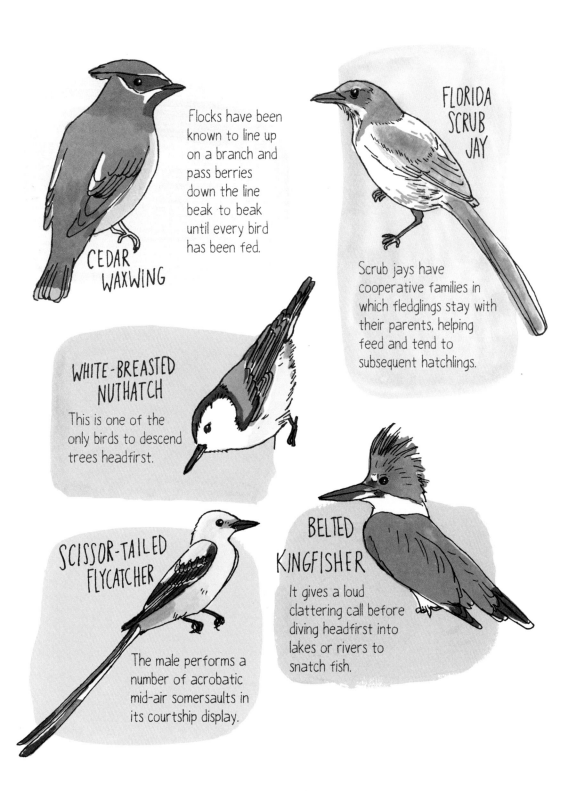

CLARK'S NUTCRACKER

This bird has a pouch beneath its tongue that can hold up to 150 pine seeds, its primary food.

BROWN-CAPPED ROSY FINCH

Finches have a "bouncing" flight with bouts of flapping interspersed with swooping glides with closed wings.

HOODED ORIOLE

Orioles weave distinctive nests shaped like deep purses hanging from branches.

GREAT CRESTED FLYCATCHER

Flycatchers prefer to include snake skins in nest linings but may substitute strips of plastic bags.

BLACK-AND-WHITE WARBLER

During the breeding season, male warblers have much more ostentatious plumage than females, but they revert to drab colors in the fall.

MOUNTAIN BLUEBIRD

Fiercely protective, a bluebird may hunker down in its nest even when approached by humans.

CACTUS WREN

This wren obtains all the liquid it needs from its diet of insects, with some seeds, fruit, and small reptiles.

STELLER'S JAY

North America's largest jay is also the noisiest, with an energetic common call: "Shaack! Shaack! Shaack!"

GILA WOODPECKER

Abandoned nest cavities in saguaro cacti become home to rats, snakes, and other animals.

BRIDLED TITMOUSE

Titmice tend to perform acrobatics while feeding: flipping, swinging, and hanging upside down.

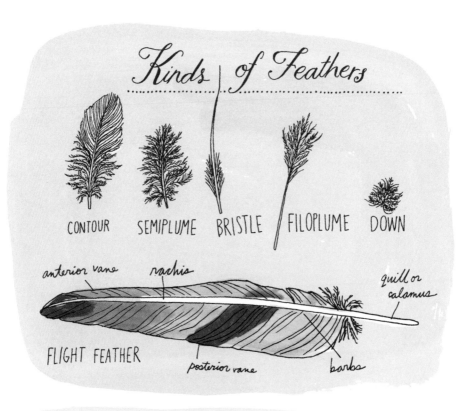
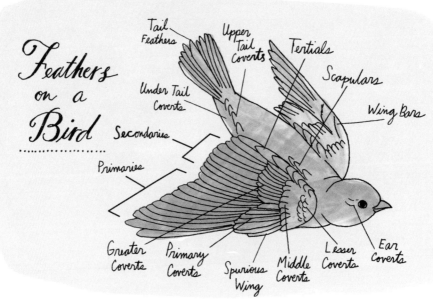

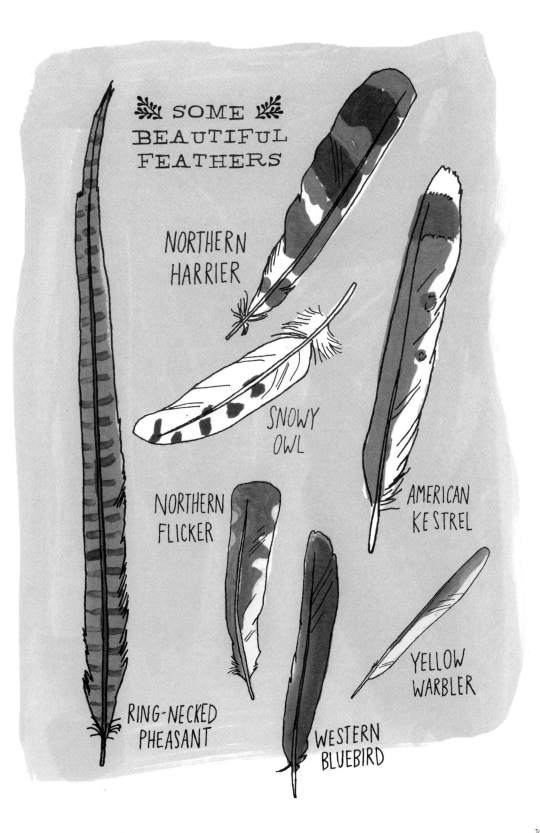

BIRDCALLS

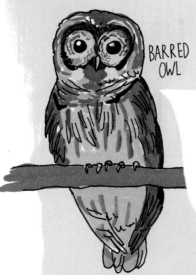

"birdie-birdie-birdie"

BARRED OWL

NORTHERN CARDINAL

"Who cooks for you all?"

Songbirds of the same species don't all sing the same song. Geographically isolated populations often develop distinct vocal repertories that, in time, can form different "dialects" within a species.

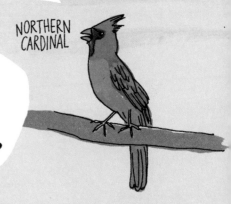

"but-I-DO-love you"

EASTERN MEADOWLARK

"Germany-Germany-Germany"

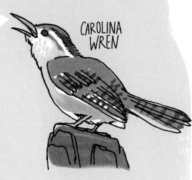

CAROLINA WREN

Songbirds learn their songs rather than inherit them. They make an innate array of sounds, but young birds learn to sing by listening to the older birds around them.

"witchity-witchity-witchity"

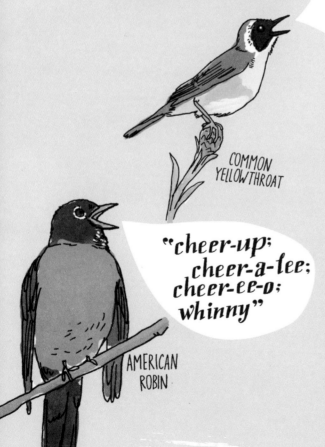

COMMON YELLOWTHROAT

Youngsters spend their first winter dreaming about those songs (literally: studies have found that they "practice" in their sleep). In the spring they begin to sing them aloud. And since most songbirds return each year to the same area, little pockets of geographically distinct songs develop.

"cheer-up; cheer-a-lee; cheer-ee-o; whinny"

AMERICAN ROBIN

A VARIETY OF NESTS

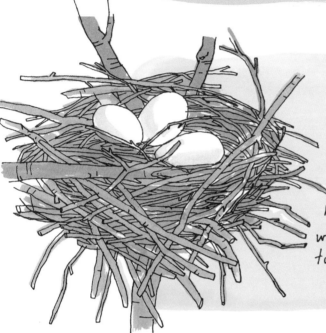

SNOWY EGRET
nests in trees, built with woven sticks and twigs, thin lining

HOUSE WREN
a cavity of plant matter lined with a variety of materials: feathers, hair, wool, cocoons, moss

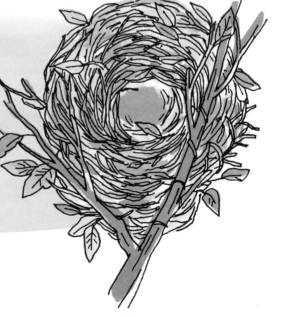

SONG SPARROW

a cup of dead grasses, weeds, and bark pieces, lined with thin grasses

ANNA'S HUMMINGBIRD

a cup made of stems and plant down, held together with spider webs, lined with plant down and feathers, decorated with lichen and moss

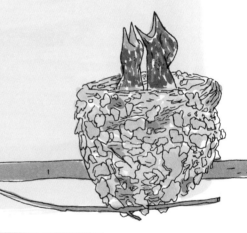

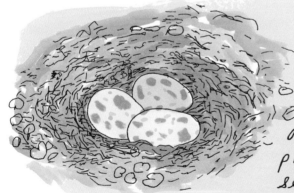

GREATER BLACK-BACKED GULL

a scrape of dead plant matter, mosses, seaweed, feathers

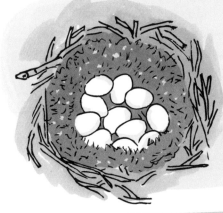

MALLARD DUCK

a hollow of down, plant debris, grasses, and leaves

BARN SWALLOW

a cup of mud pellets and fibers, lined with feathers; built in caves or rafters of buildings

VERDIN

a spherical insulated nest of sticks with thorns all around them, lined with spider webs and fine grasses, and then a thick layer of feathers and plant down

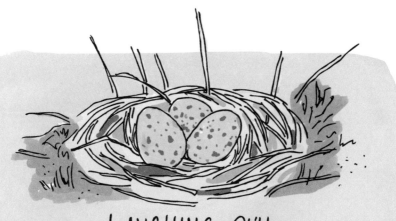

LAUGHING GULL
................
arranged in beach grass
or found in a shallow hole
in the sand, lined with grasses
and sticks

ROBIN
................
made of twigs, weeds, grass
and string, rags and debris.
lined with mud and grasses

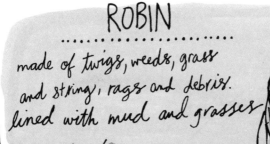

YELLOW WARBLER
................
a cup of stems, wool, and
plant down, lined with fibers,
cotton, and feathers, found
in a branch fork

Extraordinary Eggs

CANADA WARBLER

HOUSE FINCH

EASTERN SCREECH OWL

AMERICAN GOLDEN PLOVER

CACTUS WREN

CALIFORNIA THRASHER

COMMON GRACKLE

HOODED ORIOLE

BLUE JAY

4 3/8 × 3"
TRUMPETER SWAN

5/8 × 1/2"

BARN SWALLOW

NORTHERN CARDINAL

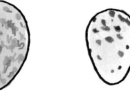
CEDAR WAXWING

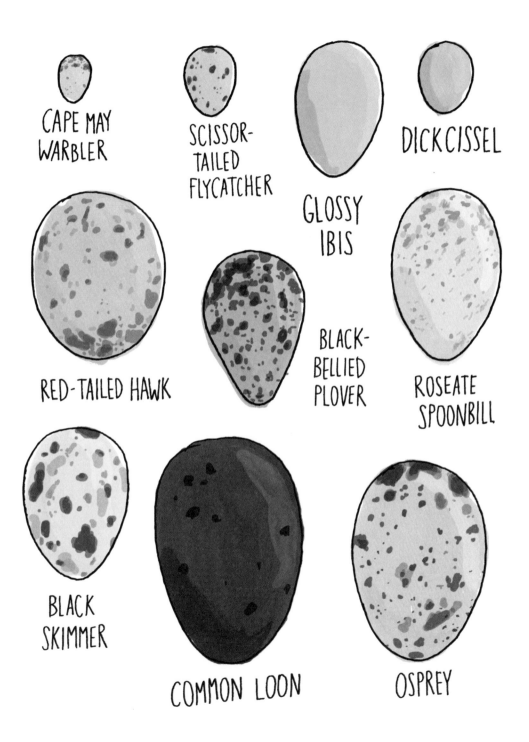

INTRIGUING BIRD BEHAVIOR

Courting

Most bird species breed in the spring, with males displaying courtship behavior such as specialized songs, dances, or acrobatic flights. Females select males that demonstrate their health and vigor in these displays, thereby ensuring healthy offspring.

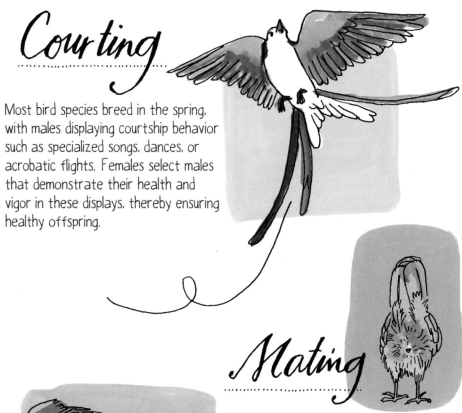

Mating

Both male and female birds have a single opening called a cloaca that is used for both waste excretion and reproduction. Males store sperm in their cloaca until a female becomes receptive. When mating occurs, the male typically balances on the back of the hunching female and arches his body so his cloaca can rub against hers. Mating may take only a second or two but is often repeated.

Preening

Birds clean, realign, protect, repair, and waterproof their feathers by preening. Most birds gather oil from a special gland near their tails and spread it over every feather with their beaks, heads, and feet. Birds may preen for several hours per day.

Bathing

Birds clean their feathers and dislodge parasites by bathing in either pools of water or shallow depressions of dust.

Anting

Several species of birds will lie near anthills with their wings spread, allowing the ants to infiltrate their feathers. The ants leave traces of formic acid, which repels parasites.

Using Tools

Some species of finch use twigs to gather insects from holes in logs or tree trunks. Crows also do this, and some have learned to open nuts by dropping them in front of moving cars. Herons have been observed using bread, left by humans feeding ducks, as bait for fish.

BIRDS OF PREY

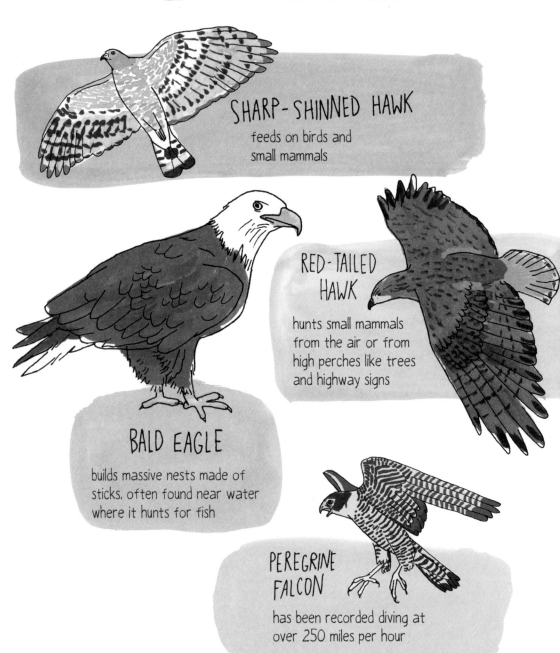

SHARP-SHINNED HAWK
feeds on birds and small mammals

RED-TAILED HAWK
hunts small mammals from the air or from high perches like trees and highway signs

BALD EAGLE
builds massive nests made of sticks, often found near water where it hunts for fish

PEREGRINE FALCON
has been recorded diving at over 250 miles per hour

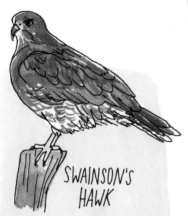

SWAINSON'S HAWK

hunts from the ground for gophers, mice, and even grasshoppers

GOLDEN EAGLE

powerful enough to hunt young deer and other large mammals

NORTHERN HARRIER

also called the marsh hawk, builds nests on the ground

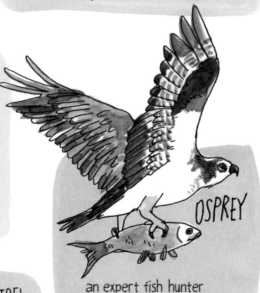

OSPREY

an expert fish hunter

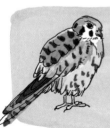

AMERICAN KESTREL

hovers above small mammals before quickly diving for the kill

OWLS

Owls have very large eyes that cannot move. Instead, they can turn their heads around almost 270 degrees, much more than most other animals. The faces of most owls are concave discs, ideal for focusing the sounds of night-scurrying prey.

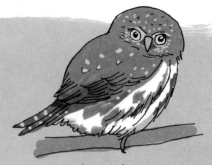

PYGMY OWL
only 6 inches in length, nests in holes in evergreens

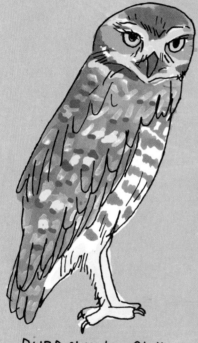

BURROWING OWL
lives in large underground burrows lined with feathers and plant matter

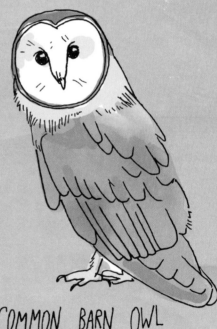

COMMON BARN OWL
can locate prey in complete darkness by sound alone

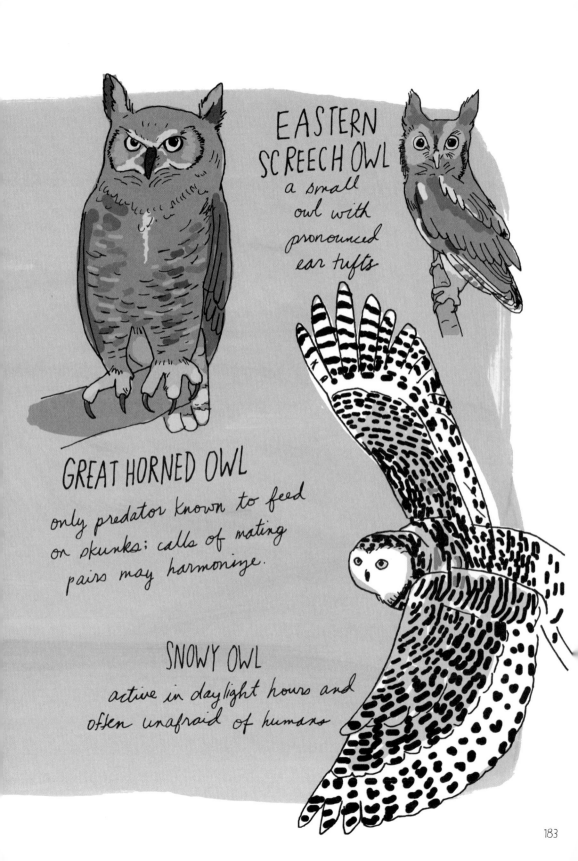

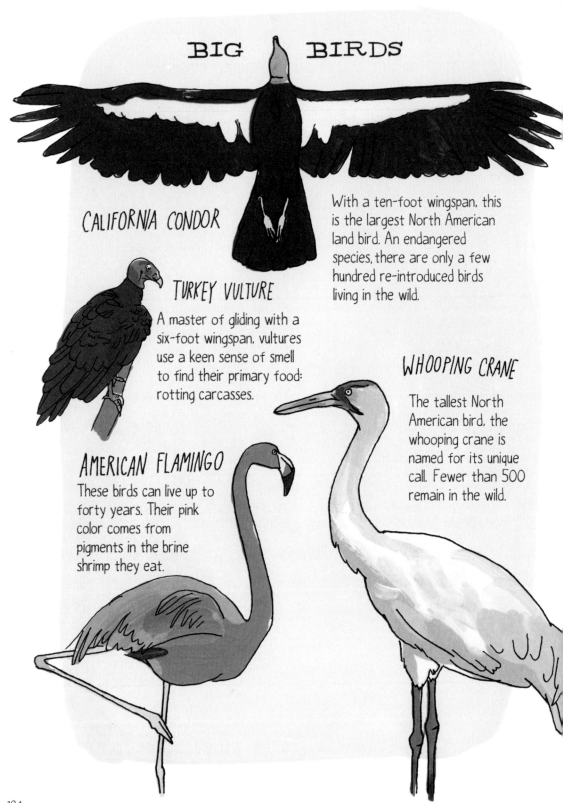

A Variety of Beaks

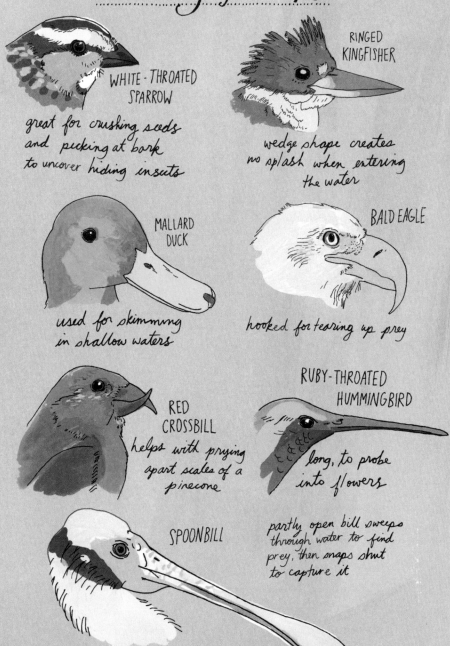

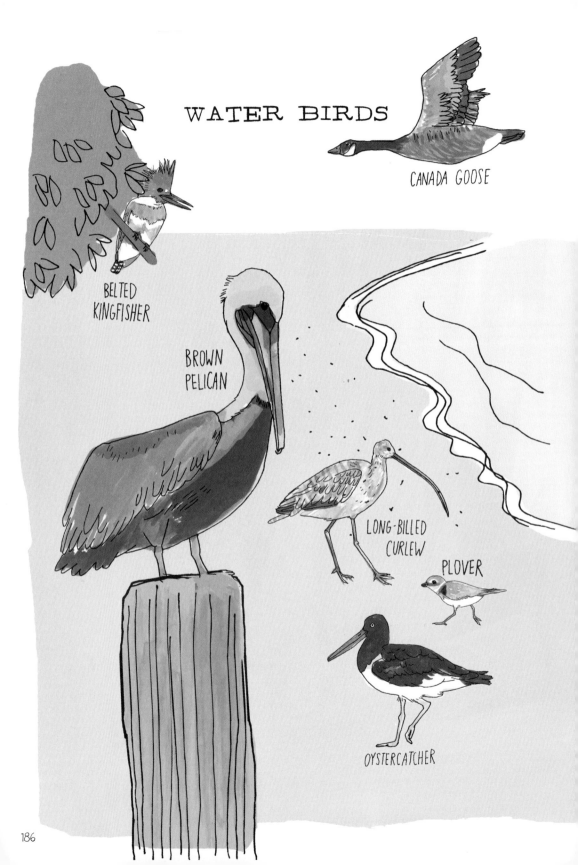

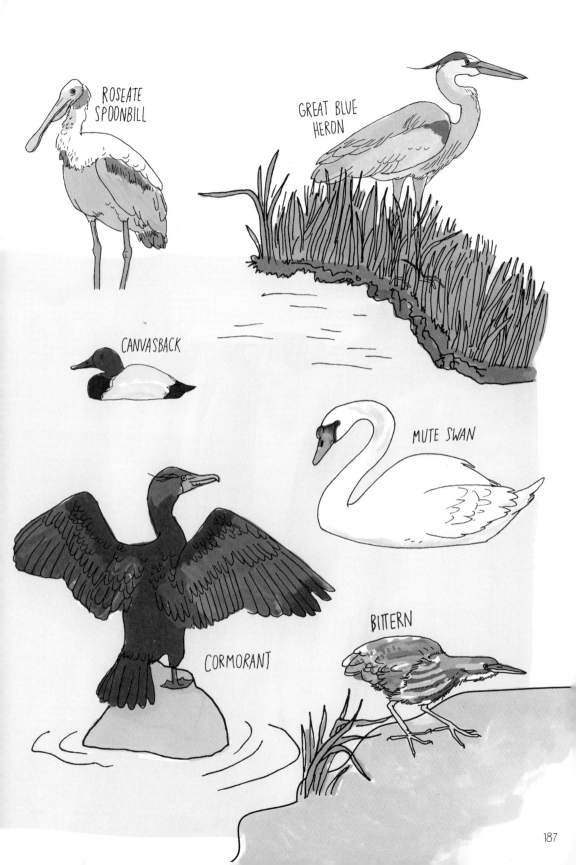

CHAPTER 7

Head above Water

WATER BODIES

Ocean

massive bodies of salt water that cover nearly two-thirds of the earth's surface

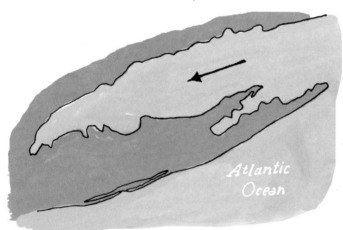

Sound

a large ocean inlet

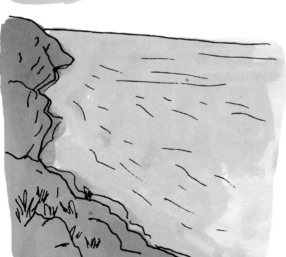

Sea

a large body of salt water that is smaller than an ocean and sometimes bordered by land

Bay

a broad sea inlet partially surrounded by land

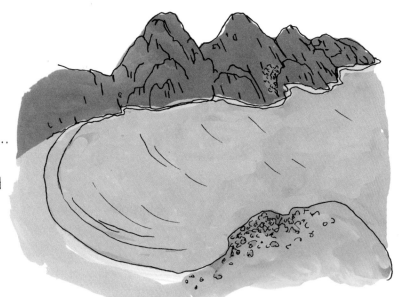

Cove

a small bay

Tidal Pool

rocky saltwater shore pools that become separate from the ocean during low tide

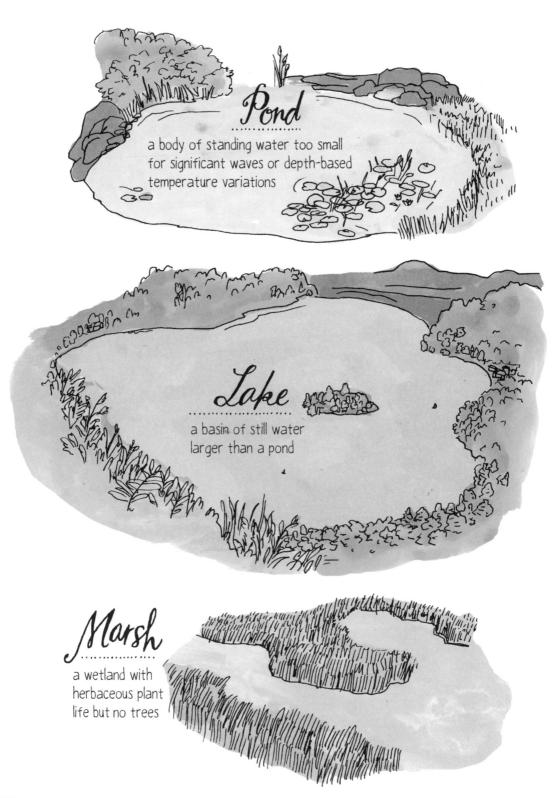

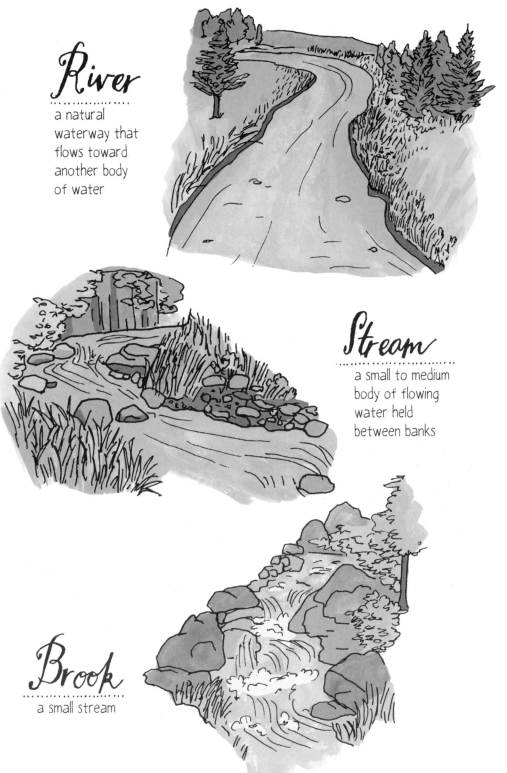

ECOSYSTEM OF A POND

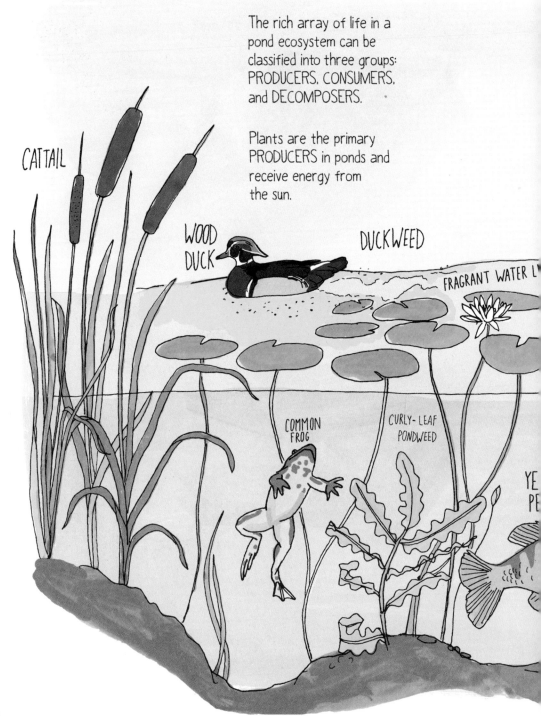

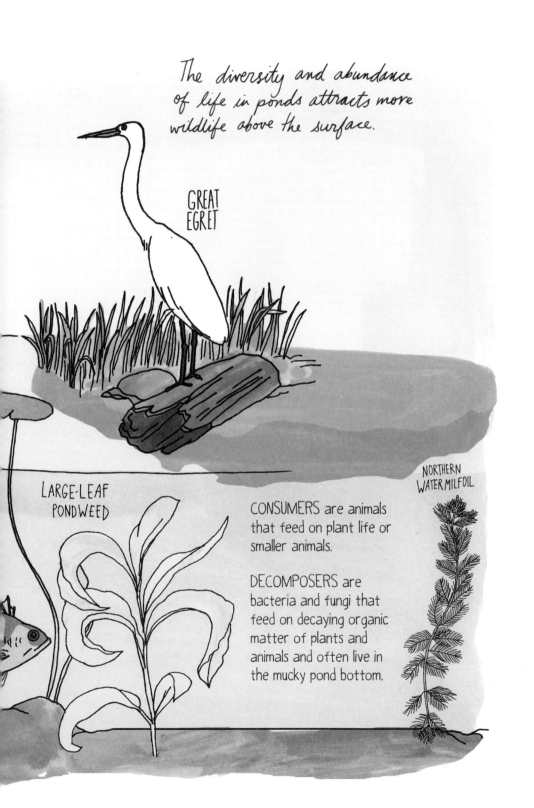

A FEW FRESHWATER FISH

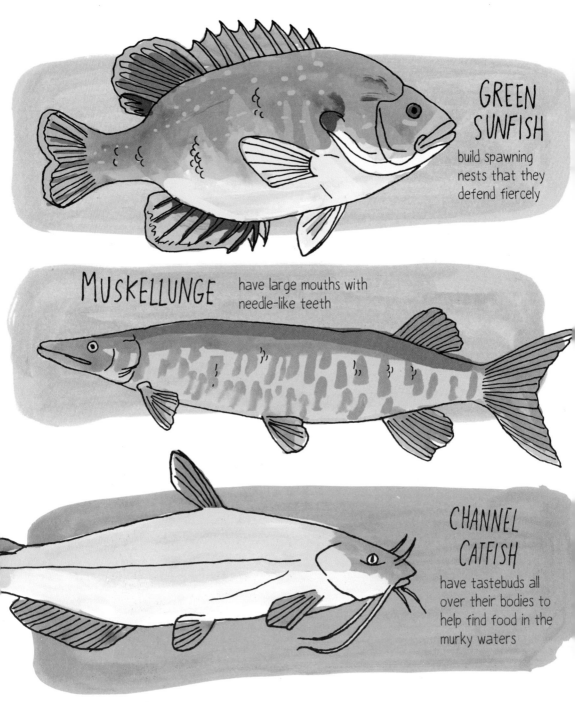

GREEN SUNFISH build spawning nests that they defend fiercely

MUSKELLUNGE have large mouths with needle-like teeth

CHANNEL CATFISH have tastebuds all over their bodies to help find food in the murky waters

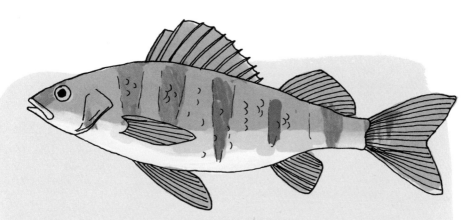

YELLOW PERCH live near shore in weedy areas, feed on insects and small fish, and are cannabalistic

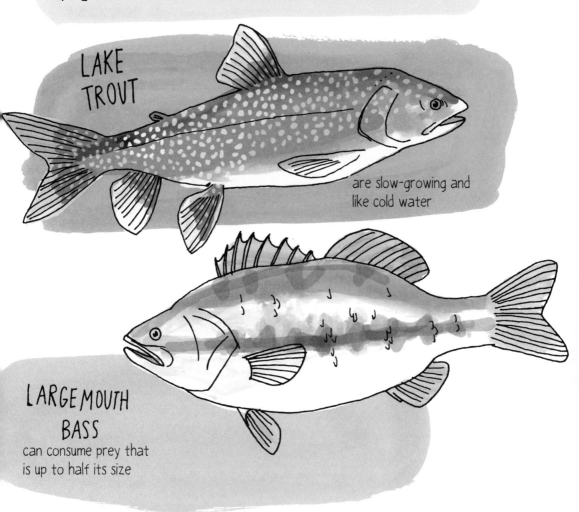

LAKE TROUT are slow-growing and like cold water

LARGEMOUTH BASS can consume prey that is up to half its size

Life Cycle of a Salmon

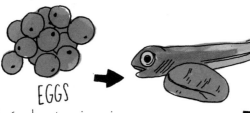

EGGS
In freshwater rivers in the autumn, female salmon dig holes, or redds, with their tails in gravelly river beds to lay eggs. Male salmon deposit their sperm, called milt, over the eggs.

ALEVIN
6 to 12 weeks later, the eggs hatch and tiny salmon, called alevin, emerge. Alevin hide in the gravel and feed from attached yolk sacs for some weeks.

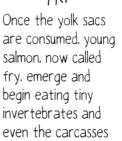

FRY
Once the yolk sacs are consumed, young salmon, now called fry, emerge and begin eating tiny invertebrates and even the carcasses of dead adult salmon.

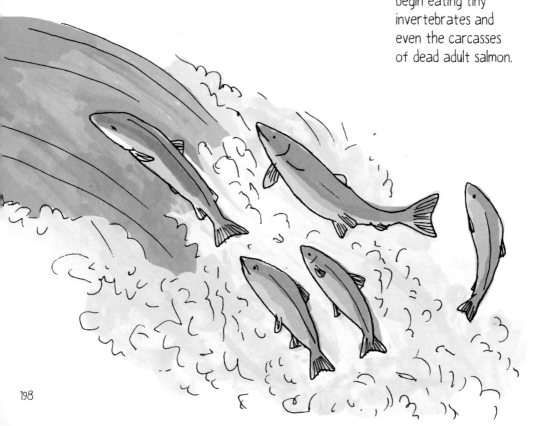

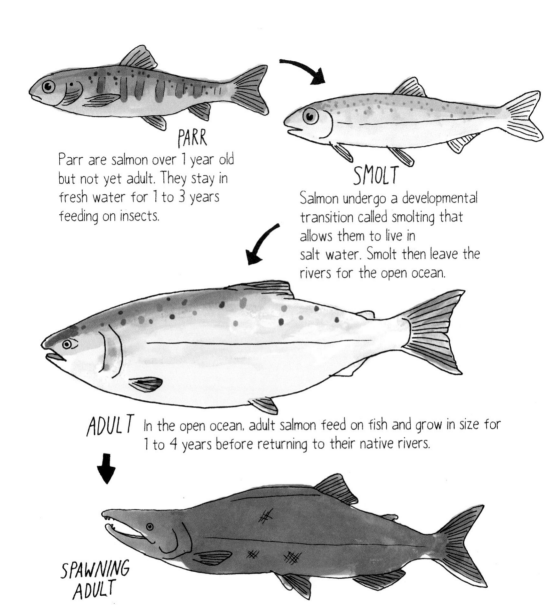

PARR
Parr are salmon over 1 year old but not yet adult. They stay in fresh water for 1 to 3 years feeding on insects.

SMOLT
Salmon undergo a developmental transition called smolting that allows them to live in salt water. Smolt then leave the rivers for the open ocean.

ADULT
In the open ocean, adult salmon feed on fish and grow in size for 1 to 4 years before returning to their native rivers.

SPAWNING ADULT
Adults return to the site of their birth to spawn, undergoing physical transformation to readapt to fresh water. Their silvery bodies darken as they expend energy to produce eggs and milt. Soon after spawning, adult salmon die, creating a rich source of food for many other animals, including their future offspring.

🌿 WATER BUGS 🌿

MAYFLY
Because its adult lifespan is so short, the mayfly is called a "one-day" fly in some languages.

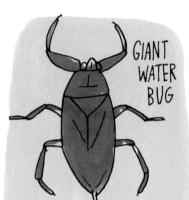

GIANT WATER BUG
The eggs are laid on the male's wings and he carries them on his back until they hatch.

WATER STRIDER
Hairs on their bodies repel water droplets so they can skate on the surface of the water.

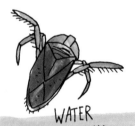

WATER BOATMAN
Their long, flat bodies enable them to swim on the bottom of ponds and streams.

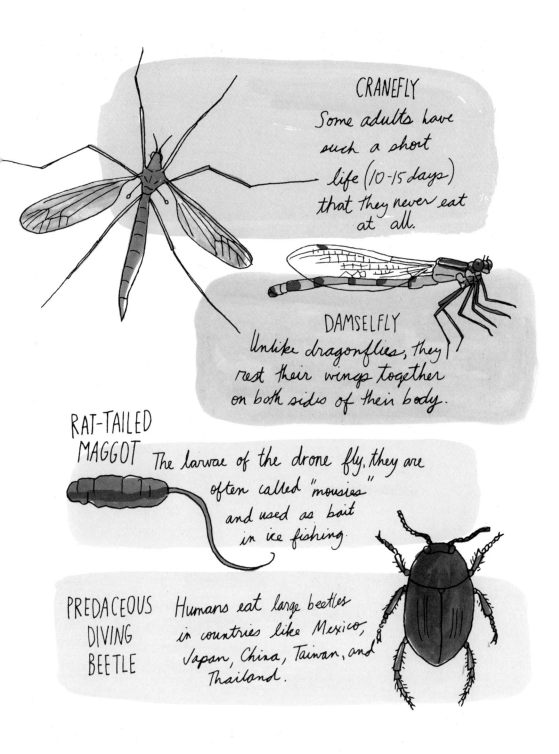

CRANEFLY
Some adults have such a short life (10-15 days) that they never eat at all.

DAMSELFLY
Unlike dragonflies, they rest their wings together on both sides of their body.

RAT-TAILED MAGGOT
The larvae of the drone fly, they are often called "mousies" and used as bait in ice fishing.

PREDACEOUS DIVING BEETLE
Humans eat large beetles in countries like Mexico, Japan, China, Taiwan, and Thailand.

TOAD VS. FROG

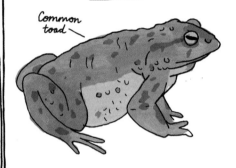

Common toad

American green tree frog

- short legs for walking and hopping
- dry, bumpy skin
- stays mostly on land
- no teeth
- non-bulging eyes
- eats insects, slugs, and worms

- long legs for jumping and swimming
- smooth, wet skin
- stays mostly in water
- tiny, sharp cone teeth on the upper jaw
- bulging eyes
- eats insects, snails, worms, and tiny fish

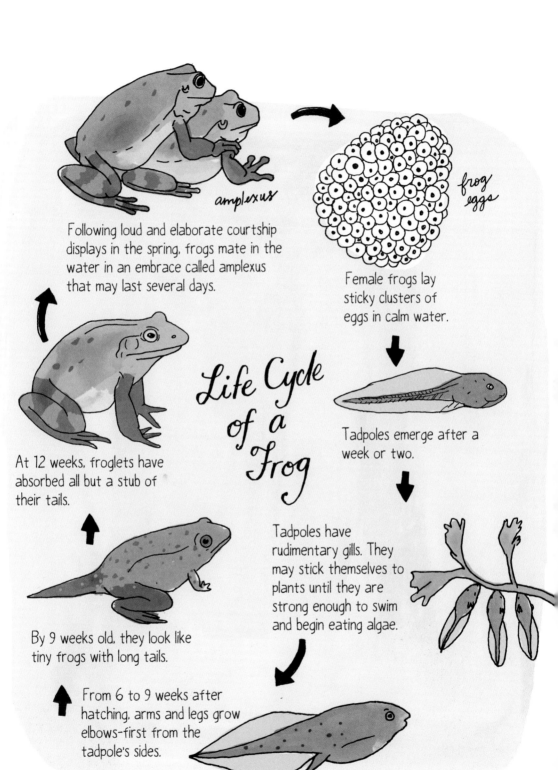

TIDAL ZONE ECOSYSTEM

Splash Zone

High Tide Zone

Low Tide Zone

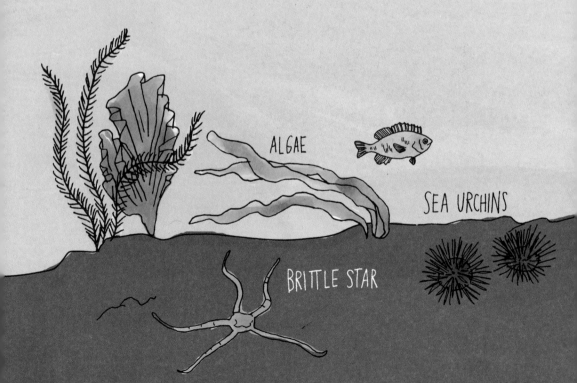

ALGAE

SEA URCHINS

BRITTLE STAR

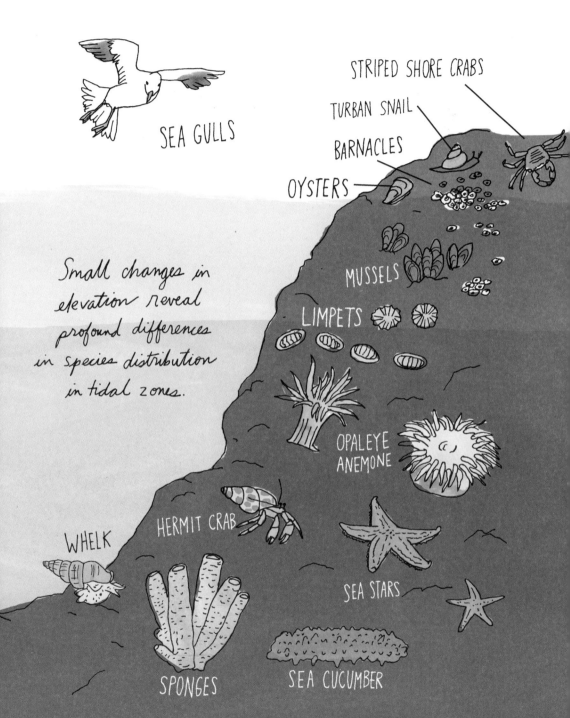

FANTASTIC SALTWATER FISH

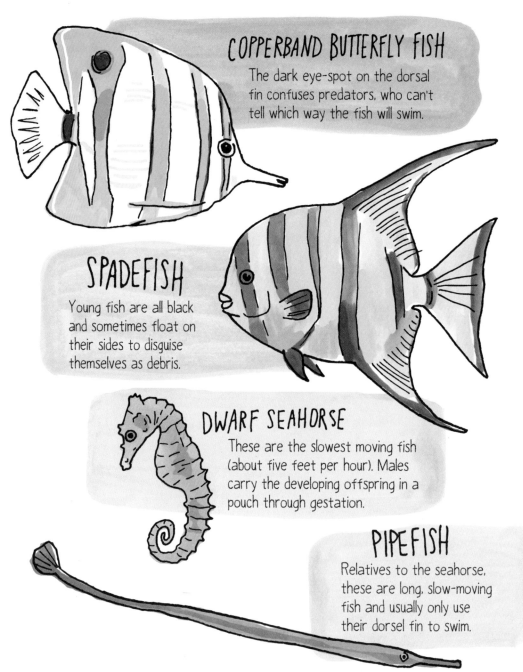

COPPERBAND BUTTERFLY FISH
The dark eye-spot on the dorsal fin confuses predators, who can't tell which way the fish will swim.

SPADEFISH
Young fish are all black and sometimes float on their sides to disguise themselves as debris.

DWARF SEAHORSE
These are the slowest moving fish (about five feet per hour). Males carry the developing offspring in a pouch through gestation.

PIPEFISH
Relatives to the seahorse, these are long, slow-moving fish and usually only use their dorsal fin to swim.

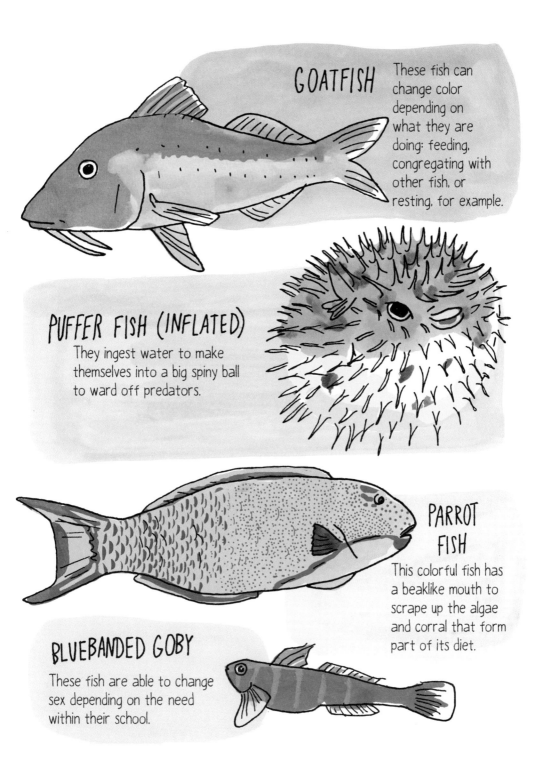

ANATOMY OF A JELLYFISH

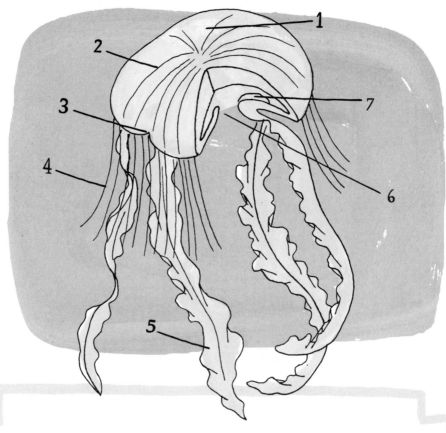

1. **bell** - umbrella-shaped body that contracts and expels water from the cavity underneath to propel the jellyfish
2. **canal** - a series of tubes that run along the bell to distribute nutrients throughout the body in what's called extracellular digestion
3. **eyespot** - light-sensitive spots on the rim of the bell
4. **tentacle** - used for touching
5. **oral arm** - injects the prey with venom
6. **mouth** -- prey goes through here to the gastric cavity
7. **gonad** - reproductive organs that produce sperm and/or egg cells

LION'S MANE
This is the largest known species, with tentacles as long as 100 feet.

MOON JELLYFISH
They tend to stay close to the surface of the water, making them easy prey for large fish, turtles, and the occasional marine bird.

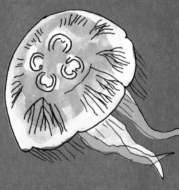

ATLANTIC SEA NETTLE
Unlike other species of jellyfish who only eat plankton, sea nettles have been known to prey on minnows, worms, and mosquito larvae by stinging them with their powerful venom.

PORTUGUESE MAN-OF-WAR
This is not a jellyfish but a siphonophore, an organism made up of many highly specialized minute individuals called zooids.

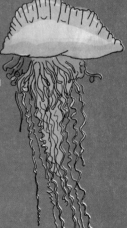

FRESHWATER
These tiny jellyfish (1 inch big) can be found in almost every state in America and almost every continent.

ON THE SAND

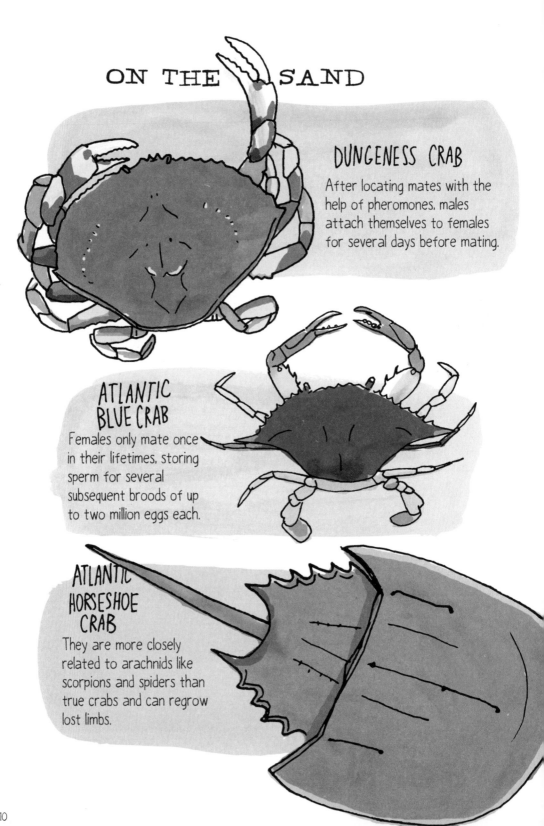

DUNGENESS CRAB
After locating mates with the help of pheromones, males attach themselves to females for several days before mating.

ATLANTIC BLUE CRAB
Females only mate once in their lifetimes, storing sperm for several subsequent broods of up to two million eggs each.

ATLANTIC HORSESHOE CRAB
They are more closely related to arachnids like scorpions and spiders than true crabs and can regrow lost limbs.

MUSSELS
They attach themselves to underwater rocks with strong byssal threads. These gluey threads are being researched for surgical and industrial applications.

HERMIT CRAB
They must find a new shell as they grow and often take the shell of a bigger hermit crab that has vacated its shell for another.

GEODUCK
The largest burrowing clam in the world can be longer than three feet and weigh more than two pounds. It can live hundreds of years.

OYSTER
Of the many different species of oysters, only a few produce commercial-grade pearls.

SKATE EGG CASE
These often wash up on the shore after the fish has hatched out.

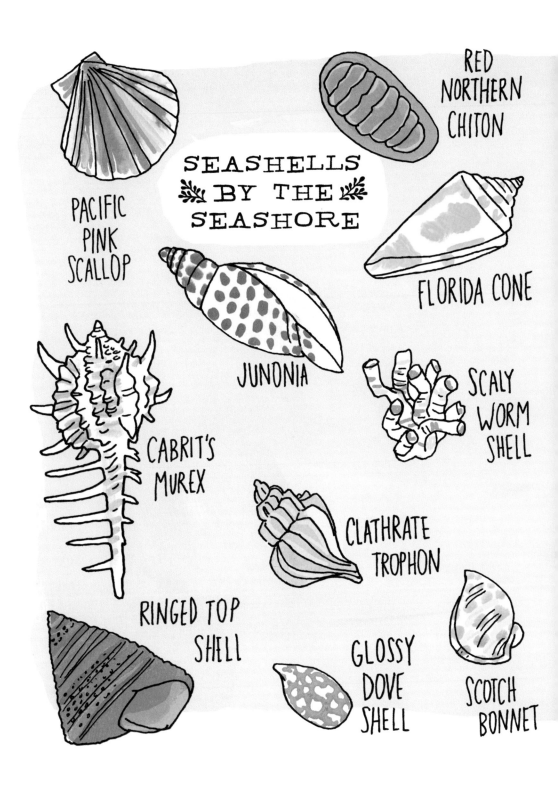

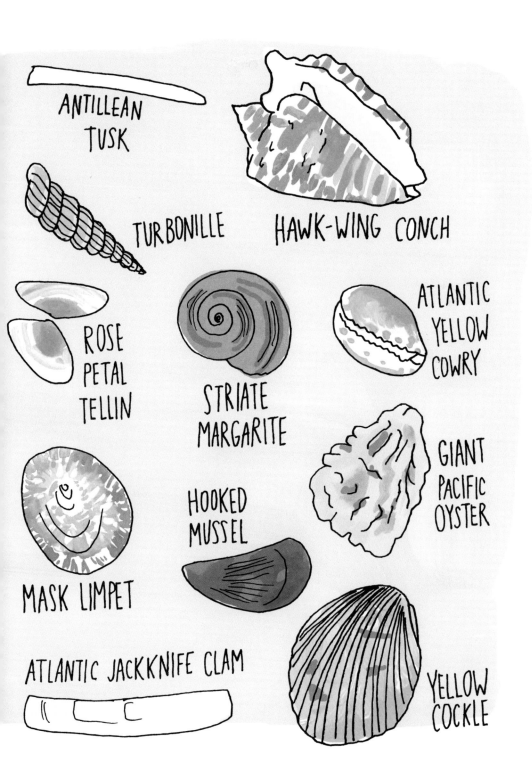

SOME SEAWEED

GIANT KELP
can grow up to a couple of feet per day until it is more than 100 feet long

SUGAR WRACK
prefers habitats protected from heavy surf

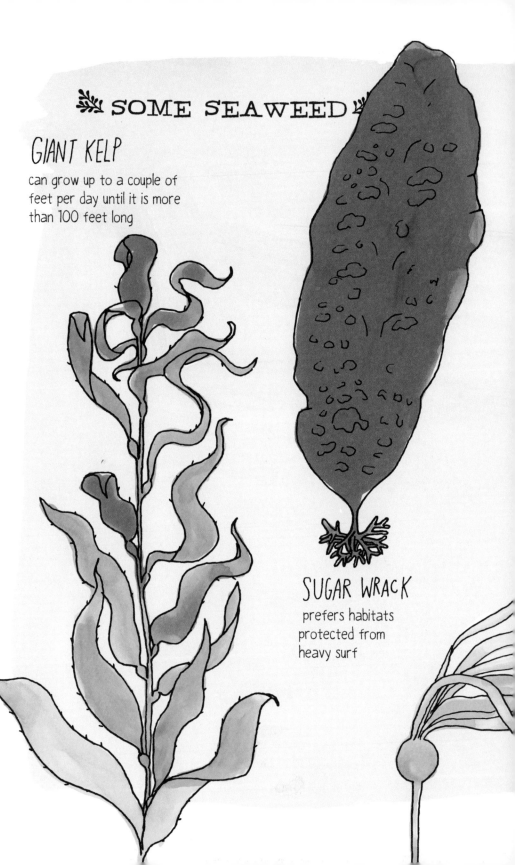

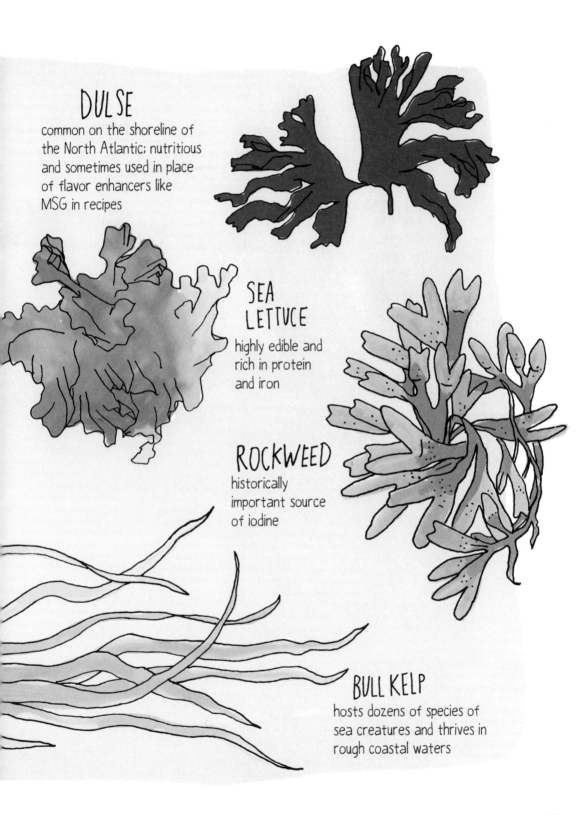

HARVESTING, PROCESSING, AND EATING SEAWEED

Seaweed is a superfood. It contains calcium, potassium, vitamins A and C, and large amounts of beneficial iodine. In some places, seaweed harvesting is limited by law to certain times of year and you may need a permit or license. Learn how to positively identify useful species and only collect from places with clean water.

Harvesting seaweed is far easier during low tide. Consult official tide tables for your area.

Cut a few seaweed leaves from each main stalk with heavy-duty scissors, without pulling the entire plant out of its mooring. Only harvest actively growing seaweed and avoid seaweed that has been washed up on shore since it can be hard to tell how old it is (though old seaweed is a great soil amendment for your vegetable or flower garden).

Dry seaweed for a few hours on clean, flat surfaces in full sun. A food dehydrator also works well. Store in airtight jars or bags.

Fresh seaweed is delicious with cucumbers, sesame seeds, and rice vinegar. Add dried seaweed to soups, salads, and even trail mix.

Seaweed Facial Mask

4 LEAVES DRIED KELP
WARM WATER
1 TBSP ALOE VERA GEL
1/4 RIPE BANANA

Grind kelp leaves into a fine powder with your mortar and pestle or coffee grinder. With a fork, mix 1 tbsp. kelp powder, a bit of warm water, and 1 tbsp. aloe vera gel in a bowl. Add the soft banana and mash with a fork. Add warm water as necessary to achieve silky texture.

Apply a thin layer of the seaweed mask to your face and relax for 15-20 minutes. Rinse off with warm water. You can use this natural facial mask every week as part of your beauty routine.

A Note About Conservation

All parts of the natural world are intimately connected. Small changes to any part of an ecosystem can have profound effects on the health and biodiversity of an entire region.

Though nature is incredibly resilient and adaptable, it is clear that we are in the midst of a period of widespread extinction of species. Most of our natural habitats are threatened by human encroachment. The conservation of expanses of pristine forests, oceans, wetlands, and grasslands is crucial for the survival of threatened species and the future health of our planet.

Your personal commitments to protect wilderness and limit wasteful consumption can make a difference. Help protect the earth's biodiversity and learn more by checking out your local conservation organizations or the Wildlife Conservation Society, the Center for Biological Diversity, the Conservation Fund, Earthworks, the Sierra Club Foundation, and the League of Conservation Voters Education Fund.

No matter where you live, connect with the nature near you in a conscientious way.

BIBLIOGRAPHY

Alden, Peter, Richard P. Grossenheider, and William H. Burt. Peterson First Guide to Mammals of North America. Boston: Houghton Mifflin, 1987.

Baicich, Paul J., and Colin J. Harrison. Nests, Eggs, and Nestlings of North American Birds. Princeton, NJ: Princeton University Press, 2005.

———. Book of North American Birds: An Illustrated Guide to More Than 600 Species. New York: Reader's Digest Assoc. 2012.

Chesterman, Charles W. The Audubon Society Field Guide to North American Rocks and Minerals. New York: Knopf, 1978.

Coombes, Allen J. Trees. New York: Dorling Kindersley, 2002.

———. Familiar Flowers of North America: Eastern Region. New York: Knopf Distributed by Random House, 1986.

Filisky, Michael, Roger T. Peterson, and Sarah Landry. Peterson First Guide to Fishes of North America. Boston: Houghton Mifflin, 1989.

Hamilton, Jill. The Practical Naturalist: Explore the Wonders of the Natural World. New York: DK Publishing, 2010.

Laubach, Christyna M., René Laubach, and Charles W. Smith. Raptor! : A Kid's Guide to Birds of Prey. North Adams, MA: Storey Publishing, 2002.

Little, Elbert L., Sonja Bullaty, and Angelo Lomeo. The Audubon Society Field Guide to North American Trees. New York: Knopf Distributed by Random House, 1980.

Mäder, Eric. Attracting Native Pollinators: Protecting North America's Bees and Butterflies: the Xerces Society Guide. North Adams, MA: Storey Publishing, 2011.

Mattison, Christopher. Snake. New York: DK Publishing, 2006.

Milne, Lorus J., and Margery J. Milne. The Audubon Society Field Guide to North American Insects and Spiders. New York: Knopf Distributed by Random House, 1980.

Moore, Patrick, and Pete Lawrence. The New Astronomy Guide : Stargazing in the Digital Age. London: Carlton, 2012.

Pyle, Robert M. The Audubon Society Field Guide to North American Butterflies. New York: Knopf Distributed by Random House, 1981.

Rehder, Harald A., and James H. Carmichael. The Audubon Society Field Guide to North American Seashells. New York: Knopf Distributed by Random House, 1981.

Scott, S D., and Casey McFarland. Bird Feathers: A Guide to North American Species. Mechanicsburg, PA: Stackpole Books, 2010.

Sibley, David. The Sibley Guide to Birds. New York: Alfred A. Knopf, 2000.

Spaulding, Nancy E., and Samuel N. Namowitz. Earth Science. Evanston, Ill: McDougal Littell, 2005.

Wernert, Susan J. Reader's Digest North American Wildlife. Pleasantville, NY: Reader's Digest Association, 1982.

Much of the type in this book was handwritten or uses fonts created from my handwriting. The lettering for titles was based on typefaces Palatino, Archive Antique Extended, Bellevue, and Nelly Script.

Thank You!

This project took me a very long time, and I feel like I have many people to thank for their help. First and foremost I need to thank my editor, Lisa Hiley, who is amazingly patient, thoughtful, and consistently a pleasure to work with. Thanks to Deborah Balmuth for always believing in my endeavors and being an encouraging voice, Alethea Morrison for her continued design expertise, and the rest of the very kind Storey team. Also special thanks to Pam Thompson for all the initial brainstorming sessions.

Thank you to my friend and partner on the book, John, who provided such great ideas and intriguing facts. He raised the bar with his knowledge, research, and well-crafted words.

This book created a little unexpected collaboration with my mom, who helped paint some of the pages (all of the perfectly detailed ones) when I was running over my deadline, and my dad, who scanned pages for me — it became a family team effort! I feel so grateful to have such continued support from my parents.

My sister is doing incredible projects in Africa, studying primates and educating the community about conservation. Visiting her this year in Uganda has been the most inspiring thing I've done and opened my eyes to see the larger picture. I am in awe of her devotion to such a great cause. You can learn more about her research at nycep.org/rothman

Thank you to my assistant painter and aspiring talent Sarah Green. I wouldn't have finished without her quick hands and uplifting whistling.

Lastly thanks to forever collaborators Jenny and Matt for their consistently spot-on advice on both design and life. And hugs to my friends, Santtu and Rudy!

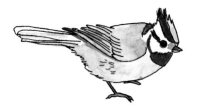

FOOD ANATOMY

THE CURIOUS PARTS & PIECES OF OUR EDIBLE WORLD

JULIA ROTHMAN
AUTHOR & ILLUSTRATOR OF FARM ANATOMY & NATURE ANATOMY

WITH HELP FROM RACHEL WHARTON

Storey Publishing

The mission of Storey Publishing is to serve our customers by
publishing practical information that encourages
personal independence in harmony with the environment.

Text and illustrations © 2016 by Julia Rothman

All rights reserved. No part of this book may be reproduced without written permission from the publisher, except by a reviewer who may quote brief passages or reproduce illustrations in a review with appropriate credits; nor may any part of this book be reproduced, stored in a retrieval system, or transmitted in any form or by any means — electronic, mechanical, photocopying, recording, or other — without written permission from the publisher.

The information in this book is true and complete to the best of our knowledge. All recommendations are made without guarantee on the part of the author or Storey Publishing. The author and publisher disclaim any liability in connection with the use of this information.

Storey books are available at special discounts when purchased in bulk for premiums and sales promotions as well as for fund-raising or educational use. Special editions or book excerpts can also be created to specification. For details, please call 800-827-8673, or send an email to sales@storey.com.

Storey Publishing
210 MASS MoCA Way
North Adams, MA 01247
storey.com

Printed in China by R.R. Donnelley
10 9 8 7 6

Library of Congress Cataloging-in-Publication Data

Names: Rothman, Julia, author. | Wharton, Rachel, author.
Title: Food anatomy : the curious parts & pieces of our edible world / by Julia Rothman ;
 with help from Rachel Wharton.
Description: North Adams, MA : Storey Publishing, [2016] | Includes bibliographical
 references and index.
Identifiers: LCCN 2016039999 (print) | LCCN 2016047165 (ebook) | ISBN 9781612123394
 (paper with flaps : alk. paper) | ISBN 9781612123400 (ebook)
Subjects: LCSH: Food. | Cooking.
Classification: LCC TX355 .R6717 2016 (print) | LCC TX355 (ebook) | DDC 641.3—dc23
LC record available at https://lccn.loc.gov/2016039999

For Sunny, who taught me to eat a real breakfast of poached eggs and avocado, who makes the best lentil soup, who can toss pizza dough like a pro, and who led me through the Finnish forest for chanterelles. Thank you for all the tasty adventures.

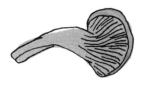

CONTENTS

INTRODUCTION .. 6

CHAPTER 1
Food for Thought .. 11

A Brief History of Food • A Few Tasty Words to Know • Place Settings • Kinds of Forks • Kinds of Spoons • In the (International) Cupboard • Traditional Ovens • A Century of Stoves • The Ice Age of Refrigeration • Fermentation

CHAPTER 2
Eat Your Fruits and Veggies 37

Dining on the Plant Family • Fruit Facts • How a Flower Becomes a Fruit • The Parents of Produce • All in the Family • Sundry Celeries • Obscure Beauties • Tropical Fruits • Berry Basics • Little Known Terms for Common Tree Fruit • Go Bananas • Citrus • Surprising Salad Greens • Famous Fungi • The Truffle Hunter • Yam vs. Sweet Potato • Beans • Shell Games • Feeling Nutty • Peanut Powered • Cracking Up • How to Make Tofu

CHAPTER 3
A Grain of Truth .. 69

Good Grains • Corn • Kinds of Rice • Growing Rice • Bread • Rolling the Dough • Baking Traditional Finnish Rye Bread • Sumptuous Sandwiches • Some Pasta Shapes • Making Pasta • Making Noodles • Asian Noodle Dishes • Jane's Noodle Pudding • Delectable Dumplings • Pancakes

CHAPTER 4
The Meat of the Matter 101

Prime Cuts • How Meat Cooks • On the Charcuterie Plate • Sausage Blends • Butchery Tools • Meaty Dishes • Five Fabulous Food Fish • How to Fillet a Fish • Regal Roe • Other Edible Sea Creatures • The Fishmonger's Lexicon • Seafood Cookery Tools • Fresh Fish • Commonly Eaten Clams • Kinds of Sushi • On the Sushi Menu • Eating the Whole Chicken • The Incredible Egg • Short Order Egg Lingo

CHAPTER 5
Dairy Queens 133

Milk Maid Math • Terms of the Trade • Delicious Dairy • How to Make Butter • Real Deal Buttermilk Pancakes • Cut the Cheese • Cheese Anatomy • The Basic Steps in Making Cheese • Types of Cheese • American Cheese • Curd Nerdisms

CHAPTER 6
Street Food 149

Serious Snacks with Funny Names • With Your Fries • Hot Dawg • Five Styles of Meat on a Stick • Anatomy of a Food Truck • On the Streets • Pizza, Pizza • Taqueria Terminology

CHAPTER 7
Season to Taste 163

6 Superb Spice Blends • That's Hot • A Little Something Sweet • In the Sugar House • Creamy Maple Mocha Pudding • Olive Oil Argot • Mustard • How to Make Vinegar • Salt • Pepper

CHAPTER 8
Drink Up! 179

Coffee • Espresso Guide • A Spot of Tea • What's Brewing? • Tea Time • When Life Gives You Lemons • Shikanjvi for Two • Fizzy Sips • The Equations of Fermented Beverages • The Basic Steps in Making Wine • Wine Tasting • Distillation • Glassware The Cocktail Maker's Toolkit

CHAPTER 9
Sweet Tooth 199

Common Cakes • Cake-Making Terms • We All Scream for Ice Cream • Sundae Anatomy • Cookies • How Chocolate Is Made • Worldly Treats • A Spoonful of Sugar • Homemade Butterscotch Sauce • Candy • In an Old-Fashioned Candy Shop • Pastries • Pastry Tools • Soft Sweets • American Pie • Donuts • The Fortune Cookie

*M*y parents always cooked a full dinner for me and my sister after they came home from work. When I think back to it now, I am in awe of their dedication to our family meals. We sat around a large round oak table at six o'clock and talked and ate. It was sesame peanut noodles, or breaded tofu, or my favorite, noodle pudding (a passed down Jewish kugel recipe, see page 95) or my dad's favorite, beer-can chicken. (We were always subjected to viewing the chicken body sitting upright on the can. To my dad, that ridiculous image never got old.) My job was usually to set the table, or clear the table, or make the salad. I didn't have much interest in helping my parents cook aside from making easy omelettes and pancakes some mornings.

In college I was poor. I remember buying a huge carton of individually packaged Cup o' Noodles from Costco for quick, cheap meals and overfilling my plate at the dining hall when I had points left on my card. After college when I moved to Brooklyn and started making some money, I ate out all the time. In one block of my neighborhood, you could take an inexpensive food tour around the world from Israel to Vietnam to Greece just a few doors down the street. When the automatic food ordering apps came around a few years ago, I could click checkout and twenty minutes later there was food at my door- falafel with red cabbage slaw, a spicy tofu Bahn Mai sandwich or a big Mediterranean salad with stuffed grape leaves and lebni on the side.

I gained an interest in food around the time I started working on my first book in this series, Farm Anatomy, about seven years ago. I stopped eating meat and paid more attention to seasonal fruits and vegetables. I began shopping more at the farmer's market near my apartment in Grand Army Plaza, and buying more organic and locally grown produce. This meant I had to cook more, or at least prepare more food. I got rid of my microwave and bought a fancy Japanese knife. I took a cooking class at the International Culinary Center in vegan cooking and learned a few techniques. (Though I mistakenly grated a bit of my finger into one of the dishes so it wasn't technically vegan!).

I am still very much a beginner cook, but I am not a beginner at eating. This book gave me a chance to explore that further. I tried to taste most of the things I drew. I went to a variety of Asian markets and came home to puree Chinese yams into pancakes and grate real fresh wasabi root. I tasted dragonfruit and horned melon, but I couldn't bring myself to eat durian. (I opened it just a crack to see what the smelly fuss was all about. I attempted, and failed to bring even a tiny piece close to my face. Instead, I laughed hysterically and practically gagged at the intense odor.)

The trips I took while working on this book became chances to try more dishes. In Amsterdam I sampled dozens of cheeses, some aged in bunkers for years, and paired them with beers brewed in an old windmill. In Uganda, I had matoke and enjoyed Rolexes (eggs rolled up in chapati) for breakfast. In Finland, I learned to make traditional rye bread from a hundred-plus-year-old root. I carved my own mixing tool from a spruce tree to use on the dough. I visited a strawberry plantation and picked the sweetest strawberries I've ever tasted (the long days full of sunshine make them exceptional.) In the winter I foraged through the snow-covered forest for chanterelles that made their way onto a pizza for a New Year's Eve celebration.

This past Thanksgiving was my biggest cooking achievement to date. I invited my parents and sister to my tiny Brooklyn apartment to celebrate the holiday. Over the phone, my mother pleaded, "Are you sure? No turkey? Why don't I make one and bring it just in case?" I assured her it would be great, though I hadn't fully convinced myself yet. I prepared a menu of coconut milk-based lentil soup, kale and farro salad, creamy potatoes, roasted kabocha squash, sriracha-coated Brussels sprouts and sweet potato pie for dessert. Miraculously, the comments coming from my family were "wow, this is actually really delicious" and "better than regular Thanksgiving."

My writing partner was Rachel Wharton. Her expertise in the culinary world made up for everything I am still learning. She shared her knowledge and researched what she didn't know. We tried to cover a range of topics on everything we could think of. But that is always impossible and this is only a small taste of what we thought would be interesting to collect and draw.

You wouldn't believe how hungry I got working on this book. As I looked back at my photos or searched the Internet for good references of meals to draw, I immediately had to run to my fridge and try and replicate the food. Cravings were unbearable and I am excited to have finished this book so I can lose the weight I gained making it.

I hope this book will inspire you to experiment with more cooking, be more curious about what you're eating, and go on more food adventures as I will continue to do. Cheers!

Julia Rothman

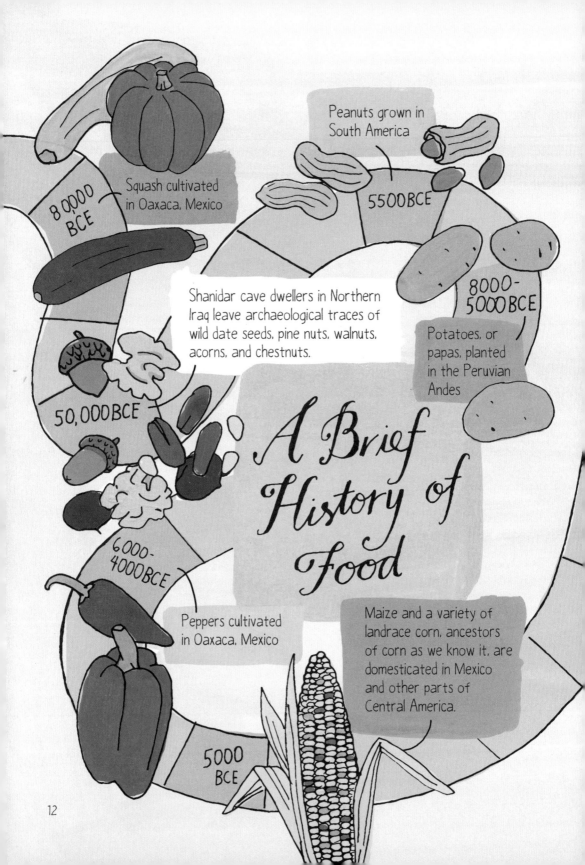

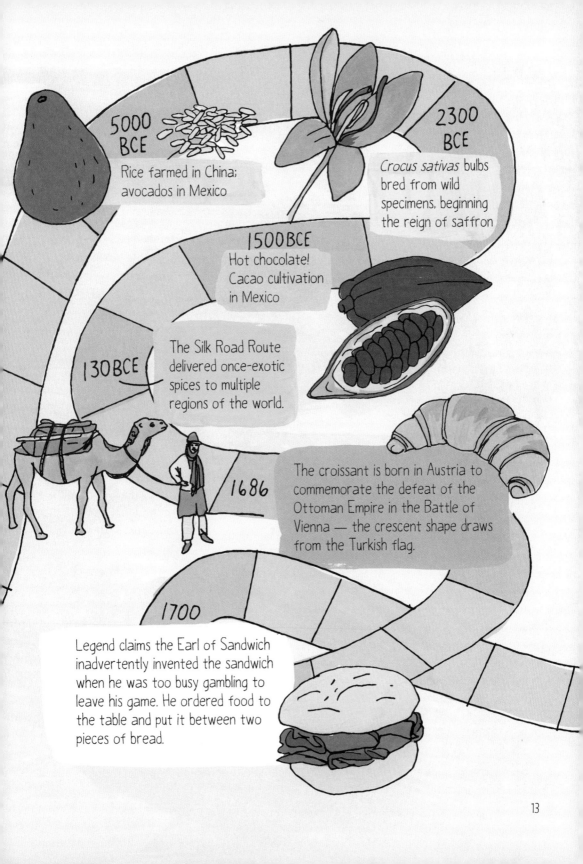

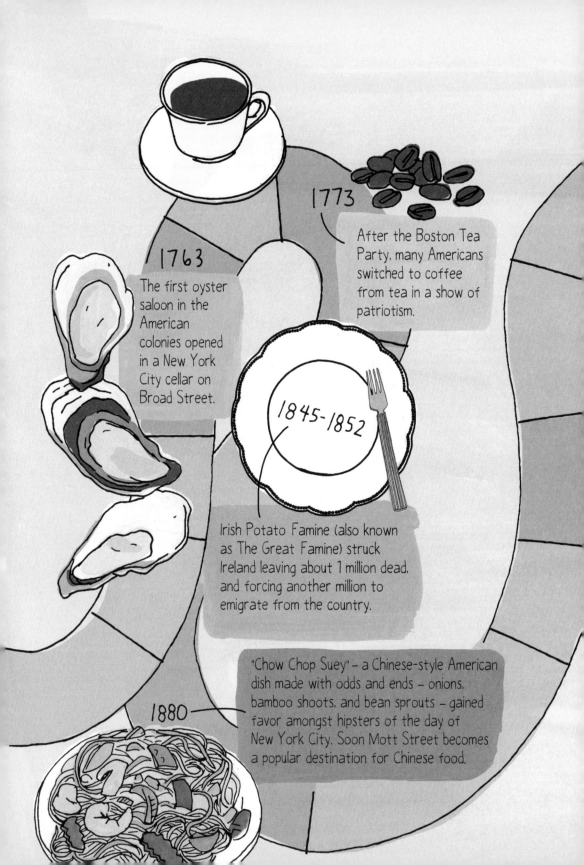

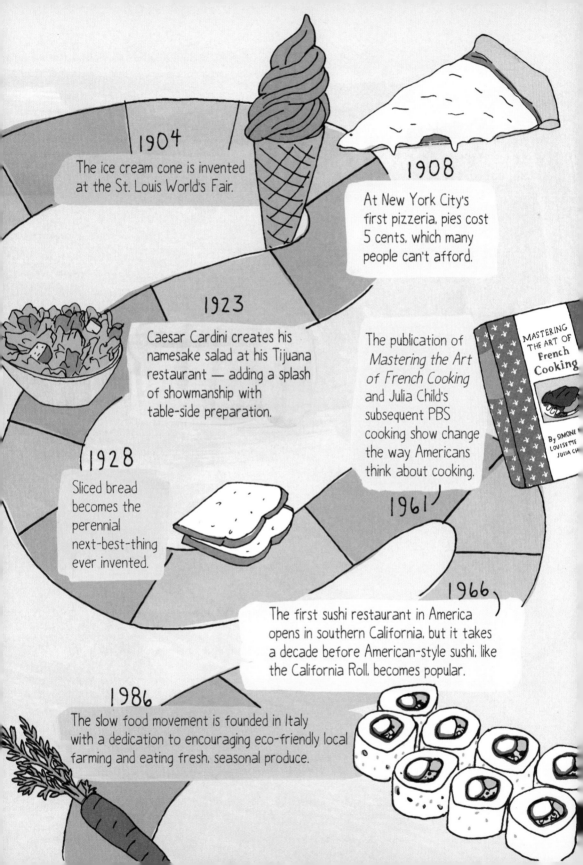

A FEW TASTY WORDS TO KNOW

acerbic. sour, bitter, or having an acidic flavor

ambrosial. having an exceptionally satisfying taste and/or smell

brackish. salty tasting

delectable. exquisitely delicious and delightful, luscious

dulcet. having a gentle sweetness

fetid. smelling awful and unpleasant

flavor. the sensation detected via mouth and nose combining taste, texture and aroma

gamy. having the flavor or aroma of game, often connotes a slightly spoiled quality

heat. Referring to the amount of spice in food

mature. fully developed or reaching a desired state

palatable. an okay taste, not particulary amazing but not awful

piquant. a spicy and sharply stimulating flavor

rich. full-bodied, heavy, robust; often used to describe overly buttery food

saccharine. overly sweet or syrupy

sharp. a strong bitter flavor

toothsome. delicious and appetizing, often tasty, healthy and fresh

umami. one of the five basic flavor profiles besides sweet, sour, bitter and salty; a pleasantly round, savory flavor

unctuous. oily-tasting, containing a rich slipperiness

woodsy. earthy, dirt-like taste, like mushrooms

PLACE SETTINGS

Formal American

Eat to the left, drink to your right. Then begin with the fork, knife, or spoon farthest away from your plate.

Chinese

Leaving a bit of food on your plate indicates to your hosts that they have provided more than enough food.

Japanese

Dishes are only partly filled, so as not to obscure the design of the serving vessel, and chopsticks are placed directly in front of each diner. In the meal itself, the balance of color, cooking techniques, and the five senses (sweet, salty, sour, etc.) are always taken into consideration.

ICHIJU-SANSAI-
(soup plus three)

- KONOMONO (pickled vegetable)
- SIDE DISH
- MAIN DISH (meat, fish, or tofu)
- RICE
- SOUP

SAIBASHI used for cooking

HASHI used for eating

HOW TO USE CHOPSTICKS:

Never lick them, cross them, or stick them directly into a bowl of rice, vertically. Not only is it considered rude, but the latter is done when making a Buddhist offering at a person's death bed.

Only move the top chopstick

Thumb remains stationary

Thai

Forks are used only to push food into the spoon, the primary utensil. Elders eat first, and meals are always shared. Even if the food is super delicious, leave a little on your plate to show that the meal was generous.

Korean Table

A traditional meal includes *banchan*, shared side dishes like marinated vegetables or kimchi. Diners usually have their own bowls of rice, and each person uses their spoons and chopsticks to serve themselves from the small plates on the table.

Indian/Nepalese

THALI

Traditionally, food is eaten with the right hand. It's considered unclean to use your left. This is a common practice in India, parts of the Middle East, and some parts of Africa.

TRAY

KATORI DISH

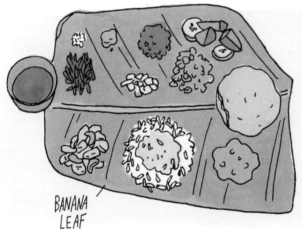

BANANA LEAF

Some families eat seated on the floor, from a large banana leaf that has a little bit of all the dishes laid out before diners.

HOW TO EAT WITH YOUR FINGERS:

- only use your right hand
- only use your fingers, not the palm of your hand
- use your thumb to push the food into your mouth
- tear breads with your thumb and finger (just right hand)

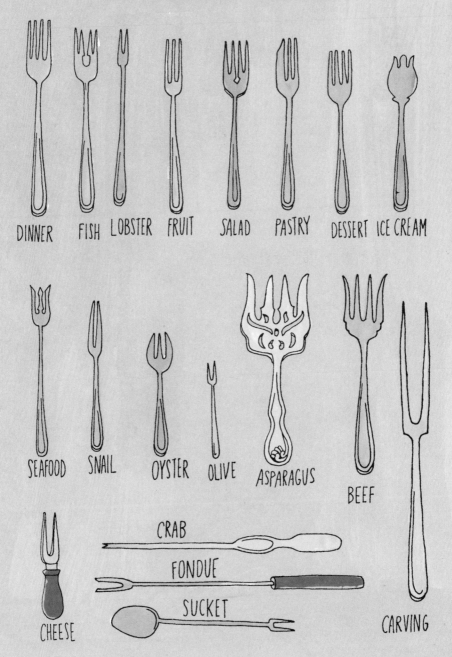

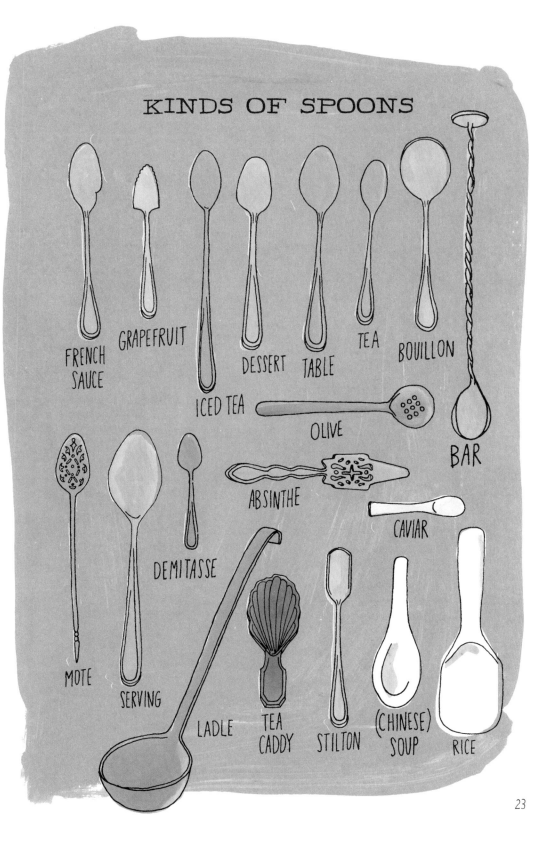

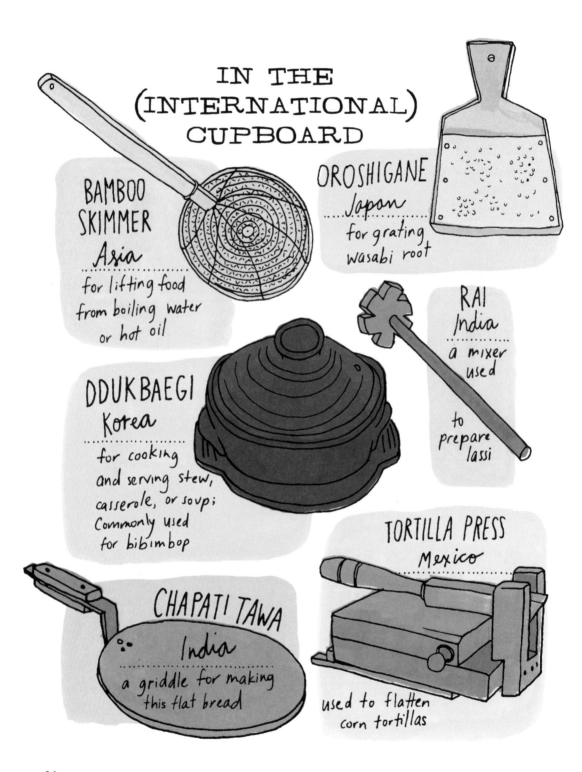

SIL-BATTA
India
for grinding lentils, preparing chutneys and masala

SPÄTZLEMAKER
Germany
for making spätzle - a noodle dumpling

AEBLESKIVER PAN
Denmark
for making spherical traditional pancakes

UROKOTORI Japan
used to scale fish

PELMENI MAKER
Russia — a mold for making dumplings

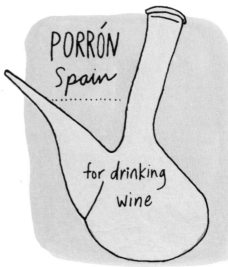

PORRÓN
Spain
for drinking wine

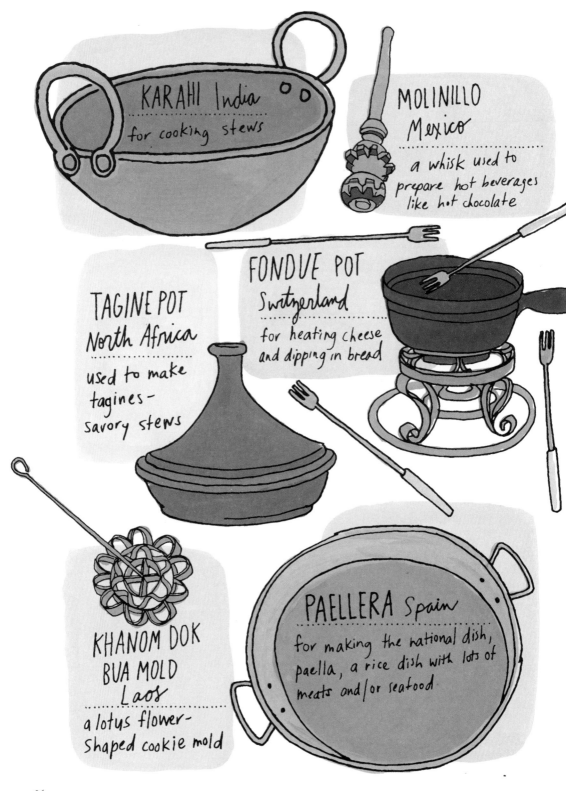

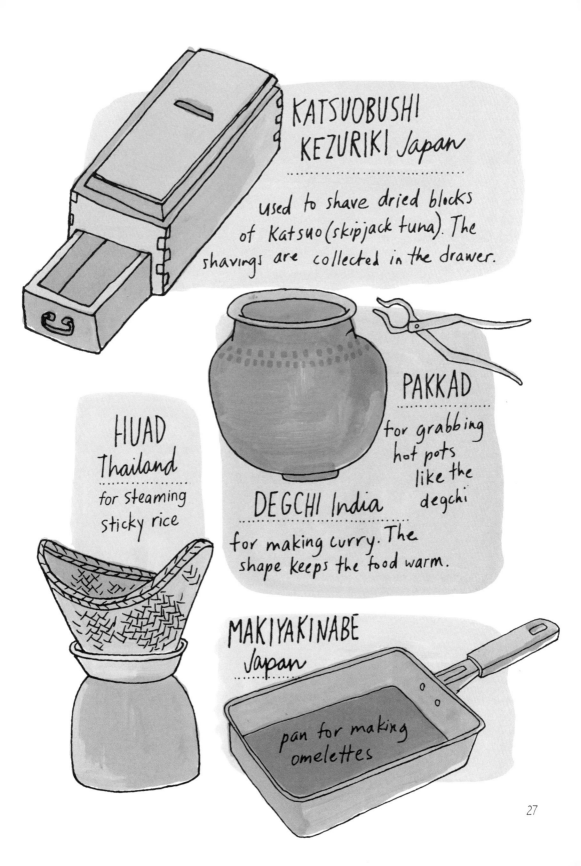

TRADITIONAL OVENS AROUND THE WORLD

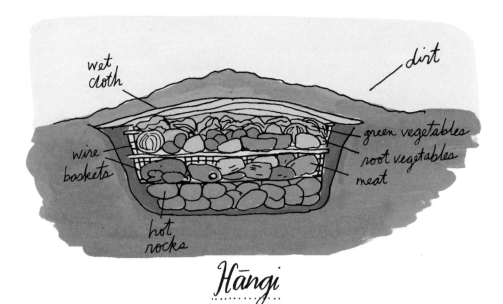

Hāngi

A traditional Maori pit oven where meat and vegetables are cooked in baskets set atop heated stones and covered with a wet cloth and a thick layer of dirt.

Horno

This beehive-shaped outdoor adobe mud oven is still used by some Native Americans to cook bread and meat, and to steam corn.

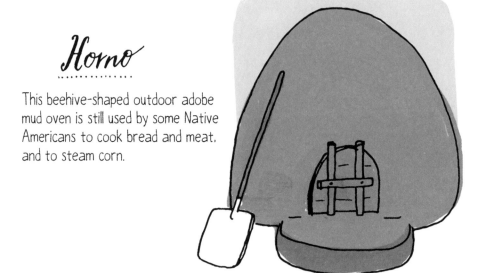

Chorkor

trays of fish

This rectangular wood-fueled oven from Ghana is used primarily to smoke fish, placed on screen frames that sit above the open flames.

Neapolitan

Built of stone and brick, these domed ovens are heated with wood or coal and date back to the Roman Republic or possibly earlier. They are still often used for making pizza.

Tandoor

A Punjabi tandoor is a traditional Indian oven made of a bell-shaped clay cylinder that is sometimes buried partially underground. They are often used to bake flatbreads like naan and roti. The raw dough is stuck to the inside of the oven and peeled off when it's fully cooked.

A CENTURY OF STOVES

1900s

1920s

1940s

1970s

THE ICE AGE OF REFRIGERATION

Modern refrigerators use chemicals and electricity to freeze or chill — but long before these were available, we used all kinds of other methods to keep our food cool.

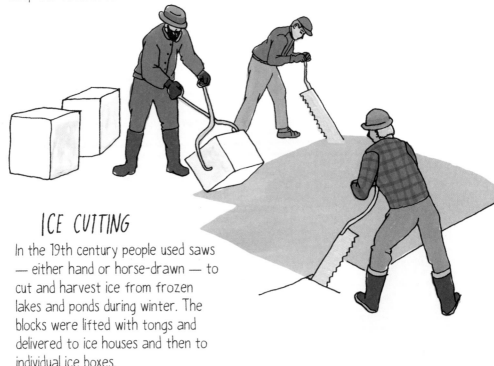

ICE CUTTING

In the 19th century people used saws — either hand or horse-drawn — to cut and harvest ice from frozen lakes and ponds during winter. The blocks were lifted with tongs and delivered to ice houses and then to individual ice boxes.

ICE HOUSE

Built partially underground with insulated walls of straw and sawdust, these were used to store blocks of ice throughout the summer.

COOLGARDIE SAFE

Invented in the 1890s and named after a Gold Rush site, this cabinet had burlap walls. Water dripped from a reservoir, saturating the burlap and keeping the interior cool as it evaporated.

ICE BOX

Before home refrigerators arrived in the 1920s, an icebox kept things chilled. One chamber of this insulated cabinet held a block of ice, and the others stored food. As the ice melted, all the chambers were cooled.

GE'S MONITOR-TOP

The first popular home refrigerator was the Monitor-Top by General Electric, which used toxic sulfur dioxide to keep food cold. When fridges with freon were introduced in the 1930s, the technology became safer and even more widespread.

FERMENTATION

Fermentation is the chemical breakdown and transformation of matter by bacteria and yeasts — it often results in effervescence, heat, and, if we're lucky, sensational food and drinks. It happens naturally but by controlling the process and the microorganisms at play, we can also influence flavor.

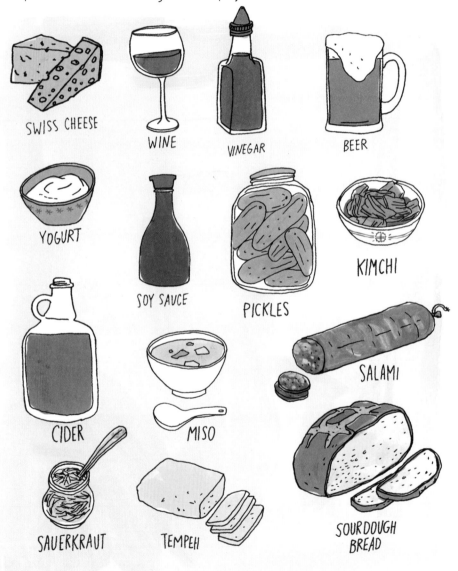

Humans have been producing fermented food and beverages since the Neolithic period. Evidence suggests early civilizations were making beer and wine 8,000 years ago; bread, possibly earlier.

Vessel for wine from 4200 BCE

Not only does fermentation alter the taste of the original ingredients, it preserves them — critically important in the centuries before canning and freezing. That's why some refer to fermentation as "controlled rot."

Before baker's yeast became available in the 20th century, cooks bought it from a brewer or captured their own wild yeasts in a sourdough starter. That's what makes sourdough bread so special, even today: Wild yeasts lend their own specific flavors in each location, unlike baker's yeast that always tastes the same.

Fermented foods are probiotic! We could not live without this good bacteria in our system.

DINING ON THE PLANT FAMILY

There are four main groups of plants.

Mosses & Liverworts

Many of these are edible, though generally considered not very tasty.

SPANISH MOSS

REINDEER MOSS

OAK MOSS

Coniferous Trees

Delicious pine nuts and young needles are used like herbs to flavor things.

Ferns

Curly fiddleheads are a spring treat.

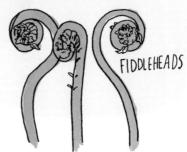

FIDDLEHEADS

Flowering Plants

Most of the fruits and vegetables we eat come from these.

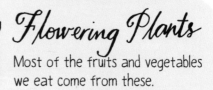

LEMON TREE

EDIBLE PARTS OF FLOWERING PLANTS

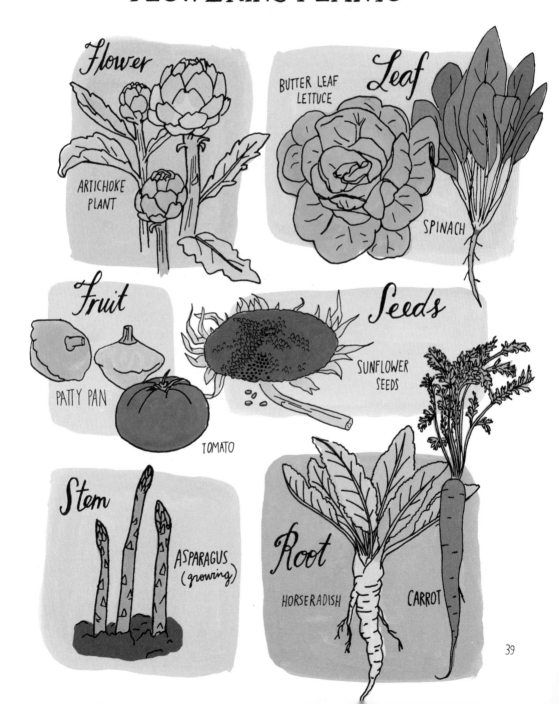

FRUIT FACTS

Cooks divide the flowering plant world into fruits (which are sweet) and vegetables (almost everything else). But to botanists, what defines a fruit is function, not flavor: A fruit is the plant's ripe, seed-bearing ovary.

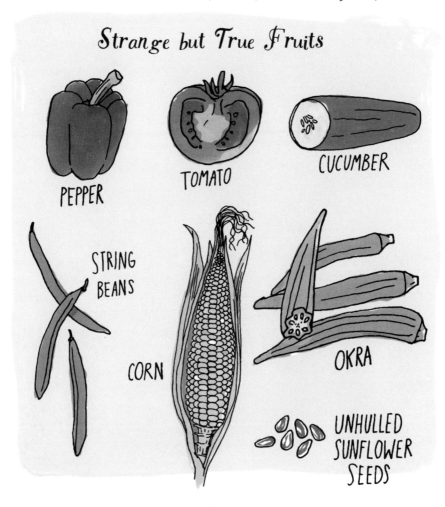

To make it more confusing, since the Tariff Act of 1883, tomatoes, cucumbers, beans and peas have been legally classified as vegetables in the USA while a 1947 ruling made rhubarb a fruit.

How a Flower Becomes a Fruit

- stigma
- style
- stamen
- petal
- sepal
- ovary

sepals and remains of stamens and styles

seed

THE PARENTS OF PRODUCE

Since antiquity humans have practiced selective farming to manipulate certain qualities of the fruits and vegetables they grow, and in the modern agricultural era, technology and science supplement this process. We usually don't notice the difference on our plates year to year, but over centuries the produce we've come to think of as common has changed so much it barely resembles its ancestors.

Original Peach

Historians say the original peach tasted like a lentil, with a waxy skin and more pit than flesh. Chinese farmers turned it into the juicy, fuzzy, sweet fruit we crave today.

FREESTONE vs. CLINGSTONE

With a freestone peach, the flesh easily separates from the pit. The flesh of a clingstone sticks to the pit, making it harder to can and freeze.

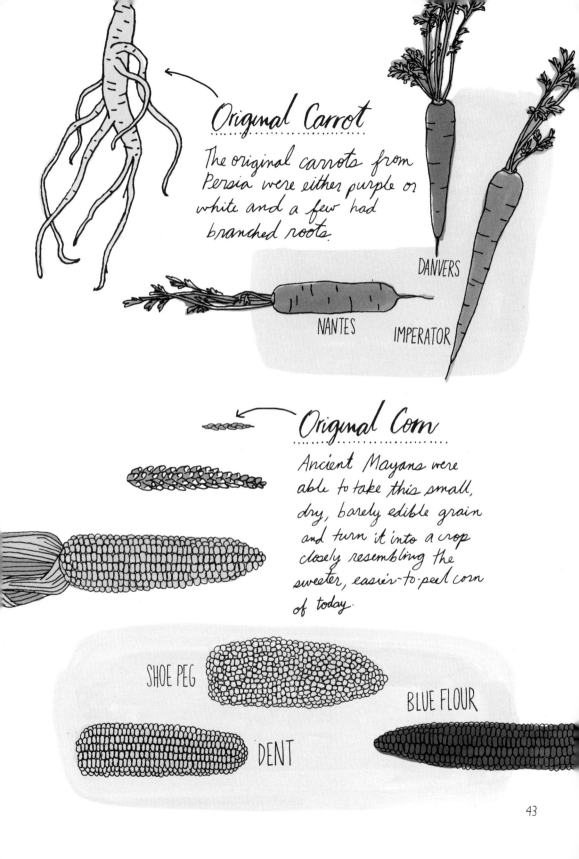

Original Watermelon

Originating from Botswana and Namibia, the watermelon used to be smaller and more bitter. The huge increase in size has made them easier to crack open. More recently, seedless varieties were developed.

DESERT KING

SUGAR BABY

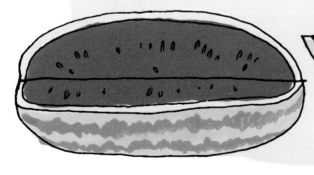

JUBILEE

HOW TO CUT A MANGO

1. Cut off the two sides as close to the pit as possible.

2. Slice into the flesh side in both directions, making a criss-cross without breaking the skin.

3. Flip the sides inside out and cut away the cubes. Cut off any remaining flesh from the pit.

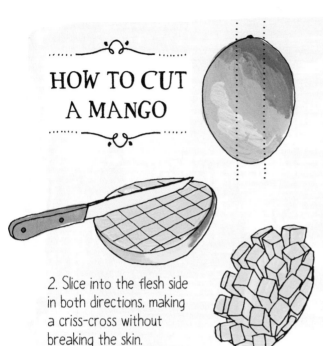

HOW TO CUT AN AVOCADO

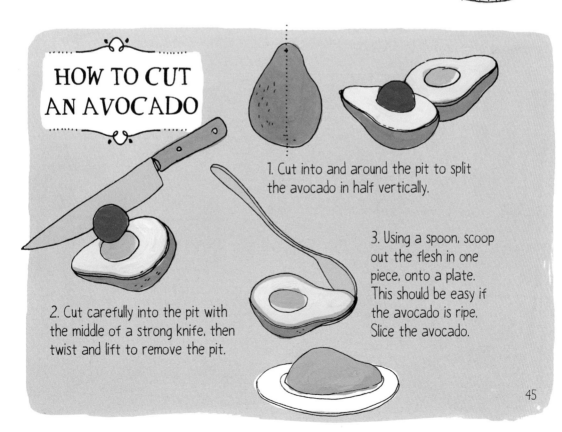

1. Cut into and around the pit to split the avocado in half vertically.

2. Cut carefully into the pit with the middle of a strong knife, then twist and lift to remove the pit.

3. Using a spoon, scoop out the flesh in one piece, onto a plate. This should be easy if the avocado is ripe. Slice the avocado.

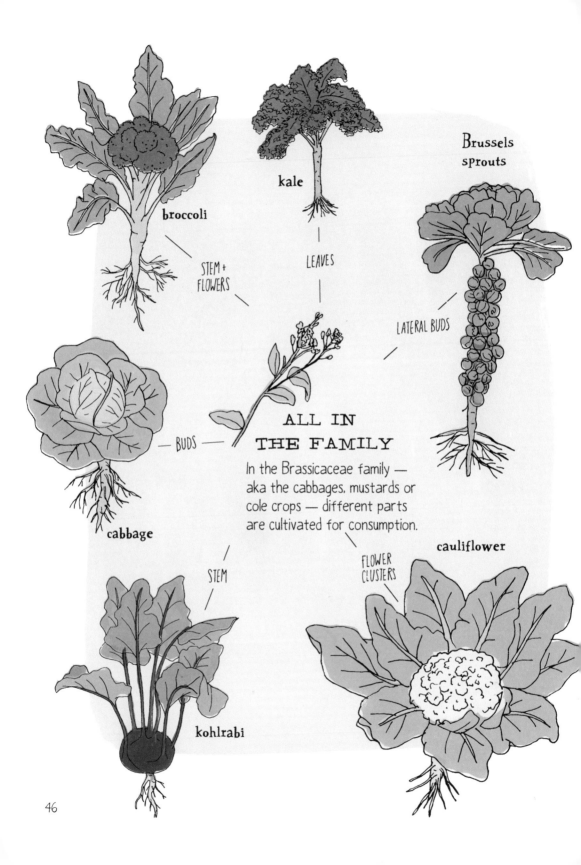

SUNDRY CELERIES

COMMON CELERY is grown for its stems.

CELERIAC is raised for its large root.

CUTTING OR LEAF CELERY is an old-fashioned plant. You eat the leaves, just like parsley or lovage, also members of the Apiaceae family.

CELERY SEED is the result of letting a celery plant flower.

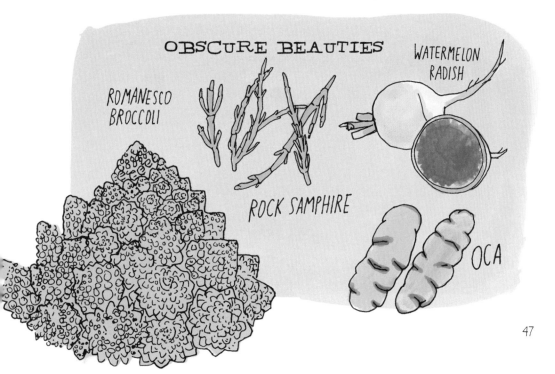

OBSCURE BEAUTIES

ROMANESCO BROCCOLI

ROCK SAMPHIRE

WATERMELON RADISH

OCA

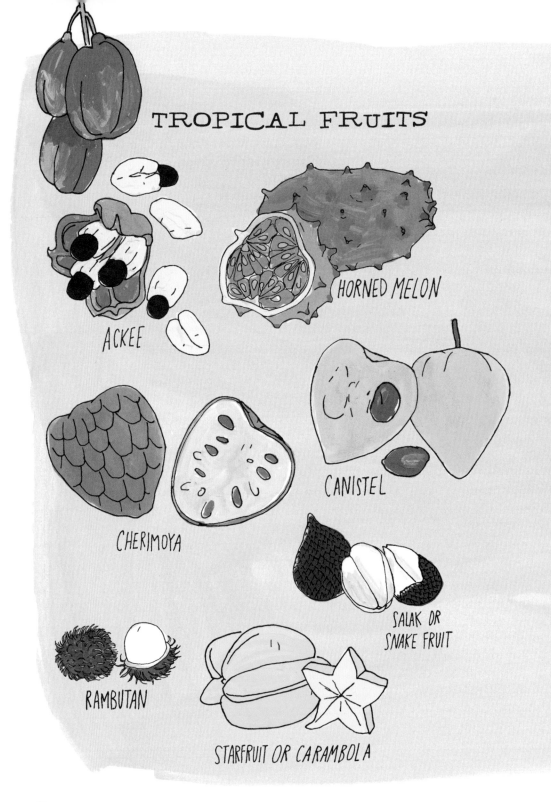

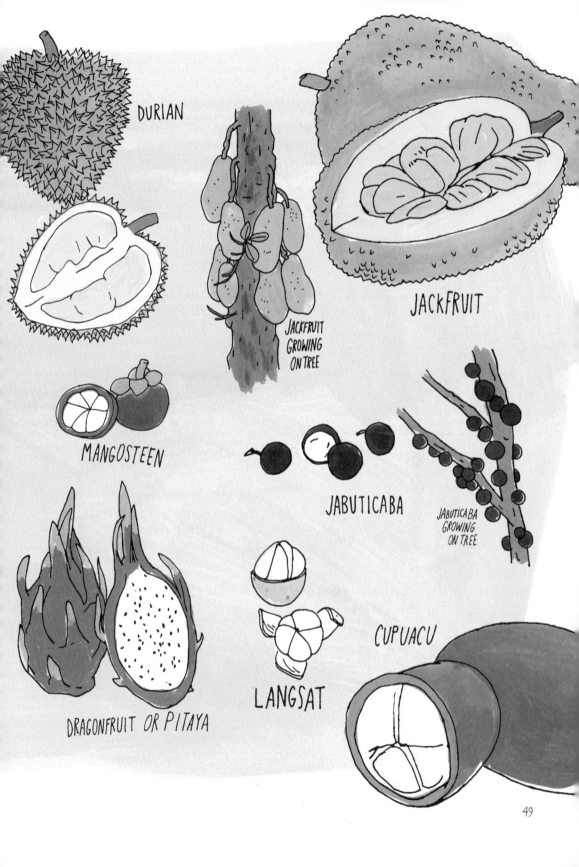

BERRY BASICS

Botanically speaking, all berries are fruits, but not all berries are berries.

Blueberries are true berries — fruits that form from one ovary that is relatively soft and has embedded seeds. (So, tomatoes, peppers and eggplants are technically berries as well.)

BLUEBERRIES
CROSS SECTION

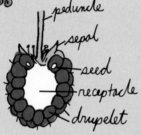

RASPBERRY

- peduncle
- sepal
- seed
- receptacle
- drupelet

Blackberries and raspberries are aggregate fruits, meaning they merge multiple ovaries.

FLOWER

MULBERRY

Mulberries are multiple fruits: where many flowers grow together.

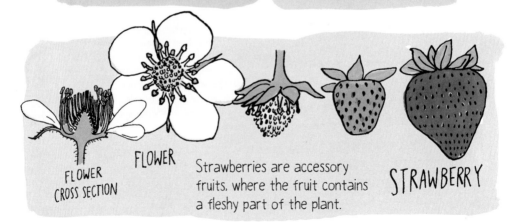

FLOWER CROSS SECTION

FLOWER

STRAWBERRY

Strawberries are accessory fruits, where the fruit contains a fleshy part of the plant.

50

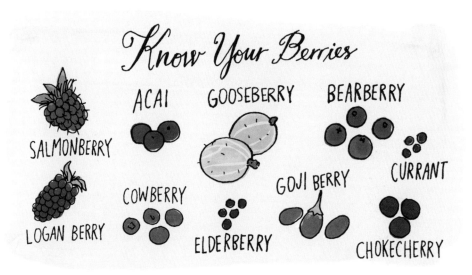

LITTLE KNOWN TERMS FOR COMMON TREE FRUIT

Drupe

Drupes — coconuts, olives, peaches, plums, and cherries — are fruits whose single seed is surrounded by a hard, stony layer. That's why many are known as "stone fruits."

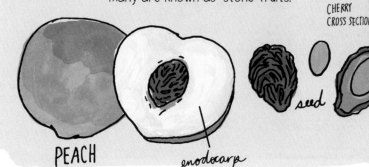

CHERRY CROSS SECTION

PEACH — endocarp — seed

Pome

Pomes — apples and pears — have a woody core that separates the seeds from the fruit.

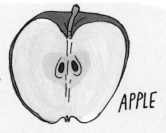

APPLE

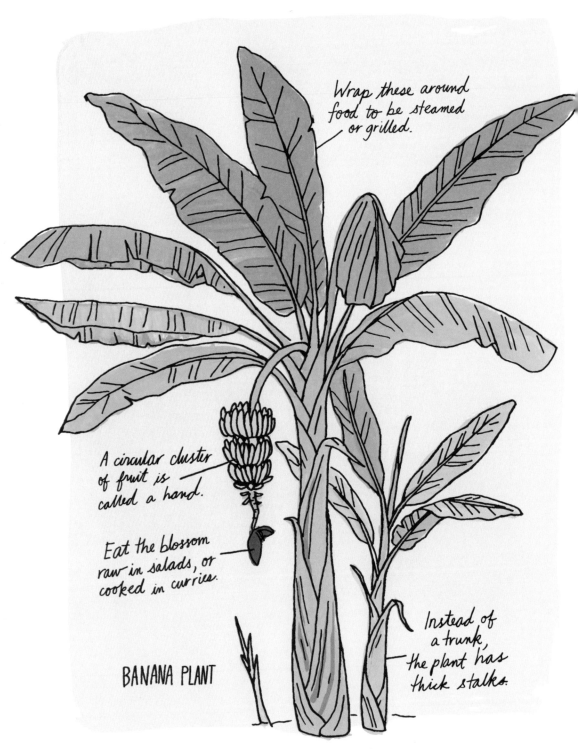

GO BANANAS

Americans typically eat only one type of *musa* — the botanical genus of which the banana is a member — but the fruit comes in many forms. There are stubby cultivars that have a tart-apple flavor and red-skinned bananas with pale pink flesh. Not to mention starchy plantains that are fried, still unripe, into chips call *tostones*.

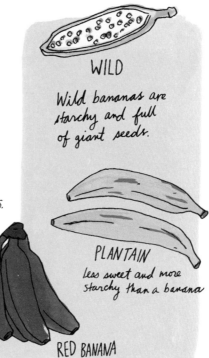

WILD
Wild bananas are starchy and full of giant seeds.

PLANTAIN
less sweet and more starchy than a banana

APPLE BANANA OR LATUNDAN

RED BANANA

SOME INTERESTING DISHES

PULUT INTI
a dessert of glutinous rice wrapped in banana leaf, topped with sweet coconut (Malaysia)

ARATIKAYA VEPUDU
raw plantain cut into cubes and fried with spices (South India)

chapati bread

MATOOKE
mashed banana (Uganda and Rwanda)

CITRUS

Non Hybrids

Botanists believe that all types of citrus descend from these four ancient wild plants.

POMELO — *Citrus maxima*

PAPEDA — a collective name for a handful of bitter, primitive species

MANDARIN — *Citrus medica*

CITRON — *Citrus reticulata*

Extraordinary Hybrids

Most citrus fruit we eat today comes from natural or human hybridization, or the process of breeding two different plants together. Botanists often use an "x" in the scientific name of a hybridized plant, to illustrate the "cross" of two different fruits.

SHIKUWASA OR HIRAMI LEMON — *Citrus x depressa*

YUZU — *Citrus ichangensis x reticulata*

MAKRUT LIME
Citrus × hystrix

CALAMONDIN
× Citrofortunella mitis

BUDDHA'S HAND
Citrus medica var. sarcodactylus

— used as a religious offering in Buddhist temples

UGLI
Citrus reticulata × Citrus paradisi

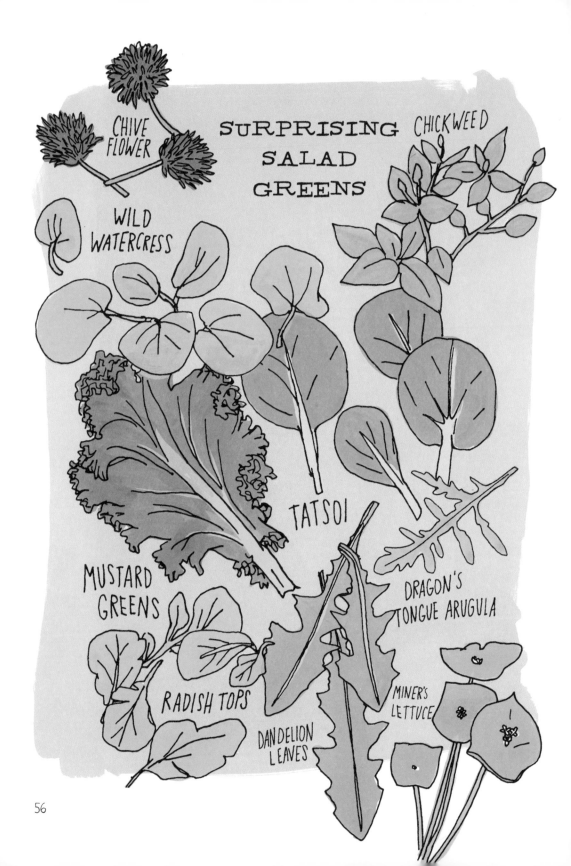

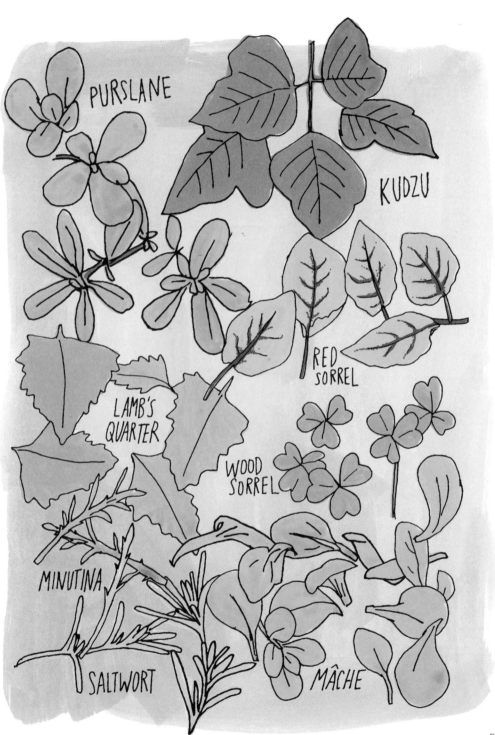

FAMOUS FUNGI

Aspergillus is a type of mold used to make soy sauce and sake. A form of *Penicillium* mold makes blue cheese.

Saccharomyces cerevisiae is the yeast used in baking, brewing, and winemaking, while *Brettanomyces* is what makes sour beers sour.

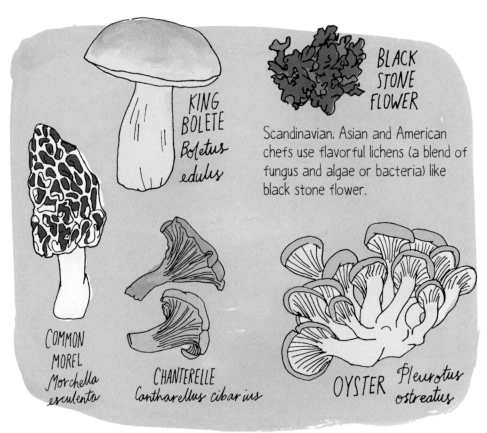

Scandinavian, Asian and American chefs use flavorful lichens (a blend of fungus and algae or bacteria) like black stone flower.

The Truffle Hunter

The fanciest fungus by far is the subterranean truffle, technically the fruiting body of fungi that grow on tree roots. Though different species grow or can be cultivated in a surprising number of countries, those found growing naturally in Europe command the highest prices, up to $10,000 per pound.

Dogs are often used for truffle hunting instead of pigs because they can more easily be trained not to eat what they find.

The Mercedes of truffles are white varieties found in the Italian Piedmont in fall. Close runners-up are black winter truffles from southern France.

WHITE TRUFFLE
Tuber magnatum

BLACK TRUFFLE
Tuber melanosporum

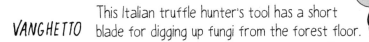

VANGHETTO — This Italian truffle hunter's tool has a short blade for digging up fungi from the forest floor.

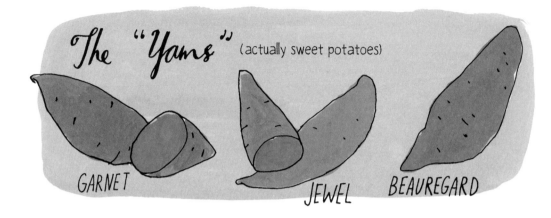

The "Yams" (actually sweet potatoes)

GARNET JEWEL BEAUREGARD

YAM VS. SWEET POTATO

Sweet potatoes — native to Central America — are sometimes called yams, but they are totally different plants. Starchy and dry, real yams are native to Africa and Asia, and can grow up to five feet long.

White Yam
DIOSCOREA ROTUNDATA Africa

Boiled and mashed or dried and smashed into a powder

Water Yam
DIOSCOREA ALATA
Philippines

aka the purple yam; used in desserts

Chinese Yam
DIOSCOREA OPPOSITA
Japan, China, Korea

Shredded or grated and used raw or lightly cooked in Japanese recipes. Also used in Chinese herbal medicine.

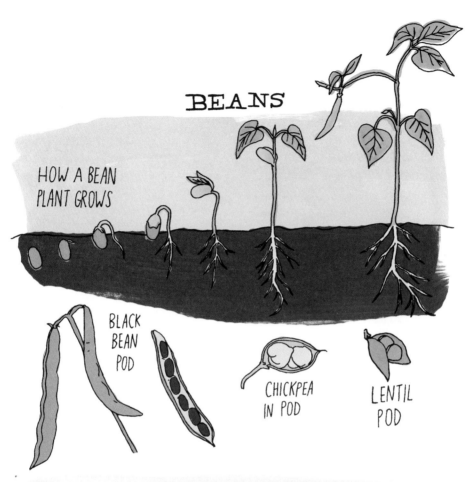
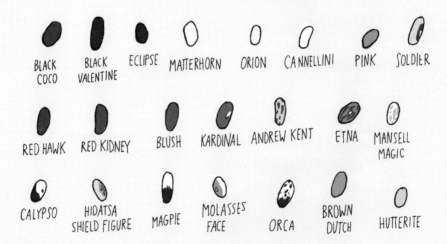

SHELL GAMES

Only a handful of what we call nuts are true botanical nuts. While the word now applies to almost anything with a hard outer layer around edible seeds, true nuts such as acorns, beechnuts, chestnuts, and hazelnuts are always indehiscent — meaning their shells are all in one piece and don't naturally pop open.

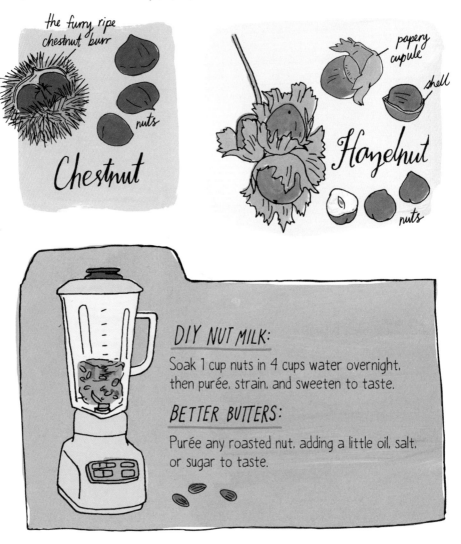

DIY NUT MILK:
Soak 1 cup nuts in 4 cups water overnight, then purée, strain, and sweeten to taste.

BETTER BUTTERS:
Purée any roasted nut, adding a little oil, salt, or sugar to taste.

FEELING NUTTY

Cashew

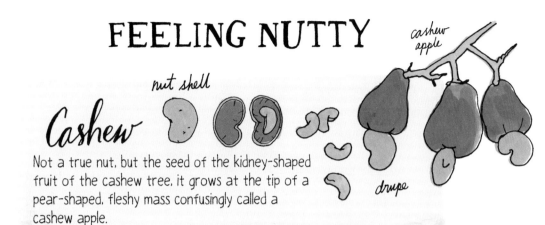

Not a true nut, but the seed of the kidney-shaped fruit of the cashew tree, it grows at the tip of a pear-shaped, fleshy mass confusingly called a cashew apple.

Walnut

Technically a drupe, or stone fruit. Dozens of varieties are cultivated for their seeds, but black walnut trees are the ones you'll see growing wild in the United States. They're not easy to hull, but they're worth the effort.

Peanut

Seeds of the peanut plant. Like lentils, peas, and soybeans, peanuts are technically legumes, which form pods containing edible grains or seeds.

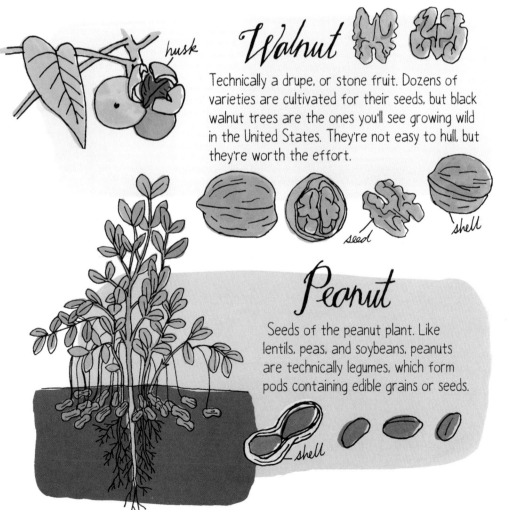

PEANUT POWERED

Bumbu Kacang

Indonesian peanut sauce made with ground, cooked nuts, spices, and usually coconut milk, soy sauce, tamarind, galangal, and garlic. Typically served with gado gado, a cooked vegetable salad, and all manner of satay, or skewered, grilled meats.

Kong Bao Ji Ding

A Chinese dish, the precursor of American Kung Pao, made with dried chiles, peanuts, and chicken.

Ka'i Ladrillo

A popular peanut brittle from Paraguay — thought to be the peanut's ancestral home — made with molasses.

Maafe

A West African dish made by simmering meat in a salty-sweet sauce of ground peanuts or peanut butter, plus tomatoes, ginger, onion, and garlic. (It's also made with the West African groundnut, a similar legume.)

Kare Kare

A Filipino stew made with meat, eggplants, beans, greens, and crushed nuts or peanut butter.

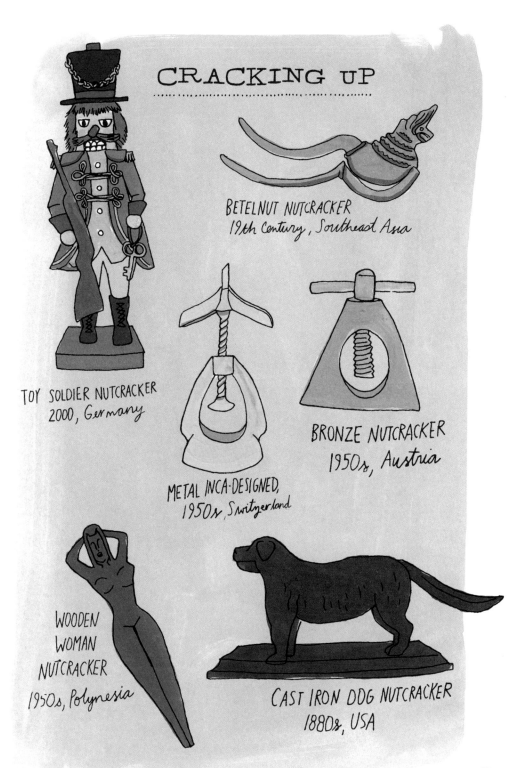

HOW TO MAKE TOFU

1. Make Soy Milk

Dried beans are soaked, mashed, cooked, and strained to make soy milk. The Japanese call the leftover pulp "okara" and add it to dishes like unohara, made with vegetables, soy sauce, and mirin.

2. Coagulate

Fresh soy milk is warmed then coagulated with "nigari," or what remains after salt is extracted from seawater. The skin that forms on the hot milk is called "yuba" — it's skimmed off and eaten too.

TOFU SKIN or YUBA

3. Curds & Whey

As in cheesemaking, tofu producers call the coagulated mixture of oil and soy protein "curds," and the leftover water that is strained off "whey."

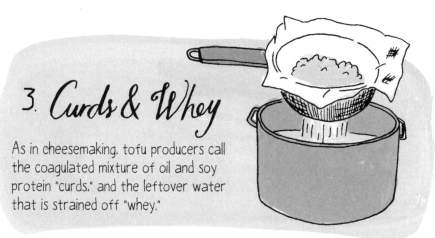

4. The Press

Tofu curds can be eaten soft — it's even served with sweet syrup like custard — or pressed into harder bricks. The longer you press, the firmer it gets.

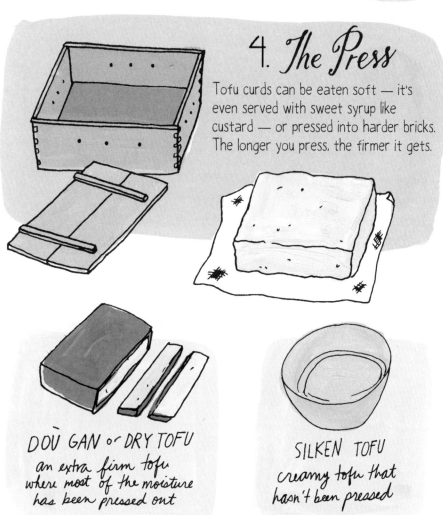

DOÙ GAN or DRY TOFU an extra firm tofu where most of the moisture has been pressed out

SILKEN TOFU creamy tofu that hasn't been pressed

Good Grains

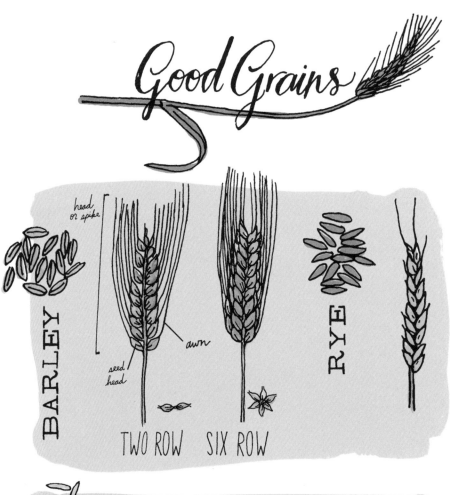

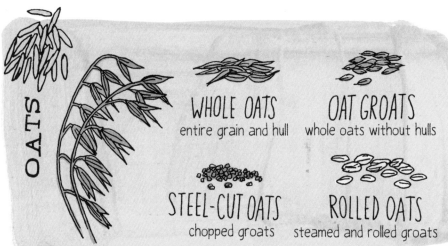

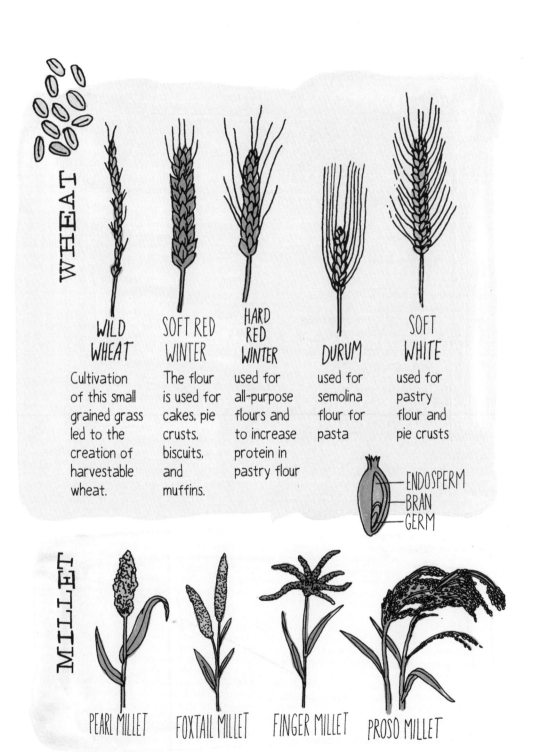

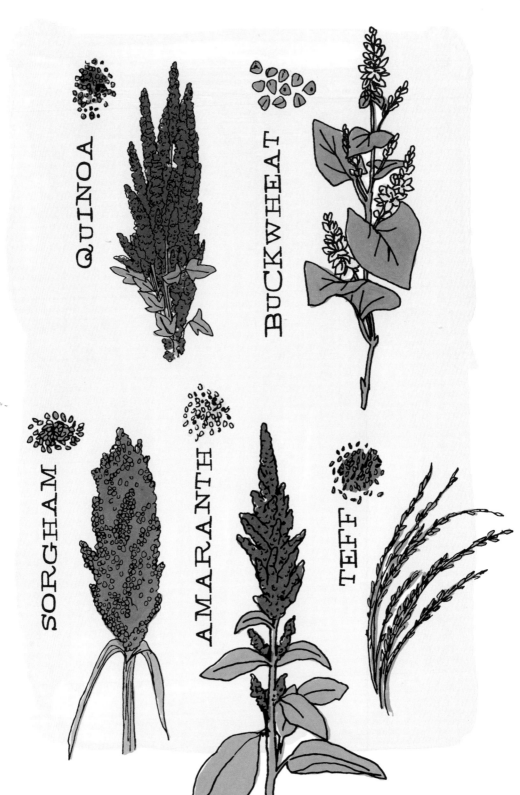

CORN

CORN PLANT

- tassel
- leaf
- node
- stalk
- brace roots
- roots

Humans cultivate many varieties of corn, including sweet corn for eating; dent or field corn, which is made into tortillas, animal feed, oil, fuel, and sweeteners; and thick-hulled flint or Indian corn, of which popcorn is a variant.

EAR

- silk
- husk
- shank

HOW POPCORN POPS

Inside each dried kernel is a little bit of water, protected by a hard, shell-like hull. When heat is applied, the water turns to steam and builds up pressure inside the kernel until it explodes.

KINDS OF RICE

ARBORIO

BASMATI

JASMINE

ROSE MATTA

BHUTANESE RED

GLUTINOUS OR STICKY

KOSHIHIKARI

CAMARGUE RED

BLACK

DARK WILD

BROWN SHORT GRAIN

RED CARGO

GROWING RICE

It usually takes three months to grow rice. One method is to hand-plant rows of seedlings in paddies that are flooded with water to prevent weeds. At three feet tall, the rice plants are cut with a knife and run through a thresher to separate the grains from the stalks. Grains are dried and then milled to remove the outer layers. With brown rice, only the husk is removed, leaving the nutty, nutrient-rich bran and germ. For white rice, all three outer layers are polished away.

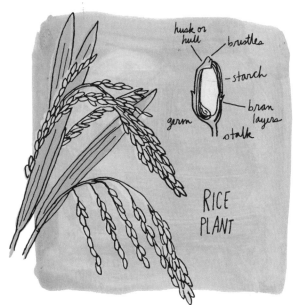

There are more than 40,000 varieties of rice. It is grown on every continent except Antarctica.

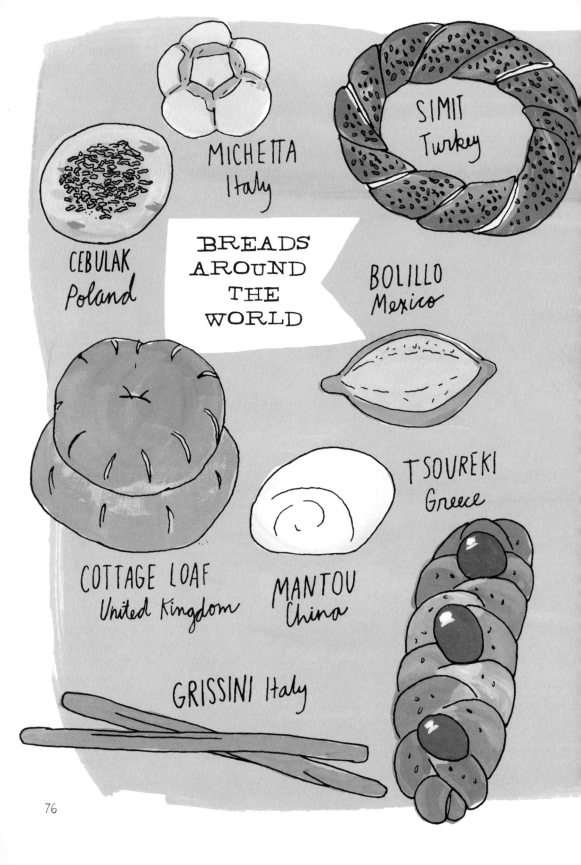

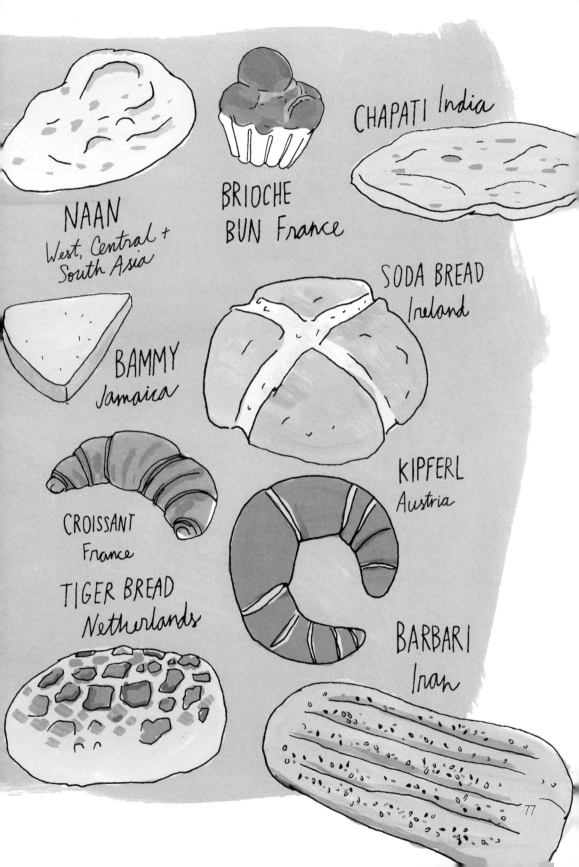

ROLLING THE DOUGH

BOILING BAGELS

Before they're baked, these Eastern European bread rings are boiled to yield an appealingly chewy, hard crust.

A TWISTED TALE

One of the many origin stories of pretzels dates back to 610 CE when Italian monks decided to bake some breads in the shape of a child crossing their arms in a pious fashion. They were given as a treat to the children for memorizing their prayers and were called "pretiolas" derived from the Latin "pretzola" meaning "little rewards."

KARELIAN PIE

These small rye bread pockets from the ancient region of Karelia — which includes parts of Finland, Russia, and Sweden — hold rice porridge and are often topped with a mixture of butter and eggs.

SWEDISH CINNAMON STAR BREAD

Often eaten during holidays, this cinnamon layered bread is formed in the shape of a star for a beautiful celebratory impression. The layered dough is cut into sections, keeping the center intact. Then each piece is twisted. During baking, the layers expand to make the star shape.

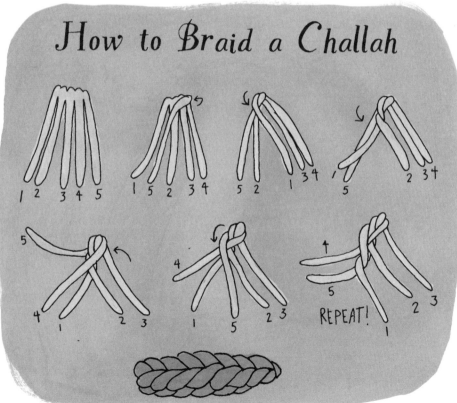

Baking Traditional Finnish Rye Bread With My Friend Pirjo Mustonen

Rye bread is a staple of every Finnish meal, usually served with cheese. It is dark, sour, and drier than many other European and American rye breads. My friend Pirjo has been making it her whole life, from a hundred-year-old sourdough starter — which she calls a "root" — that has been passed down by her family. Here's her three-day baking process.

DAY 1

The root is removed from the freezer where it is stored. It is about 3/4 cup of the dough from the last bake.

DAY 2 MAKING THE DOUGH

ROOT
12½ CUPS OF LUKEWARM WATER
1/2 to 1 TEASPOON OF YEAST
1½ POUNDS OF MEDIUM-ROUGH RYE FLOUR

Put the root of the bread into a large bowl or bucket. Mix the root, water and yeast. Add flour, stirring every few hours. Cover the bowl with a cloth.

MIXING TOOL
Made from carving the top of a spruce tree

DAY 3

1 TABLESPOON OF SALT
2½ - 3 POUNDS OF MEDIUM-ROUGH RYE FLOUR

Add salt into the dough. Mix the flour into the dough little by little. The dough should feel soft but also solid. Gather the dough into a mound and make a cross in it with a knife. This helps you determine how much it has risen. Cover the bowl with a cloth. Let it rise for 2-3 hours.

Dust the table with flour. Set the dough on the table and pull off about 3/4 cup of the dough. THIS WILL BE THE NEXT ROOT OF THE BREAD. Store the root in the freezer.

Divide the remaining dough into five even pieces.

Knead the pieces of dough by rolling them into long snake-like pieces and then curling those up into coils. Repeat that a few times.

Gather the dough and use both hands to roll it back and forth on the table in a cone shape. Form the dough into a mound. Continue that process with the rest of the pieces.

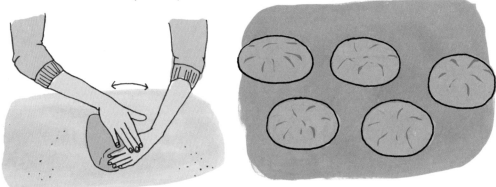

Cover and let them rise for 1½ hours. Preheat the oven to 450°F.

Prick each mound with a fork a few times.
Bake for about 1 hour. (Piryo uses a wood-burning oven.) Remove the breads and cover them as they cool.

Enjoy with butter and cheese!

SUMPTUOUS SANDWICHES

BAGEL LOX New York, USA
bagel, cured salmon, cream cheese, sometimes onion and capers

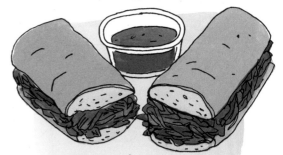

BEEF AU JUS France
miniature French bread loaf, roast beef, dip of meat drippings

BAURU Bauru, Brazil
French bun with crumb removed, mozzarella, roast beef, tomato and pickled cucumber

CEMITA Mexico
brioche-like sesame seed roll, sliced avocado, beef milanesa, panela (white cheese), onion, papalo herb and red sauce

CHEESE STEAK Philadelphia, USA
long, soft roll, thin-sliced rib-eye or top round beef, melted cheese, and sometimes sauteed onion, peppers, and mushrooms

CHACARERO Chile
roll, thin-sliced churrasco-style steak, tomatoes, green beans, chile pepper

CHORIPÁN
South America

crusty bread, chorizo, sauces like chimichurri (green sauce of parsley, garlic, oregano, oil and vinegar)

DOUBLES
Trinidad and Tobago

bara (flat fried bread), channa (curried chickpeas), mango, shadon beni herb, cucumber, coconut, tamarind, pepper sauce

FISCHBRÖTCHEN
Northern Germany

fish, onions, pickles, and a sauce such as remoulade, ketchup, or cocktail

FALAFEL
Middle East

pita bread, falafel (deep-fried ball made of ground chickpeas or fava beans), lettuce, tomato, pickled vegetables, hot sauce, tahini sauce

GATSBY *Cape Town, South Africa*

long roll, french fries, meat (masala steak, chicken, sausage) or seafood (fish or calamari)

FRANCESINHA *Porto, Portugal*

bread, ham, linguiça, fresh sausage (chipolata), steak or roast meat, cheese, tomato and beer sauce

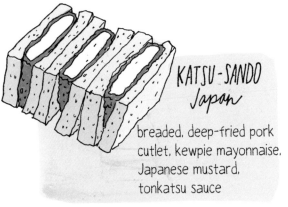

KATSU-SANDO
Japan

breaded, deep-fried pork cutlet, kewpie mayonnaise, Japanese mustard, tonkatsu sauce

LAMPREDOTTO
Florence, Italy

crusty bun, tripe from the fourth stomach of the cow, parsley green sauce, hot chile sauce

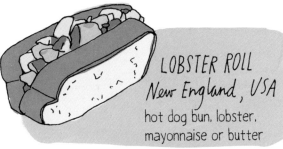

LOBSTER ROLL
New England, USA

hot dog bun, lobster, mayonnaise or butter

MONTE CRISTO
United States

bread dipped in egg batter, ham, cheese, powdered sugar, maple syrup or jam on the side

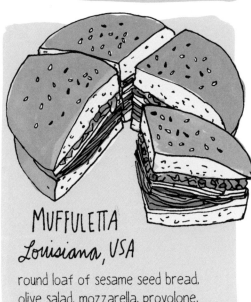

MUFFULETTA
Louisiana, USA

round loaf of sesame seed bread, olive salad, mozzarella, provolone, mortadella, salami, ham, giardiniera, or pickled vegetable relish

PAN BAGNAT
Nice, France

French sourdough, hard-boiled eggs, anchovies, tuna, raw vegetables, olive oil

TOAST HAWAII
Germany

white bread toast, ham, cheese, pineapple, maraschino cherry

TRAMEZZINI
Italy

white bread without crusts, triangular cut. fillings vary: tuna and olives, arugula and parmesan, prosciutto and mozzarella

YAKISOBA-PAN
Japan

fried buckwheat noodles, pork, vegetables, yakisoba sauce, pickled ginger, dried seaweed, on a hot dog roll

VEGEMITE
Australia

bread with Vegemite – a food paste made from leftover brewer's yeast extract, vegetables, and spice additives

BÁNH MÌ *Vietnam*

a baguette roll stuffed with pork, chicken, fish, or even tofu, typically garnished with fresh cucumber, cilantro, pickled carrots and radishes

MAKING PASTA

Pasta dough can be made from combining just flour and eggs.

The dough is then put through a machine to make it into very thin sheets, or to cut it into long strands.

HOME PASTA ROLLER MACHINE

Those sheets could be used to make ravioli.

Or the dough can be put through an extruder machine to make shaped pasta.

RESTAURANT-SIZED EXTRUDER

FUSILLI LINGUINI RIGATONI

The dough gets pushed through different dies and cut to the correct length.

Some Classic Dishes...

TAGLIATELLE AL RAGU BOLOGNESE FETTUCCINE ALFREDO CACIO E PEPE

MAKING NOODLES

Making noodles by hand is a long-standing Asian tradition — the earliest text describing the process dates to 1504.

LAMIAN

Lamian are Chinese wheat flour noodles "pulled" from a single piece of high-gluten dough — hence the English translation to "pulled noodles." In one method, the gluten is developed by repeatedly stretching the dough and letting it snap against a counter, then twisting it over on itself.

To make the noodles, the finished dough is stretched wide, then folded over on itself, creating two thick strands. Those are stretched and then folded over, creating four thinner strands. And so on, until the desired thinness of noodle is achieved.

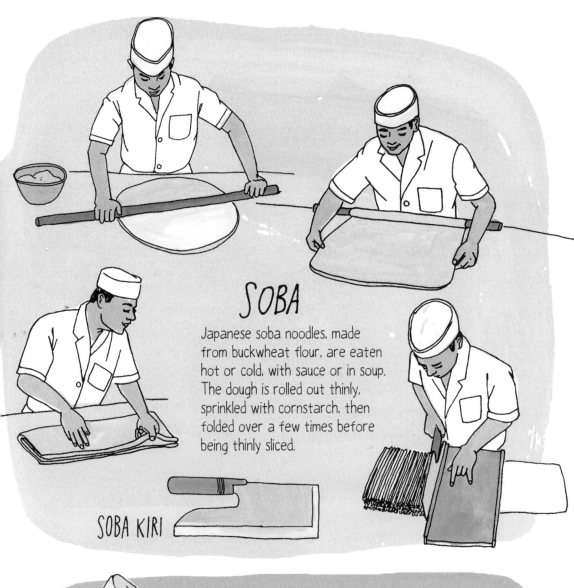

SOBA

Japanese soba noodles, made from buckwheat flour, are eaten hot or cold, with sauce or in soup. The dough is rolled out thinly, sprinkled with cornstarch, then folded over a few times before being thinly sliced.

SOBA KIRI

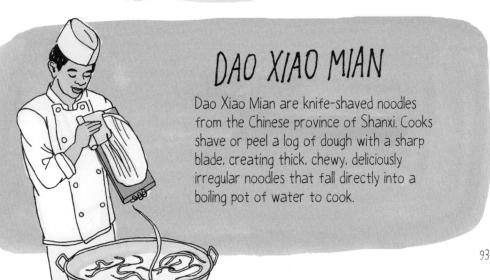

DAO XIAO MIAN

Dao Xiao Mian are knife-shaved noodles from the Chinese province of Shanxi. Cooks shave or peel a log of dough with a sharp blade, creating thick, chewy, deliciously irregular noodles that fall directly into a boiling pot of water to cook.

ASIAN NOODLE DISHES

LAKSA, Singapore
rice noodles, and prawns or fish in a spicy, coconut milk curry soup

DAN DAN NOODLES, China
noodles, pork and scallion in a spicy Sichuan sauce

DRUNKEN NOODLES (PAD KEE MAO) Thailand and Laos
broad rice noodles, soy sauce, fish sauce, meat or seafood, vegetables, and a chile, pepper, and basil seasoning

MILMYEON, Korea
long thin noodles made of flour and sweet potato starch in a meat broth with vegetables and egg

KYAY OH, Myanmar
rice noodles, meat balls, pork broth

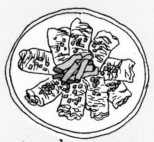

BÁNH HỎI, Vietnam
rice noodles woven into clumps, scallions, meat

Jane's (My Mom) Noodle Pudding

10-12 OZ. BROAD EGG NOODLES
1 STICK SWEET BUTTER
1 LB. POT CHEESE OR FARMER CHEESE
16 OZ. SOUR CREAM
8-10 EGGS
3/4 CUP SUGAR
GROUND CINNAMON

(It is best if the refrigerated ingredients are at room temperature)

1. Boil the noodles until they are al dente, the shortest time on the instructions.
2. While the noodles boil, beat the eggs well with a whisk in a large bowl. Add in the pot cheese, sugar and sour cream. It should be well mixed and soupy. If it's not soupy, add an extra beaten egg or two.
3. Drain the noodles, tossing them gently until all the excess water is removed. Transfer them to a large bowl.
4. Take the stick of butter and swirl it around the hot drained noodles. This will melt the butter and evenly distribute it among the cooling noodles.
5. When the noodles have cooled off, fold the cheese, sour cream, sugar and egg mixture in with the noodles until it is all combined evenly.
6. Pour it all into a greased baking dish approximately 9x13".
7. Sprinkle the top with a dusting of cinnamon. Bake at 350° for approximately 1 hour or until the top is browned and the egg custard has set.
8. Let stand. Cut into square portions. Serve hot or cold.

DELECTABLE DUMPLINGS FROM AROUND THE WORLD

KHINKALI
Georgians fill these with minced meat and dust them with black pepper. Traditionally, the knot of dough on top — known as the kuchi, or belly button — isn't eaten.

CANEDERLI
Bread dumplings from the Alps of northeast Italy, often flavored with smoked, cured meat called speck. The many native German-speakers in this region call them Knödel.

PELMENI
These savory Russian ravioli are known for their thin and delicate skins.

SIN MANTI
Armenia's open-faced, baked lamb dumplings are often eaten with yogurt.

Fufu is often used in lieu of utensils to carry food to the mouth

MODAK

An Indian sweet that comes in many flavors, it is thought to be a favorite of the Hindu god Ganesh.

MODAK IN MOLD

FUFU

These African or West Indian dumplings made from cassava, semolina, or corn flour are usually eaten with soup or stew.

MOMO

This famous South Asian dish is made in many shapes and with myriad fillings, including yak.

HALUŠKY

Topped with cheese and bacon, Slovakia's rustic potato gnocchi are considered the national dish.

XIAO LONG BAO

Also known as soup dumplings, these juicy Shanghainese pork dumplings are usually served straight from the xiaolong, or steamer that gives them their name.

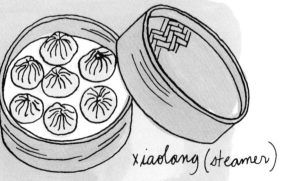

xiaolong (steamer)

PANCAKES AROUND THE WORLD

INJERA, Ethiopia
a spongy, fermented flatbread made from teff flour

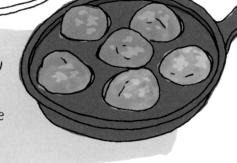

ÆBLESKIVER, Denmark
spherical pancakes made from flour, buttermilk, cream, eggs and sugar

HOTTEOK, Korea
a sweet pancake filled with brown sugar, honey, peanuts and cinnamon

SERABI, Indonesia
rice flour pancakes made with coconut milk, and pandan leaf juice, which turns them green

CHATAMARI, Nepal

a rice pancake snack with toppings of meat and vegetables and sometimes egg and cheese

BLINTZES, Russia

a very thin wheat flour pancake that is folded to hold cheese or fruit before getting sauteed

DOSA, India

made from fermented batter. this rice and urad bean pancake is served with a variety of chutneys

CREPE, France

a thin wheat or buckwheat flour pancake served folded up with either sweet or savory fillings

CHAPTER 4

The Meat of the Matter

PRIME CUTS

BEEF

1 NECK
2 CHUCK
3 RIB
4 SHORT LOIN
5 LOIN END
6 RUMP
7 ROUND
8 DIAMOND
9 HIND SHANK
10 SIRLOIN TIP
11 FLANK
12 SHORT PLATE
13 ENGLISH CUT
14 BRISKET
15 FORESHANK

When meat is sliced, it is always cut against the grain. This makes it more tender.

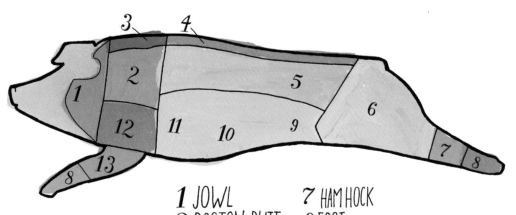

PORK

1 JOWL
2 BOSTON BUTT
3 CLEAR PLATE
4 BACK FAT
5 CENTER CUT
6 HAM
7 HAM HOCK
8 FOOT
9 LEAF FAT
10 SIDE OR BELLY
11 SPARERIBS
12 PICNIC SHOULDER
13 HOCK

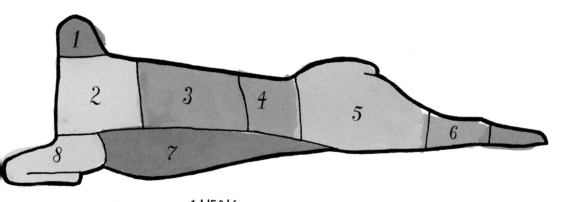

LAMB

1 NECK
2 CHUCK
3 RACK OR RIB
4 LOIN
5 LEG
6 SHANK
7 BREAST
8 FORESHANK

HOW MEAT COOKS

Meat is mostly muscle, or little bundles of cells filled with fibers made up of proteins. Protein molecules are essentially tightly wound coils. Apply heat and the structure of those fibers change: The bonds that hold the coils break, and the molecules inside unwind. The fibers then shrink as water is squeezed out, and the unwound protein molecules coagulate, or join together into a semi-solid state. This process is called denaturing; it also explains why the texture of meat grows firmer as it cooks.

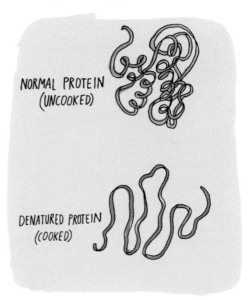

NORMAL PROTEIN (UNCOOKED)

DENATURED PROTEIN (COOKED)

Cooking Temperatures

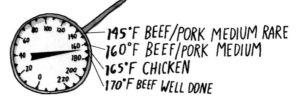

- 145°F BEEF/PORK MEDIUM RARE
- 160°F BEEF/PORK MEDIUM
- 165°F CHICKEN
- 170°F BEEF WELL DONE

WET HEAT

Boiling, steaming, and stewing are ideal for tough meats or those with lots of sinew or muscle.

Bollito misto is a prized Italian dish where many tougher cuts of meat and a stewing hen are simmered for hours in aromatic stock. They make a similar dish in France called pot-au-feu, or "pot on the fire."

BOLLITO MISTO

DRY HEAT

These methods transfer heat directly to the meat by hot air, fire, or the cooking surface itself. Frying is considered "dry" because oil is used instead of water.

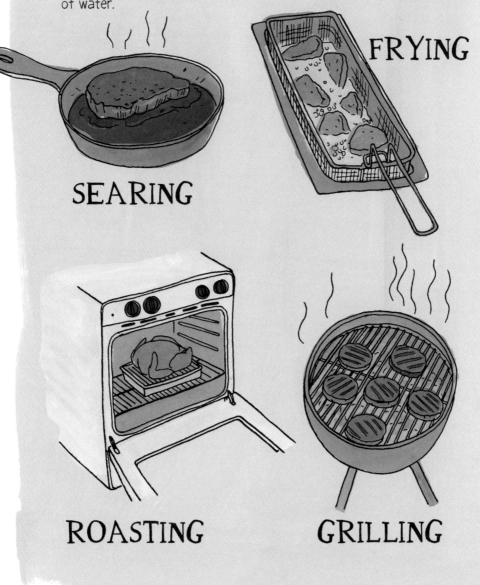

SEARING

FRYING

ROASTING

GRILLING

On the Charcuterie Plate

It may have started as a simple pre-refrigeration technique to preserve meat, but the art of charcuterie — from the old French words "char" (flesh) and "cuit" (cooked) — now produces some of world's most coveted flavors.

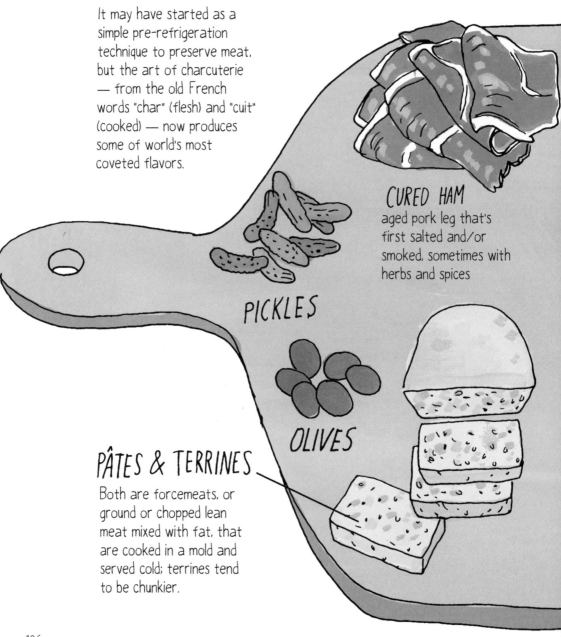

CURED HAM
aged pork leg that's first salted and/or smoked, sometimes with herbs and spices

PICKLES

OLIVES

PÂTES & TERRINES
Both are forcemeats, or ground or chopped lean meat mixed with fat, that are cooked in a mold and served cold; terrines tend to be chunkier.

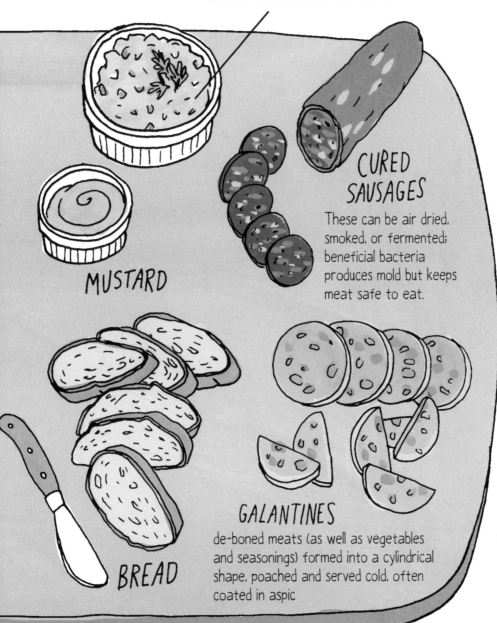

SAUSAGE BLENDS

SUMMER SAUSAGE
beef, sugar, mustard seed, garlic powder, cayenne, red pepper flakes, liquid smoke

BRATWURST
pork, veal, powdered milk, pepper, sage, onion, mace, and celery

MILD ITALIAN
pork, fennel, black pepper

MORCILLA
pork blood, fat, rice, onions, black pepper, paprika, cinnamon, cloves, oregano

KIELBASA
pork, white pepper, coriander, garlic

MERGUEZ
lamb or beef, cumin, chile pepper, harissa, sumac, fennel, garlic

CHORIZO MEXICANA
pork, chiles, coriander, cumin, cloves, cinnamon, garlic, paprika, salt, pepper, vinegar

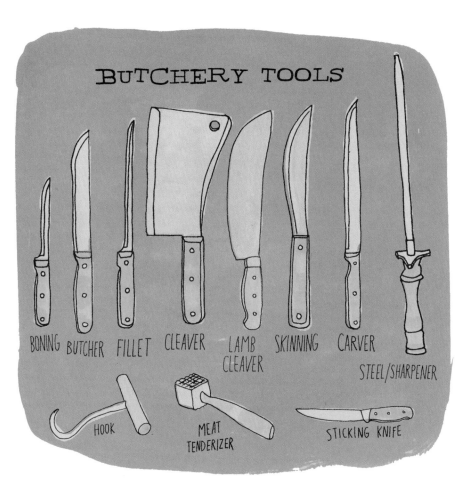

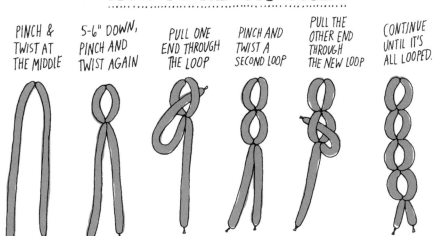

MEATY DISHES AROUND THE WORLD

BULGOGI, South Korea
thin slices of beef marinated in soy sauce, sugar, sesame oil, garlic, and other ingredients, including mushrooms or pureed pears

MEAT PIE, Australia
diced or minced meat with gravy, onions, and mushrooms in a double crust, personal-sized pie shell, often topped with ketchup

LECHÓN ASADO, Cuba
a whole pig or leg marinated in sour orange juice, garlic, and oregano

PEKING DUCK, China
duck are specially bred, carefully seasoned, boiled, dried, and roasted to yield extra-crispy skin

HÁKARL, Iceland

an extremely pungent ancient Icelandic dish — shark is buried, left to ferment, then hung for several months to dry

GOULASH, Hungary

a brick-red Hungarian beef and vegetable stew whose most important ingredient is the paprika

BIGOS, Poland

sauerkraut and meat stew, sometimes served in a hollowed loaf of bread

DÖNER KEBAB, Turkey

seasoned meat stacked and cooked on a vertical spit, then thinly shaved to order over rice or in a sandwich

KIBBEH, Middle East/ North Africa

patties of finely ground meat, spices, onions and bulgur, or cracked wheat — it can be fried, baked or served raw

FIVE FABULOUS FOOD FISH

rainbow trout

Unlike most species of fish commonly called trout — found in freshwater rivers and lakes — the Pacific Northwest species of these salmon relatives often spend a stint in the Pacific Ocean before returning to cold-water streams to spawn.

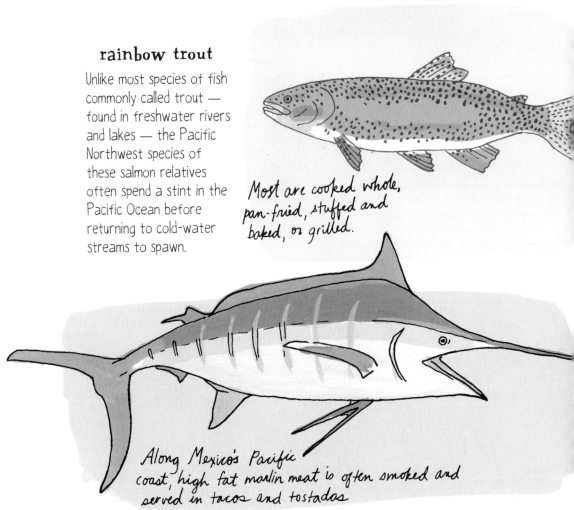

Most are cooked whole, pan-fried, stuffed and baked, or grilled.

Along Mexico's Pacific coast, high fat marlin meat is often smoked and served in tacos and tostadas

blue marlin

Some females of these pointy-billed fish grow to be more than 14 feet long, making them of the most coveted species for deep-water sport fishing. Though commercially fished in far smaller numbers, its numbers are decreasing, making it an endangered species.

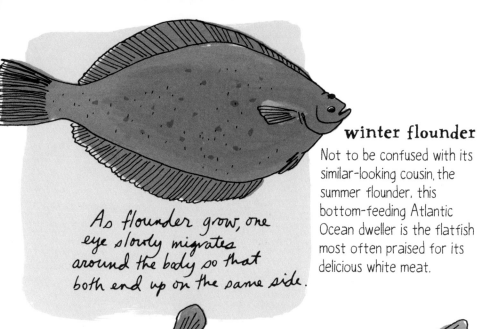

winter flounder

Not to be confused with its similar-looking cousin, the summer flounder, this bottom-feeding Atlantic Ocean dweller is the flatfish most often praised for its delicious white meat.

As flounder grow, one eye slowly migrates around the body so that both end up on the same side.

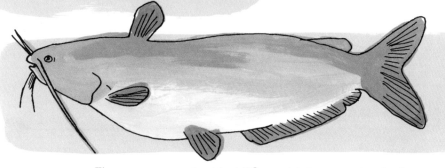

channel catfish

The most commonly fished U.S. catfish is one of hundreds of diverse, international species that share the name. Like this "channel cat," most are freshwater, bottom-feeding fish with whisker-like organs called barbels, and skin or plates instead of scales.

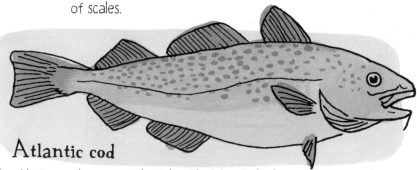

Atlantic cod

A cold-water, deep-sea fish with mild, flaky flesh that for centuries has been salted, dried, then shipped around the globe, leading to a worry the species is on the verge of disappearing.

How to Fillet a Fish

Make a deep cut just behind the head about halfway through the fish to the spine.

Working from the head toward the tail, slide the knife along the backbone of the fish all the way to the tail to make your fillet.

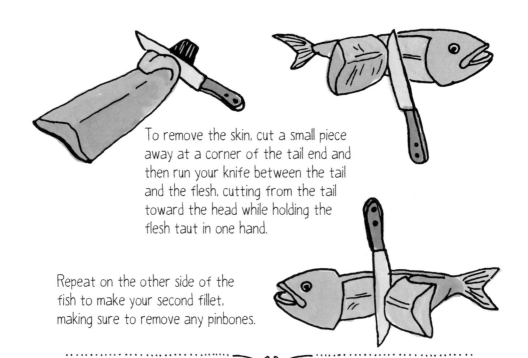

To remove the skin, cut a small piece away at a corner of the tail end and then run your knife between the tail and the flesh, cutting from the tail toward the head while holding the flesh taut in one hand.

Repeat on the other side of the fish to make your second fillet, making sure to remove any pinbones.

REGAL ROE

The roe, or eggs, from many kinds of fish and shellfish are eaten around the world as nutrient-packed delicacy.

The term roe refers not to the individual egg but the collective egg masses, which are sometimes fried.

Caviar traditionally refers only to the roe from wild sturgeon from the Caspian or Black seas — the Beluga, Sterlet, Ossetra, and Sevruga species, in order of their desirability.

Giant sturgeon can live for a century, and it often takes nearly two decades for them to start producing eggs.

OTHER EDIBLE SEA CREATURES

Cephalopods

Squid, octopus, and cuttlefish are a type of mollusk with symmetrical bodies, big heads, and tasty tentacles.

MAKING CALAMARI

Sepia a la plancha, grilled cuttlefish, eaten in Spain

Sauteed calamari (squid)

Oktapodi krasato, a Greek dish of stewed octopus in red wine

Bivalves

Clams, oysters, scallops, cockles, and mussels are mollusks known for their hinged shells. Many bivalves are famously eaten "on the half-shell."

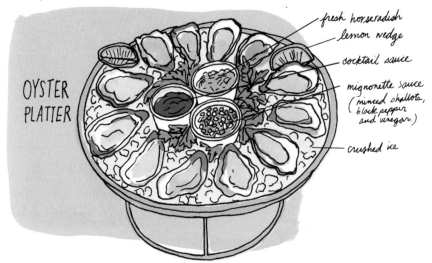

OYSTER PLATTER

- fresh horseradish
- lemon wedge
- cocktail sauce
- mignonette sauce (minced shallots, black pepper and vinegar)
- crushed ice

Crustaceans

Crab, lobster, shrimp, krill, and crayfish have exoskeletons — in other words, their bones are on the outside of their bodies.

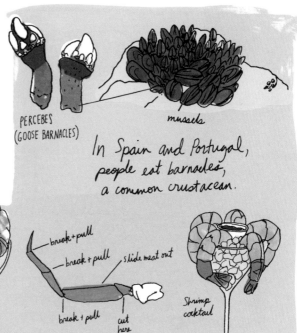

PERCEBES (GOOSE BARNACLES)

mussels

In Spain and Portugal, people eat barnacles, a common crustacean.

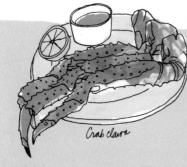

Crab claws

break + pull
break + pull
slide meat out
break + pull
cut here

EATING CRAB CLAW

Shrimp cocktail

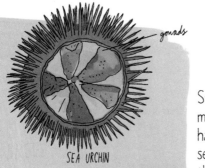

gonads

SEA URCHIN

Echinoderms

Starfish are the most recognizable members of this family, all of which have 5-point radial symmetry, but sea urchins and sea cucumbers are the most widely consumed.

Spiky sea cucumber soaked in vinegar — served in China at celebrations

Uni Ikura Donburi — uni with roe over rice

The edible part of a sea urchin — in Japanese, it's called uni — is actually its soft orange gonads.

THE FISHMONGER'S LEXICON

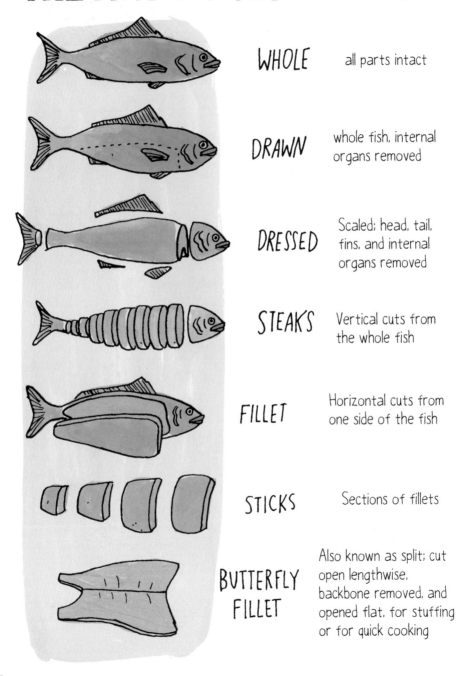

	WHOLE	all parts intact
	DRAWN	whole fish, internal organs removed
	DRESSED	Scaled; head, tail, fins, and internal organs removed
	STEAKS	Vertical cuts from the whole fish
	FILLET	Horizontal cuts from one side of the fish
	STICKS	Sections of fillets
	BUTTERFLY FILLET	Also known as split; cut open lengthwise, backbone removed, and opened flat, for stuffing or for quick cooking

SEAFOOD COOKERY TOOLS

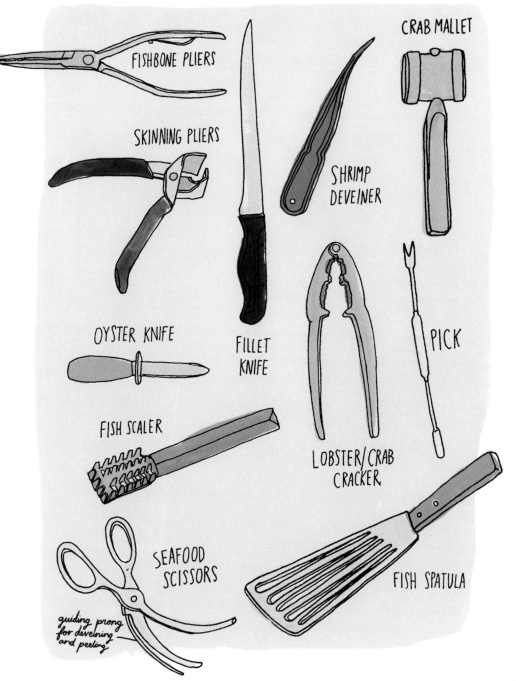

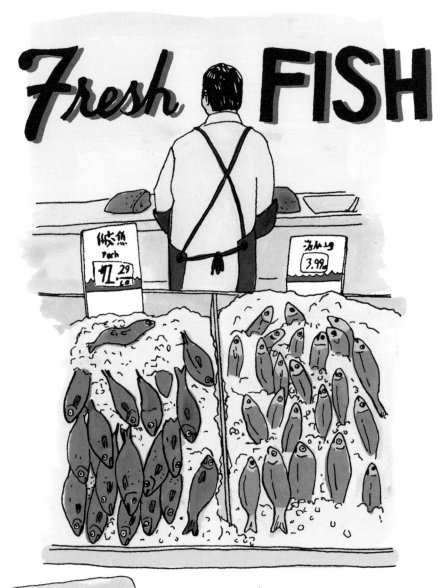

COMMONLY EATEN CLAMS

CLAM RAKE

LITTLENECK
These hard-shell clams — Northeasterners sometimes call them quahogs — are the same clam as top necks, cherrystones, and chowders, just harvested when they're smaller.

IPSWICH
Also called soft-shell clams or steamers, these Atlantic Coast clams are named for Ipswich, MA. They have lighter colored, oblong, brittle shells and are sometimes fried whole and sold as "clam bellies."

GEODUCK
Pronounced gooey-duck, this extra-large clam has a long, thick neck that occasionally spurts water; it's generally sliced before being served raw or cooked.

MANILA
Originally from Asia, these smaller clams typically have a striped, hard shell.

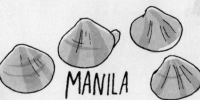

RAZOR
One of many clams with long, thin shells that look a little like a straight razor.

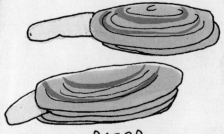

KINDS OF SUSHI

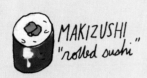
MAKIZUSHI
"rolled sushi"

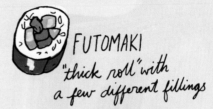
FUTOMAKI
"thick roll" with a few different fillings

HOSOMAKI
"thin roll" with one filling

TEMAKI
cone shaped "hand roll"

NIGIRIZUSHI
"hand-pressed" mound with fish draped on top

GUNKANMAKI
"warship roll" vessel holding soft ingredients

URAMAKI
"inside-out roll" with nori inside of rice

TEMARIZUSHI
"ball sushi" made using plastic wrap

OSHIBAKO
"pressed" in a box

CHIRASHI
"scattered sushi" bowl of rice topped with fish and vegetables

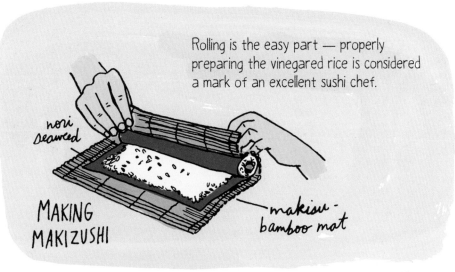

Rolling is the easy part — properly preparing the vinegared rice is considered a mark of an excellent sushi chef.

nori seaweed

makisu - bamboo mat

MAKING MAKIZUSHI

The box, traditionally made of wood, is known as an *oshizushihako*.

MAKING OSHIBAKO

Fugu sashi - pufferfish sashimi

Cooks in Japan have to be licensed to prepare sushi from the poisonous fugu, or puffer fish. Unless properly treated, its organs contain toxins that can paralyze or even kill diners.

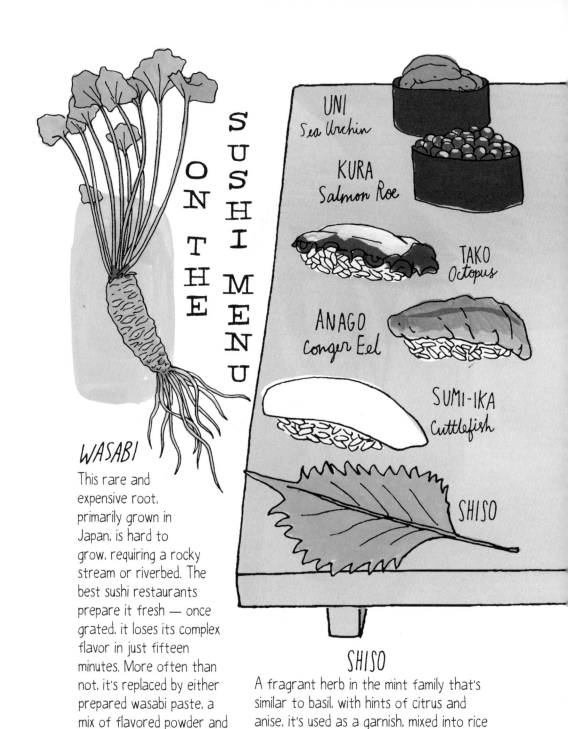

ON THE SUSHI MENU

- UNI — Sea Urchin
- KURA — Salmon Roe
- TAKO — Octopus
- ANAGO — Conger Eel
- SUMI-IKA — Cuttlefish
- SHISO

WASABI

This rare and expensive root, primarily grown in Japan, is hard to grow, requiring a rocky stream or riverbed. The best sushi restaurants prepare it fresh — once grated, it loses its complex flavor in just fifteen minutes. More often than not, it's replaced by either prepared wasabi paste, a mix of flavored powder and water, or dyed horseradish root, a close relative.

SHISO

A fragrant herb in the mint family that's similar to basil, with hints of citrus and anise, it's used as a garnish, mixed into rice or soups, and occasionally layered into sushi itself.

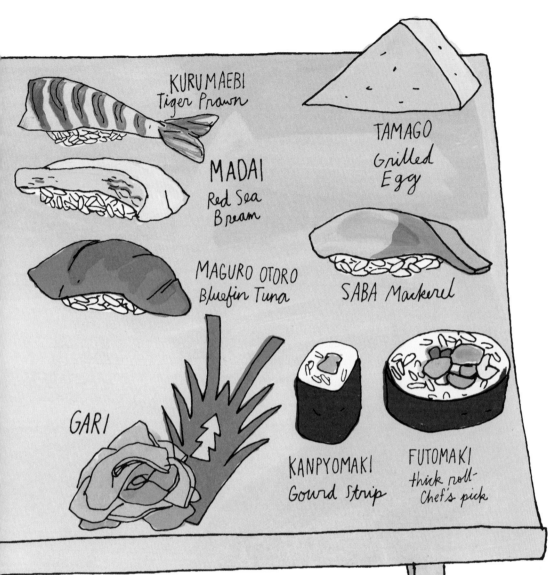

GARI
These thin slices of young pickled ginger are used a palate cleanser. Naturally a pale rose color, the hot pink versions are dyed.

Soy sauce is used sparingly. Only the fish side should be lightly dipped, never the rice.

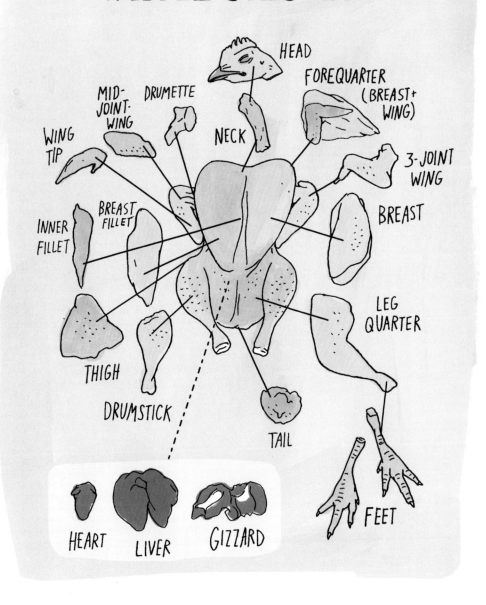

POULTRY TERMS

broiler domesticated, hybridized chickens bred for meat

capon a castrated rooster

cornish a cross between the Cornish Game and Plymouth or White Rock chicken breeds

poussin In the U.K., a young female chicken; in the U.S., a Cornish hen

pullet young chickens bred for egg-laying, in the stage between chicks and hens

squab a young, domesticated pigeon

THE INCREDIBLE EGG

BINDS ingredients in dishes like meatballs or crab cakes

LEAVENS soufflés or cakes

INDUSTRIAL-SIZED CAKE MIXER

THICKENS custards, puddings and sauces

EMULSIFIES mayo, salad dressings and sauces

GLAZES pastries

CLARIFIES stock

PREVENTS crystallization in boiled candies + frosting

MAKING BOILED CANDY

128

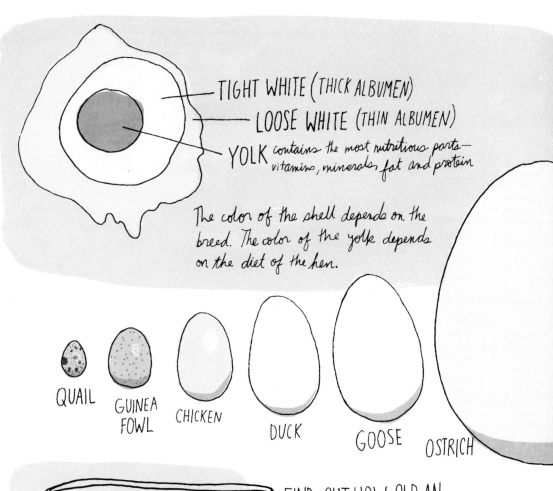

TIGHT WHITE (THICK ALBUMEN)
LOOSE WHITE (THIN ALBUMEN)
YOLK contains the most nutritious parts— vitamins, minerals, fat and protein

The color of the shell depends on the breed. The color of the yolk depends on the diet of the hen.

QUAIL GUINEA FOWL CHICKEN DUCK GOOSE OSTRICH

FIND OUT HOW OLD AN EGG IS BY PLACING IT IN WATER. BECAUSE OLDER EGGS HAVE BIGGER AIR CELLS, THEY WILL FLOAT.

FRESH — 1 WEEK OLD — 2-3 WEEKS OLD — VERY OLD

SHORT ORDER EGG LINGO

ADAM + EVE ON A LOG

ADAM + EVE ON A RAFT

ADAM + EVE ON A RAFT AND WRECK 'EM

CLUCK + GRUNT

COWBOY WESTERN

DROWN THE KIDS (boil the eggs)

ETERNAL TWINS

FRY TWO LET THE SUN SHINE

FAMILY REUNION

KISS THE PAN

MAKE IT CRACKLE

SCRAPE TWO

TWO DOTS + A DASH

WRECKED + CRYING

WRECKED HEN WITH FRUIT

DOUGH WELL DONE WITH COW TO COVER

SHINGLE WITH A SHIMMY + A SHAKE

BURN THE BRITISH

MILK MAID MATH
AVERAGE PERCENTAGE OF BUTTERFAT

- EUROPEAN BUTTER — 82-86%
- AMERICAN BUTTER — 80%
- CREAM — 45%
- HEAVY CREAM — 36%
- MEDIUM CREAM — 30%
- LIGHT CREAM — 18-30%
- HALF & HALF — 10.5-18%

- WHOLE MILK — 3.25%
- REDUCED FAT MILK — 2%
- BUTTERMILK — 1-2%
- LOW-FAT MILK — 1%
- SKIM MILK — 0-0.5%

TERMS OF THE TRADE

buttermilk the liquid that remains after butter forms

cream the fat solids that rise to the top after the milk settles

cultures bacteria that change milk sugar (lactose) into lactic acid; used to make yogurt, buttermilk, and many types of cheese

curds the soft solids that form after rennet is added to milk

homogenization a process that breaks up milk fat and distributes it evenly to prevent the cream from rising to the top

pasteurization the process of briefly heating raw milk to at least 145°F and then cooling it quickly to increase shelf life

raw milk fresh from the cow (or goat or sheep) and has not been pasteurized

rennet contains enzymes that cause milk to coagulate and form cheese

whey the liquid by-product of cheese or yogurt making; it can be used to make other cheeses, such as ricotta

BAKING TIP: In a pinch, make "acidified buttermilk" by adding 1 tablespoon of vinegar or lemon juice to 1 cup of milk and letting it sit until it curdles, about ten minutes.

DELICIOUS DAIRY

YOGURT

This cultured product forms when a starter is added to milk; the end result contains probiotics that promote good digestion and overall health.

SOUR CREAM

Fresh, unpasteurized cream is allowed to sour at room temperature; naturally occurring bacteria cause the thick texture and tangy flavor. Today it's often made commercially with the addition of bacterial cultures.

CLOTTED CREAM

Also called Devonshire or Cornish cream, this delicious British product is made by steaming and slowly cooling high-fat cow's milk so that the fat rises to the top and "clots."

CREAM CHEESE

This high-fat (33%), high-moisture, spreadable cheese made of cow's milk was invented not in Philadelphia but in New York State.

CRÈME FRAÎCHE

Made with a technique similar to sour cream, this tangy topping is looser in consistency, tastes less sour, and has a higher fat content.

CLABBER

An old-fashioned ingredient once used as a leavener, it's made by letting unpasteurized milk sour over a few days until thick. It can be eaten sweet or savory, just like yogurt.

COTTAGE CHEESE

This simple cheese is made by heating milk with rennet and buttermilk until it forms solid curds and then pressing out the whey.

RICOTTA

Traditionally made by heating leftover whey from the cheese-making process until the remaining protein solidifies into soft, fluffy curds, today ricotta typically comes from milk heated with an acidulant until it separates into curds and whey.

FARMER'S CHEESE

In the United States, pressed cottage cheese can be made with cow, sheep, or goat's milk.

HOW TO MAKE BUTTER IN THREE EASY STEPS

STEP 1

Whip the the best-quality heavy cream you can find with a mixer or in a food processor until yellow curds begin to separate from the buttermilk. (You will need at least two cups of heavy cream to yield 1 cup of buttermilk.)

STEP 2

Strain off the buttermilk from the curds. (Save it to make pancakes.)

STEP 3

Form the curds into a ball, and knead them with a wooden spoon to remove as much buttermilk as possible.

Real Deal Buttermilk Pancakes

2 CUPS OF FLOUR
2 TABLESPOONS SUGAR
4 TEASPOONS BAKING POWDER
1 TEASPOON BAKING SODA
1 TEASPOON FINE SEA SALT
2 CUPS REAL BUTTERMILK
4 TABLESPOONS UNSALTED BUTTER, MELTED
2 LARGE EGGS, BEATEN
VEGETABLE OIL, COOKING SPRAY OR BUTTER

1. Preheat a griddle or large skillet to medium-high heat, or until a drop of water dances on the surface but doesn't immediately steam away.
2. In a large mixing bowl, stir together the flour, sugar, baking soda, baking powder, and salt.
3. In a medium mixing bowl, whisk together the buttermilk, melted butter, and beaten eggs.
4. Add the buttermilk mixture to the dry ingredients and stir until just combined — you should have a few lumps.
5. Grease the griddle with oil, spray, or butter. Cook pancakes a few at a time — adding more oil as necessary — flipping them once after the bottoms have browned and bubbles form on the top. Serve with syrup or jam.

Cut the Cheese

A great cheese plate displays a range of flavors, textures, shapes, and colors. Use cheeses made from different types of milk, of different ages, all cut into different shapes. It also demands accompaniments, usually sweet ones: Try a few types of excellent honey, fig or other fruit preserves, or a selection of dried fruits and nuts.

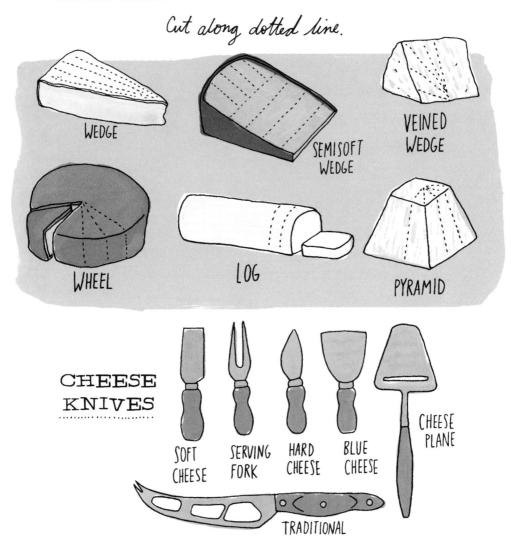

CHEESE ANATOMY

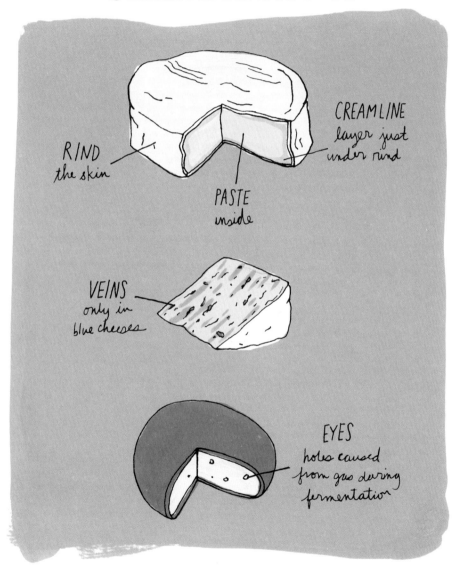

The Basic Steps in Making Cheese

1. HEAT THE MILK

2. ADD STARTER

The starter is made of active bacteria that convert lactose to lactic acid and help control the rate of ripening.

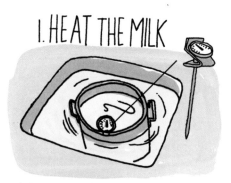

3. ADD RENNET

Rennin is an enzyme that helps the milk coagulate and form into the curd.

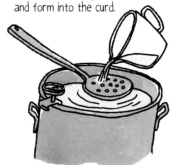

4. CUT THE CURDS

curd knife

5. COOK THE CURDS

6. DRAIN THE CURDS

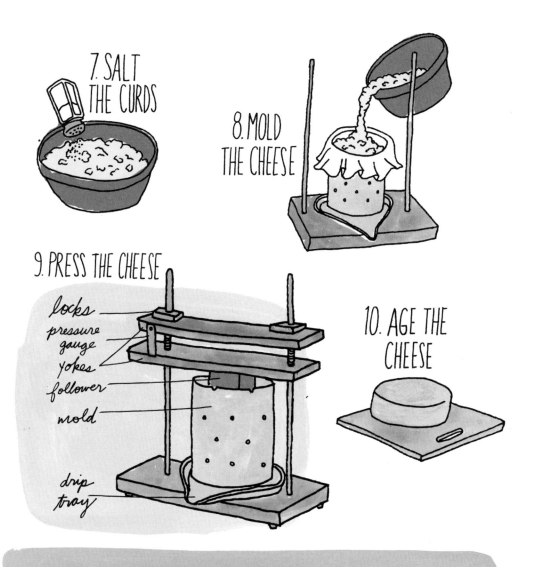

The old story goes that cheese was first created centuries ago when nomadic tribes stored fresh milk in pouches made of calves' stomachs as they trekked across the desert.

MILK + NATURAL RENNET IN THE STOMACH + WARM TEMPERATURES = CHEESE

TYPES OF CHEESE

Cheese can be made from the milk of any mammal — buffalo, horses, even yaks and camels — though cow, goat, and sheep's milk cheeses are the most common. Beyond type of milk, there are many ways to classify a cheese, but cheesemongers recognize these categories.

Fresh

Young, soft, moist cheeses that are not aged, or only cured for a very short period.

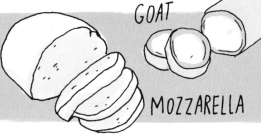

GOAT

MOZZARELLA

Bloomy Rind

Has a soft, sometimes fuzzy, mushroomy, edible white rind resulting from the introduction of molds to the outside of a cheese. These are also often called soft-ripened because they are ripened from the outside in.

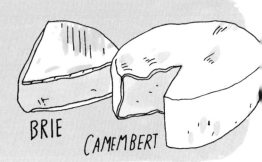

BRIE

CAMEMBERT

In Europe these young cheeses are traditionally made with raw milk, but in the U.S., it's illegal to sell raw milk cheeses that have not been aged for at least 60 days.

Washed Rind

Any cheese with a rind washed or moistened with anything from saltwater to beer or bourbon that fosters growth of flavor and aroma-producing bacteria, creating so-called "stinky cheese." (You don't have to eat the rind!)

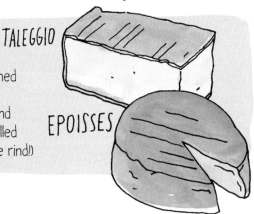

TALEGGIO

EPOISSES

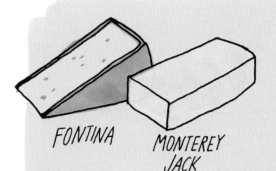

Semi Soft

Cheeses with a range of flavors that are generally smooth, moist, and creamy on the inside with little or no rind.

FONTINA
MONTEREY JACK

Firm / Hard

These cheese are generally aged longer, have a thicker rind you probably don't eat, and are intensely flavored rather than mild or creamy. Many cheeses like Cheddar or Gouda are found in firm and hard forms, depending on how long they are aged.

CHEDDAR
PARMIGIANO-REGGIANO
GOUDA

These cheeses are all PDO, a European certification meaning "protected designation of origin," that is granted to agricultural products that represent a certain region and are made to a certain standard.

Blue

The veins or marbling are created by mold cultures injected into the cheeses as they're made. Most are complex, sharp, and salty-sweet.

ROQUEFORT
GORGONZOLA

AMERICAN CHEESE

American cheese is generally made by heating and mixing particles of other types of cheese. Real American cheese — or "pasteurized process American cheese," depending on how many types of cheeses are used — is mainly cheese, plus a small amount of acid (to keep the pH low and bacteria at bay), some extra cream or milk fat, water, salt, coloring, and spices. If more of those and other ingredients such as dairy by-products, emulsifiers, and oil are added, it must be labeled "process cheese food" (like Velveeta) or "process cheese product" (like Cheez Whiz, sold as either a spread or a sauce).

American cheeses and their ilk are high-moisture cheeses, which is one reason why they melt so easily. The less moisture in a cheese, the more it'll separate when heated. Of course the addition of cream, water and, in some cases, oil or emulsifiers to keep the product smooth and consistent also helps.

grilled cheese sandwich

CURD NERDISMS

Affineur

A French term for the experienced professionals who are responsible for a cheese as it ages, making sure it properly ripens or matures. This role often requires hands-on care, such as washing of rinds.

Cheddar

When used as a verb, a cheesemaking technique that describes a method of stacking and turning curds to ensure they're evenly pressed, resulting in a smooth, firm texture.

Transhumance

Despite its name, this is the tradition of moving livestock, not people, from one grazing area to another as seasons change, typically to low ground in winter and highlands in summer. In the Alps, this results in some of the world's best cheeses and spectacular fall festivals.

Pasta Filata

An Italian term for the cheesemaking technique behind mozzarella, caciocavallo, provolone, and other cheeses. The curds for these cheeses are stretched, pulled, or kneaded.

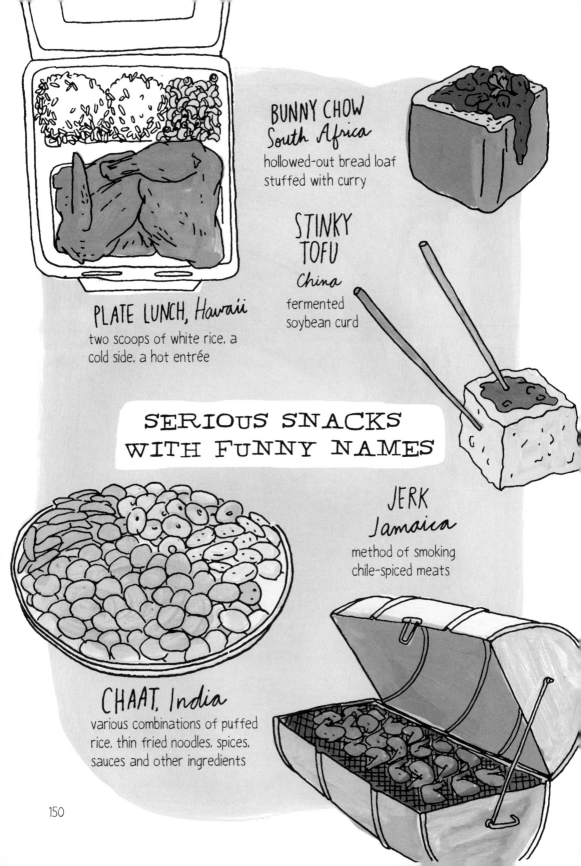

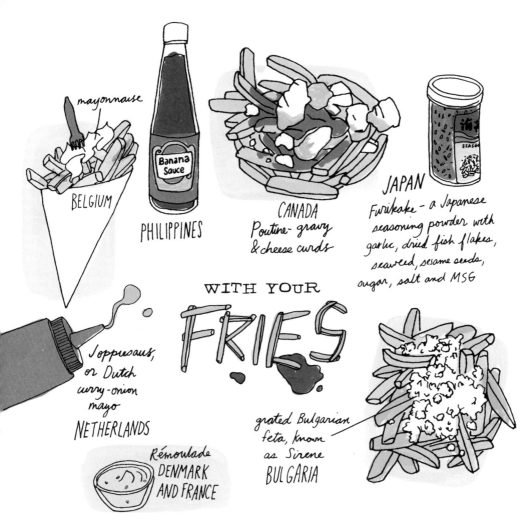
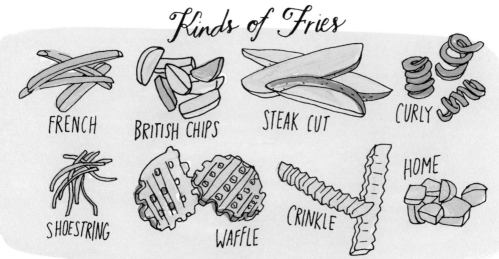

CHILEAN COMPLETO

mashed avocado, mayo, diced tomatoes, and sauerkraut, with the chile-pepper condiment called pebre on the side

COLOMBIAN PERRO CALIENTE

toppings usually include but are not limited to: pineapple chunks, a Russian-dressing-like pink sauce, ketchup, crushed potato chips, and cheese

BRAZILIAN COMPLETO

seasoned ground beef, shredded carrots, diced ham, potato sticks, canned corn, hard-boiled eggs, cilantro, and a mix of chopped bell peppers, tomatoes, and onions

DANISH RØD PØLSE

or "red sausage," a skinny deep red wiener served with raw onions, rémoulade, and sliced cucumbers

ICELANDIC PYLSUR

fried dried onions and pylsusinnep (sweet brown mustard) on a frank made of lamb

NYC "DIRTY WATER" DOG

simmered in water and sold from carts, topped with brown mustard, sauerkraut, and tomatoey sweet onion sauce

LA STREET DOG

bacon-wrapped, often topped with various items including grilled onions, diced tomato, and a whole roasted chile pepper

FIVE STYLES OF MEAT ON A STICK

ESPETINHO

"little skewer" in Brazilian Portuguese, and filled with almost anything you can think of and grilled over charcoal. Usually served with hot sauce and farinha, or crunchy coarsely ground flour.

CHISLIC

a South Dakota specialty of grilled cubed meats — venison, lamb, mutton, etc. — spiced and served on toothpicks with saltine crackers and garlic powder

SATE

meats marinated in coconut milk, turmeric, and other spices, served with peanut sauce and pickled vegetables, traditionally grilled on a banana leaf rib in Southeast Asia

ANTICUCHOS

Peruvian meats, typically beef hearts, marinated in vinegar, chile, cumin, and garlic and skewered with a potato or piece of bread

ARROSTICINI

skewers of mutton from the Abruzzo region of Italy that are cooked on a special long grill called a canala, after its canal-like shape

ANATOMY OF A FOOD TRUCK

Based on plans from PrestigeFoodTrucks.com

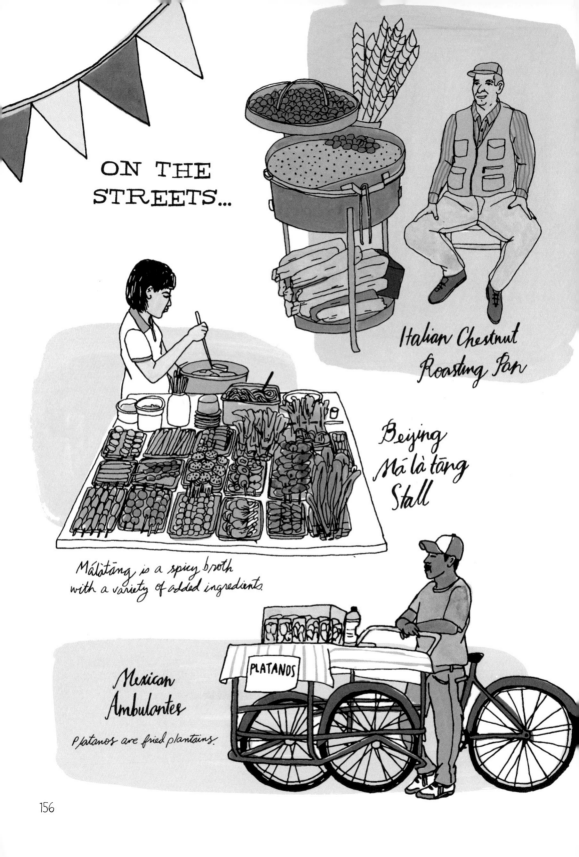

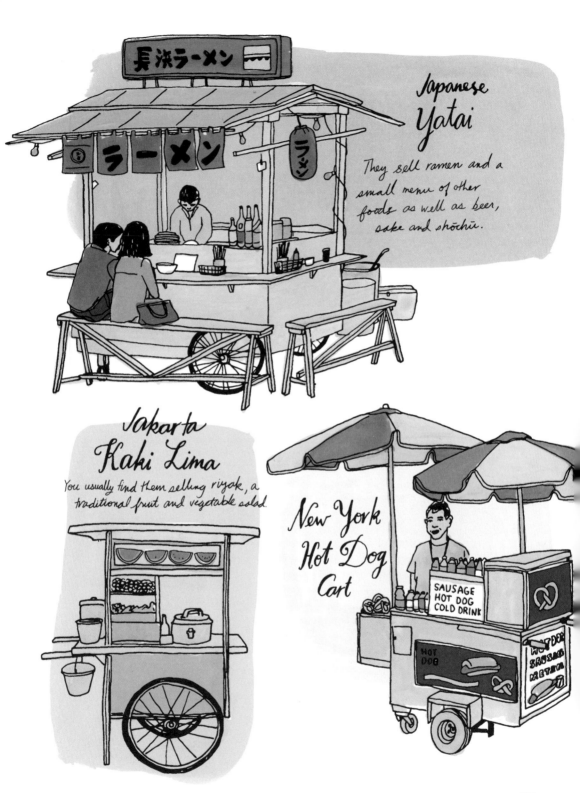

PIZZA, PIZZA!

New York Slice
Sold at small pizza places on every street, this plain cheese slice usually costs little more than a dollar.

Sicilian Pizza Slice
In America, this is a thick square pie with a crunchy base and generally a fluffy, airy, almost bready crust.

New Jersey Tomato Pie
A thick, dense crust is topped with a thick layer of crushed tomatoes and a small amount of grated cheese, similar in style to the sfincione made in the Sicilian city of Palermo.

Chicago Deep Dish
Pizza cooked in a deep-sided pie pan; the cheese generally goes underneath the toppings with the sauce on top.

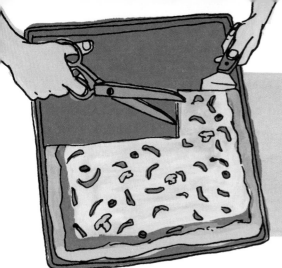

Pizza al Taglio

This Roman-style pizza is baked in long rectangular pans in electric ovens and often cut with scissors and sold by weight.

Detroit Deep Dish

A thick, chewy crusted pizza related to the Sicilian, baked in a well-oiled pan so that the crust appears almost fried; it is sometimes baked twice.

Neapolitan Pizza Margherita

Originating near the Italian city of Naples, with a puffy crust made possible in part by quick cooking in a wood-fired oven, this pizza should be made with basil, tomatoes from San Marzano, and buffalo milk mozzarella from Campania.

St. Louis Pizza

It has cracker-thin crust topped with Provel (a white processed-cheese blend of cheddar, Swiss, and provolone) and is cut into squares.

TAQUERIA TERMINOLOGY

TACOS DE... BUCHE - pig stomach
CABEZA - cow head
LENGUA - beef tongue
ARABES - spicy ground lamb wrapped tightly in a flour tortilla

TORTA
a sandwich of almost any kind, usually dressed with beans, chile, and avocado, and often served on a soft, split-top roll called a telera

SUADERO
thin cuts of beef taken from between the belly and the upper thigh, often cooked on a special domed griddle

TLAYUDA
a large crispy tortilla topped with beans, lard, and other toppings, especially mozzarella-like strands of Oaxacan cheese

GORDITA DE CHICHARRÓN
a fried plump cake of masa (gordita is "chubby" in Spanish) filled with chile-stewed pork rinds

ALAMBRE
a mixed grill of meats, onions, peppers, and melty cheese served with a stack of tortillas

CHAPTER 7
Season to Taste

6 SUPERB SPICE BLENDS

Chinese Five Spice

An aromatic blend with a little bit of heat thanks to the tongue-tingling sensation provided by the Szechuan peppercorns, which are unrelated to black pepper or chiles. This is usually used for rich meats or flavored oils, and ingredients vary by region.

Mix the following:

- 1 TABLESPOON GROUND CINNAMON
- 1 TABLESPOON GROUND CLOVES
- 1 TABLESPOON FENNEL SEED, TOASTED AND GROUND
- 1 TABLESPOON GROUND STAR ANISE
- 1 TABLESPOON SZECHUAN PEPPERCORNS, TOASTED AND GROUND

Za'atar

A tart spice blend usually made with thyme, sesame seeds, and the tiny, sour, dark-red fruit of the sumac plant, which are dried and ground into a powder. Za'atar is often sprinkled on warm bread topped with plenty of good extra-virgin olive oil.

Mix the following:

- 2 TABLESPOONS MINCED FRESH THYME
- 2 TABLESPOONS SESAME SEEDS, TOASTED
- 2 TEASPOONS GROUND SUMAC
- 1/2 TEASPOON SEA SALT

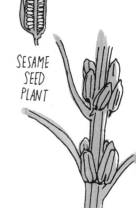

PEQUIN PEPPERS

Mitmita

Not as well known as the more complex Ethiopian spice mix called berbere, this blend of mostly chile is sprinkled on beans or blended with clarified butter to make the raw beef dish called "kitfo."

Grind the following into a fine powder.

½ POUND DRIED PEQUIN OR AFRICAN BIRD'S EYE CHILES
1 TABLESPOON BLACK CARDAMOM PODS, SHELLS REMOVED AND SEEDS TOASTED
½ TABLESPOON WHOLE CLOVES, TOASTED
¼ CUP SEA SALT

PODS

CARDAMOM PLANT

SEEDS

Garam Masala

A go-to spice on the Indian subcontinent - garam roughly means "heat mix" - it varies from cook to cook and has plenty of warming spices.

Toast the following until fragrant, then grind into a fine powder.

4 TABLESPOONS CORIANDER SEEDS
1 TABLESPOON CUMIN SEEDS
1 TABLESPOON BLACK PEPPERCORNS
1½ TEASPOONS BLACK CUMIN SEEDS
1½ TEASPOONS GROUND GINGER
SEEDS FROM 4 PODS OF BLACK CARDAMOM
25 WHOLE CLOVES
2-INCH PIECE OF CINNAMON STICK, CRUSHED
1 BAY LEAF, CRUSHED

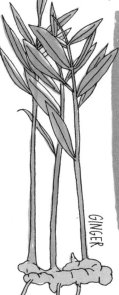
GINGER

CUMIN

BAY LEAVES

CORIANDER SEEDS

CORIANDER

Hawaij

This all-purpose spice mix of Yemeni origin is added to soups, vegetables, roasted meats, or rice. Another version with anise, fennel, ginger, and cardamom is used to enhance coffee and tea.

Toast the following until fragrant, then grind into a fine powder.

- 6½ TABLESPOONS BLACK PEPPERCORNS
- ¼ CUP CUMIN SEED
- 2½ TABLESPOONS CORIANDER SEEDS
- 1½ TABLESPOONS GREEN CARDAMOM PODS, CRUSHED
- 3½ TABLESPOONS GROUND TURMERIC

ROOT

TURMERIC PLANT

CHILE PEPPER

Shichi-Mi Tōgarashi

Also known as seven-spice pepper, this is used as a table condiment and sprinkled atop soups and other food in Japan.

Toast the following (except for ground ginger, if using), and coarsely grind together.

- 3 TEASPOONS CHILE FLAKES
- 3 TEASPOONS JAPANESE SANSHO PEPPER OR SZECHUAN PEPPERCORNS
- 1 TEASPOON DRIED SEAWEED
- 3 TEASPOONS DRIED TANGERINE PEEL
- 2 TEASPOONS WHITE SESAME SEEDS, TOASTED
- 1 TEASPOON BLACK SESAME SEEDS, TOASTED
- 1 TEASPOON POPPY OR HEMP SEEDS, TOASTED, OR SUBSTITUTE GROUND GINGER

SZECHUAN PEPPER

POPPY SEED PODS

THAT'S HOT!

The key ingredient in any hot sauce is the chile, a fruit with a vast range of flavors that develop as peppers ripen. In many countries, unique chiles and hot sauces are foundational flavors of the cuisine.

CAYENNE

The hot, earthy, ripe red Cayenne chile, fermented with salt, barrel-aged, and diluted with vinegar, flavors the quintessential Louisiana-style hot sauce.

SCOTCH BONNET

In the West Indies, the floral Scotch Bonnet gets blended with vinegar or sour citrus juice, often with a little carrot and onion.

BIRD'S EYE

In southeast Asia, skinny, very hot and fruity Bird's Eye chiles are traditionally crushed with garlic, onions, and lime juice and diluted with fish sauce.

Capsaicinoids make peppers uniquely flavorful; there are different kinds and peppers have more of some than others. The best-known is capsaicin, which makes peppers hot. They're most prominent in membranes and seeds.

RED SAVINA	350,000-550,000
HABANERO	100,000-325,000
THAI	70,000-100,000
CAYENNE	30,000-50,000
SERRANO	8,000-25,000
JALAPEÑO	2,500-4,500
ANAHEIM	500-2,500
SWEET BELL	0

The Scoville scale measures the human perception of heat in hot sauce.

A LITTLE SOMETHING SWEET

AGAVE PLANT

Agave Syrup

Made from the same spiky-leaved plant family that gives us tequila and mescal, the unrefined version can be very dark and richly flavored with earthy minerals.

Honey

The biggest factor in the flavor of honey is actually the flower. The most prized varieties tend to be monofloral, meaning they come from bees that forage from a hillside full of lavender, say, or maybe a citrus grove, or a field of golden wheat. Mass-produced honey — blended from many sources, including bees fed sugar-water — is best used for sweetness, not flavor.

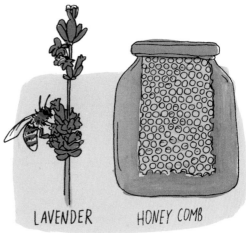

LAVENDER HONEY COMB

Honeycomb is both beautiful and edible. Try it on a cheese plate.

Cane Syrup

This dark, sweet, complexly flavored and mineral-rich sweetener made from reducing pressed sugarcane juice is a beloved product in Louisiana.

SUGARCANE STALK

Sugar

It is most often made from sugar beet or sugarcane juice boiled until it begins to form solid crystals, which are then dried. For white sugar, any remaining plant matter is also refined away until nothing is left but pristine, colorless grains.

Molasses

The brown, flavorful liquid left over from refining sugar, molasses can also be made from the juice of grapes, dates, pomegranates, and other sweet crops.

MOLASSES

Corn Syrup

Chemically derived from cornstarch, it differs from light corn syrup, which is seasoned with vanilla flavor and salt; dark corn syrup (combined with molasses, caramel flavor, and salt); and high-fructose corn syrup, which was created to taste sweeter, dissolve easily, and hold moisture, making it ideal for processed foods.

SORGHUM

Sorghum Syrup

Less familiar to many Americans, it is squeezed from stalks of sorghum grass.

SUGAR HOUSE

In the Sugar House

Produced primarily in the northeast US and Canada, maple syrup is made by boiling down sap from sugar or black maple trees in early spring, just before they send out new leaves.

Sap becomes syrup at 7 degrees above the boiling point of water. It takes 40 to 80 gallons of sap to make a single gallon of syrup.

SPILES + BUCKETS

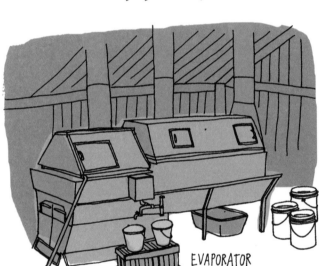
EVAPORATOR

SUGAR BUSH
a stand of sap-producing sugar maples

SPILES
the metal or plastic spouts or taps that are driven into a tree to send the sap dripping into the buckets

SUGAR HOUSE the building where the sap is boiled

EVAPORATORS giant shallow metal pans perched atop a fire fueled by wood or gas

GRADE A also called Vermont Fancy, is the lightest syrup in color and flavor. Sap collected later in the season when the tree buds swell produces darker syrup, or Grade B.

Creamy Maple Mocha Pudding

3 TABLESPOONS CORNSTARCH
1 TABLESPOON POWDERED INSTANT COFFEE
1 TEASPOON UNSWEETENED COCOA POWDER
PINCH OF SALT
3 EGGS YOLKS
3 CUPS MILK
½ CUP PURE MAPLE SYRUP
1 TABLESPOON UNSALTED BUTTER
1 TEASPOON VANILLA EXTRACT

1. In a large, heavy-bottomed pot, combine the cornstarch, coffee, cocoa, and salt; whisk to mix. In a mixing bowl, whisk the egg yolks slightly, then add the milk and maple syrup. Stir into the pot.

2. Over medium-high heat, gradually bring the mixture to a boil, stirring gently but constantly, with a rubber spatula. Be sure to scrape the sides as you stir. Boil for 1 minute, stirring constantly. Remove from heat and stir in the butter and vanilla.

3. Ladle into four or five individual serving bowls. To prevent a skin from forming, place a piece of wax paper, cut to size, on top of each. Cool, then chill for several hours before serving.

OLIVE OIL ARGOT

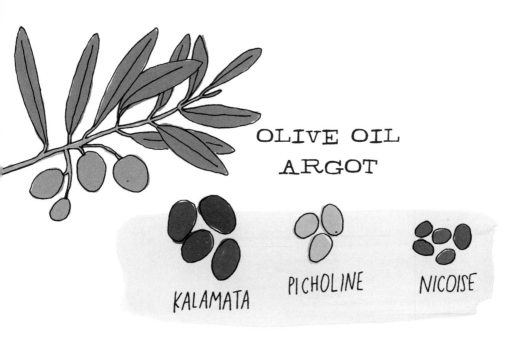

Acidity

The International Olive Council grades olive oil first by acidity level — the lower it is, generally, the more complex the flavors and higher the antioxidants. Plain "olive oil" is around 2% acidity, "virgin" oil is 1.5%, and "extra-virgin" — the highest quality — is 0.8% acidity or lower.

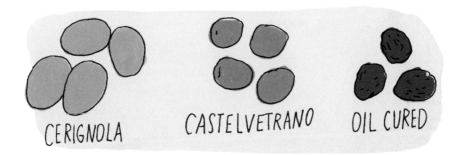

Olives ripen from green to black. They are bitter if eaten raw, so all table olives are cured with a mix of brine or lye; some are then macerated in oil.

First Cold Press

In truth all extra-virgin oil is first cold press — heat and multiple pressings yield lots of oil, but of low quality.

OLD STYLE OLIVE PRESS

Harvest Date

The best extra-virgin oil is pressed and bottled right after harvest. Some oils, however, are stored in stainless steel vats and bottled years later.

New Harvest

This is the very first pressing of oil for the harvest and the most intense in flavor. In the northern hemisphere, this pressing is done in fall; in the southern, the spring.

Unfiltered

Tiny particles of fruit are left in the bottle. It's often more flavorful, but be careful using this with heat — the particles can burn.

Country of Origin

The closer the harvest is to the bottler, the better. If the label mentions olives come from many countries, use the oil for cooking, not as a condiment. You might also see symbols like the European mark of PDO (protected designation of origin), which certifies that the oil represents a historical, regional style.

MUSTARD

Mustard is made from the tiny round seeds of different varieties of mustard plant, which can be crushed, ground, cracked, or left whole, often blended with vinegar, wine or other seasonings.

 YELLOW/WHITE MUSTARD SEEDS have a milder heat.

 BROWN AND BLACK MUSTARD SEEDS are hot and spicy.

In the Belgian city of Ghent is Tierenteyn-Verlent, a 225-year-old mustard shop founded by Adelaide Verlent, a widow who sold spices until a relative learned how to finely grind mustard seeds in France (a technique and style of white-wine mustard now known as Dijon, after the city where the style was perfected). The counters, jars and cabinets are all original, and you can still buy their sharp mustard to go in stoneware crocks stoppered with corks. Those and other vessels in various shapes and sizes are filled to order from ancient wooden mustard barrels.

How to Make Vinegar in 5 Steps

1. Fill a glass container with good quality cider, beer, or wine.

2. Add a vinegar "mother," a small amount of natural vinegar that contains acetobacter, the bacteria that convert ethanol (alcohol) into acetic acid (vinegar). Most mothers come with a jellyfish-like blob that is actually cellulose, a by-product of fermentation. You can get one from a friend, or use one left behind in a bottle of naturally fermented vinegar. Any vinegar mother can theoretically work in any kind of alcohol, though they grow more accustomed to the alcohol they are in over time.

3. Cover the jar tightly with a clean dishtowel or a few layers of cheesecloth. Set it aside in a place where the temperature won't go below freezing or above 90° F. The higher the temperature, the faster your alcohol ferments into vinegar. If you see mold at any point, best to throw it out and start again.

4. Now you wait, tasting every week. After a month, it should begin to taste like vinegar, and will start to grow more acidic over time. Pour off the vinegar when you like the taste, and then top off the jar with alcohol to make more.

5. To store your vinegar, you can either refrigerate it to slow down the fermentation process, or strain and heat it to 155°F to stop the fermentation altogether. This means you can store it at room temperature without a change in flavor. If you want to get fancy, you can age it further in wood barrels to mellow its flavor.

SALT

TABLE SALT
is refined into smooth, uniform, small grains and mixed with anti-caking agents and often potassium iodide, then sold as iodized salt.

KOSHER SALT
is essentially table salt with a larger, flakier grain size. It is not always certified kosher—today the name refers mainly to style, not substance.

SEA SALT
can cover a wide range of salts with varying qualities, but it is generally larger grained and flakier than table or kosher salt.

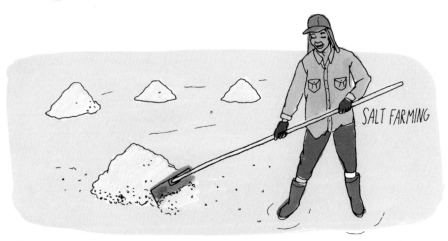

SALT FARMING

Salt nerds like to joke that technically all salt is sea salt, since it is either processed from salt mined from deposits under the earth — which were once great seas — or evaporated in one manner or another from sea water. Since antiquity, coastal salt makers have moved sea water throughout a series of small, shallow ponds until salt finally crystallizes into a thick crust on the top. Traditionally, this is raked together into baskets and then milled or ground into coarse or fine products.

PIPER NIGRUM, the pepper plant

PEPPER

White, green, and black peppercorns all come from the seeds of the same tropical vine, each with a similar but slightly different flavor. White peppercorns are ripe seeds with the skin removed; green are unripe and then treated so that they remain green; and black are unripe, often cooked, and then dried. There are many varieties of peppercorn plants grown around the tropics, each with their own sought-after flavor profile.

 PINK

 TELLICHERRY BLACK

 MALABAR BLACK

 SARAWAK WHITE

 MUNTOK WHITE

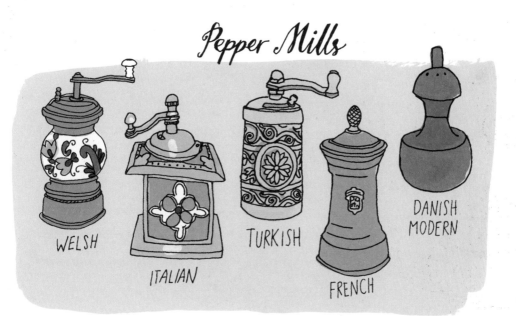

Pepper Mills

WELSH — ITALIAN — TURKISH — FRENCH — DANISH MODERN

CHAPTER 8
Drink Up!

COFFEE

A coffee bean is the seed of the bright-red stone fruits produced by coffee trees. Inside the coffee cherries, as they are called, are "green" coffee beans, which are processed to remove their membrane and pulp, roasted, ground, and then brewed. These steps, as well as the way the tree is grown and where, create different flavors in coffee.

While there are also many different kinds of coffee beans, the two most commonly grown are Arabica and the Robusta varietals. Generally speaking, the former has more fruity flavor and acidity, the latter more caffeine.

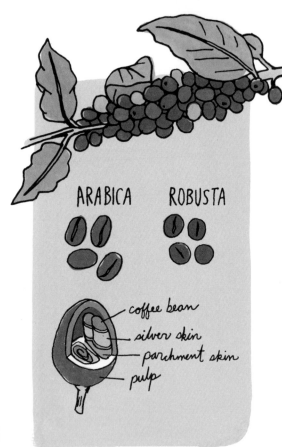

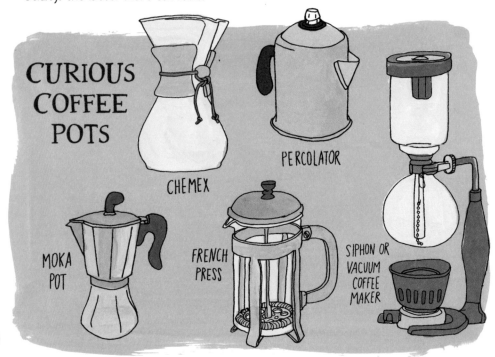

ESPRESSO GUIDE

ESPRESSO

RISTRETTO

MACCHIATO

CAFÉ CREME

CAPPUCCINO

AMERICANO

BREVE

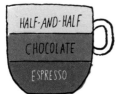
MOCHA BREVE

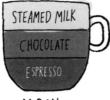
MOCHA

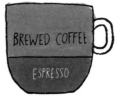
BLACK EYE

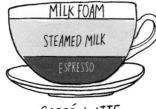
CAFFÉ LATTE

CAFFÉ AU LAIT

CAFÉ CON LECHE

Espresso Machine

An espresso machine forces very hot pressurized water through packed coffee grinds and then a filter to produce a thick, concentrated liquid.

The first was patented in 1884 by Angelo Moriondo in Turin, Italy, but this updated design came in 1901 and was manufactured for the La Pavoni company in Milan.

CAFFEINE

8 OUNCES BLACK TEA
14-70 MG

8 OUNCES GREEN TEA
24-45 MG

SINGLE ESPRESSO
80-100 MG

1 CUP BLACK COFFEE
100-125 MG

A SPOT OF TEA

Real tea — everything else is just an herbal infusion — is made from the leaves and leaf buds of just one Asian shrub: *Camellia sinensis*. Though there are many cultivars and special growing regions, all tea is harvested from just two main varieties: Chinese and Indian Assam.

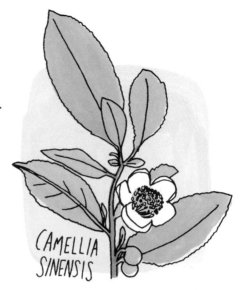

CAMELLIA SINENSIS

tender new shoots, picked only a few days per year, then quickly dried to avoid any oxidation

tea leaves that are quickly dried after harvest to avoid any oxidation

large, mature leaves allowed to oxidize slightly before they're dried

younger tea leaves that are bruised and fully oxidized before being dried

tea leaves that are allowed to ferment and age

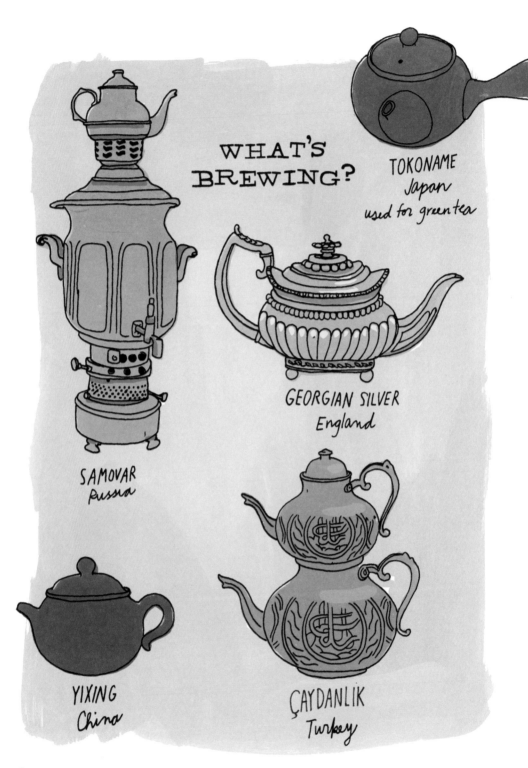

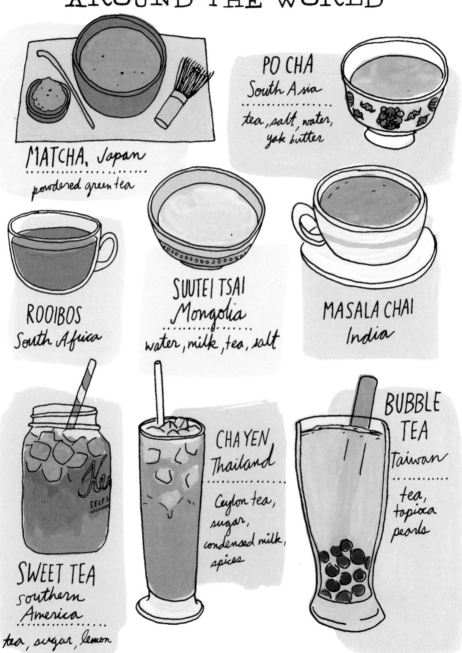

When Life Gives You Lemons...

PAPELÓN CON LIMÓN
a Venezuelan drink made with earthy, dark brown, unrefined cane sugar, water, and lime or lemon juice

LIMONANA
a mix of freshly squeezed lemon juice, spearmint leaves, and water served in the Middle East

CHANH MUỐI
Vietnamese lemonade made with whole, salt-preserved lemons or limes, sugar, and water or seltzer

ARNOLD PALMER
a 50-50 blend of lemonade and iced tea, named after an American golfer who reportedly asked for the drink; also known as a "half and half"

STYLES OF ICE

 NUGGET

 FLAKE

 GOURMET

 SPHERES

 BLOCK

 FULL AND HALF CUBES

 CRESCENT

 CRUSHED

 LEWIS ICE BAG

Shikanjvi for Two

A spiced lemonade from the Indian subcontinent, also known as nimbu pani. Ingredients vary — try adding muddled ginger, saffron threads, or rose water along with the mint.

- 1 TEASPOON CUMIN POWDER
- 2 TABLESPOONS FRESHLY SQUEEZED LEMON JUICE
- 1/2 TEASPOON KALA NAMAK, OR INDIAN BLACK SALT
- 3 TABLESPOONS SUGAR
- 4 FRESH MINT LEAVES, OPTIONAL
- 1-2 CUPS LARGE ICE CUBES

1. Heat the cumin powder in a small skillet over medium to medium-high heat until it begins to smell fragrant and toasted. Remove pan from heat and set aside.
2. Pour two cups of cool water into a 1-quart mason jar with a lid.
3. Add the lemon juice, kala namak, and sugar. Cover the jar and shake until the sugar has dissolved.
4. Add two mint leaves to the bottom of each serving glass. Fill each glass with ice cubes, top with the shikanjvi, and stir until the ice has slightly melted and the drink is cold. Serve immediately, topped with more mint leaves, if desired.

FIZZY SIPS

Gasogene
the top is for the gas, the bottom the liquid

Soda Siphon
a valve in the spout keeps the contents pressurized

SELTZER WATER

The original seltzer water was actually "Selter" water, or naturally effervescent mineral spring waters from the German town of Selters. Though there are still natural sources for sparkling mineral waters, today most seltzer is man-made, thanks to a process refined by Englishman Joseph Priestley in 1767. Though it once contained minerals or salts, today it's usually just water and carbon dioxide gas. The latter, dissolved in water at a low concentration, creates carbonic acid, which is what gives seltzer, also known as carbonated water, a slightly tart flavor.

Codd-Neck
filled upside down; the marble floats up into the well to create a seal

SOFT DRINK

Carbonated, flavored water with added sweeteners and flavorings, often with color, preservatives, and occasionally caffeine. Made in contrast to "hard" drinks, aka those with alcohol. Known as "pop" or "soda" in different regions of the United States.

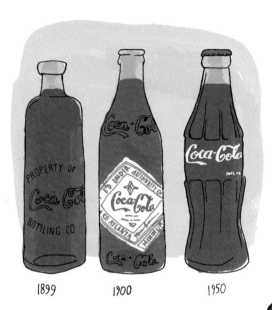

1899 1900 1950

COLA

A carbonated, flavored soft drink with caramel color and caffeine, inspired by traditional drinks that originally contained caffeine from the kola nut and cocaine from coca leaves. John Pemberton invented Coca-Cola in 1886 by making a nonalcoholic version of a coca-leaf wine that was made by a French pharmacist as early as 1863.

ROOT BEER

Originally, a noncaffeinated soft drink flavored with the bark of the root of the sassafras tree, though now more often artificial flavorings.

SARSAPARILLA

This non-caffeinated soft drink is no longer made from the sarsaparilla vine — except in Australia and the UK — but instead from sassafras and birch trees. Often also called root beer, it was once very popular in the 19th-century American West.

BIRCH BEER

Made from the sap and bark of different birch trees, the flavor and color vary depending on the locale. It is most often made in the northeast United States.

THE EQUATIONS OF FERMENTED BEVERAGES

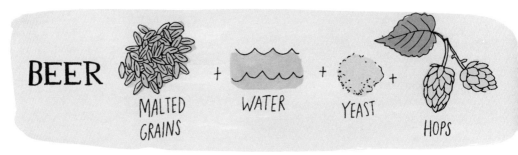

BEER + MALTED GRAINS + WATER + YEAST + HOPS

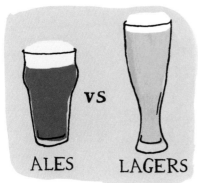

ALES vs LAGERS

Beer is usually divided into a few main categories, depending on what kind of yeasts are used to make it. Ale yeasts work at warmer temperatures, rise to the surface during fermentation, and typically produce fruity flavors technically known as esters. Lager yeasts — a classic lager style is a pilsner — require colder temperatures and sink to the bottom.

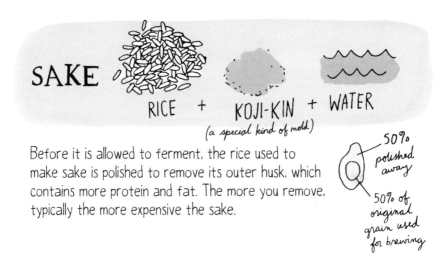

SAKE + RICE + KOJI-KIN (a special kind of mold) + WATER

Before it is allowed to ferment, the rice used to make sake is polished to remove its outer husk, which contains more protein and fat. The more you remove, typically the more expensive the sake.

50% polished away

50% of original grain used for brewing

KOMBUCHA

TEA + (YEAST+BACTERIA) + SUGAR
 SCOBY

A centuries-old drink popular for its tangy flavor and healthful properties, kombucha is made by fermenting strong sweet tea with a SCOBY (Symbiotic Colony of Bacteria and Yeast).

CIDER

APPLE JUICE + YEAST

Just as for wine, the sweetest, biggest fruit does not yield the tastiest cider, which traditionally meant an alcoholic beverage rather than apple juice.

Secondary Fermentation

Fermentation creates some carbon dioxide, but that's not what makes a bottle of Champagne so bubbly. To do that, you add what's known as liqueur de tirage — a mix of wine, sugar, and yeast — to the wine as it's bottled, in a process called secondary fermentation. Also known as bottle-conditioning, a similar process is used to make some kinds of beer and cider.

The Basic Steps in Making Wine

1. HARVESTING GRAPES

2. CRUSHING THE GRAPES

3. MACERATION

The skin, seeds and pulp of the grapes are mashed with the fermenting juice. This process leaches the tannins, color and flavor.

White wine can be made with red grapes — you just don't use the skins. For a rosé, they are kept in the macerating tub for just a few hours.

4. FERMENTATION

SUGAR + YEAST
↓
ALCOHOL + CO_2

5. AGING Aging a wine improves its aroma, color, and taste. Different types of vessels are used to hold the liquid during this stage.

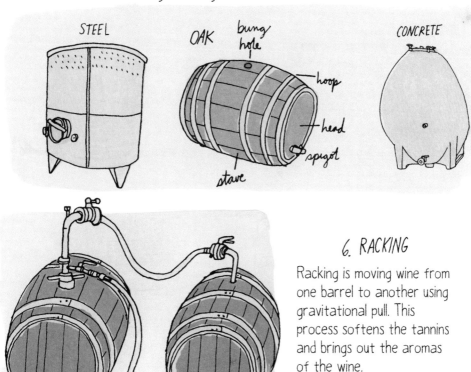

6. RACKING

Racking is moving wine from one barrel to another using gravitational pull. This process softens the tannins and brings out the aromas of the wine.

7. FILLING & CORKING

Bottles corked with synthetic corks can be stored upright. With natural cork, wines are stored on their sides so the cork doesn't dry out.

WINE TASTING

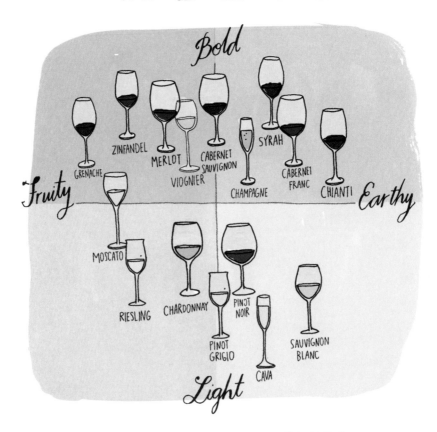

PARTS OF A GLASS

- rim
- bowl
- stem
- foot

QUICK TERMS

BODY - how a wine feels in your mouth (light, medium or full)

CRISP - the right amount of acidity

DRY - not sweet

EARTHY - tastes and smells like organic matter

FIRM - stronger tannin flavor

NOSE - the aroma

Distillation

The type of base liquid and the process of aging, often in wood barrels, affect flavor. So does distillation itself, a complex process that at the expert level is as much art as science.

FERMENTED SUGARCANE OR MOLASSES = RUM
CORN, WHEAT, AND RYE = WHISKEY
FERMENTED AGAVE JUICE = TEQUILA
FERMENTED POTATOES = VODKA

The Cocktail Maker's Toolkit

Two Mixed Drinks Every Adult Should Know:

MANHATTAN

2 OUNCES RYE WHISKEY
1 OUNCE SWEET VERMOUTH
2 DASHES ANGOSTURA BITTERS

MARTINI

1 OUNCE DRY VERMOUTH
4 OUNCES GIN

Common Cakes

ANGEL FOOD CAKE

PINEAPPLE UPSIDE DOWN CAKE

CARROT CAKE

BUNDT CAKE

BLACK FOREST CAKE

CHEESECAKE

SWISS ROLL CAKE

MARBLE POUND CAKE

STRAWBERRY SHORTCAKE

TORTA TRES LECHES

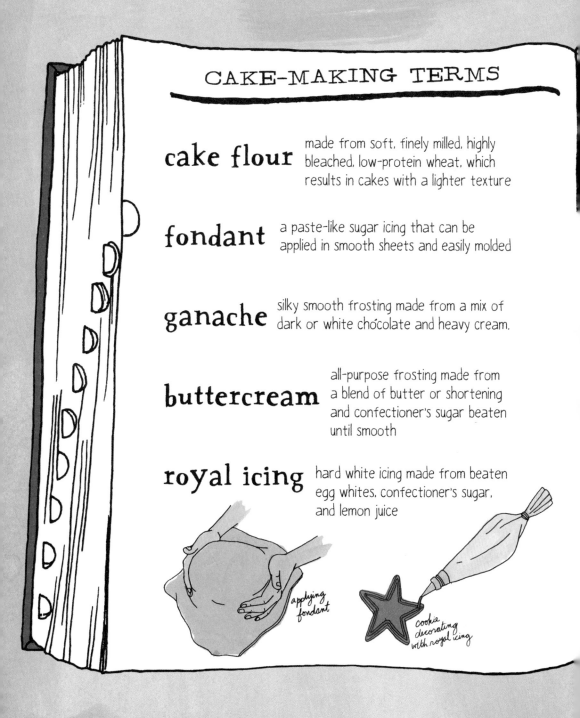

WE ALL SCREAM FOR ICE CREAM

AMERICAN, NEW YORK, OR PHILADELPHIA-STYLE
ice cream made with just sugar, milk, and cream

FRENCH-STYLE
ice cream based on a custard, or a heated blend of milk and eggs

SOFT SERVE
similar to American-style ice cream, but made with less butterfat, churned with much more air, and served at a warmer temperature and softer texture

FROZEN CUSTARD
similar to soft serve, but made with more butterfat and the addition of egg yolks; typically churned with less air

GELATO
Italian version, made with less fat and churned at a lower speed, resulting in a dense consistency

KULFI
Indian-style frozen, dairy-based dessert that is not ice cream but frozen milk, sugar, and water

BOMBE
ice cream in a mold, often with a base of cake or cookies

BAKED ALASKA
a layer of cake topped with ice cream and covered with meringue, then quickly browned in a very hot oven

20TH CENTURY ASIAN ICE SHAVING MACHINE

Shaved Ice

Served throughout the world in various forms, this treat originated in Japan, where it has been made for 1500 years and is called kakigōri. The basic formula is shaved or chipped ice saturated with flavored syrups; toppings include condensed milk, red beans, corn kernels, and jellies.

COOKIES

- LINZER SABLÉ
- CHOCOLATE CHIP
- ANIMAL CRACKERS
- RAINBOW COOKIE
- SAVOLARDI
- ALFAJORES
- STROOPWAFEL
- QUARBIYA
- BLACK & WHITE
- SNICKERDOODLE
- BROWNIE & BLONDIE
- SPECULOOS

Gingerbread itself — a stiff dough originally sweetened with honey and flavored with ginger and other spices — dates back several centuries. The craft of forming it into elaborately decorated shapes arose in Europe during the 12th and 13th centuries. German bakers in the 16th century developed the craft into an art form practiced by professional guilds.

How Chocolate Is Made

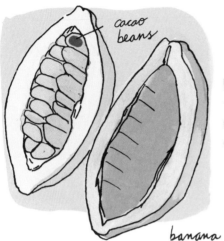

1. HARVEST

Ripe pods are cut from cacao trees and split open like coconuts, revealing the white pulp that contains the cacao beans.

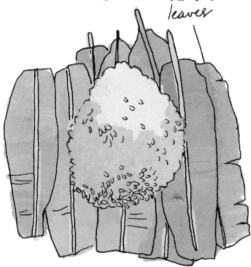

2. FERMENTATION

The pods and pulp are fermented to develop flavor and then dried and sorted for shipping to chocolate makers. The beans are now called cocoa beans.

3. ROASTING

Beans are roasted to the chocolate maker's specifications, revealing different flavors and aromatics.

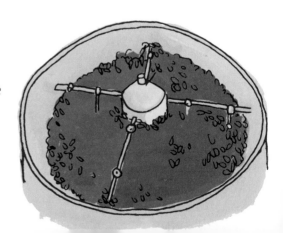

4. CRACKING & WINNOWING

The roasted beans are broken into pieces and the papery outer shell is blown off with fans. The small pieces of cocoa bean are known as nibs and are sometimes used in desserts and as decoration.

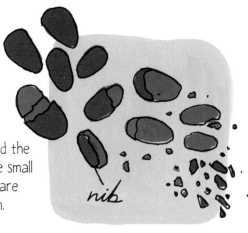
nib

5. GRINDING & CONCHING

Nibs are ground to produce both cocoa liquor, the essence of chocolate, and cocoa butter, a pure fat; the remaining dry solids are used to make cocoa powder. Conching is the process of heating and mixing cocoa liquor, cocoa butter (or for cheaper candy, another fat), and sugar for hours or even days to create a smooth, flavorful blend.

conching machine

6. TEMPERING

Before being poured into molds, chocolate is repeatedly heated and cooled, which results in a bar or bon bon that is shiny and glossy, rather than soft and crumbly.

mold

tempering machine

WORLDLY TREATS

Moon Cake
CHINA

Vinarterta
ICELAND

Kokis
SRI LANKA

Sakuramochi
JAPAN

Maple Candy
CANADA

Zefir
RUSSIA

Mujigae-tteok
KOREA

Petit Fours
FRANCE

Brigadeiro
BRAZIL

A SPOONFUL OF SUGAR

In the United States, dark brown or light brown sugar is most commonly made from refined white sugar crystals with added molasses.

Demerara, turbinado, and muscovado sugars — sometimes called "raw" sugars — are made by retaining some of the molasses naturally found in sugarcane as the sugar is processed. These vary in crystal size and intensity of flavor.

The most deeply flavored sugars come from evaporated, unprocessed sugarcane juice, rich with molasses. Depending on the country, this is called panela, rapadura, jaggery, piloncillo, kokuto — all of which come in dense blocks, rather than crystals — or unrefined whole cane sugar.

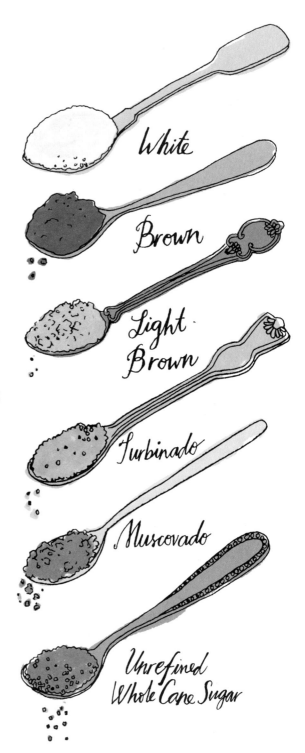

Homemade Butterscotch Sauce

While the term caramel refers to candies and sauces made by browning white sugar, butterscotch refers to those made with brown sugar. (Toffee, on the other hand, is butterscotch candy that has been cooked to the hard-crack stage.) While true butterscotch should contain butter, today most recipes for butterscotch or caramel both contain butter and also milk or cream.

4 TABLESPOONS UNSALTED BUTTER
1 CUP DARK BROWN SUGAR
3/4 CUP HEAVY CREAM
1/2 TEASPOON SALT

1. In a heavy-bottomed saucepan, melt the butter over medium-low heat. When it begins to soften, add the sugar and stir until all the crystals are moistened.
2. Cook the butter-sugar mixture, stirring occasionally, until it begins to bubble and thicken, just a few minutes.
3. Whisk in the cream, then bring the mixture to a simmer and cook, whisking occasionally, until the mixture is thick and glossy.
4. Whisk in the salt, adding more to taste. Let cool completely before refrigerating for up to two weeks.

CANDY

A lot of candies are made by boiling sugarwater until it reaches a desired consistency. The ratio of sugar to water and the length of the boil affect the process, but the textures of candy products progress from syrup to soft and chewy to hard and finally, brittle. The correct stage is judged by how a spoonful of the hot mixture reacts when dropped into cold water, from forming a soft ball to creating brittle threads.

SUGAR STATE	TEMPERATURE	PERCENT SUGAR	EXAMPLE
SOFT BALL	234-241°F	85%	FUDGE
FIRM BALL	244-248°F	87%	SOFT CARAMEL
HARD BALL	250-266°F	90%	GUMMY BEARS
SOFT CRACK	270-289°F	95%	SALTWATER TAFFY
HARD CRACK	295-309°F	99%	LOLLIPOPS

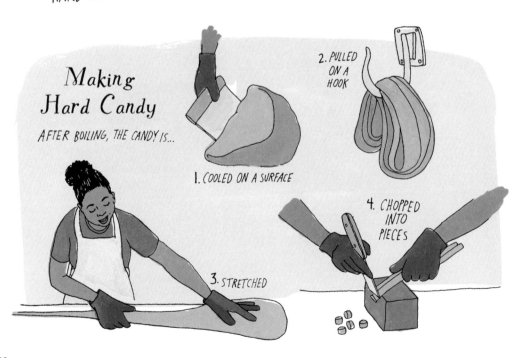

Making Hard Candy

AFTER BOILING, THE CANDY IS...
1. COOLED ON A SURFACE
2. PULLED ON A HOOK
3. STRETCHED
4. CHOPPED INTO PIECES

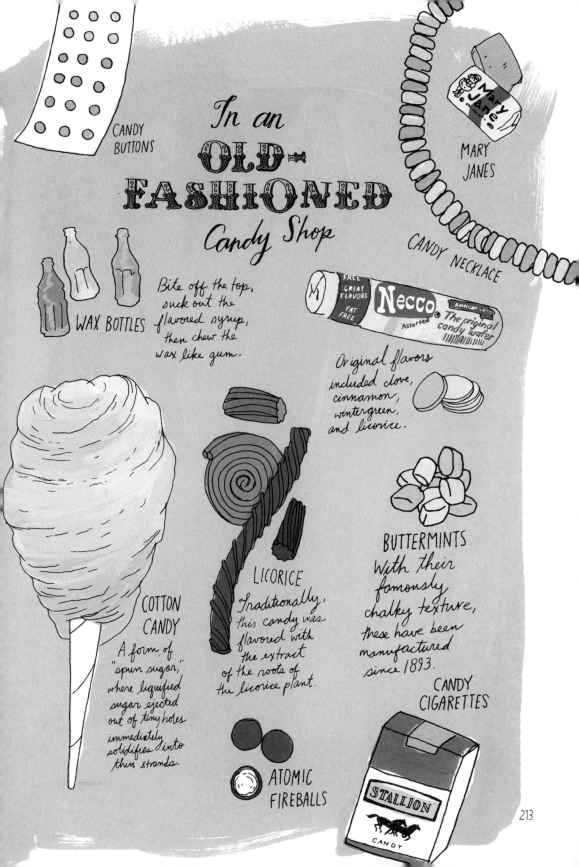

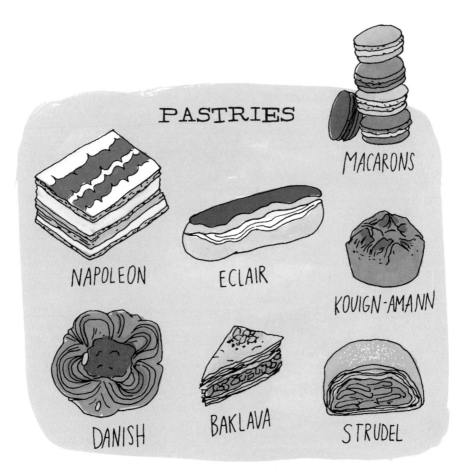

Making Puff Pastry

"Laminate" is the professional term to describe the process whereby butter or fat is repeatedly folded and smeared into a dough, resulting in a flaky, crispy, multi-layered texture.

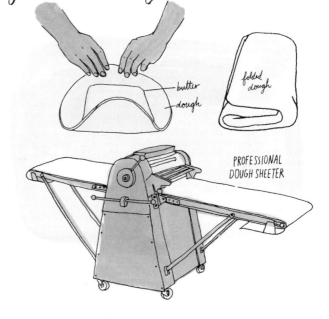

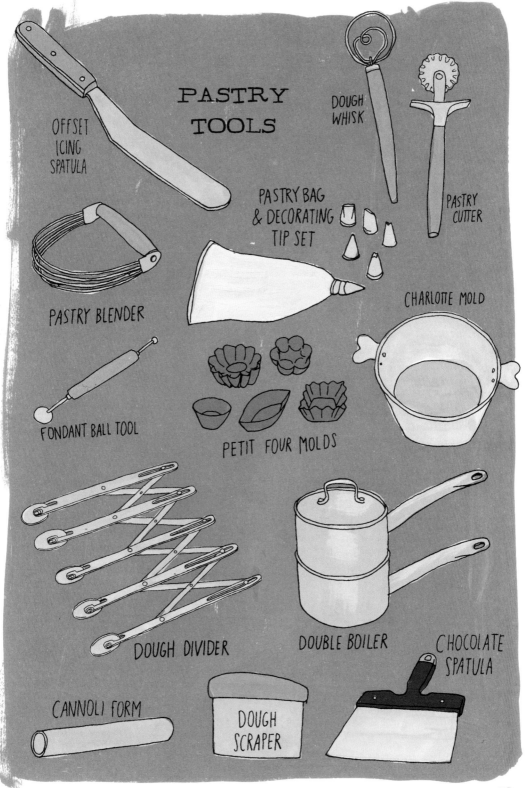

SOFT SWEETS AROUND THE WORLD

WHITE NOUGAT

Chewy confections made with roasted nuts, whipped egg whites, candied fruit, and sugar or honey. A star on its own in Italy and Spain, in the US it is better known as the filling for candy bars.

HALVA

This dense Middle Eastern, Asian, and southeastern European sweet is made from a paste of many different kinds of ingredients, including semolina, sesame seeds, fruits, or eggs and nuts.

MARZIPAN

A paste of ground almonds, sugar, and sometimes egg, which is colored and molded into elaborate shapes. Made around the world and known by many names, marzipan sweets are often a specialty at Christmas.

DODOL

A toffee-like sweet made from coconut milk, natural brown sugar, and rice flour, it is sold throughout southeast Asia in dozens of flavors.

MARSHMALLOW

Sugar is boiled until all the water is gone, mixed with gelatin or gum arabic, and then added to beaten egg whites. A form of this confection, thickened with the sap of the marshmallow plant (*Althaea officinalis*), was made in ancient Egypt.

BARFI

South Asian sweets made by cooking condensed milk and sugar until thick, then cooling it and cutting into small pieces. It comes in a variety of shapes and flavors, including carrot, mango, coconut, pistachio, cardamom, and rose water.

Known as *lokum* in Turkish, this jelly candy was originally made during the Ottoman Empire, which fostered its spread throughout that region. Made of sugar syrup cooked with a thickener, the squares are often flavored with rose water and dusted with powdered sugar.

TURKISH DELIGHT

American Pie

1. BANANA CREAM A custard pie made with sliced bananas and a graham cracker cookie crust, topped with whipped cream
2. SOUR CHERRY with a lattice crust
3. LEMON MERINGUE Lemon curd filling topped with meringue (whipped egg whites and sugar)
4. CHOCOLATE CHESS Southern-style custard pie flavored with cocoa powder and thickened with cornmeal
5. GRASSHOPPER A mint-flavored, whipped cream-filled pie with a crushed chocolate cookie crust.
6. BEAN A sweet custard pie made with mashed navy beans
7. DOUBLE CRUST APPLE Best made with tart baking apples that retain their texture
8. PECAN Filled with a mix of eggs, butter, dark corn syrup or molasses and whole pecans

THE FORTUNE COOKIE

The history of this crisp little cookie that contains a paper fortune — given out as an after-dinner gift in restaurants run by Chinese expatriates around the world — is a murky one.

A handful of California bakers, most of them Japanese, claimed to have been the first to bake them in the United States in the 1900s, and indeed a similar cookie has long been made in Kyoto. One thing we do know: it wasn't traditionally consumed in China.

People who love to eat are always the best people. —Julia Child

There is no sincerer love than the love of food. —George Bernard Shaw

Cauliflower is nothing but cabbage with a college education. —Mark Twain

First we eat, then we do everything else. —MFK Fisher

THANK YOU

These books take longer than a year to finish and so much research, editing, drawing, painting and laying out happens with the help of so many other people.

First, I have to thank Rachel Wharton, my partner on this book. I couldn't have asked for a better person to work with. She made it easy and fun and researched and wrote such fascinating information to make this come together.

My editor, Lisa Hiley, who is always patient and helps me stay on track. Also all of the other wonderful collaborators I have at Storey. It's been so many years working with them, I think I can call them my friends: Deborah Balmuth, Alethea Morrison, Maribeth Casey, and everyone else at that welcoming office.

Eron Hare, my truly amazing assistant, who sat by my side painting, helping with ideas and organizing me. I couldn't have finished without his help.

Mira Evnine, who helped me with intial brainstorms and connected me to the food world.

Jim Datz, for taking me on expertly led Asian market excursions.

Jenny, "pro kale massager," and Matt, "pro pastry eater," who help with everything I do in work and life.

Gretta Keene, for giving me the best tools to get me through the biggest obstacles even when they get way too overwhelming.

My parents and sister, who continue to be the best, most supportive family.

Pirjo and Esko Mustonen, who welcomed me into their home to learn the traditional cooking of Finland. And Ari Korhonen, for letting me come pick strawberries.

And Santtu Mustonen, who this book is dedicated to, who taught me how to really eat and is just all-around inspiring.

FARM ANATOMY

THE CURIOUS PARTS & PIECES OF COUNTRY LIFE

JULIA ROTHMAN

The mission of Storey Publishing is to serve our customers by
publishing practical information that encourages
personal independence in harmony with the environment.

Text and illustrations © 2011 by Julia Rothman

All rights reserved. No part of this book may be reproduced without written permission from the publisher, except by a reviewer who may quote brief passages or reproduce illustrations in a review with appropriate credits; nor may any part of this book be reproduced, stored in a retrieval system, or transmitted in any form or by any means — electronic, mechanical, photocopying, recording, or other — without written permission from the publisher.

The information in this book is true and complete to the best of our knowledge. All recommendations are made without guarantee on the part of the author or Storey Publishing. The author and publisher disclaim any liability in connection with the use of this information.

Storey books are available at special discounts when purchased in bulk for premiums and sales promotions as well as for fund-raising or educational use. Special editions or book excerpts can also be created to specification. For details, please call 800-827-8673, or send an email to sales@storey.com.

Storey Publishing
210 MASS MoCA Way
North Adams, MA 01247
www.storey.com

Printed in China by R.R. Donnelley
20 19 18 17 16 15 14 13

CONTENTS

INTRODUCTION .. 6

CHAPTER 1
Breaking Ground .. 10
Layers of the Soil • Topsoil Chart • The Texture Triangle • Mineral Nutrients • Crop Rotation • Contour Farming and Terracing • Windbreaks • Predicting Weather • Composting • An Acre Is...

CHAPTER 2
Raised in a Barn .. 22
Barn Styles • Timber Construction • Trusses • Barn Doors, Bracing, and Hardware • Barn Cupolas • Barn Birds • Farm Buidings • Animal Housing • Feeders • Fencing

CHAPTER 3
Tools of the Trade .. 44
Tractors • Tractor Implements • How to Plow a Field • Inside a Combine • Other Machines • Felling, Bucking, Splitting and Stacking • In the Toolshed

CHAPTER 4
Plant a Seed .. 66
Average Frost Dates • Vegetable Anatomy • Squash Varieties • Build a Bean Teepee • Dry Bean Varieties • Pepper Varieties • Tater Tower • 4 Ways to Grow Tomatoes • Tomato Varieties • How to Can Tomatoes • Herb Chart • Growing Grains • Planting an Orchard • Apple Varieties • Good Bugs • Bad Bugs

CHAPTER 5
Separating the Sheep from the Goats 106

Animal Terms • Parts of a Rooster • Comb Styles • Chicken Breeds • Fresh Eggs • Duck and Goose Breeds • Heritage Turkeys • Parts of a Beef Animal • How a Cow's Stomach Works • Cow Breeds • How to Milk a Cow • Parts of a Goat • Goat Breeds • Hoof Trimming • Knots • Parts of a Horse • Horse Markings and Tail Styles • Parts of a Hoof • Draft Horse Breeds • Draft Harness • Mules • Parts of a Pig • Pig Breeds • Livestock Water Consumption • Parts of a Sheep • Sheep Breeds • Shearing Sheep • Parts of a Rabbit • Rabbit Breeds • Rabbit Coat Types • Parts of a Bee • Anatomy of a Beehive

CHAPTER 6
Country Wining and Dining170

In an Old-Fashioned Country Kitchen • Wine-Making Equipment • Edible Flowers • The Basics of Breadmaking • Dairy Terms • The Basic Steps in Making Cheese • Butchering Knives • How to Cut Up a Chicken • Prime Cuts of Beef • Build a Barrel Smokehouse • Prime Cuts of Pork • Dry Curing • Prime Cuts of Lamb • Freezing Meat • Pressure Canning • Root Cellaring • Making Maple Syrup

CHAPTER 7
Spinning a Yarn ...206

Carding and Spinning Yarn • Natural Dyes • How to Make a Flower Press • How to Make a Cornhusk Doll • Making Rag Rugs • Making Candles • Quilt Patterns

My husband, Matt, was seven years old when his grandparents decided to move from Omaha, Nebraska, back to a farm. His grandfather was ill and wanted to return to the rural lifestyle of his youth for the remainder of his life. Matt's parents decided to make the move with them. His grandparents found an old farm with two houses, one for them and the other for Matt and his parents, in the tiny town of Tabor, Iowa.

Matt grew up doing all kinds of chores: collecting eggs, chopping logs, shoveling manure, walking beans. Although his family didn't farm for profit, they did raise goats, sheep, angora rabbits, and chickens. They cultivated a garden that grew all kinds of vegetables, which they canned and stored in the root cellar. They owned a plot of farmland surrounding their houses that they rented each season to a farmer who rotated growing corn and soybean crops.

I grew up in New York City and only left to go to college before returning. Matt also moved to New York City a few years after he finished college in Chicago. We were introduced by mutual friends. The first time we officially hung out, we walked around the crowded streets of Astoria, Queens, and over the noise of the subway, I asked him about growing up on a farm. I had lived in the city my whole life and the idea seemed so foreign to me. He told me one year they had two turkeys, one named Thanksgiving and one named Christmas.

When our relationship grew more serious, we decided to spend the Christmas holiday at his parents' farm. We had a long drive from the Omaha airport, and I arrived wide-eyed. We drove down a long empty road surrounded by what seemed like endless fields on either side of us. We ascended a little hill and arrived just before the sun was setting.

I was immediately excited when greeted by a little herd of goats. They stood up against the fence and thrust their heads around to force us to pet them. The pupils of their eyes were rectangular, and

they had no ears. Besides being so funny looking, they got very noisy as we approached them. Before I knew it, cats – so many of them – were circling between my ankles, meowing and asking for our attention as well. We trudged through snow as Matt showed me around. His mother threw us extra hats and scarves. I was surprised at how many buildings there were and how huge the barn seemed. It felt surreal – everything was covered in white. It looked so quiet and undisturbed. Every which way I looked seemed like a winter scene on a postcard.

Matt took me into the middle of the cornfield that night, and I was scared to death. I never had walked through a cornfield that big before and certainly not at nighttime. I remembered all the horror movies I had seen that involved cornfields. Once we were in the middle of it, I started begging Matt to take me back, too afraid to leave on my own. Instead, he told me to look up at the stars. It was really dark and there were billions, more than I had seen anywhere in my life. Some of them looked like they had been smudged across the sky, clusters of tiny stars. That's still my favorite thing about visiting his farm, how beautiful the sky looks at night.

We have visited the farm many times since then, and each time we return home, I bring back something I have learned and a story to share. One time a few jars of canned rhubarb made their way to our Brooklyn apartment and we baked a pie using Matt's mother's favorite recipe to share with my family. Another time we came home with a small piece of old wood from the barn that we used to make a decorative shelf.

Working on this book has given me a chance to learn more about what it's like to live off the land and to better understand Matt's roots. In small ways I hope to bring the ideals and traditions he grew up on back into our daily lives. Matt keeps teasing me that when we go back to visit Tabor again, I can impress everyone with my knowlege by pointing out the spring-tooth harrow the farmer is using, or identify the qualities of the breeds of chickens their neighbors have. I am really looking forward to that!

Julia Rothman

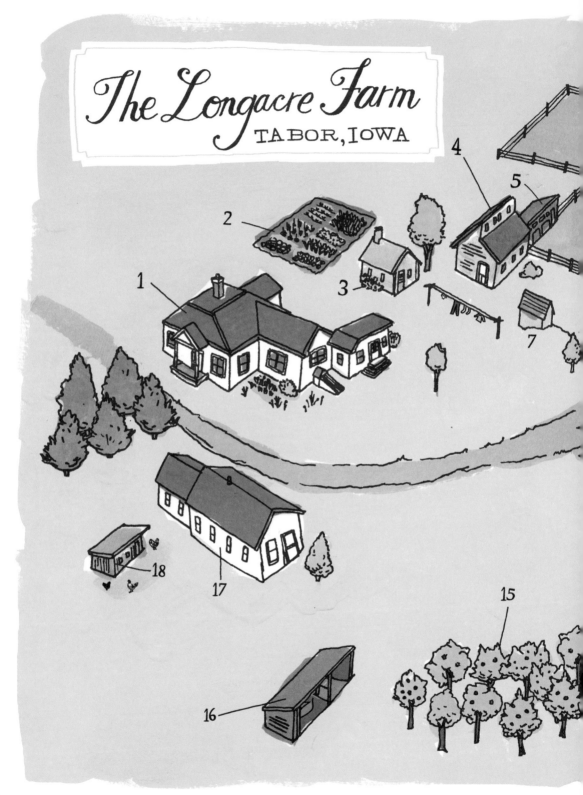

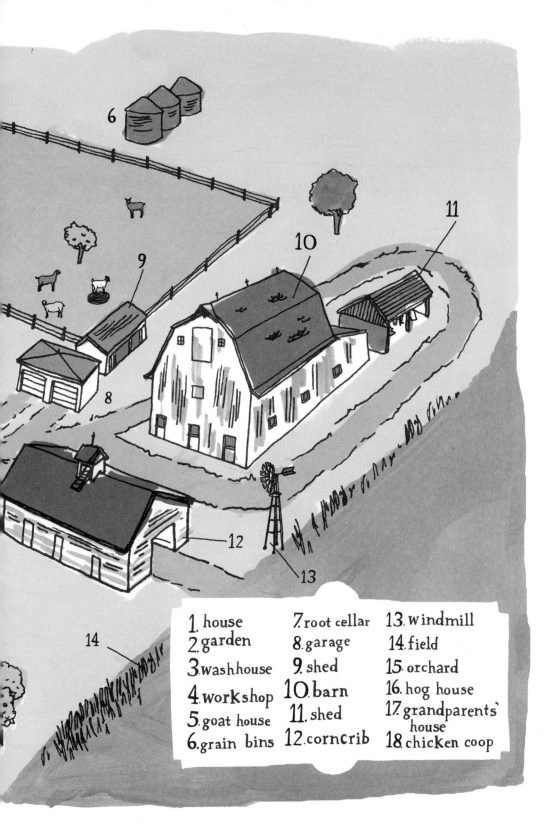

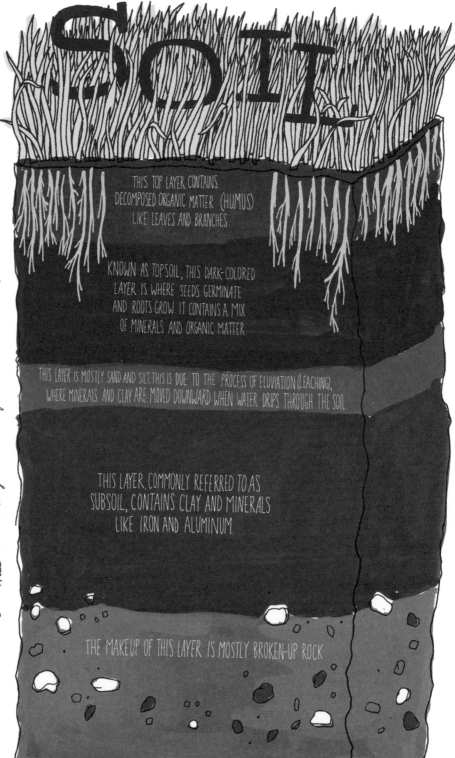

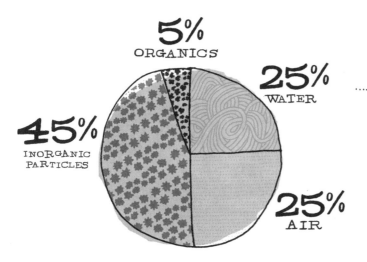

Topsoil

Healthy topsoil has a breakdown of matter as shown in this chart.

The Texture Triangle

Soil is classified into 12 textural types. With this chart you can determine which class your soil falls into depending on how much clay, sand, and silt it contains.

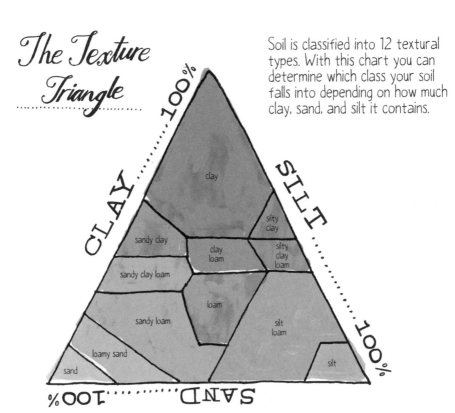

MINERAL NUTRIENTS IN SOIL

Plants extract many essential mineral nutrients from the soil. These are divided into two groups: macronutrients and micronutrients. Primary macronutrients are the major nutrients that plants need the most of for proper growth and survival.

Micronutrients are only needed in tiny amounts. Strange coloration, stunted growth, or multiple buds in plants could be signs that soil is lacking certain nutrients. Doing a soil analysis will determine what those deficiencies are.

Macronutrients

Primary

N - NITROGEN | P - PHOSPHORUS | K - POTASSIUM

Secondary

Ca - CALCIUM | Mg - MAGNESIUM | S - SULFUR

Micronutrients

Cl - CHLORINE | Cu - COPPER | Fe - IRON | Mn - MANGANESE | Mo - MOLYBDENUM | Zn - ZINC | B - BORON

Crop Rotation

To maintain soil fertility and prevent nutrient depletion, farmers rotate the crops they grow each year. Rotating crops also reduces erosion, helps prevent weeds, and controls insect pests.

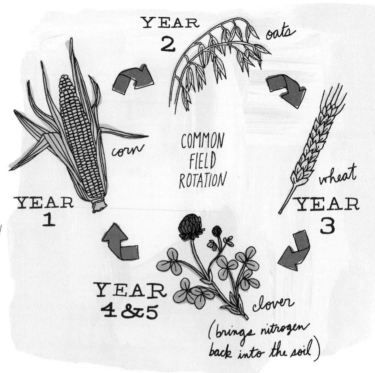

COMMON FIELD ROTATION

- YEAR 1: corn
- YEAR 2: oats
- YEAR 3: wheat
- YEAR 4 & 5: clover (brings nitrogen back into the soil)

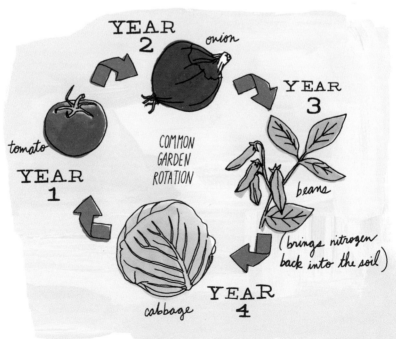

COMMON GARDEN ROTATION

- YEAR 1: tomato
- YEAR 2: onion
- YEAR 3: beans (brings nitrogen back into the soil)
- YEAR 4: cabbage

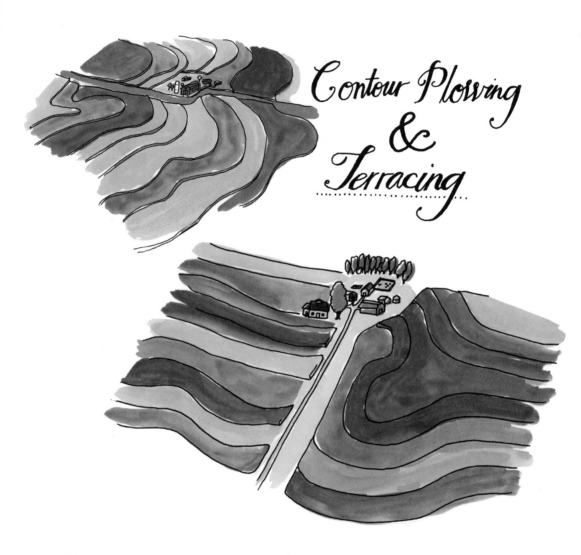

Contour Plowing & Terracing

To prevent soil erosion on sloped land, farmers plow across a field, tracing the natural contours. The small ridges left from plowing stop the runoff and prevent weathering of the soil.

Another method is terracing, where the land is formed into level, shallow steps. This is often used in rice farming because rice requires heavy watering.

Windbreaks

Rows of trees and shrubs can prevent soil erosion and provide protection from the wind. They are a good way to help conserve energy. By providing shade they keep the home cool in the summer. In the winter, they block wind, keeping the home warmer. They also deter snowdrifts.

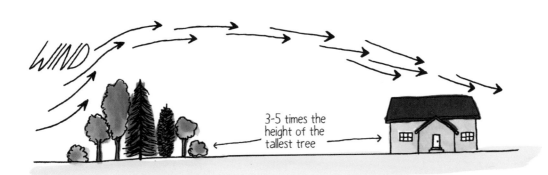

3-5 times the height of the tallest tree

Predicting Weather

You can't always rely on your local weather report. Here are some ways to predict weather so you're not caught off guard by a storm while working in the field:

Cloud formations: Certain types of clouds are good indicators of precipitation or storms.

Morning dew on the grass: Heavy dew means there aren't strong winds drying it off. That usually is a good indicator that there isn't a storm coming.

Animal behavior: Birds fly lower to the ground when a storm is coming because the air pressure hurts their ears. Cows will huddle together or lie down in preparation.

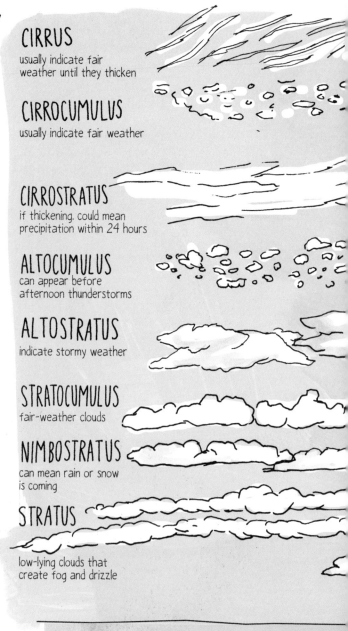

CIRRUS
usually indicate fair weather until they thicken

CIRROCUMULUS
usually indicate fair weather

CIRROSTRATUS
if thickening, could mean precipitation within 24 hours

ALTOCUMULUS
can appear before afternoon thunderstorms

ALTOSTRATUS
indicate stormy weather

STRATOCUMULUS
fair-weather clouds

NIMBOSTRATUS
can mean rain or snow is coming

STRATUS
low-lying clouds that create fog and drizzle

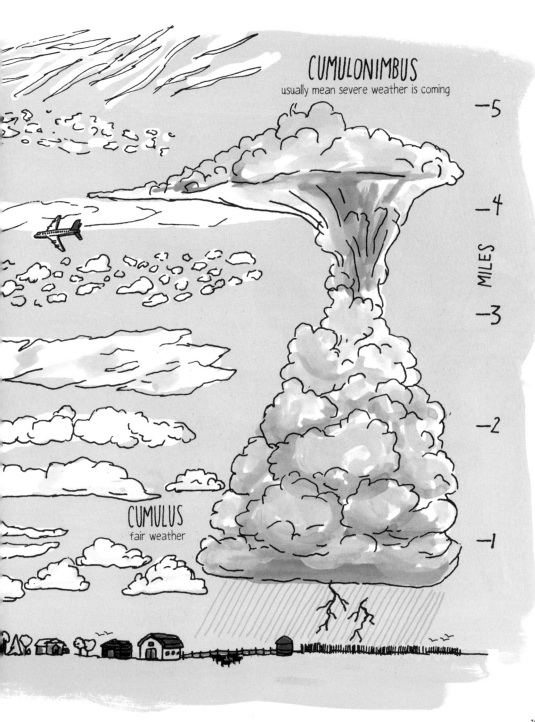

Composting

Composting is the process that uses bacteria to decompose organic waste into nutrient-rich fertilizer. For best results, layers of nitrogen-rich (green) and carbon-rich (brown) ingredients are piled in a bin in a 3 to 1 ratio. Soil organisms break it down into nutritious organic matter in just over two weeks.

GREENS
high nitrogen

GARDEN WASTE
KITCHEN WASTE
GRASS CLIPPINGS
COFFEE GROUNDS
HAIR

BROWNS
high carbon

PAPER
DRY LEAVES
WOOD CHIPS
STRAW
SAWDUST

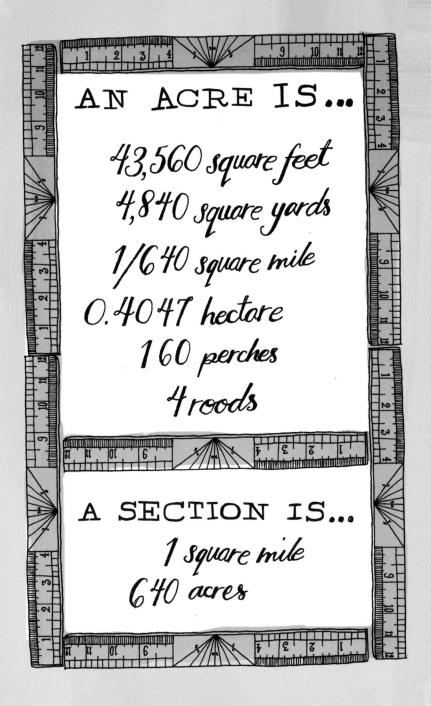

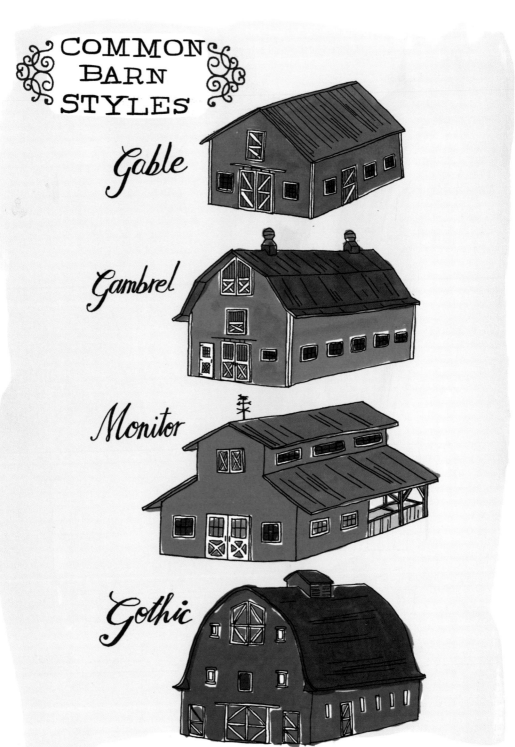

TIMBER CONSTRUCTION

Barns are constructed with heavy timber frames made of posts and beams that are fastened together by different types of joints.

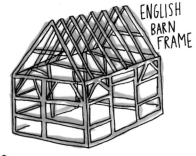
ENGLISH BARN FRAME

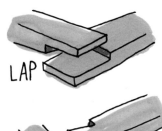
LAP

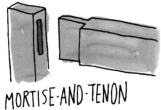
MORTISE-AND-TENON

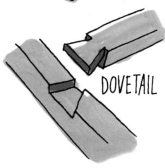
DOVETAIL

RAFTER SEAT

TRUSSES

To support large roofs, rafters are assembled into triangular configurations called trusses. Here are some different styles:

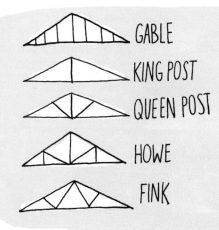
GABLE
KING POST
QUEEN POST
HOWE
FINK

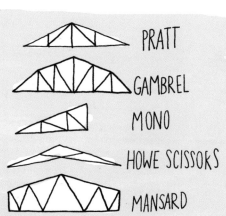
PRATT
GAMBREL
MONO
HOWE SCISSORS
MANSARD

COMMON BARN DOORS

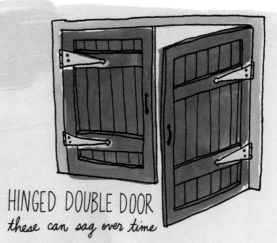

HINGED DOUBLE DOOR
these can sag over time

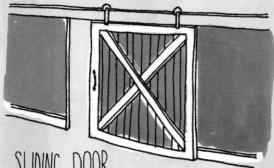

SLIDING DOOR
permits easy access for tractors and other vehicles

HINGED SINGLE DOOR

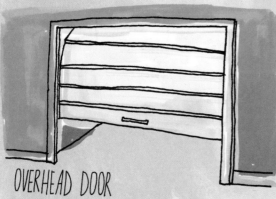

OVERHEAD DOOR
good option but more expensive

HINGED DUTCH DOOR
keeps animals enclosed while still allowing light to come in

BRACING

the bigger the door, the more bracing you'll need

BRACE + FRAME

HORIZONTAL BRACE

Z-BRACE

DOUBLE Z-BRACE

X-BRACE

HARDWARE

simple latches work fine for most closures

SIMPLE LATCH

SURFACE BOLT

WROUGHT-IRON LATCH

SPRING TRANSOM CATCH

HOPPER WINDOW

Placed high on the wall, this type of window provides great ventilation and prevents drafts flowing over the animals.

BARN CUPOLAS

The tops of barns are often adorned with cupolas that help with ventilation. They come in many different shapes and styles and may have a lightning rod or weathervane on top.

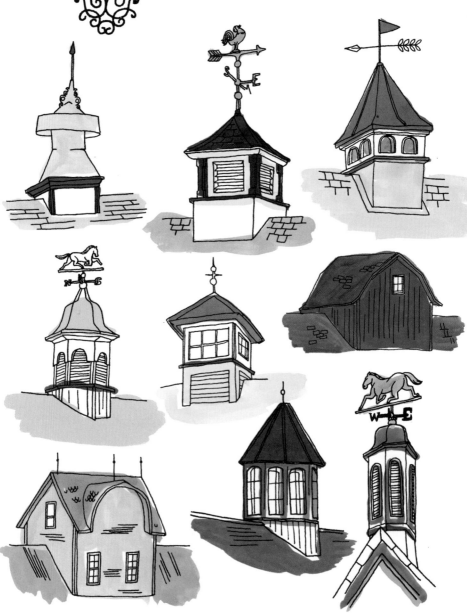

BARN BIRDS

Barn Swallow

These are the most widespread species of swallow in the world. They commonly reside in the rafters of barns. They make cup-shaped nests of mud and grass, which they attach to a wall or ledge. With a nice flying swoop they feed on flying insects.

Barn Owl

Barn owls also like to nest in man-made structures like abandoned barns. They are raptors and feed on rodents. You can attract barn owls by hanging a nest box in your yard about 15-25 feet up.

NEST BOX

Corncrib

This building is used to dry and store corn still on the cob. Once dried, it is used to feed livestock. The walls of a corncrib are usually slatted to provide good airflow.

Hay Shed

Square bales need to be covered to protect them from rain and keep them dry. They are often stored in a hayloft or in a covered area that a tractor can get easy access to for loading and unloading.

Grain Bins & Silos

Grain bins store dry grain heads removed from the stalk. A silo can store silage, which is preserved fodder. Silage is harvested while the grain is still immature. The entire plant is chopped and then stored in the silo in an oxygen-free atmosphere so it ferments.

GRAIN BIN GRAIN SILO

The American Windmill

Windmills are an iconic feature of the farm landscape. It's common for old windmills to be kept just as decoration, but many still serve their original purpose of pumping water.

Harnessing the energy of the wind, the vanes rotate, putting the pump into motion. The tail helps pivot the wind wheel so it always faces directly into the wind. The pump obtains fresh water from aquifers deep under the ground. The excess water can be pumped into a water tank and stored.

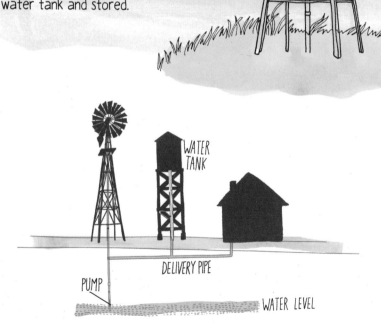

Chicken Coop

Chicken coops can be built in all kinds of shapes and sizes. The three things that are essential for a coop are a place for food and clean water; a clean, dry nesting area, and a good area for scratching. Coops are placed in protected areas of the farm so that predators like hawks, weasels, or stray dogs can't get to them. Chickens should have a minimum of 2 square feet per bird. The number of chickens determines how big the coop is.

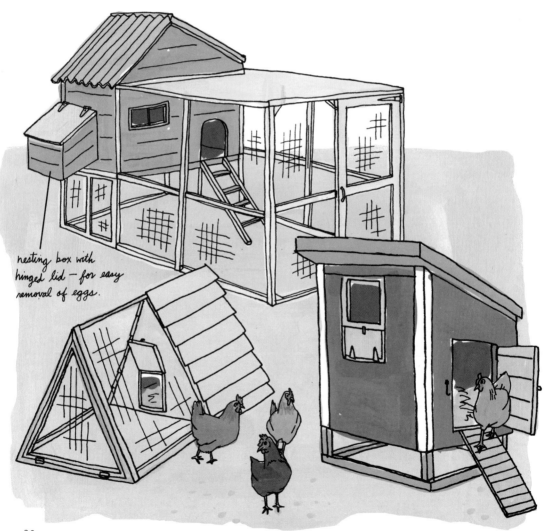

nesting box with hinged lid — for easy removal of eggs.

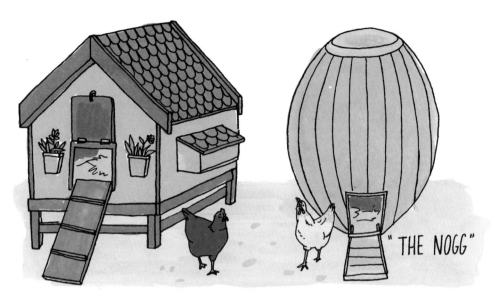

Some coops are built to be portable so the coop can change location throughout the year. Chickens scratch and peck and tear up the ground, so being able to move the coop is helpful.

Many people have found creative ways to build interesting coops. They've made them look like miniature houses or have built them atop old wagons. Instead of building your own, you can buy a prefabricated chicken coop. As the popularity of keeping chickens has grown, new modern designs are becoming available, such as the Nogg.

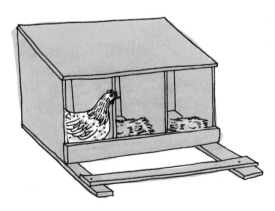

NESTING BOX
Inside the coop, nests provide a private place for chickens to lay eggs. Nesting boxes have slanted roofs so chickens won't stand or roost on them.

ROOST
Chickens like to roost at night, so perches are provided inside the coop.

A hanging chicken feeder discourages chickens from sitting on the feeder. The high sides prevent chickens from scooping the food out onto the ground.

These waterers are filled, screwed together and then flipped. The water flows into the bowl at the bottom.

Chickens need calcium to form eggs with hard shells. They also need grit to help them break down and digest feed. A hopper containing these supplements needs to be available to chickens.

A brooder box is used when chicks are hatched without their mother.

The box is kept warm with an overhead light. Small feeders and waterers sit on a bed of litter or paper.

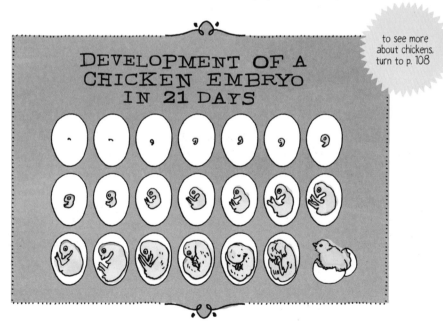

to see more about chickens, turn to p. 108

Portable Shade Structures

Cattle do well outside all year round. In extreme heat, portable structures might be assembled to give some shade to the animals if natural shade is lacking.

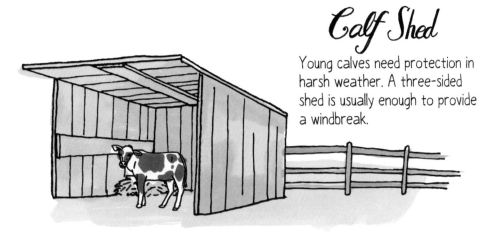

Calf Shed

Young calves need protection in harsh weather. A three-sided shed is usually enough to provide a windbreak.

Calf Creep Feeder

These special pens allow calves access to a special grain mix without letting cows get to it.

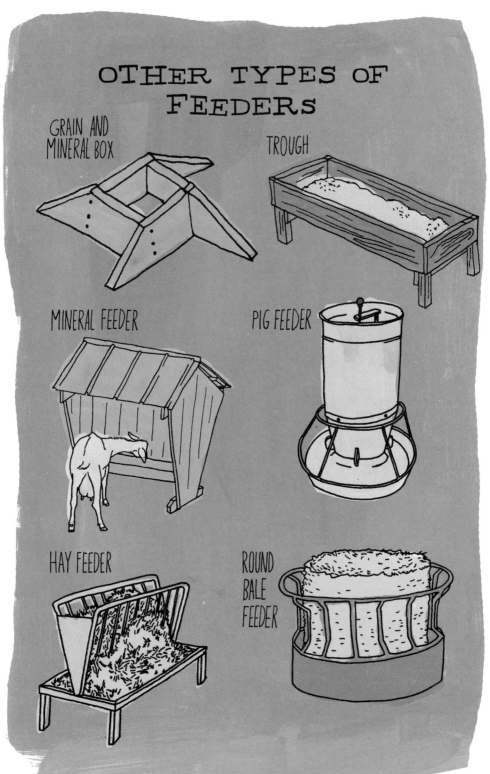

Goat House

Goats need protection from rain, wind, and snow. In a snug shed, they can keep warm in very cold weather, but when it's hot, they need plenty of ventilation and shade. Straw makes good bedding and a new layer should be added every few days. In the spring and fall, clean out the layers of old bedding and start fresh.

Proper fencing is important, as goats are great climbers and can wiggle through surprisingly small holes. Experienced goat keepers like to say that a fence that can't hold water won't hold a goat. An old cable spool or tractor tire makes a fun perch.

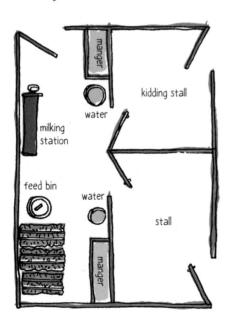

A goat house is usually divided into one main stall and a separate one used for kidding or to isolate a sick animal. Feed and supplies must be stored securely where curious goats can't reach them. Mangers and water buckets are often located on the other side of a wall that has cutouts for the goats to reach them without making a mess or wasting feed.

Sheep Shed

A three-sided shed with good ventilation works well to protect sheep from heat, rain, snow, and wind.

Lambing pens, or jugs, are sheltered areas that keep newborn lambs safe from being trampled or being exposed to cold, wet weather. They should be 4x6 feet, with walls low enough for the ewe to look over.

JUG

Horse Barn

The more light and ventilation in a horse barn, the better. Mold, mites, and dust can cause horses to develop respiratory ailments. There should be a window installed in each stall above the height of the horse. Using double Dutch doors allows the horses to look out. The tack room is where all the harnesses and saddles are stored, hanging on hooks.

HAY FEEDER

AUTOMATIC WATERER

Rabbit Hutch

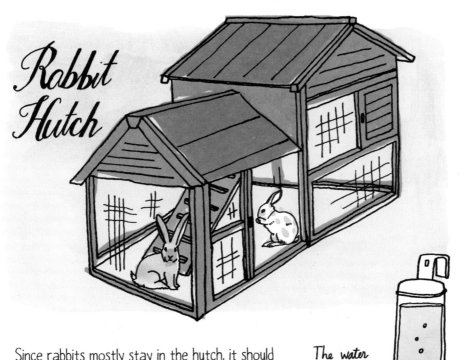

Since rabbits mostly stay in the hutch, it should have enough room for them to eat and move around. Rabbits can withstand subzero cold but they need to be protected from wind, rain, and snow. They also need shade in hot weather.

Most hutches are made from galvanized welded wire. The floor is wire as well so droppings can fall through to a tray that can be easily cleaned out.

The water bottle hooks onto the side of the cage.

CARRIER

The feeder has a screen to let small pieces and dust fall through.

Pasture Fencing

 BARBED WIRE FENCE

Space posts about 10 ft. apart. Dig or cement posts 3 ft. into the ground.

CORRAL FENCE

The most durable woods for fencing are juniper, split pitch pine, black locust, Osage orange, and Gambel oak.

NET WIRE FENCE

Stretch wire leaving a tiny bit of slack for contraction in cold weather.

ELECTRIC FENCE

Do not let fence wire touch anything metal or it will short out. Wet wood will also cause it to short.

Gates

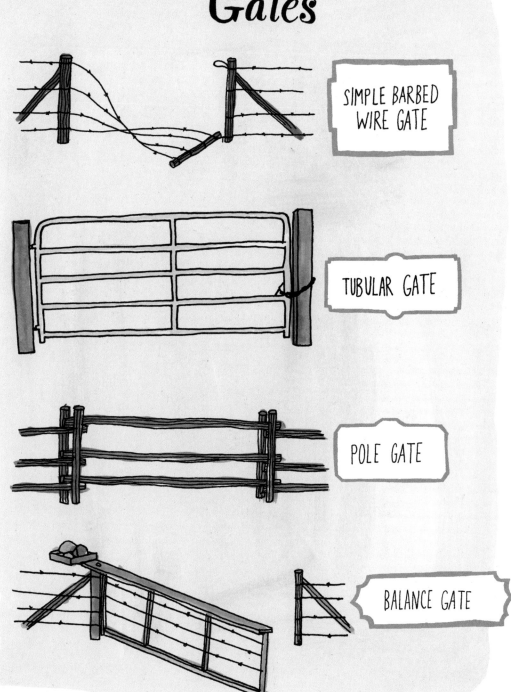

THE TRACTOR & ITS IMPLEMENTS

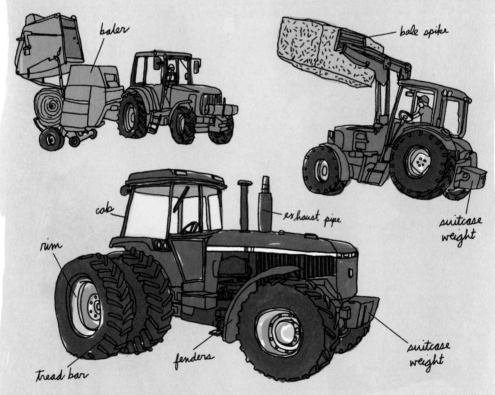

Using a wide range of attachments, the tractor can perform a huge assortment of tasks and is usually considered the most important piece of machinery on a farm.

Tractors through the Years

Waterloo Gasoline Traction Company built this tractor in 1914. John Deere bought out Waterloo in 1918 and used this popular two-cylinder format for many years.

1914
JOHN DEERE
Waterloo Boy

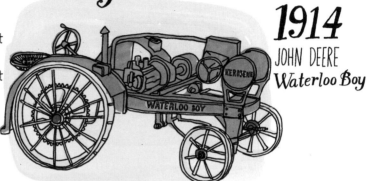

1948
FORD 8N

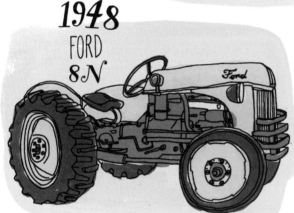

In 1945 Henry Ford's 28-year-old grandson, Henry II, took over the company, which was losing money. He created a new tractor with 20 improvements over the previous model. It was a huge success and over 100,000 were sold in the first year.

In the 1970s comfort became important. Companies made dust-free cabs with air-conditioning. In this model a filter cleaned the cab air when the doors were shut. A radio, cassette player, and fancier seats were other options.

1973
INTERNATIONAL 1486

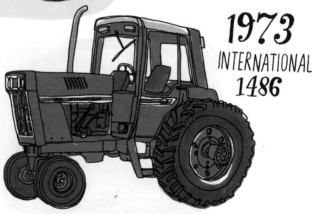

How to Plow a Field

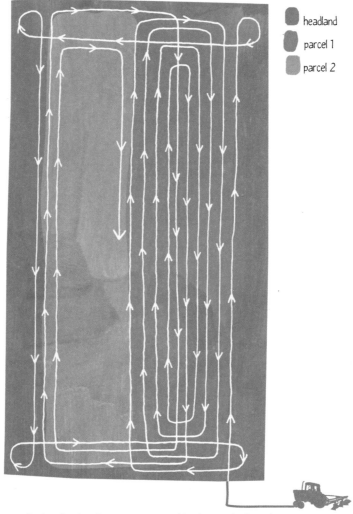

Starting in the headland, make a circuit around both parcels then plow up the middle of the field. Plow Parcel 1 in a circular pattern until there is a strip of unplowed land in the middle. Head to Parcel 2, making your first turn down the unplowed strip in Parcel 1. Finish plowing Parcel 2 in a circular pattern, then plow the rest of the headland.

Plow

The plow turns the top layer of soil, exposing the nutrients while covering over weeds and other vegetation.

to see the layers of soil, turn to p. 12

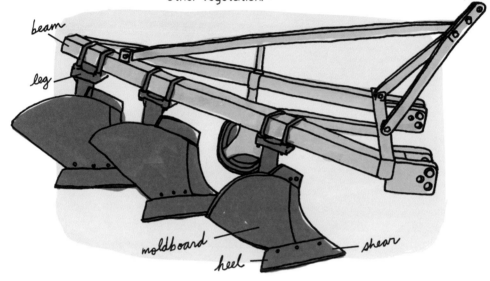

beam, leg, moldboard, heel, shear

OLD-FASHIONED HORSE-DRAWN PLOW

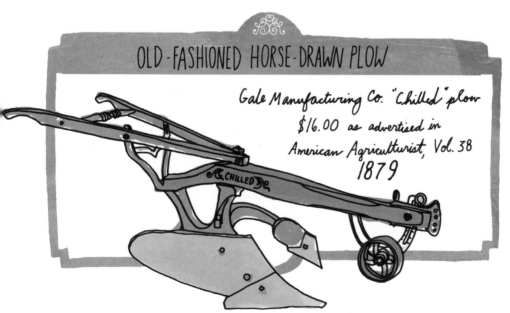

Gale Manufacturing Co. "Chilled" plow $16.00 as advertised in American Agriculturist, Vol. 38
1879

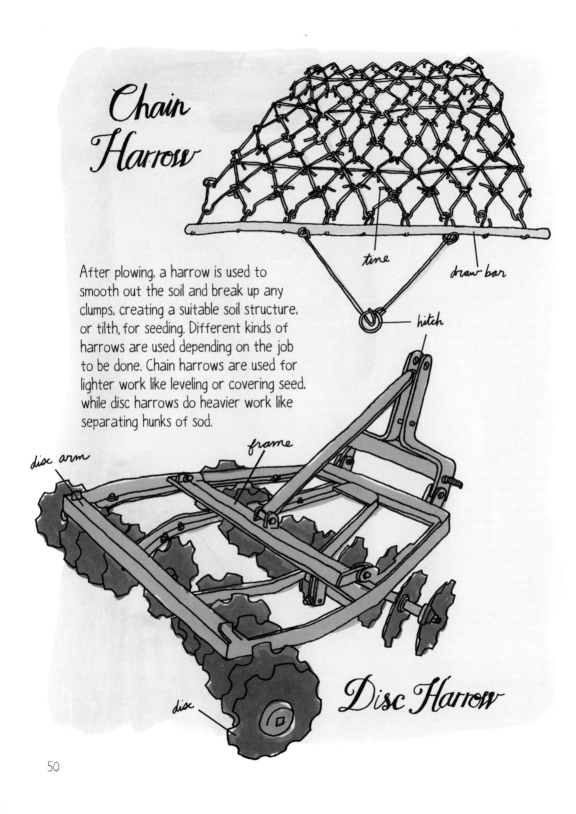

Chain Harrow

After plowing, a harrow is used to smooth out the soil and break up any clumps, creating a suitable soil structure, or tilth, for seeding. Different kinds of harrows are used depending on the job to be done. Chain harrows are used for lighter work like leveling or covering seed, while disc harrows do heavier work like separating hunks of sod.

Disc Harrow

Grain Drill

Grain drills evenly distribute seeds in close rows at specific depths. A hopper of seeds is connected to a series of tubes. The hopper releases the seeds in set amounts and they fall through the tubes. Each tube is arranged behind a blade called a coulter that cuts the soil right before the seeds fall into it.

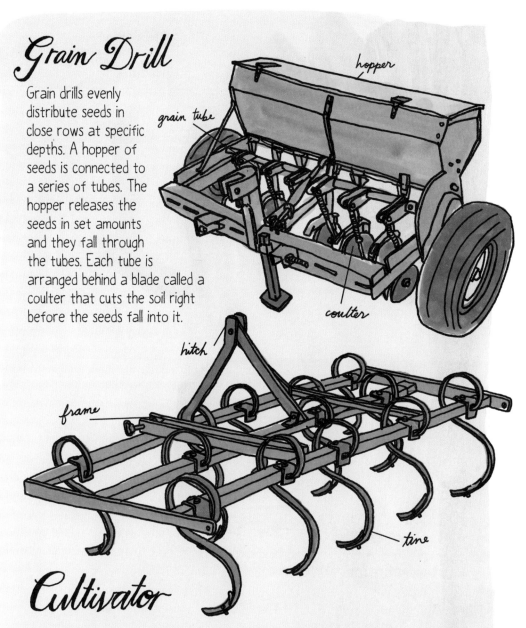

Cultivator

Cultivators can be used both before or after planting. A field cultivator stirs and aerates the soil to get it ready for seeds. A row cultivator weeds between crop rows. Depending on the type of crops that need weeding, there are a variety of cultivators with different-shape blades and arrangements available.

HARVESTING HAY

Hay is usually a mixture of grasses and legumes like alfalfa and clover.

TIMOTHY GRASS ORCHARD GRASS CLOVER ALFALFA

Sickle Mower

cutter bar

The first step in harvesting hay is mowing it and letting it dry. Next it gets raked into a long row called a windrow.

Hay Rake

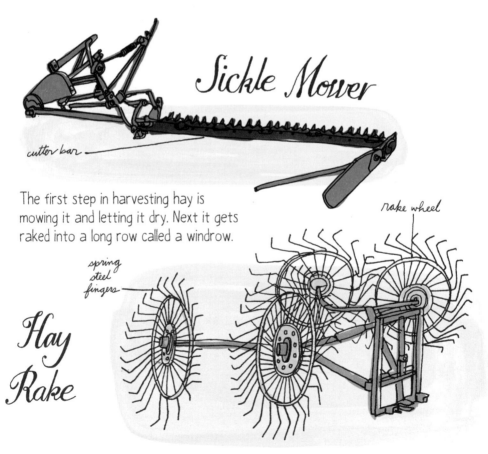

rake wheel

spring steel fingers

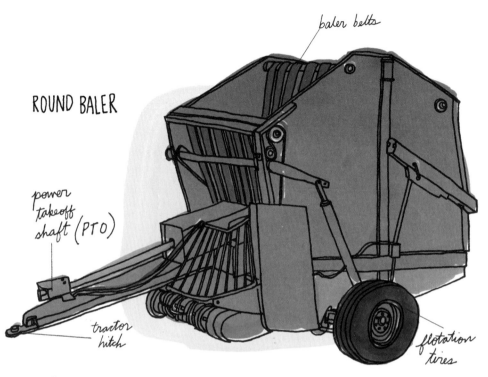

Hay Baler

Balers collect and compact hay into squares or rounds and bind them with twine or netting so they're easy to move, store, and distribute.

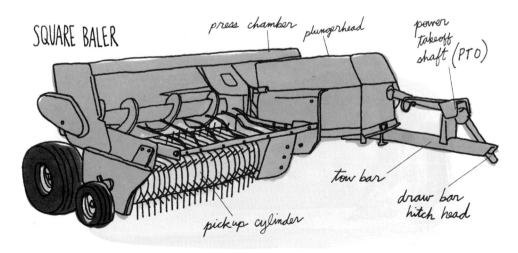

Square

Small square bales weigh 50-80 pounds. Large square bales can weigh anywhere from 750-2000 pounds. Moisture easily penetrates square bales so they need to be stored under cover. Because they stack easily and are lighter, they are more convenient to use for feeding and bedding.

Round

Round bales can weigh a ton or more. They are usually wrapped in plastic so they can be stored outside. Round bales spoil quickly after being opened, so they need to be eaten soon. For this reason they are more suitable for cows, as horses can't tolerate moldy hay.

vs.

Hay Fork

Hay forks attach to the front of a tractor and aid in the moving and stacking of bales.

Hay Elevator

Hay elevators are used to make high stacks of small square bales or for loading them into the hayloft.

Combine

Combines got their name because they combine several operations for harvesting crops into one process. They cut, reap, thresh, and winnow grains like wheat, oats, barley, and rye and crops like corn and soybeans. Finished grains are dumped into a cart pulled by a tractor traveling next to the combine.

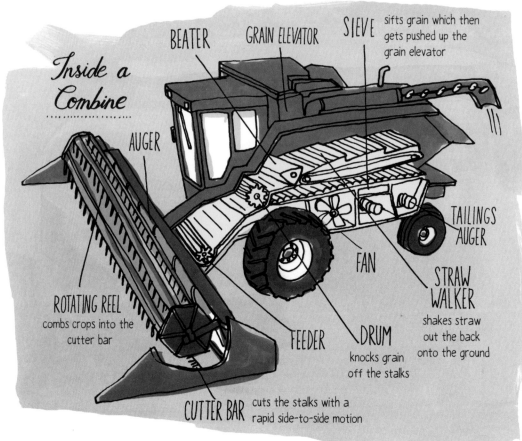

Inside a Combine

- **BEATER**
- **GRAIN ELEVATOR**
- **SIEVE** sifts grain which then gets pushed up the grain elevator
- **AUGER**
- **TAILINGS AUGER**
- **ROTATING REEL** combs crops into the cutter bar
- **FEEDER**
- **FAN**
- **DRUM** knocks grain off the stalks
- **STRAW WALKER** shakes straw out the back onto the ground
- **CUTTER BAR** cuts the stalks with a rapid side-to-side motion

Corn Picker

Corn pickers can either be attached to the front of the tractor, or be a pulled implement. As they move through the rows of corn, they remove the ears from the standing stalks.

to see the anatomy of a cornstalk, turn to p. 83

Gravity Wagon

These carts have angled sides, making it easier for grain or fertilizer to funnel out.

Grinder

Powered by the tractor, portable grinders allow farmers to store grains and process feed on the spot when they need it, instead of at a stationary mill.

Manure Spreader

Manure spreaders spray manure collected from livestock over a field.

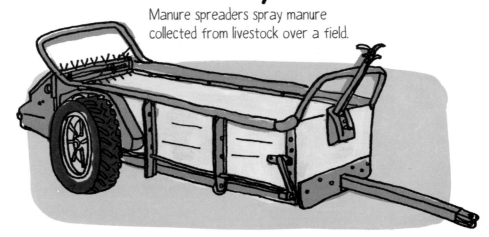

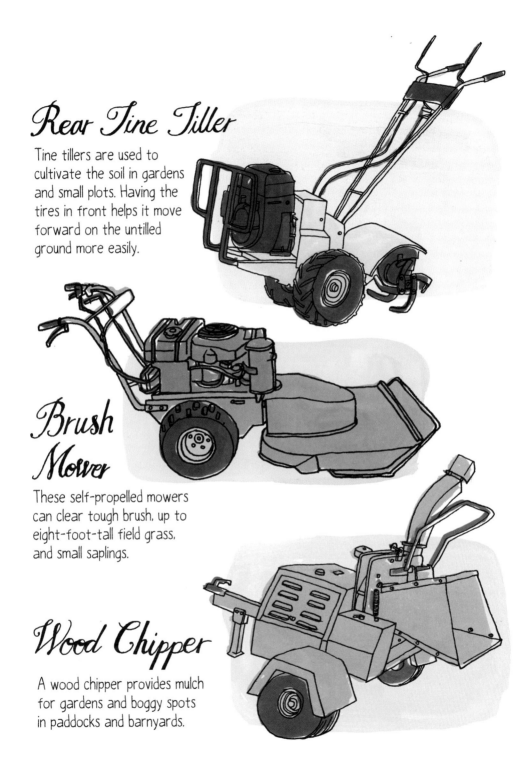

Rear Tine Tiller

Tine tillers are used to cultivate the soil in gardens and small plots. Having the tires in front helps it move forward on the untilled ground more easily.

Brush Mower

These self-propelled mowers can clear tough brush, up to eight-foot-tall field grass, and small saplings.

Wood Chipper

A wood chipper provides mulch for gardens and boggy spots in paddocks and barnyards.

Chainsaw

A chainsaw is a necessity if you want to harvest wood for lumber or burning.

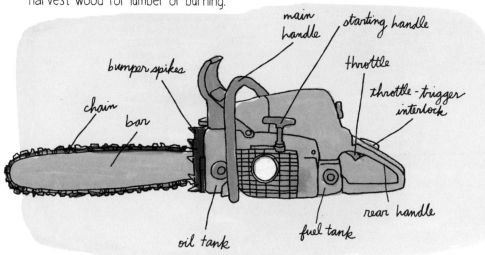

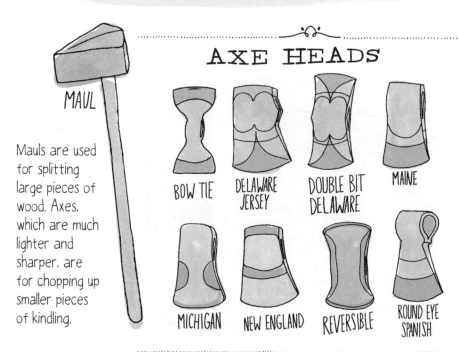

AXE HEADS

MAUL

Mauls are used for splitting large pieces of wood. Axes, which are much lighter and sharper, are for chopping up smaller pieces of kindling.

BOW TIE

DELAWARE JERSEY

DOUBLE BIT DELAWARE

MAINE

MICHIGAN

NEW ENGLAND

REVERSIBLE

ROUND EYE SPANISH

FELLING

Felling is the process of cutting down a tree. Here are the basic steps:

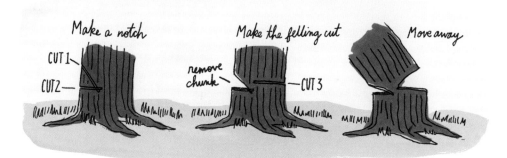

BUCKING

Once the tree falls, the limbs are cut off and the trunk is chopped up into stove-length pieces. This process is called bucking.

SPLITTING

After bucking, the wood pieces are split into smaller, more manageable chunks. This is done starting on the outside perimeter, moving around to each side, also known as peeling. The leftover middle is split in half.

STACKING

Before a pile is stacked, long pieces of wood, called stringers, are placed on the ground to protect the wood from getting wet. Next, pieces of wood are stacked in alternating directions to make a column. This is the cribbing, which provides a sturdy support for the pieces stacked parallel between the two ends.

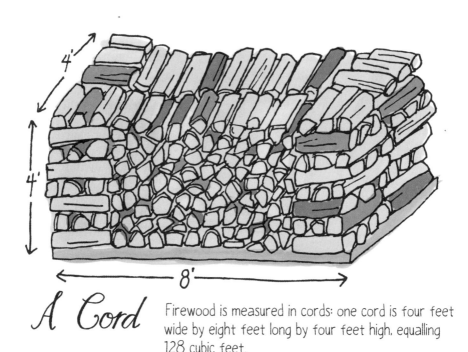

A Cord — Firewood is measured in cords: one cord is four feet wide by eight feet long by four feet high, equalling 128 cubic feet.

TREE IDENTIFICATION

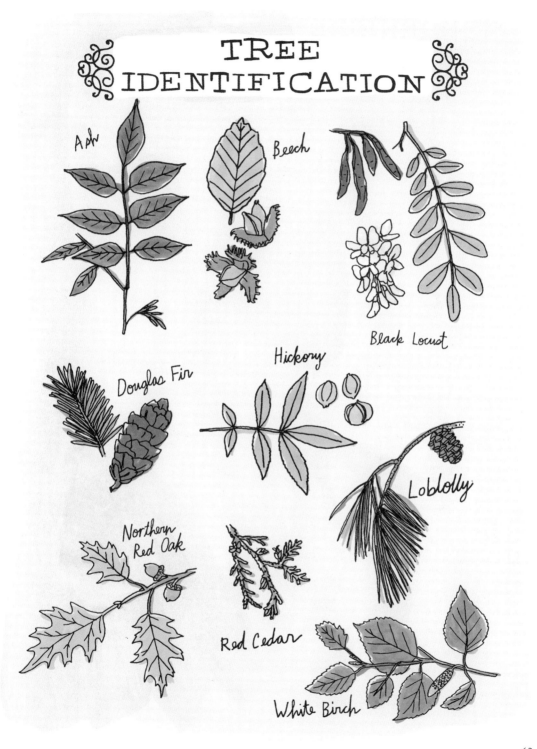

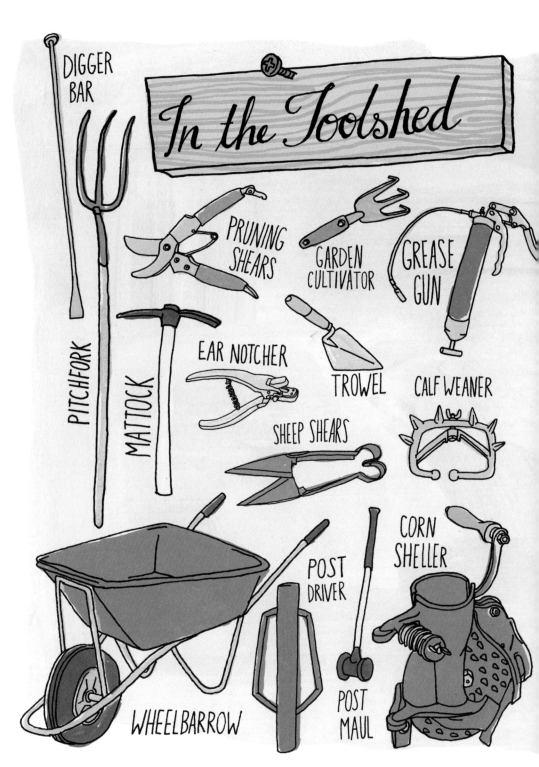

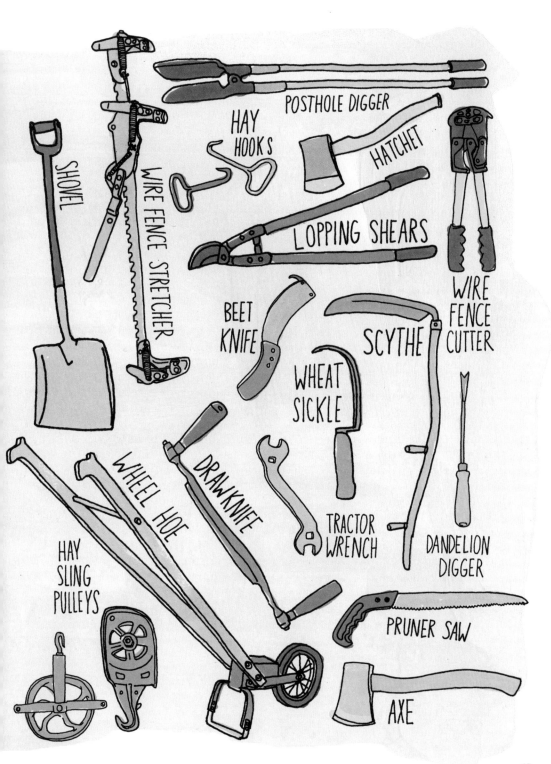

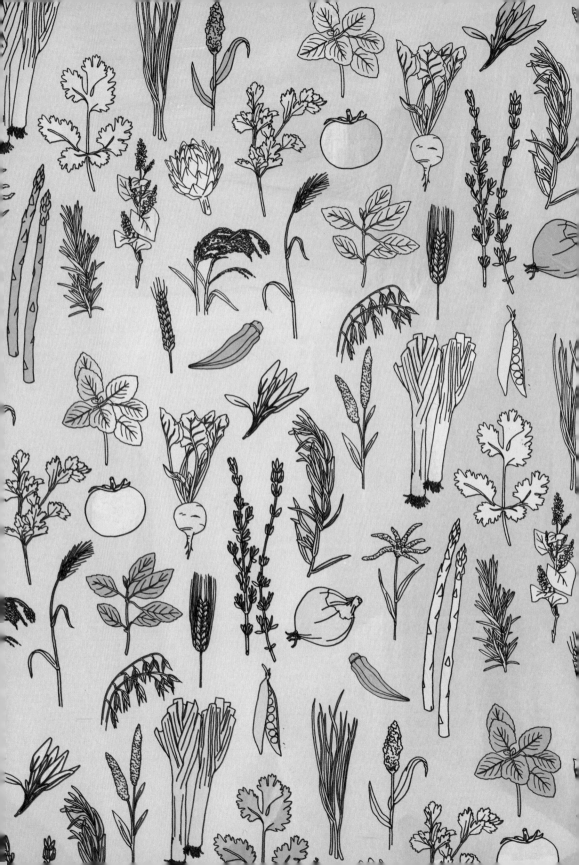

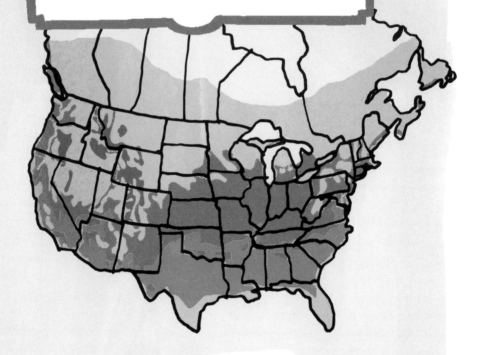

Chenopodiaceae / Beet Family

beets
(BETA VUGARIS)

- garden beets are a biennial; they grow best in cool climates in sandy loam
- both the leaves and the root are edible
- thinner taproots are more tender
- best root size is between 1-2" diameter
- sugar beets are raised for their sugar content. About a pound of sugar (identical to the chemical makeup of cane sugar) can be made from 8 pounds of sugar beets.

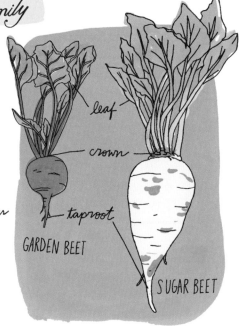

GARDEN BEET — leaf, crown, taproot
SUGAR BEET

spinach (SPINACIA OLERACEA)

- three varieties of spinach include Savoy, semi-Savoy, and flat-leaf.
- Savoy has wrinkled, curly, dark green leaves.
- semi-Savoy is a less curly leaf spinach that is easier to clean
- flat-leaf has smooth leaves. It's used for soup, baby food and canned and frozen spinach. The flavor is milder than Savoy.
- spinach is packed with antioxidants and rich with iron
- spinach is a hardy plant and can tolerate cold
- it is also fast-growing. From planting to harvesting, it takes 40-45 days.

SAVOY
FLAT LEAF

Volvovski Family Borscht

This is my best friend Jenny's family recipe, passed down for many generations. It's really delicious!

- 8 CUPS CHICKEN OR VEGETABLE BROTH
- 3 MEDIUM POTATOES
- 3-4 MEDIUM BEETS
- 2 SMALL CARROTS OR 1 BIG ONE
- 1/5 OF A SMALL CABBAGE
- 1 CUP DICED TOMATOES
- 1 ONION
- 3-4 CLOVES OF GARLIC
- A BIG BUNCH OF PARSLEY
- 3 BAY LEAVES
- SALT AND PEPPER
- 1 TABLESPOON LEMON JUICE
- SOUR CREAM

Chop up the onion and garlic. Peel and grate the beets and carrots. Peel and cube the potatoes. Finely chop the cabbage.

In a pan, sauté the onion (5 min.) and then the garlic (1 min.), then add the beets and the carrots and the diced tomatoes. Sauté for another 15-20 minutes (medium heat).

Pour the broth and bay leaves into a large pot, and bring to a boil.

Add the potatoes. When it boils again, throw in the cabbage. After five minutes, add the sautéed vegetables, **lower heat** and let simmer for five to ten minutes. Add chopped parsley, lemon juice, and salt and pepper to taste and simmer for another minute or two.

Serve with sour cream.

Compositae/Daisy Family

artichoke (CYNARA SCOLYMUS)

- globe artichokes are actually flower buds that are harvested before they flower.
- they can't tolerate cold weather.
- they are high in fiber and folic acid.

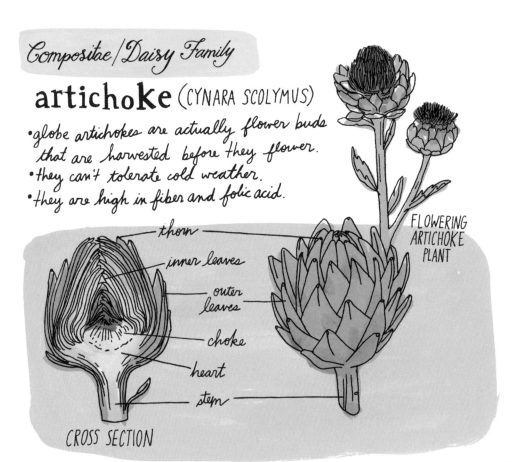

CROSS SECTION — thorn, inner leaves, outer leaves, choke, heart, stem

FLOWERING ARTICHOKE PLANT

lettuce
(LACTUCA SATIVA)

- lettuce starts as a rosette-shaped plant but eventually the stem will lengthen and flower. This is called bolting.
- lettuce is harvested before bolting. The leaves become very bitter after it begins bolting.

LETTUCE BOLTING

Brassicaceae / Cabbage Family

broccoli
(BRASSICA OLERACEA)

- broccoli is made of large flower heads that will blossom if the plant isn't harvested

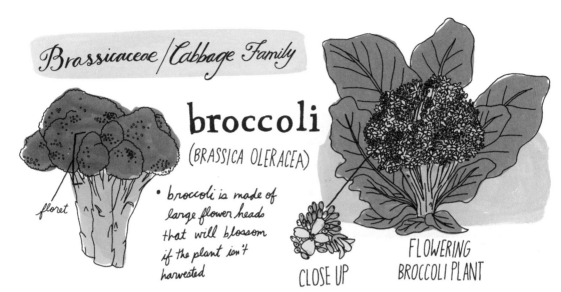

floret

CLOSE UP

FLOWERING BROCCOLI PLANT

cabbage
(BRASSICA OLERACEA)

- easy to grow in a home garden
- cabbage can bolt or split if the weather gets too warm

Brussels sprouts
(BRASSICA OLERACEA)

- Brussels sprouts resemble miniature cabbages that grow on a stalk
- the sprouts are harvested when they grow to 1"-2" in diameter, before they yellow

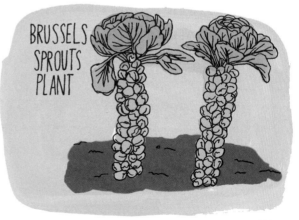

BRUSSELS SPROUTS PLANT

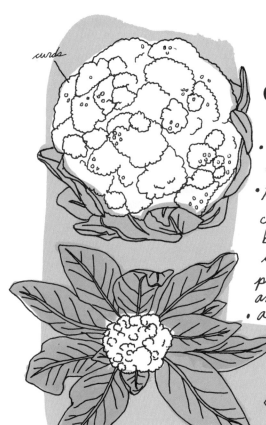

cauliflower
(BRASSICA OLERACEA)

- cauliflower heads can be white, green, or purple.
- to keep the heritage varieties creamy white, you need to blanch the heads. When it is a few inches in diameter, pull the leaves over the head and tie at the top
- a mature head is 6-8" diameter

BLANCHING CAULIFLOWER

radish
(RAPHANUS SATIVUS)

- fast growing
- some radishes are grown for their seeds, which contain oil

rutabaga
(RHEUM × CULTORUM)

- also called yellow turnip
- originated as a cross between a turnip and a cabbage.

Cucurbitaceae / Gourd Family

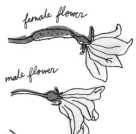

female flower

male flower

cucumber (CUCUMIS SATIVUS)

- cucumbers grow on a vine that can be trained onto a support to grow vertically.
- some varieties of cucumbers are self-pollinating

Freezer Dills

- 6 cups thinly sliced cucumbers
- 1 large onion, sliced thinly
- 2 tablespoons pickling salt
- 1 cup sugar
- 1 cup white vinegar
- 2 cloves of garlic, minced
- 3 tablespoons dill seed
- ½ teaspoon crushed red pepper

1. In a large bowl, combine cucumbers and onion. Sprinkle 2 tablespoons of the salt over the vegtables; let stand for 2 hours. Rinse under cold running water; drain well.

2. In a large glass bowl, combine the sugar, vinegar, garlic, dill seed, and red pepper. Stir well to dissolve the sugar. Add drained cucumbers and onion. Mix well.

3. Pack into freezer bags or containers and freeze. Defrost in the refrigerator for 8 hours before serving.

squash (GENUS CUCURBITA)

*squash types are divided into summer squash (harvested as immature fruit) and winter squash (harvested when mature).

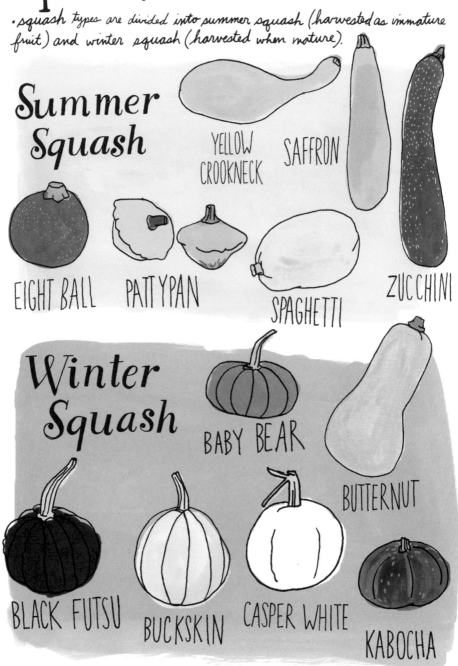

Summer Squash
- YELLOW CROOKNECK
- SAFFRON
- EIGHT BALL
- PATTYPAN
- SPAGHETTI
- ZUCCHINI

Winter Squash
- BABY BEAR
- BUTTERNUT
- BLACK FUTSU
- BUCKSKIN
- CASPER WHITE
- KABOCHA

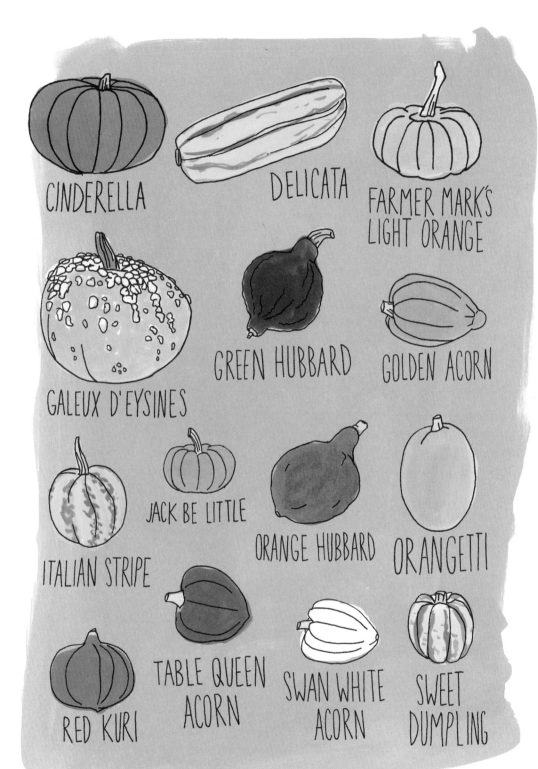

Fabaceae / Pea Family

beans (PHASEOLUS VULGARIS)

- Snap beans are grown for the young green pods
- dried beans are a good source of protein
- sometimes beans are grown solely to enrich the soil with nitrogen.

HOW A BEAN PLANT GROWS

peas
(PISUM SATIVUM)

- an annual plant
- any mature peas can be harvested and used as split peas
- some varieties are eaten whole: snow, sugar/snap

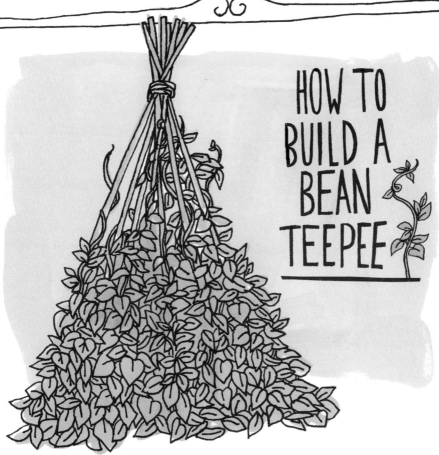

HOW TO BUILD A BEAN TEEPEE

1. Find a sunny place in your garden. Dig the soil over in a circular shape about four feet in diameter.

2. Push eight poles into the ground at least six inches deep around the outside of the circle. Leave space to enter.

3. Tie the poles together at the top tightly with string or twine.

4. Plant two runner beans or pole beans per pole, about two inches deep on inside of circle.

5. Water thoroughly. Beans should appear in one to two weeks. Once plants have grown a few inches, weave gently around the poles. Plants will reach the top in seven to eight weeks.

Dry Bean Varieties

When pods are fully matured and completely dry you can harvest dry beans. Thresh the pods and collect and store the beans in airtight jars.

Andrew Kent

Black Coco

Calypso

Etna

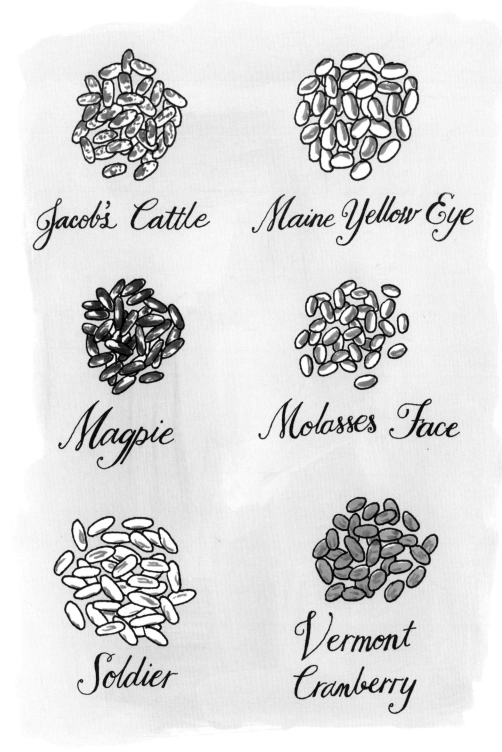

Alliaceae / Onion Family

onion
(ALLIUM CEPA)

- bulbing is triggered by day length. "Long day" varieties need more daylight hours in order for bulbs to form.

leek
(ALLIUM AMPELOPRASUM PORRUM)

- similar to an onion but has a stalk rather than a bulb.

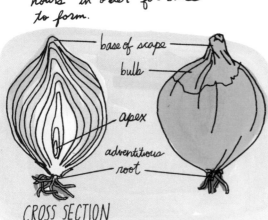

CROSS SECTION

Asparagaceae

asparagus
(ASPARAGUS OFFICINALIS)

- best grown from crowns. Crowns are planted in trenches that get filled as the spears grow.

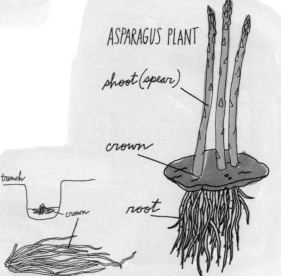

ASPARAGUS PLANT

Poaceae / Grass Family

corn

- each stalk can produce as many as 4 ears of corn
- seeds are planted in blocks to ensure pollination
- uses lots of nitrogen

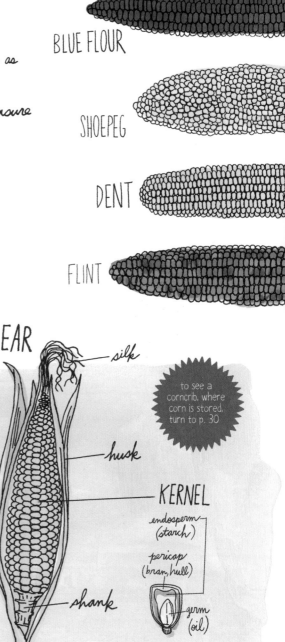

SWEET

BLUE FLOUR

SHOEPEG

DENT

FLINT

CORN PLANT
- tassel
- leaf
- node
- stalk
- brace roots
- roots

EAR
- silk
- husk
- shank

KERNEL
- endosperm (starch)
- pericap (bran, hull)
- germ (oil)

to see a corncrib, where corn is stored, turn to p. 30

83

Solanaceae/Nightshade Family

eggplant
(SOLANUM MELONGENA)

- plant has large leaves and star-shaped lavender flowers
- very sensitive to cold. It needs temperatures 70°F or above to grow.

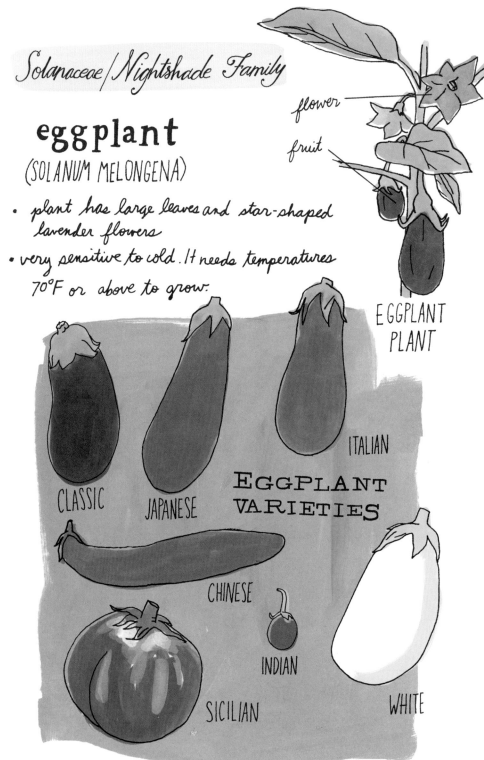

pepper
(CAPSICUM ANNUUM)

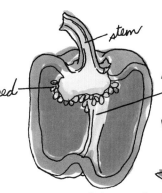

CROSS SECTION (stem, seed, membrane)

PEPPER PLANT

- cut off peppers instead of pulling off to avoid damaging the plant
- be careful when picking hot peppers, as the juice can burn your fingers.
- red peppers are green peppers that stay on the plant long enough to ripen fully

SWEET PEPPER VARIETIES

ACE

ISLANDER

POBLANO

HUNGARIAN SWEET BANANA

PURPLE BEAUTY

SWEET CHERRY

VALENCIA

The heat in peppers is measured in Scoville units. The higher the Scoville units, the spicier the pepper and the more capsaicin it contains. Capsaicin is the heat-producing compound in chili peppers.

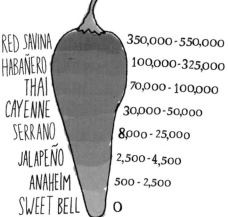

RED SAVINA	350,000 - 550,000
HABAÑERO	100,000 - 325,000
THAI	70,000 - 100,000
CAYENNE	30,000 - 50,000
SERRANO	8,000 - 25,000
JALAPEÑO	2,500 - 4,500
ANAHEIM	500 - 2,500
SWEET BELL	0

potato
(SOLANUM TUBEROSUM)

- potatoes can be grown from whole potatoes or pieces that contain an eye.
- the potato plant produces tubers underground and flowers at the top.
- dig for potatoes once the plant blooms

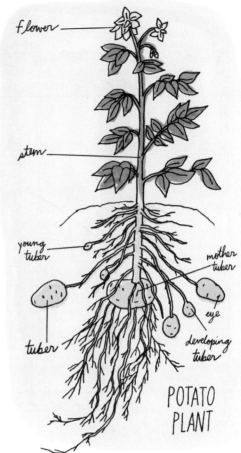

POTATO PLANT

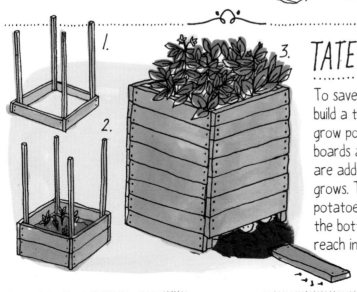

TATER TOWER

To save space you can build a tater tower to grow potatoes. The side boards and soil or straw are added as the plant grows. To harvest the potatoes, just unscrew the bottom boards and reach inside.

tomato
(LYCOPERSICON ESCULENTUM)

- the two main groups of tomatoes are determinate and indeterminate.
- Determinate are bush tomatoes that stop growing when the top bud fruits. All of the tomatoes on a determinate plant ripen at the same time. They don't need to be staked or pruned.
- Indeterminate varieties are vine tomatoes. They will keep growing until killed by frost. They require support like cages and stakes.

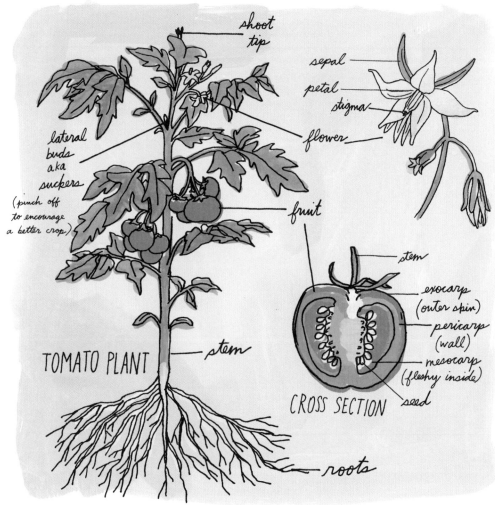

4 Ways to Grow Tomatoes

STAKE

Place the stake before putting the plant in. Tie the plant to the stake loosely.

UPSIDE DOWN

Slip plant through the hole in the bottom of a pot. Turn upside down and fill with soil. Hang on a sunny porch.

CAGE

Place cage over plant. No need to tie or prune. Wrap plastic around the cage to protect young plants in cold weather.

TRELLIS

Build structure shown below and stretch heavy twine between the top and bottom braces. Set plants about 12 inches apart. Wrap stems around twine as they grow. Use a different cord for each stem.

How to Can Tomatoes

1. Wash tomatoes for 30 seconds in boiling water.

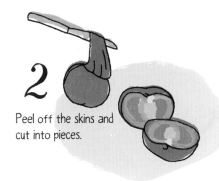

2. Peel off the skins and cut into pieces.

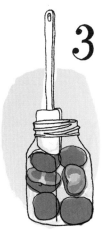

3. Pack the tomatoes tightly into a sterilized jar. Use a rubber spatula to push around the tomatoes and release any air bubbles. Leave 1/2 inch of headspace.

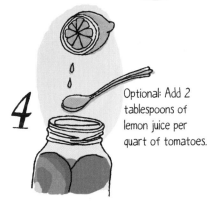

4. Optional: Add 2 tablespoons of lemon juice per quart of tomatoes.

5. Wipe the jar lip and put on the lids. Screw on the band.

6. Put jars in bath canner, cover with 1-2 inches of water and put on lid. When it starts to boil start timing. Process for 85 minutes.

Umbelliferae / Carrot Family

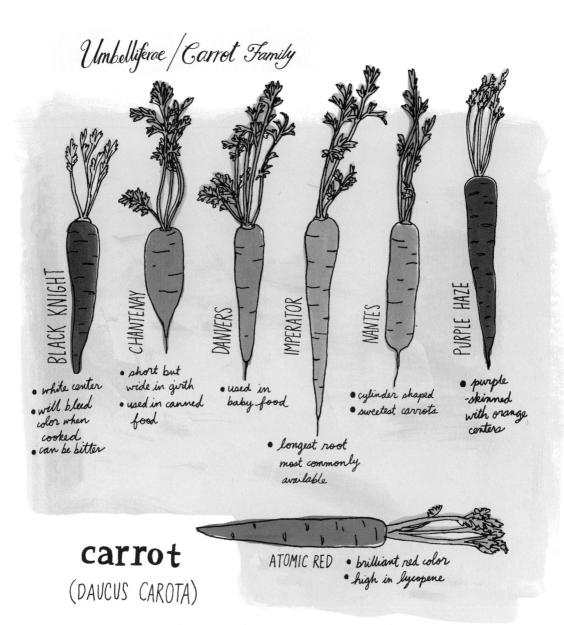

BLACK KNIGHT
- white center
- will bleed color when cooked
- can be bitter

CHANTENAY
- short but wide in girth
- used in canned food

DANVERS
- used in baby food

IMPERATOR
- longest root most commonly available

NANTES
- cylinder shaped
- sweetest carrots

PURPLE HAZE
- purple-skinned with orange centers

ATOMIC RED
- brilliant red color
- high in lycopene

carrot
(DAUCUS CAROTA)

- Carrots are bright orange because of the beta-carotene they contain.
- Eating too many carrots can actually turn your skin orange. The condition is called carotenemia and most often occurs in children and vegetarians.

Carrot Cake

- 2 cups sifted unbleached all-purpose flour
- 2 teaspoons baking powder
- 1½ teaspoons baking soda
- 1½ teaspoons ground cinnamon
- 1 teaspoon salt
- ¼ teaspoon ground allspice
- ¼ teaspoon freshly grated nutmeg
- 1 cup vegetable oil
- 1 cup granulated sugar
- ¾ cup firmly packed light brown sugar
- 4 large eggs
- 1 tablespoon finely grated orange zest
- 1 teaspoon vanilla extract
- 3 cups lightly packed, finely shredded carrots
- 8 ounces crushed pineapple, drained
- 1 cup toasted chopped walnuts
- Cream cheese frosting
- Toasted coconut, to garnish (optional)

1. Preheat the oven to 350°F. Thoroughly grease and flour a 9- by 13-inch baking pan.
2. Sift flour, baking powder, baking soda, cinnamon, salt, allspice, and nutmeg into a medium bowl.
3. Beat the oil, granulated sugar, and brown sugar in a large bowl until thoroughly combined. Add the eggs, one at a time, beating well after each addition. Add the mixture, mixing just until batter is smooth and blended. Fold in the carrots, pineapple, and walnuts. Spoon the batter into the prepared pan.
4. Bake for 35 minutes, until a tester inserted into the center of the cake comes out clean.
5. Cool the cake on a wire rack.
6. Frost with cream cheese frosting when completely cool. Sprinkle with the toasted coconut if desired.

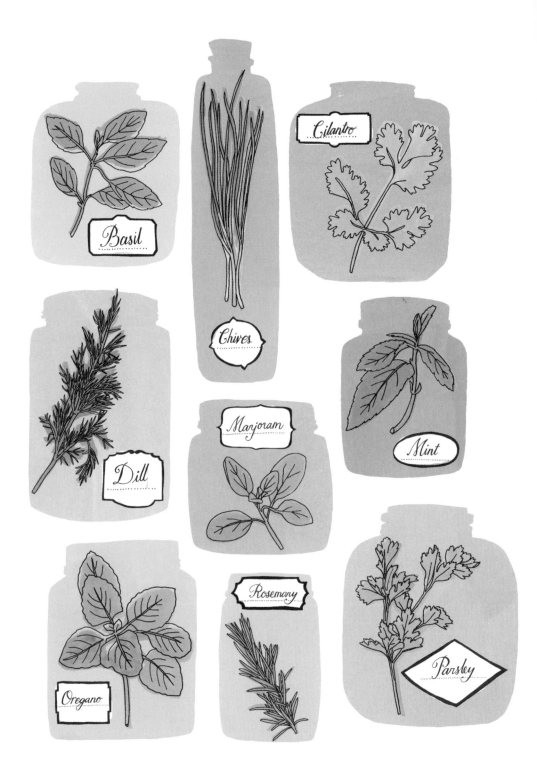

Herb Bread Blend

4 TABLESPOONS DRIED ROSEMARY
4 TABLESPOONS DRIED SAGE
4 TEASPOONS DRIED CHIVES
4 TEASPOONS DRIED ITALIAN PARSLEY

1. Combine all ingredients and mix well. Store in an airtight container away from heat and light.

2. For herb bread, add 3½ tablespoons of blend to a standard bread recipe. Add to soda bread, bread stuffings, scones, biscuits, cheese twists, and focaccia.

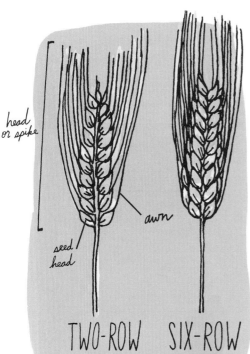

Barley

- barley can be bearded, have bristles or be beardless
- does best in cool climates
- sow in blocks to choke out weeds
- harvest when seeds are dry and golden

Six row has more protein in the grain, making it more nutritious

Buckwheat

- grows quickly
- grains contain high-quality protein
- tolerates poor soil
- harvest when 75% of seeds are ripe

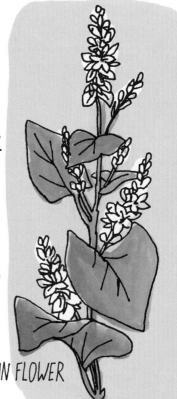

BUCKWHEAT IN FLOWER

Buckwheat Pancakes

2 TEASPOONS ACTIVE DRY YEAST
2 CUPS MILK, SCALDED AND COOLED TO LUKEWARM
2 CUPS BUCKWHEAT FLOUR
½ TEASPOON SALT
2 TABLESPOONS MOLASSES
½ TEASPOON BAKING SODA, DISSOLVED IN
¼ CUP LUKEWARM WATER
1 EGG
¼ CUP VEGETABLE OIL

1. In a mixing bowl, combine yeast and milk, stirring to dissolve. Stir in flour and salt until mixture is smooth. Cover with a cloth and let stand at room temperature overnight.

2. Before cooking, stir in molasses, soda, egg, and oil. Grease a skillet lightly and spoon on batter. Cook until bubbles begin to form around edges, 2 to 3 minutes. Turn pancakes over and continue cooking until browned.

Millet

- thrives in poor soil where other grains can't grow
- attracts birds like doves, quail, and songbirds

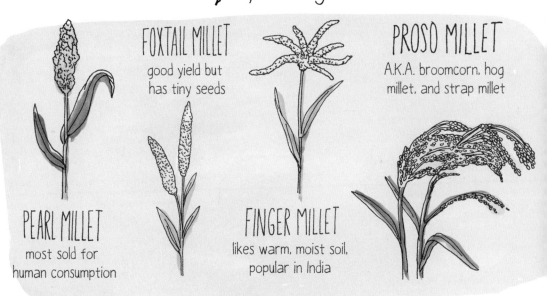

FOXTAIL MILLET — good yield but has tiny seeds

PROSO MILLET — A.K.A. broomcorn, hog millet, and strap millet

PEARL MILLET — most sold for human consumption

FINGER MILLET — likes warm, moist soil, popular in India

Oats

WHOLE OATS — entire grain and hull

OAT GROATS — whole oats without hulls

STEEL-CUT OATS — chopped groats

ROLLED OATS — steamed and rolled groats

- if soil is too fertile, plant can fall over
- harvest when grain is cream-colored

Oatmeal Crisps

- 2 CUPS SHORTENING
- 2 CUPS FIRMLY PACKED BROWN SUGAR
- 2 CUPS GRANULATED SUGAR
- 4 EGGS
- 2 TEASPOONS VANILLA EXTRACT
- 2 TEASPOONS BAKING SODA
- 1 TEASPOON SALT
- 6 CUPS OLD-FASHIONED OATS
- 3 CUPS ALL-PURPOSE FLOUR
- 1 CUP CHOPPED NUTS
- 6 OUNCES (1 CUP) CHOCOLATE MORSELS (OPTIONAL)

1. Mix together all of the ingredients. Put several large spoonfuls of dough onto a sheet of waxed paper. Chill at least overnight.

2. Preheat oven to 350°F. Bake the dough on ungreased baking sheets for about 7 minutes, or until edges just begin to lightly brown. The dough keeps for weeks rolled up in the refrigerator, and it is easy to slice and bake at any time.

Yield: 6 dozen

Rye

- rye berries are rich in fiber throughout endosperm
- be careful of ergot, a disease caused by fungus. It is poisonous to humans and animals

RYE WITH ERGO

Wheat

- likes full sun and well-drained soil
- harvest when stalks turn from green to browns, yellows, and golds

PARTS OF A WHEAT BERRY

- ENDOSPERM — starch
- BRAN — multi layered outer skin, rich in nutrients
- GERM — embryo, rich in vitamins

TYPES:
- DURUM — used for semolina flour for pasta
- HARD RED SPRING — used to make bread, bread flour
- HARD RED WINTER — used for all-purpose flours and to increase protein in pastry flour
- SOFT RED WINTER — used for cakes, pie crusts, biscuits, and muffins
- HARD WHITE — used for bread and brewing
- SOFT WHITE — used for pastry flour and pie crusts

Whole-Wheat Granola Coffee Cake

½ CUP UNBLEACHED ALL-PURPOSE WHITE FLOUR
1 TEASPOON BAKING SODA
½ TEASPOON SALT
1¼ CUPS OF WHOLE-WHEAT FLOUR, PREFERABLY STONE-GROUND
1 EGG
1 CUP BUTTERMILK OR SOUR MILK
¼ CUP UNSALTED BUTTER, MELTED
½ CUP MAPLE SYRUP

FOR THE TOPPING:
¼ CUP WHOLE-WHEAT FLOUR
¼ CUP FIRMLY PACKED BROWN SUGAR
¾ CUP GRANOLA (PREFERABLY HOMEMADE)
½ CUP CHOPPED PECANS OR WALNUTS
1 TEASPOON CINNAMON
4 TABLESPOONS (½ STICK) UNSALTED BUTTER, MELTED

1. Preheat oven to 375°F. Sift together the white flour, baking soda, and salt. Mix in the whole-wheat flour with a fork. In a large bowl, beat the egg until very light; add the buttermilk, butter, and maple syrup and beat well to blend. Add the flour mixture and fold in gently until just combined. Spread batter smoothly in a buttered 8-inch square pan or its equivalent.

2. To make the topping, toss the flour, sugar, granola, pecans, and cinnamon with a fork. Drizzle the butter over the mixture and toss again. Sprinkle over the batter.

3. Bake the coffee cake about 25 minutes, or until a toothpick inserted into the cake comes out clean. Serve warm from the pan with unsalted butter. To reheat, cover with foil.

Yield: 9 servings

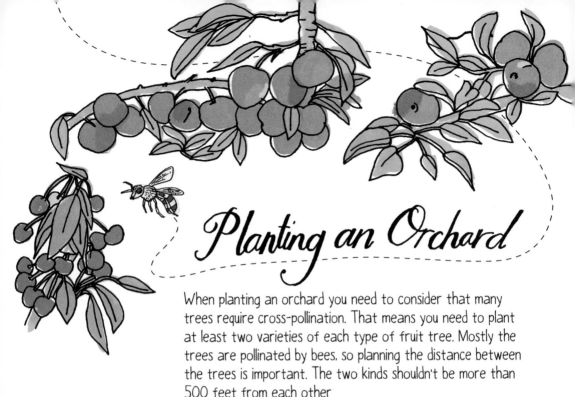

Planting an Orchard

When planting an orchard you need to consider that many trees require cross-pollination. That means you need to plant at least two varieties of each type of fruit tree. Mostly the trees are pollinated by bees, so planning the distance between the trees is important. The two kinds shouldn't be more than 500 feet from each other

CROSS-POLLINATION

In large orchards pollinizer trees are scattered among the others.

Dwarf fruit trees produce fruit the same size and flavor as standard trees, but are easier to maintain and harvest.

POPULAR APPLE VARIETIES

AUTUMN GOLD

BALDWIN

BLACK TWIG

BRAEBURN

CORTLAND

EMPIRE

FUJI

GALA

GRANNY SMITH

GOLDRUSH

HARALSON

HONEYCRISP

MACOUN

PINK LADY

RED DELICIOUS

RHODE ISLAND GREENING

KEEP THESE BUGS OUT OF YOUR GARDEN!

CABBAGE LOOPER
- consumes leaves
- mostly affects cabbage family crops

FLEA BEETLE
- attacks all kinds of plants
- different species affect different plant groups

WHITEFLIES
- suck sap from cucumber, potato, and tomato plants

ASPARAGUS BEETLE
- feeds on tips and spears of asparagus

COLORADO POTATO BEETLE
- larvae eat potato leaves
- also could affect eggplant, pepper, and tomato

CORN BORER
- damages corn ears and stalks by chewing tunnels

MEXICAN BEAN BEETLE
- feeds on beans and other legumes

SQUASH BUG
- sucks out juices of plants: cucumber, melon, pumpkin, and squash

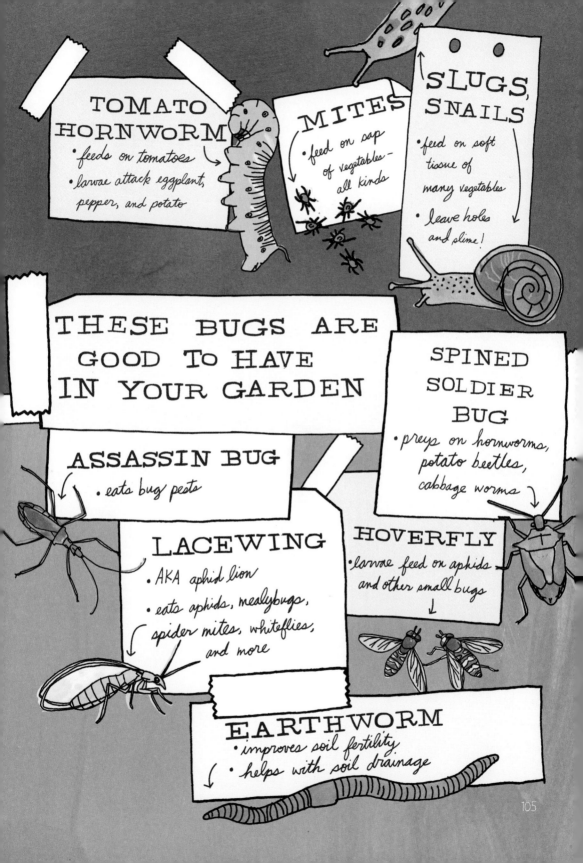

CHICKEN TERMS

bantam a miniature chicken
boiler a chicken 6 to 9 months old
broiler a 2- or 3-pound young chicken
chick a baby chicken
clutch batch of eggs that hatch together
cockerel a rooster under a year old
flock group of chickens
hen a female chicken
nest egg a fake egg put in the nest to encourage laying
pullet a female chicken under 1 year old
roaster a chicken weighing 4 to 6 pounds
rooster a male chicken

PARTS OF A ROOSTER

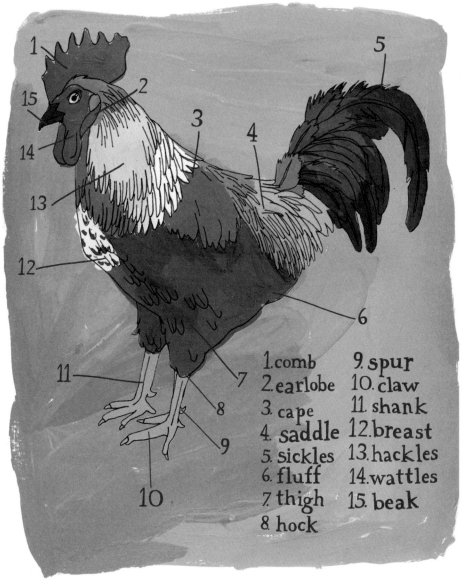

1. comb
2. earlobe
3. cape
4. saddle
5. sickles
6. fluff
7. thigh
8. hock
9. spur
10. claw
11. shank
12. breast
13. hackles
14. wattles
15. beak

COMB STYLES

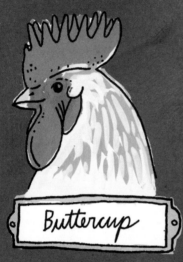
Buttercup

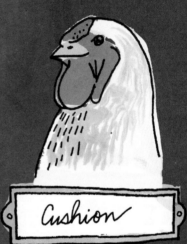
Cushion

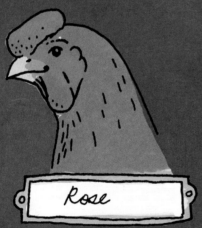
Rose

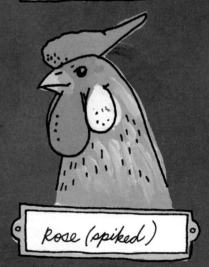
Rose (spiked)

EGG BREEDS

Ancona
- lays large white eggs

Cock 6 lb.
Hen 4.5 lb.

Leghorn
- lays large white eggs
- one of the most popular breeds

Cock 6 lb.
Hen 4.5 lb

Minorca
- lays extra-large chalky white eggs
- prone to frostbite

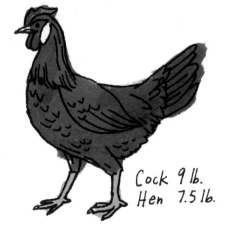

Cock 9 lb.
Hen 7.5 lb.

MEAT BREEDS

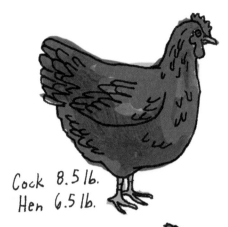

Cock 8.5 lb.
Hen 6.5 lb.

Australorp
- Australia's national breed

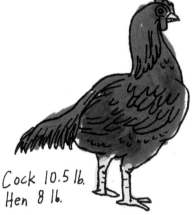

Cock 10.5 lb.
Hen 8 lb.

Cornish
- developed in Cornwall, England

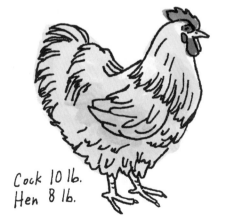

Cock 10 lb.
Hen 8 lb.

Orpington
- great disposition

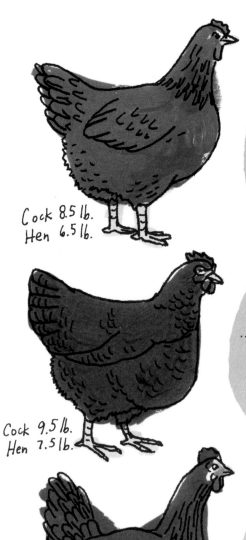

DUAL BREEDS
(MEAT + EGGS)

New Hampshire
- great for meat production

Cock 8.5 lb.
Hen 6.5 lb.

Plymouth Rock
- docile disposition
- one of the most popular breeds

Cock 9.5 lb.
Hen 7.5 lb.

Rhode Island Red
- lays large brown eggs
- state bird of Rhode Island

Cock 8.5 lb.
Hen 6.5 lb.

ANATOMY OF AN EGG

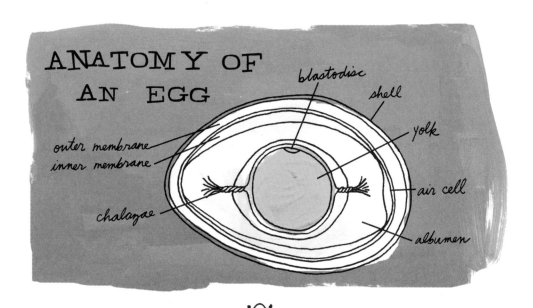

Predators

To figure out the predator attacking your chickens, look for footprints around the area.

BOBCAT

COYOTE

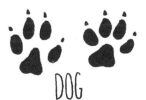
DOG

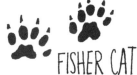
FISHER CAT

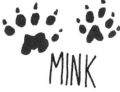
MINK

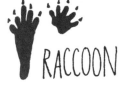
RACCOON

RED FOX

WEASEL

WOLF

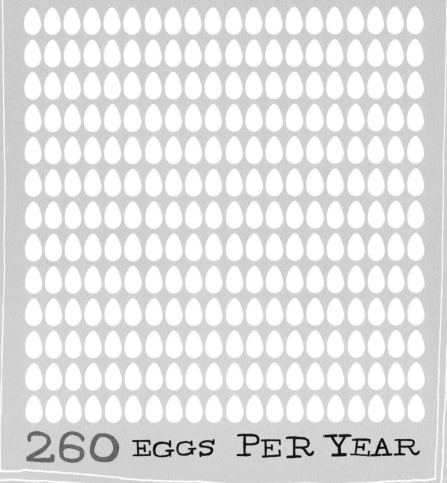

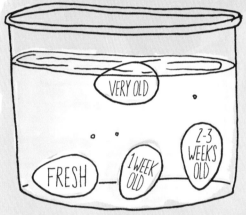

FIND OUT HOW OLD AN EGG IS BY PLACING IT IN WATER. BECAUSE OLDER EGGS HAVE BIGGER AIR CELLS, THEY WILL FLOAT.

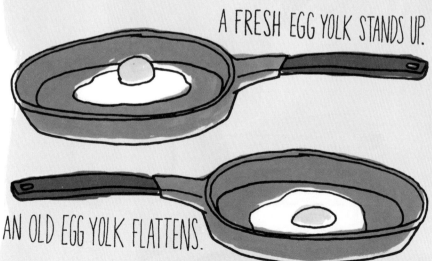

A FRESH EGG YOLK STANDS UP.

AN OLD EGG YOLK FLATTENS.

OTHER POULTRY

DUCKS

Call
- high-pitched quack
- docile and friendly
- comes in gray, white and other colors
- delicate hatchlings

Mallard
- small domestic duck
- seasonal layer

Mandarin
- hens and drakes share parenting duties
- often a symbol of loving couples in Chinese culture

Runner
- upright stance
- weighs about 4 lbs.
- lays 140-180 eggs a year

GEESE

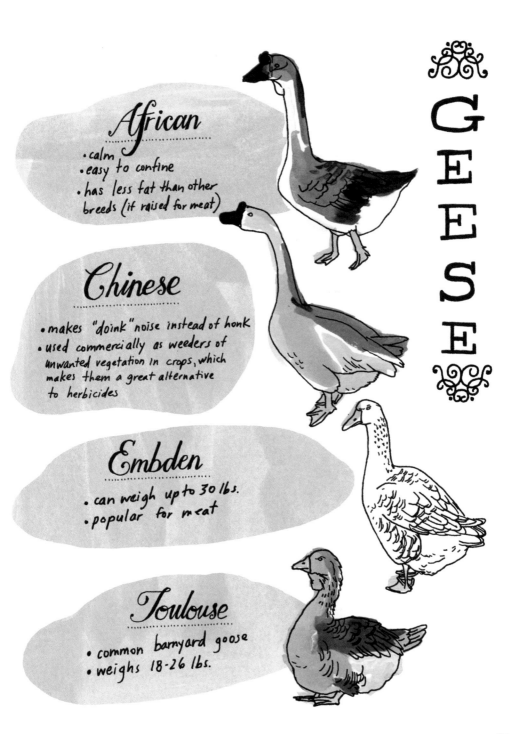

African
- calm
- easy to confine
- has less fat than other breeds (if raised for meat)

Chinese
- makes "doink" noise instead of honk
- used commercially as weeders of unwanted vegetation in crops, which makes them a great alternative to herbicides

Embden
- can weigh up to 30 lbs.
- popular for meat

Toulouse
- common barnyard goose
- weighs 18-26 lbs.

HERITAGE TURKEY BREEDS

HERITAGE: Most commercially produced turkeys are Broad-Breasted Whites, a breed that was developed to quickly convert feed into body weight, especially breast meat. These birds cannot mate normally and artificial insemination must be used to produce fertile eggs. According to the American Livestock Breeds Conservancy, a heritage breed is defined by its ability to reproduce naturally, grow to maturity slowly, survive outdoor living conditions, and have a long, productive lifespan (5-7 years for hens, 3-5 for toms).

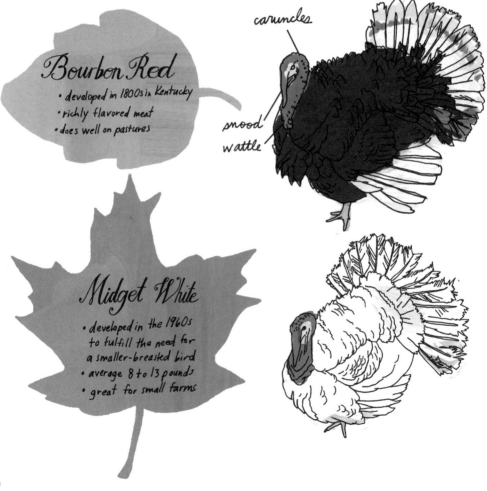

Bourbon Red
- developed in 1800s in Kentucky
- richly flavored meat
- does well on pastures

Labels: caruncles, snood, wattle

Midget White
- developed in the 1960s to fulfill the need for a smaller-breasted bird
- average 8 to 13 pounds
- great for small farms

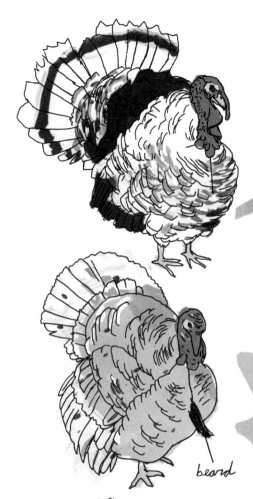

Royal Palm
- mostly kept as an exhibition bird
- toms known to be nonaggressive
- hens are good mothers

beard

Slate
- aka Lavender
- color is solid to ashy blue with black flecks

Standard Bronze
- one of the most popular turkey breeds
- originated as a cross between a European domestic turkey and wild turkey

BEEF ANIMAL TERMS

bucket calf calf fed milk from a bucket
bull an uncastrated male
calf a young animal under a year old
calving the act of giving birth to a calf
cow a female bovine animal
dogie a motherless or neglected calf
freshen to give birth and start producing milk
heifer a young female
open not pregnant
springer a cow about to give birth
steer a castrated male
weanling recently weaned calf
yearling calf about one year old

PARTS OF A BEEF ANIMAL

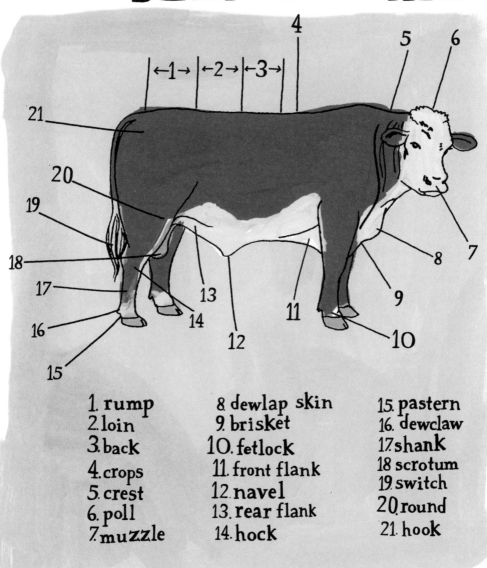

1. rump
2. loin
3. back
4. crops
5. crest
6. poll
7. muzzle
8. dewlap skin
9. brisket
10. fetlock
11. front flank
12. navel
13. rear flank
14. hock
15. pastern
16. dewclaw
17. shank
18. scrotum
19. switch
20. round
21. hook

How a Cow's Stomach Works

COWS ARE RUMINANTS, WHICH MEANS THEY HAVE A SPECIALIZED DIGESTIVE SYSTEM WITH A FOUR-CHAMBER STOMACH. THE FOUR COMPARTMENTS ARE THE RUMEN, RETICULUM, OMASUM, AND ABOMASUM.

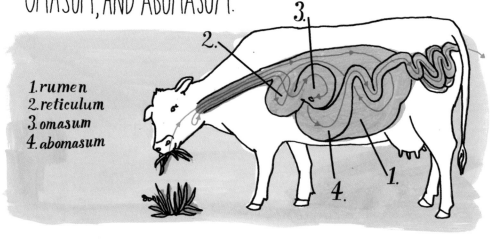

1. rumen
2. reticulum
3. omasum
4. abomasum

The rumen is the largest section and can hold a huge amount of partially digested food. The bacteria in the rumen soften the food.

With a honeycomb wall, the reticulum traps foreign matter that accidentally gets ingested. The reticulum also softens the food further into cud. The cud gets regurgitated and returns to the cow's mouth, where it's chewed more than fifty times before it's swallowed again.

The omasum traps any big chunks of undigested food and sends them back to the reticulum.

Lastly the abomasum acts just like a human stomach and produces enzymes that digest the food. The rest is sent out through the intestines.

BRITISH BEEF

Angus
- high-quality meat
- known for ease in calving
- popular for crossbreeding with larger cattle

Hereford
- large frame
- mellow disposition

Shorthorn
- good mothers
- calves born small

CONTINENTAL BEEF

Charolais
- French breed
- heavily muscled
- good carcass characteristics

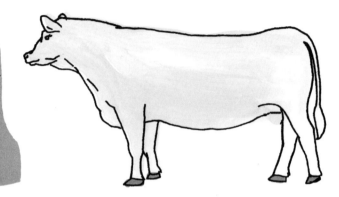

Limousin
- French breed
- well muscled
- medium-sized
- good mothering abilities

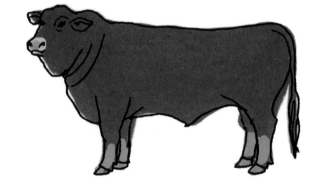

Simmental
- Swiss breed
- excellent milk production for beef animal
- rapid growth

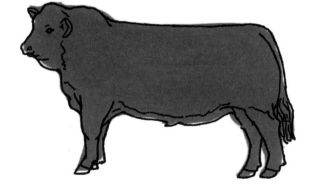

OTHER BREEDS

Belted Galloway
- AKA "Beltie"
- lean, flavorful meat
- have a double coat of hair
- can survive harsh climates

Brahman
- developed in U.S. from 4 Indian breeds
- withstands heat well

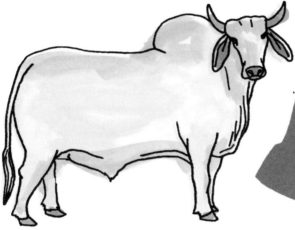

Texas Longhorn
- icon of the West
- good resistance to disease
- okay in rugged areas and can travel long distances

DAIRY BREEDS

Ayrshire
- rich white milk
- good udders
- long-lived
- do well on pastures

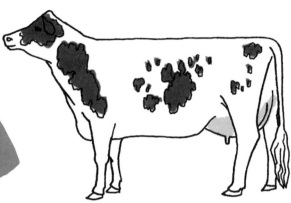

Brown Swiss
- milk has high butterfat and protein content
- docile
- good feet and legs

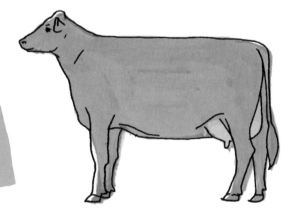

Guernsey
- golden yellow milk rich in butterfat
- high concentration of calcium and vitamins
- good for cheese making

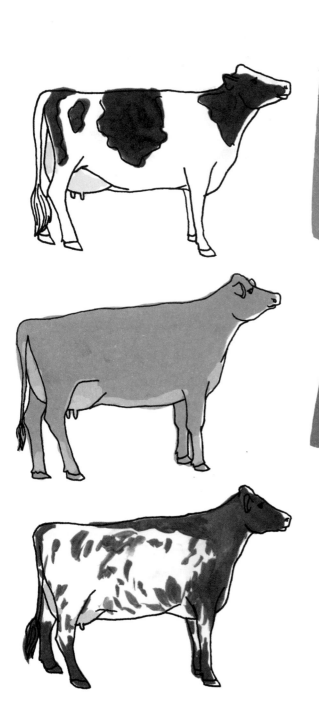

Holstein
- largest dairy breed
- most common in America
- produce very high volume of milk but with lower percentage of butterfat + protein

Jersey
- smallest of major dairy breeds
- can be playful
- rich, creamy milk

Milking Shorthorn
- excellent disposition
- easy calving and good mothering abilities

How to Milk a Cow

- First make sure your fingernails are clipped and your hands are clean. Then clean the cow's teats with soapy warm water.

- Position yourself on a low stool with a bucket between your legs.

- Starting on the right side, hold one teat in each hand.

- Begin applying pressure with your thumb and pointer finger and then continue squeezing downward with the rest of the fingers.

- Milk one teat at a time, alternating between your two hands.

- Point the stream into the bucket. When the teats are finished they will feel soft and flat. Then move on to milk the other two quarters.

- Cows need to be milked twice a day at 12-hour intervals.

MILKING MACHINE

Milking machines are used to milk large numbers of cows more efficiently. You can milk more cows in much less time using the machine. It takes about 15-20 minutes to milk a cow by hand. It takes about 5 minutes with a machine.

Using teat cups, the machine simulates the suction of a nursing calf. The milk is sucked up tubes into a collection bucket.

PASTEURIZING MILK

To prolong shelf life, milk is pasteurized. You can buy a home pasteurizing machine, or for small amounts you can use your stove top. Heat milk to 145-165 °F and keep heating for 30 more seconds. Cool quickly.

GOAT TERMS

buck or **billy** (SLANG) uncastrated male goat
buckling a young male goat
dam a mother goat
doe or **nanny** (SLANG) a female goat
doeling a young female goat
kid a baby goat
sire father goat
wether castrated male
yearling a goat about 1 year old

PARTS OF A GOAT

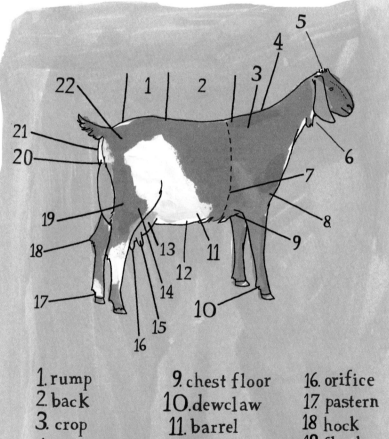

1. rump
2. back
3. crop
4. withers
5. poll
6. dewlap
7. heart girth
8. brisket
9. chest floor
10. dewclaw
11. barrel
12. milk vein
13. udder
14. stifle
15. teat
16. orifice
17. pastern
18. hock
19. flank
20. escutcheon
21. pinbone
22. thurl

DAIRY GOAT BREEDS

Alpine
- great milk production
- adaptable to various climates

La Mancha
- small ears
- calm demeanor

Nubian
- good-natured
- make nice pets
- dual purpose— meat and dairy

MEAT GOAT BREEDS

Boer
- meaty carcass
- breed all year round

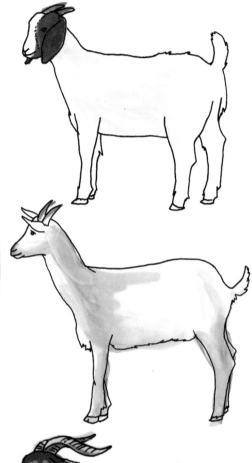

San Clemente
- smaller size
- considered an endangered breed

Spanish
- prolific breeder
- pretty, curling horns

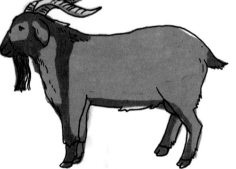

FIBER GOATS

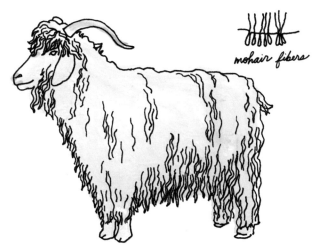
mohair fibers

Angora
- produce 7-16 lbs. of mohair fleece per year
- prone to getting parasites
- mellow disposition

skin — primary fiber — down

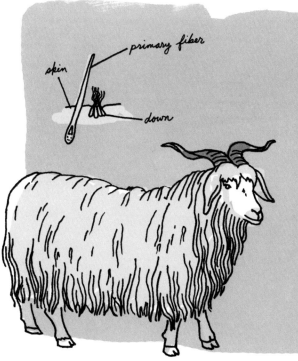

Cashmere

Cashmere is the fiber of the undercoat of over 60 breeds of goats. It's supersoft and warm and often used to make luxury fabrics. Goats used for cashmere can only produce ⅓ lb. of cashmere per year, making it extremely rare and valuable. Highly productive cashmere goats can cost thosands of dollars.

The name "cashmere" came from the Indian region of Kashmir, where the goats grew long coats to keep warm.

Hoof Trimming

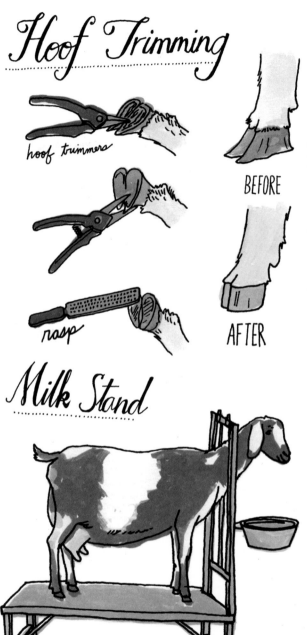

After it rains is the best time to trim a goat's hooves. They will be softer.

- First pick out all the dirt.
- Next trim off the overgrown parts on the front and heel.
- Trim the hoof walls one slice at a time until the sole is pinkish.
- Lastly, use a rasp to file the hoof so it's smooth.

Milk Stand

Simple maintenance of goats is difficult without a milk stand. This structure holds a goat in place while providing it with a snack. That way it can be milked, its hooves can be trimmed, and it can receive medication or be clipped for a show.

These simple knots are commonly used for tying up animals:

double half hitch

This knot acts like a slipknot and is quick and easy to tie.

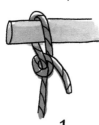 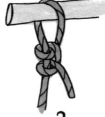

1 2

square

This is a more complex version of the overhand knot. Use this knot to tie two pieces of rope together.

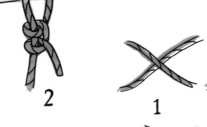

1 2 3 4

bowline

This nonslip knot will not tighten when pulled.

1 2

3 4

quick release

This nonslip knot is easily undone even when very tight.

1 2 3

EQUINE TERMS

broodmare a female horse used for breeding
colt uncastrated male horse under 4 years old
dam mother horse

filly a female horse under 4 years old

foal baby horse that's still nursing
gelding a castrated male horse
horse mule or **john** a castrated male mule
jack an uncastrated male donkey
jenny a female donkey

mare female horse over 4 years old
mare mule or **molly** a female mule
sire father horse

stallion an uncastrated male horse over 4 years old
tandem two horses or mules hitched one in front of another
team two horses or mules hitched side by side
teamster person driving the horses or mules

PARTS OF A HORSE

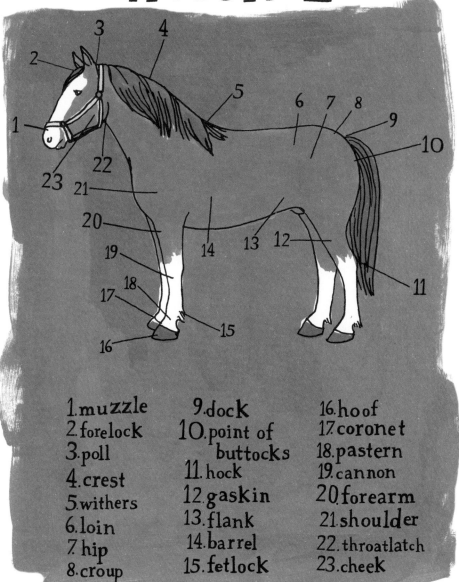

1. muzzle
2. forelock
3. poll
4. crest
5. withers
6. loin
7. hip
8. croup
9. dock
10. point of buttocks
11. hock
12. gaskin
13. flank
14. barrel
15. fetlock
16. hoof
17. coronet
18. pastern
19. cannon
20. forearm
21. shoulder
22. throatlatch
23. cheek

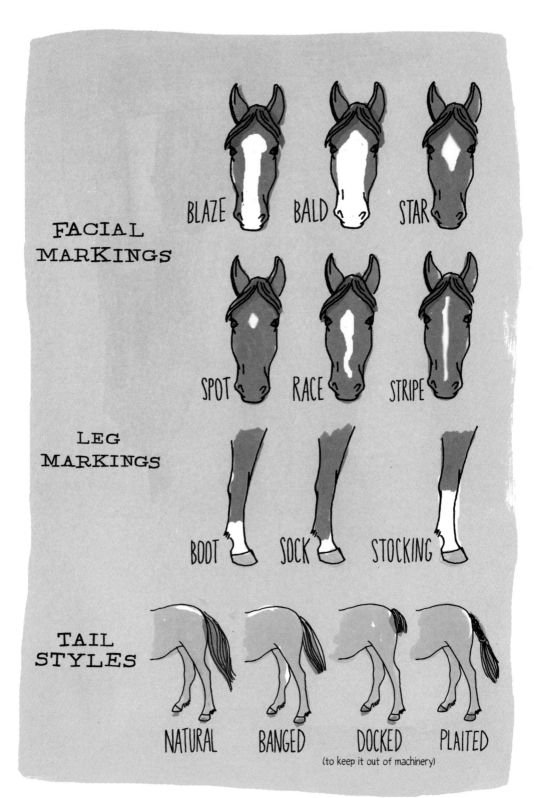

Parts of a Hoof

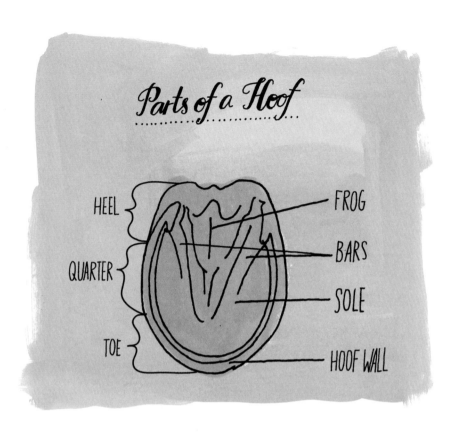

Grooming Tools

removes mud from hoof

DANDY BRUSH
removes dried sweat and mud from body

CURRY COMB
used to remove loose hair

MANE COMB
for untangling mane and tail

BODY BRUSH
used over entire coat (in circular motion)

SWEAT SCRAPER
used to wipe off sweat, or water after hosing horse off

DRAFT HORSE BREEDS

Horses are measured in "hands," not inches or feet. A hand is 4 inches, so a 15-hand horse is 60 inches, or 5 feet, tall. The measurement is taken from the top of the withers (highest point of the shoulder), not the head.

American Cream
- only draft breed developed in U.S.
- breed traces to a single mare named "Old Granny"
- often used for pleasure driving

Belgian
- preferred color is sorrel (reddish gold, with lighter mane and tail)
- known as an easy keeper
- popular in the U.S.

Clydesdale
- developed in Scotland
- the famous Budweiser hitch horse
- prized for their flashy leg action

An average riding horse measures 14-16 hands and weighs 800-1,200 pounds. A draft horse typically stands around 16-18 hands and weighs 1,500-1,800 pounds or more.

Percheron
- usually black or gray
- very little feathering on legs
- the bareback breed of the circus

Shire
- tallest of the draft breeds, measuring up to 19 hands
- heavy feathering protects legs in wet conditions

Spotted Draft
- only spotted draft breed
- North American registry established in 1995

Harnesses

Before tractors, horses were the power behind the cultivation of farmland. They provided the ability to haul heavy loads and pull large equipment. Today some small farms still use horses for plowing, mowing, cultivating, and logging, among other tasks. Draft horses are also often used for carriage rides, providing a nostalgic, "green" ride.

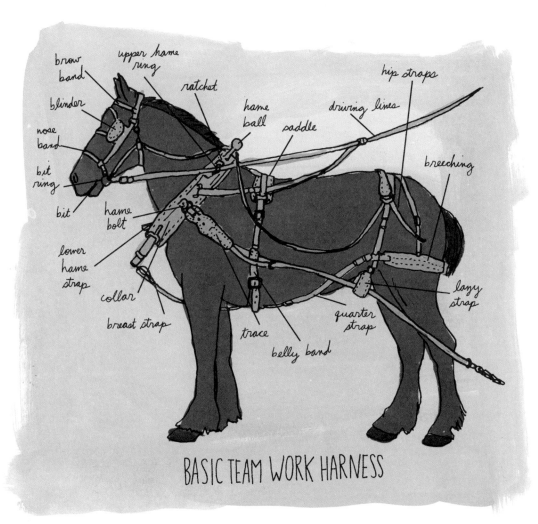

BASIC TEAM WORK HARNESS

MULES

A mule is the offspring of a jack (male donkey) and a mare (female horse). A hinny is the offspring of a stallion (male horse) and jenny (female donkey). Mules do not reproduce because they inherit an odd number of chromosomes (63) from their parents, which causes infertility.

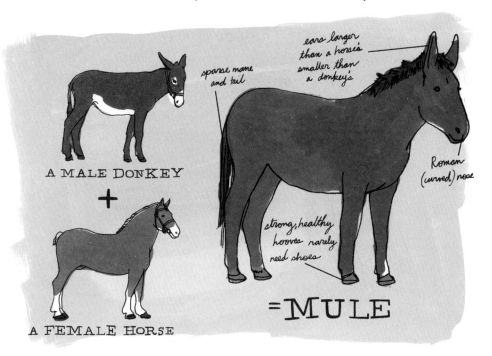

For farm work, breeders cross Mammoth donkeys (the largest type) with draft-breed mares (usually Belgians or Percherons) to produce draft mules that can weigh up to 1,200 pounds. Mules are valued for their strength, stamina, and intelligence. They are reputed to be stubborn but have good sense and the ability to think for themselves. They tend to be very healthy and will not overeat or drink too much water, as horses sometimes do.

PIG TERMS

boar intact adult male
farrow to give birth to a litter of piglets
gilt young female
piglet infant pig
shoat a young weaned pig
sow adult female who has given birth
stag a castrated boar
barrow a male who has been castrated at a young age
runt the smallest pig in a litter
sucker a pig between birth and weaning

PARTS OF A PIG
(A.K.A. SWINE OR HOG)

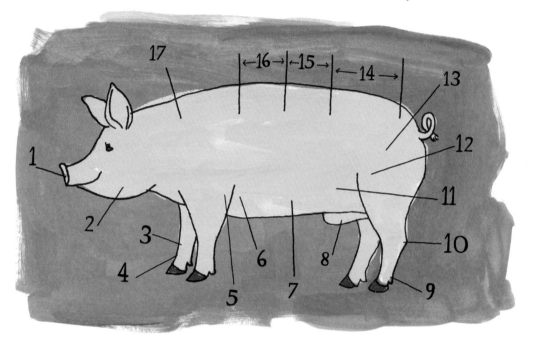

1. snout
2. jowl
3. cannon bone
4. pastern
5. elbow
6. foreflank
7. belly
8. sheath
9. dewclaw
10. hock
11. rear flank
12. stifle joint
13. ham
14. **rump**
15. loin
16. **back**
17. shoulder

POPULAR PIG BREEDS

Berkshire
- well muscled
- pork has large loin eye areas and is considered "premium" table quality
- can have respiratory problems

Black Poland
- exceptional meat quality
- produce many litters

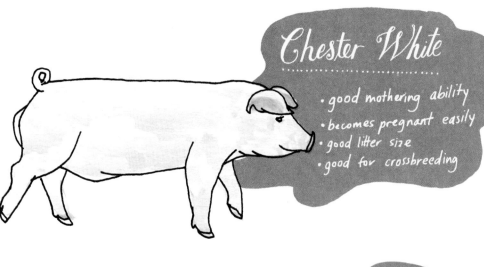

Chester White

- good mothering ability
- becomes pregnant easily
- good litter size
- good for crossbreeding

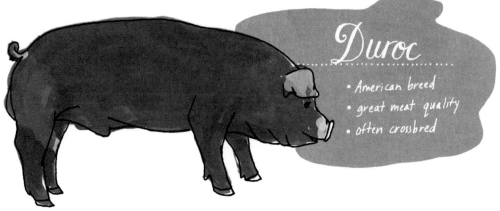

Duroc

- American breed
- great meat quality
- often crossbred

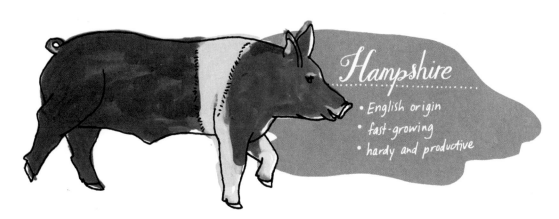

Hampshire

- English origin
- fast-growing
- hardy and productive

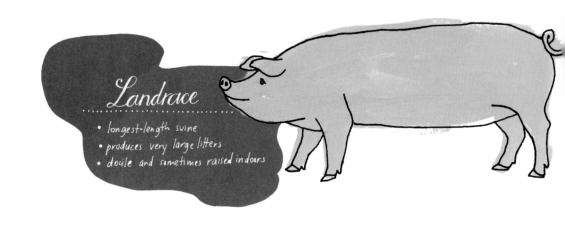

Landrace
- longest-length swine
- produces very large litters
- docile and sometimes raised indoors

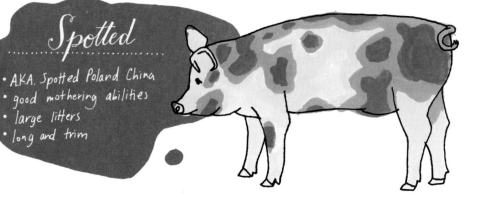

Spotted
- AKA Spotted Poland China
- good mothering abilities
- large litters
- long and trim

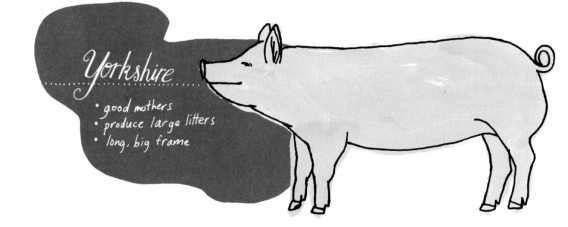

Yorkshire
- good mothers
- produce large litters
- long, big frame

DAILY WATER CONSUMPTION OF LIVESTOCK

AVERAGE GALLONS PER DAY PER ANIMAL

Animal	Gallons
Chicken	4-10 for every 100 chickens
Pig	2-5
Goat	1-3
Sheep	1-4
Horse	8-15
Cow	10-25
Steer	7-19

SHEEP TERMS

lamb a sheep less than 1 year old
ewe or **yoe** (SLANG) a female sheep
dam mother sheep
flock a group of sheep
gummer an old sheep that has lost its teeth
ram or **buck** (SLANG) a male sheep
wether a castrated male sheep

open face closed face polled horned

white face 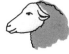 black face 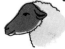 prick ear 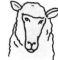 lop ear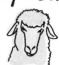

PARTS OF A SHEEP

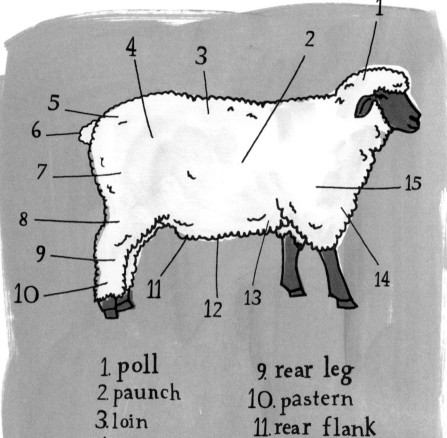

1. poll
2. paunch
3. loin
4. hip
5. rump
6. dock
7. thigh
8. twist
9. rear leg
10. pastern
11. rear flank
12. belly
13. foreflank
14. brisket
15. shoulder

SHEEP BREEDS

Corriedale
- large-sized
- gentle temper
- dual-purpose: wool and meat
- good herding instinct

Dorset
- medium-sized
- great disposition
- easy lambing
- great fleece for hand spinning

Hampshire
- large meat sheep
- gentle

Katahdin
- have hair, not wool
- require no shearing because they shed
- make great pets
- can tolerate extreme weather

Romney
- best suited to cool, wet areas
- long, soft fleece good for hand spinning

Suffolk
- large breed
- lambs grow fast
- can be headstrong

Shearing Sheep

Sheep are sheared about once a year. It's important for the animals' health and makes them more comfortable in the hot summer months.

Sheep will sit still when held in the chair hold. In this position the sheep is sitting on his rump with your legs as a support. This position is also useful for administering shots and trimming hooves.

Shearing can be done manually with hand shears or with electric clippers. Electric clippers are more expensive but they are much faster. They can be very noisy, which can make the sheep more nervous. An experienced shearer can shear a sheep in less than two minutes, removing the fleece in one piece.

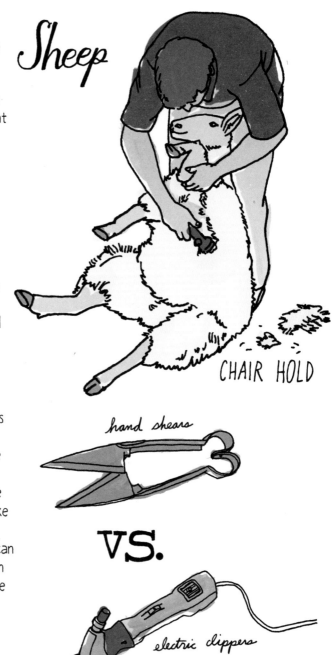

CHAIR HOLD

hand shears

VS.

electric clippers

Skirting the Fleece

After a sheep is shorn, the fleece needs to be skirted. This means dirty and contaminated sections of wool, like the head, face, belly and leg, are removed. This is done on a skirting table, which is slatted to let any loose pieces fall through to the floor.

Grading the Wool

The texture and density of a sheep's wool varies depending on what part of the body it is from:

1 fine, dense wool
2 medium density
3 medium density
4 medium density
5 medium density
6 coarse and thin

RABBIT TERMS

buck male rabbit
dam mother rabbit
doe female rabbit
dwarf a rabbit weighing no more than 3 pounds
junior a rabbit less than 6 months old
kindle to give birth to a litter
kit baby rabbit
Lagomorpha the order of mammals that includes rabbits; they are not rodents
litter the kits produced in a single birth
lop ear having ears that flop down rather than stand upright
rabbitry place where rabbits are kept
sire father rabbit

PARTS OF A RABBIT

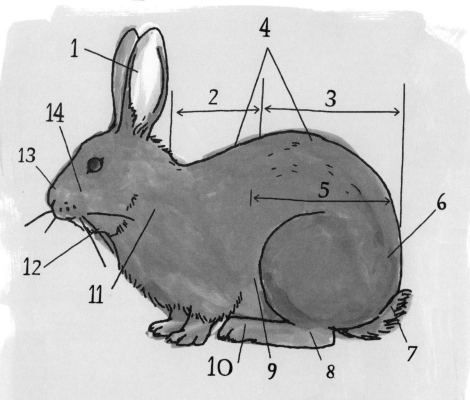

1. ear
2. forequarters
3. hindquarters
4. loin
5. saddle
6. rump
7. tail
8. hock
9. belly
10. foot
11. shoulder
12. dewlap
13. muzzle
14. cheek

SMALL PET BREEDS

Dutch
- 3.5 - 5.5 lbs.
- mild personality

Mini Lop
- less than 6.5 lbs.
- outgoing personality

Mini Rex
- about 4 lbs.
- easygoing personality

Netherland Dwarf
- approx. 2.5 lbs.
- smallest breed
- small litters

MEAT BREEDS

Californian
- 9-10 lbs.
- cross between New Zealand, Chinchilla, and Himalayan

Champagne D'Argent
- 12-18 lbs.
- one of the oldest breeds
- turns silver as it ages

New Zealand
- 9-12 lbs.
- top-quality meat
- fur can be red, black, or white

Palomino
- 9-10 lbs.
- good temperament
- two varieties: golden and lynx

ANGORA BREEDS

English
- 5-7.5 lbs.
- very soft wool
- fanciest breed

French
- 7.5-10.5 lbs.
- slightly coarser wool
- normal hair on ears, face and feet

Giant
- at least 9.5 lbs.
- largest of Angora breeds

Satin
- 6.5-10 lbs.
- wool has nice sheen

COAT TYPES AND COLORS

ANGORA
long soft wool that can be spun into yarn

REX
a short, plush coat that comes in a variety of colors

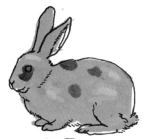

SATIN
hollow hairs give the coat a lustrous shine

AGOUTI
AGOUTI HAIR

fur has a salt-and-pepper appearance caused by bands of color on individual hairs

BROKEN
spots or blotches of color on a white background

POINTS
dark ears, nose, and feet against a lighter coat

SELF
a single unbroken coat color

TICKED
having an outer coat of stiff guard hairs over a downy undercoat

BEE TERMS

absconding when the entire colony leaves for a new location because of unfavorable conditions

anther male part of a flower where pollen is contained

beehive the home of the honeybee

cell a single hexagon-shaped unit in a comb

colony a community of bees with one queen

comb the hexagon-shaped wax cells of a nest

dancing the way bees communicate

drone a male bee

honey nectar that has been collected, cured, and stored in the honeycomb

nectar the sugar source made by plants to attract pollinators

pheromone a chemical secreted by bees for communication

pollen tiny grains made by the male part of the flower that contain reproductive cells and are collected by bees for food

queen an egg-laying female bee

swarming when a portion of the colony leaves to make a new home

worker a female who doesn't lay eggs

PARTS OF A BEE

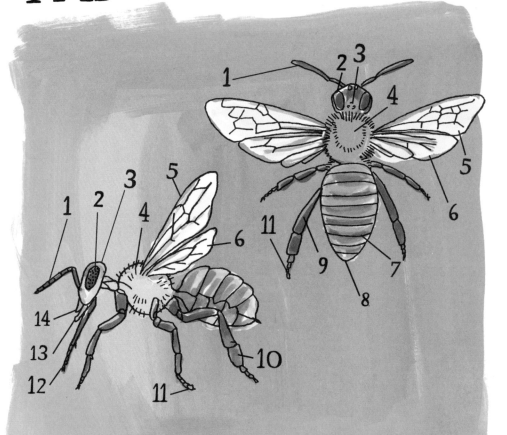

1. antenna
2. compound eye
3. ocellus
4. thorax
5. forewing
6. hindwing
7. abdomen
8. stinger
9. femur
10. tibia
11. tarsal claw
12. proboscis
13. mandible
14. labrum

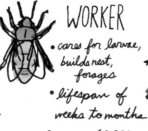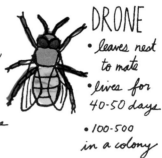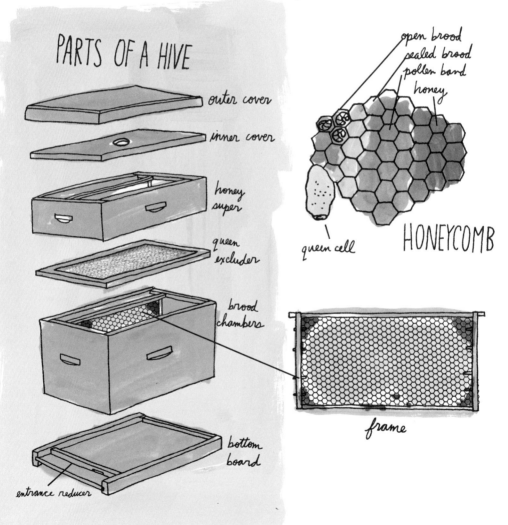

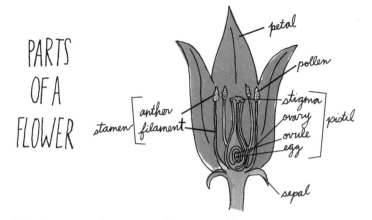

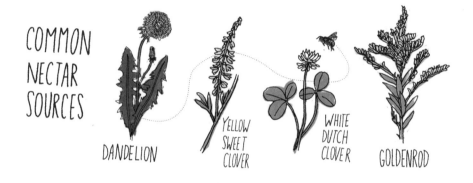

In an Old-Fashioned Country Kitchen

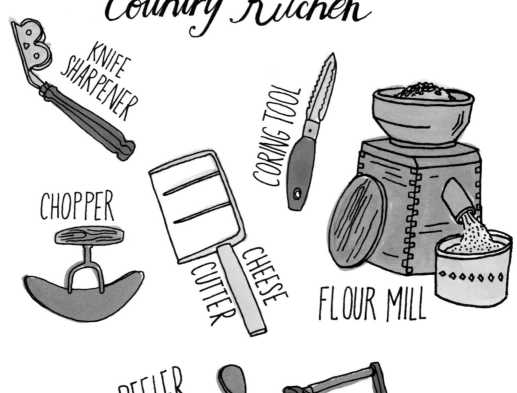
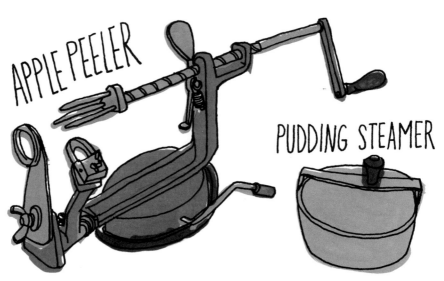

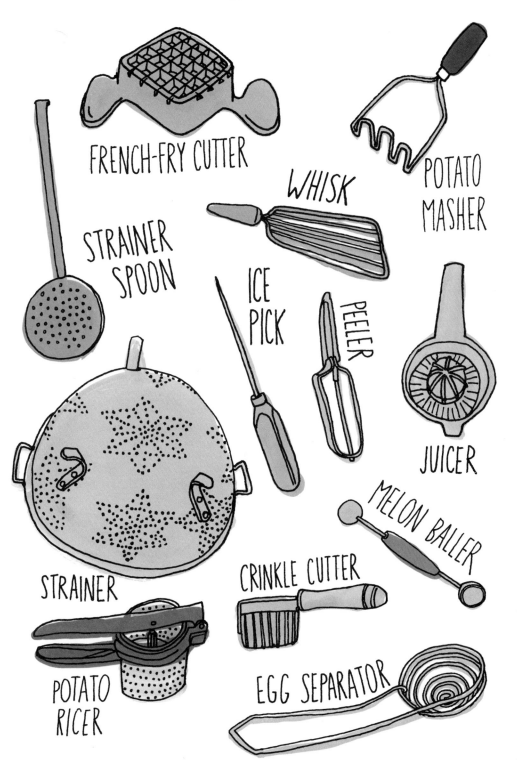

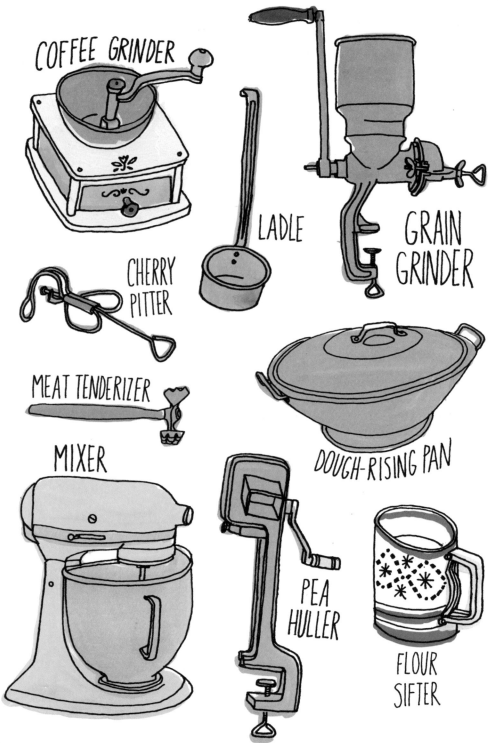

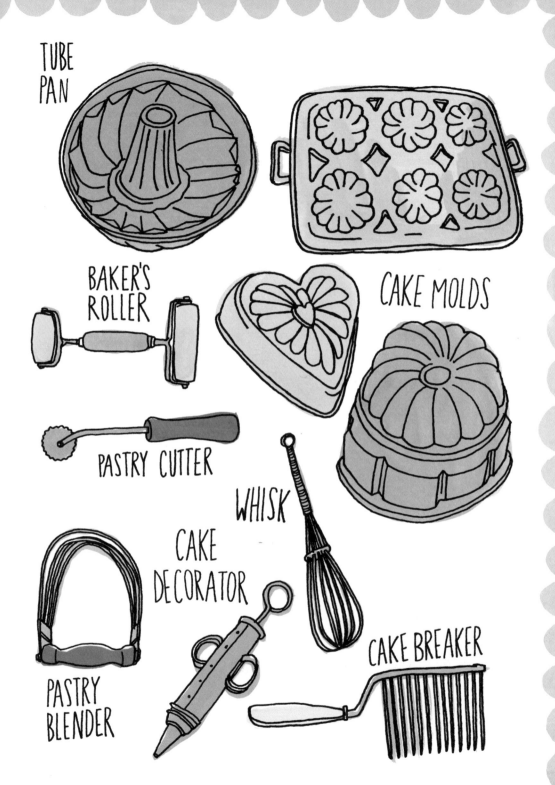

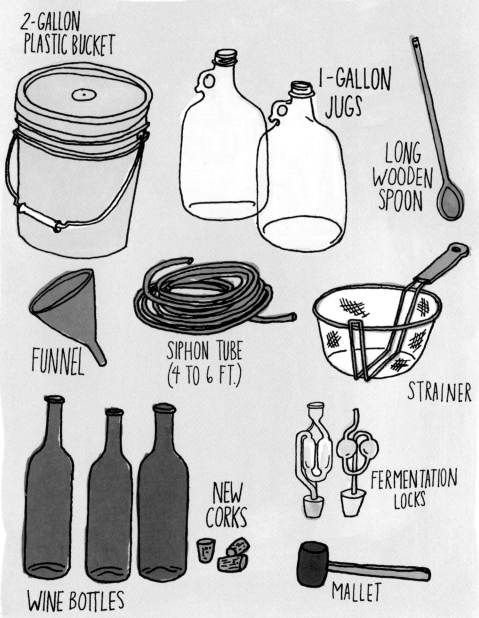

Dandelion Wine

3 QUARTS DANDELION BLOSSOMS
1 GALLON WATER
2 ORANGES WITH PEEL
1 LEMON WITH PEEL
3 POUNDS SUGAR
1 OUNCE FRESH YEAST OR 3 PACKETS INSTANT YEAST
1 POUND RAISINS

1. Collect the blossoms when they are fully open on a sunny day. Remove any green parts; they will impair the fermentation.

2. In a large pot, bring the water to a boil and pour it over the flowers. Cover and let steep for 3 days.

3. Juice the oranges and the lemon, save the peels, and reserve the liquid.

4. Add the orange and lemon peel to the flower-water mixture and bring to a boil. Remove from heat and strain out the solids, then add the sugar, stirring until it is dissolved. Allow to cool.

5. Add the orange and lemon juice, yeast, and raisins to the liquid. Put everything into a bucket with a loose lid (so gas can escape) to ferment.

6. When the mixture has stopped bubbling (2 days to a week), fermentation is complete. Strain the liquid through several layers of cheesecloth and transfer to sterilized bottles. Slip a deflated balloon over the top of each bottle to monitor for further fermentation. When the balloon remains deflated for 24 hours, fermentation is complete. Cork the bottles and store in a cool, dark place for at least 6 months before drinking.

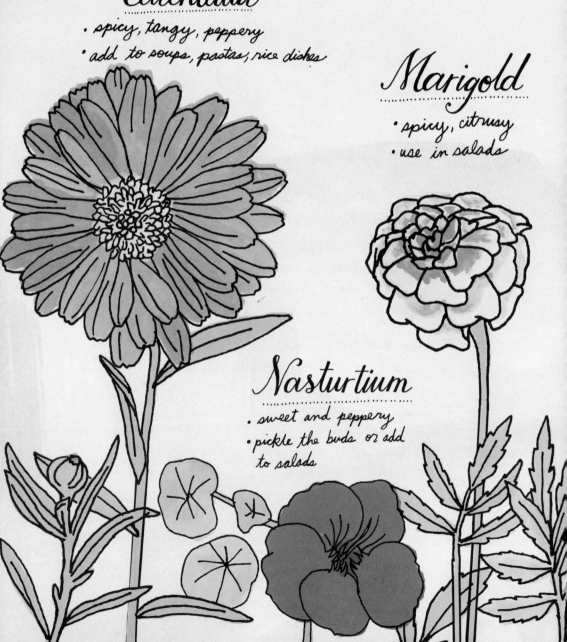

Bachelor's Button
- sweet, spicy, clove-like
- use as garnish

Dianthus
- clove-like, nutmeg-like
- use to decorate cakes, steep in wine

Violas
- sweet-perfumed
- use in salads, or to decorate drinks and frosted cakes

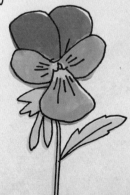

The Basics of Breadmaking

EASY, BASIC, and GOOD WHITE BREAD

2 CUPS WARM WATER
2 TABLESPOONS HONEY
1 TABLESPOON ACTIVE DRY YEAST
2 TABLESPOONS LIGHT OIL
2 TEASPOONS SALT
5-6 CUPS UNBLEACHED ALL-PURPOSE FLOUR
2 TABLESPOONS RAW WHEAT GERM
½ CUP NONFAT DRY MILK

1. PROOF THE YEAST

Pour 2 cups of warm (100°F) water into a large mixing bowl. Add the dry yeast and honey, and set aside for 10 to 15 minutes. The mixture will become frothy when the yeast has been activated.

2. COMBINE THE INGREDIENTS

Add the oil, salt, and 2 cups of flour. Mix well by hand or with a stand mixer that has a dough-hook attachment. Mix in the wheat germ, dry milk, and 2-3 additional cups of flour. Mix until the dough is stiff.

3. KNEAD THE DOUGH

Sprinkle flour on a clean, flat surface. Dust your hands with flour and turn the dough out onto the surface. Knead the dough until it springs back when pressed.

4. LET IT RISE

Grease a large bowl generously with butter or oil and place the dough inside turning it once to coat all sides. Cover the bowl with a clean kitchen towel and place it in a warm, draft-free spot. Let the dough rise until it has doubled in size. This can take 45 minutes to a few hours.

for an Herb Bread Blend recipe, turn to p. 95

5. PUNCH IT DOWN

Punch the dough down with your fist. Knead it a few more times on a lightly floured surface. Cut the dough into equal pieces, cover, and let rest for 5 to 15 minutes.

6. PREP THE PANS

Grease two 8- or 9-inch loaf pans. Roll each piece of dough into a ball and flatten it a bit. Place each in a pan. It should fill it halfway. Brush the top with melted butter. Cover the pans and let the dough rise a second time for about 45 minutes to an hour. Preheat the oven to 375 degrees.

7. BAKE IT

Place pans in the oven and bake for 25 to 30 minutes. The loaves should be light brown and should sound hollow when thumped. Tap the back of the pan to release the bread. Let cool on a rack.

8. ENJOY!

Slice them up and spread with butter.

CREAM the fat solids that rise to the top after the milk settles

CULTURES friendly bacteria that change milk sugar (lactose) into lactic acid; used to make yogurt, buttermilk, and many types of cheese

CURDS the soft solids that form after rennet is added to milk

HOMOGENIZATION a process that breaks up milk fat and distributes it evenly to prevent the cream from rising to the top

RAW MILK milk that is fresh from the cow (or goat or sheep) and has not been pasteurized

RENNET contains enzymes that cause milk to coagulate and form cheese

PASTEURIZATION the process of briefly heating raw milk to at least 145°F and then cooling it quickly to increase shelf life

WHEY the liquid by-product of cheese or yogurt making; it can be used to make other cheeses such as ricotta

IN THE DAIRY

Buttermilk
is the liquid that remains after butter forms.

Butter
is made from heavy cream that is churned or whipped into solid granules and then kneaded to remove excess liquid (whey).

Sour Cream
forms when fresh, unpasteurized cream is allowed to sour at room temperature; naturally occurring bacteria cause the thick texture and tangy flavor.

Yogurt

is a cultured product that forms when a starter culture is added to milk; the end result contains probiotics that promote good digestion and overall health.

Cottage Cheese
is made by heating milk with rennet and buttermilk until it forms solid curds and pressing out the whey.

183

The Basic Steps in Making Cheese

1. HEAT THE MILK

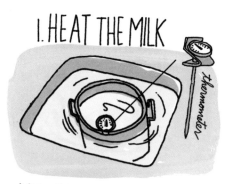

2. ADD STARTER

The starter is made of active bacteria that convert lactose to lactic acid and help control the rate of ripening.

3. ADD RENNET

Rennin is an enzyme that helps the milk coagulate and form into the curd.

4. CUT THE CURDS

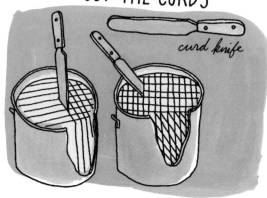

curd knife

5. COOK THE CURDS

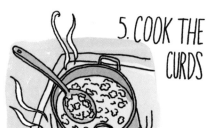

6. DRAIN THE CURDS

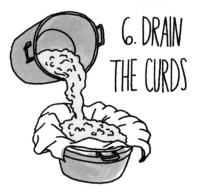

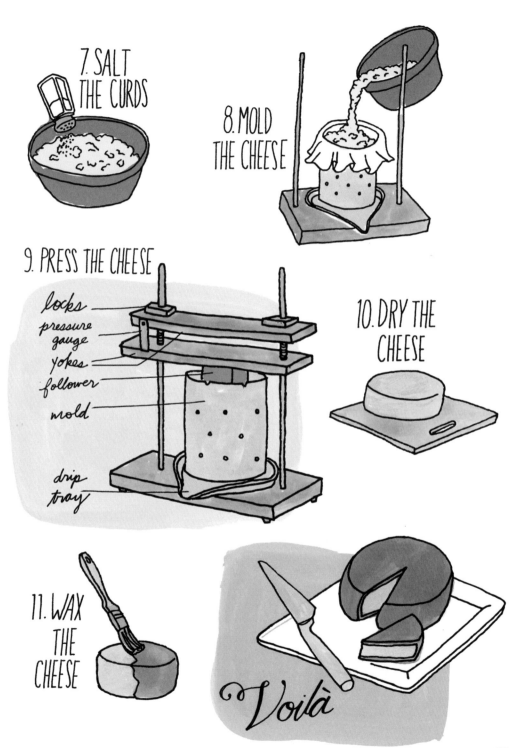

BUTCHERING KNIVES

BONING · BUTCHER · FILLETING · CLEAVER · SKINNING · CARVING

SHARPENING STEEL

How to Cut Up a Chicken

1. Cut the skin between the thighs and the body.

2. Snap the hip joints by grasping both legs and pulling outwards.

3. Cut off the leg by rocking the knife from the bottom to the top.

4. Cut through leg joint to separate the thigh from the drumstick. Do the other leg the same way.

5. Pull wings away from body and cut close to the bone.

6. For buffalo wings, cut the wings into three parts.

7. Stand the chicken on its neck and cut from tail to neck along the ends of the ribs on both sides to free the back. Snap it in half and separate the ribs from the lower back.

8. Break out the breastbone. Cut the breast in half.

1 NECK
2 CHUCK
3 RIB
4 SHORT LOIN
5 LOIN END
6 RUMP
7 ROUND
8 DIAMOND

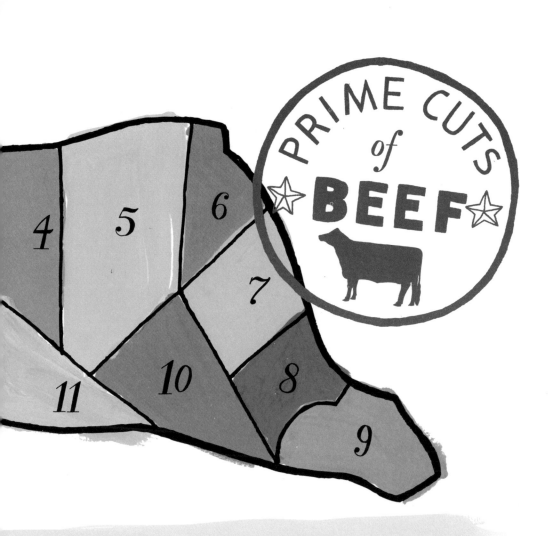

9 HIND SHANK
10 SIRLOIN TIP
11 FLANK
12 SHORT PLATE
13 ENGLISH CUT
14 BRISKET
15 FORESHANK

Shepherd's Pie

2 CUPS MINCED ROAST BEEF
1 CUP DICED COOKED CARROTS
1 CUP GREEN PEAS
½ CUP DICED COOKED ONIONS
2 CUPS MASHED POTATOES
1 CUP CHEDDAR CHEESE, GRATED

1. Preheat broiler.
2. Combine the roast beef, carrots, peas, and onions.
3. Spread the beef mixture over the bottom of a 9 x 12" glass or ceramic dish. Then spread a thick layer of mashed potatoes on top and, with a fork, draw lines down the pan.
4. Sprinkle the cheddar on top and broil for about 10 minutes, or until the mashed potatoes are browned. Serve immediately.

Yield: 6 servings

A simple smokehouse can be made with a metal barrel connected to a fire pit. Make sure to clean it periodically. Also make sure no animals can get into it when it's not in use. Only use hardwood (i.e. maple, birch, chesnut). Use a baffle to distribute the smoke in the chamber.

Meat	Smoking temperature
POULTRY	180°F
BEEF, VEAL, AND LAMB ROASTS	145-170°F
PORK	160-170°F

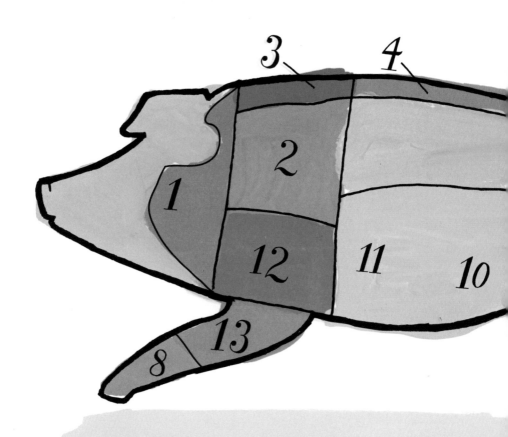

1 JOWL
2 BOSTON BUTT
3 CLEAR PLATE
4 BACK FAT
5 CENTER CUT
6 HAM

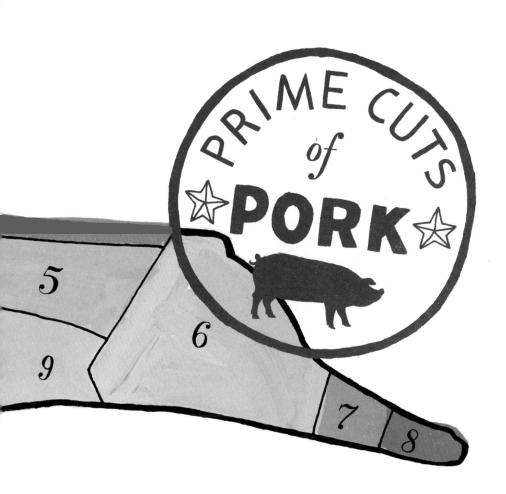

7 HAM HOCK
8 FOOT
9 LEAF FAT
10 SIDE OR BELLY
11 SPARERIBS
12 PICNIC
13 SHOULDER HOCK

Dry Curing

USE 1 OUNCE OF THIS MIXTURE FOR EACH POUND OF MEAT:

8 POUNDS OF CURING SALT
3 POUNDS OF CANE SUGAR
2 OUNCES OF SALTPETER (POTASSIUM NITRATE)
1 OUNCE OF SODIUM OR POTASSIUM NITRATE
PLUS OPTIONAL SEASONINGS SUCH AS PEPPER, GARLIC, AND ONION

- Rub each piece of meat thoroughly with the mixture. Cover outside entirely.
- Put a thick layer of the mixture on the inside of a large box that has holes cut out of the bottom.
- Put the largest pieces in the box, not letting them touch. Cover them completely with the mixture.
- Add the smaller pieces, cover them, and close the box.
- Keep refrigerated at 34°F for about 4 days. Then it's time to overhaul the meat, which means removing it and repacking it again the same way. Cure for 2 days per pound of meat. (In cold weather, lengthen the time, in warm weather shorten it.)
- After this the pieces can be removed, soaked in cold water, and cleaned.

How to Wrap a Ham

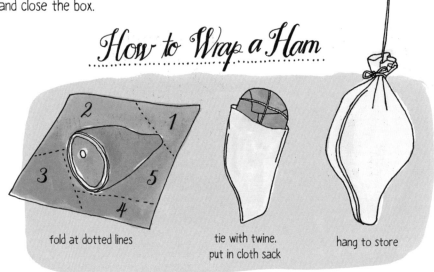

fold at dotted lines · tie with twine, put in cloth sack · hang to store

Baked Ham with Pineapple

1 8-TO-10 POUND HAM
2 TABLESPOONS WHOLE CLOVES
2 CUPS APPLE JUICE OR CIDER
1 CUP HOT HONEY MUSTARD OR DIJON MUSTARD
2 8 1/4-OUNCE CANS CRUSHED PINEAPPLE IN SYRUP
2/3 CUP HONEY
1/2 TEASPOON GROUND GINGER

1. Preheat oven to 325°F. Place the ham on a rack in a roasting pan; insert cloves into ham in a diamond pattern with rows 3 to 4 inches apart. Pour juice into the bottom of the pan. Heat on the stove top until the juice boils; then place the pan in the oven. Cook until the internal temperature of the ham reads 160°F, about 20 minutes per pound.

2. For the glaze, combine mustard, pineapple (with its juice), honey, and ginger in a saucepan. Bring to a boil over medium heat; reduce heat and simmer 5 minutes, stirring occasionally.

3. About 40 minutes before the ham is ready, score the surface in diamond shapes and spread the glaze over the surface. Return the ham to the oven and baste with the glaze every 10 minutes.

Yield: 8-12 servings

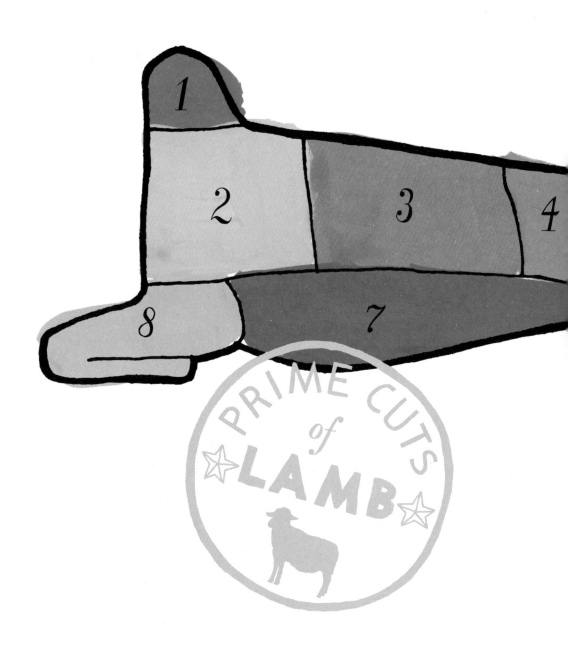

1 NECK
2 CHUCK
3 RACK OR RIB
4 LOIN
5 LEG
6 SHANK
7 BREAST
8 FORESHANK

Oven Lamb Stew

2 TABLESPOONS VEGETABLE OIL
2 POUNDS LEAN LAMB, CUT INTO 1-INCH CUBES
1 MEDIUM ONION, SLICED
2 CUPS WATER
1 TABLESPOON WORCESTERSHIRE SAUCE
2 TABLESPOONS UNBLEACHED ALL-PURPOSE FLOUR
2 TABLESPOONS COLD WATER
1 CUP FRESH OR FROZEN PEAS
3 MEDIUM CARROTS, SLICED
1 STALK CELERY, SLICED
SALT AND FRESHLY GROUND BLACK PEPPER

1. Preheat oven to 325°F. In a large heavy skillet, heat the oil and brown the lamb. Add the onion and sauté for 5 minutes, stirring frequently. Drain off the fat. Add the water and Worcestershire. Bake, covered, for 1½ hours.

2. Remove the skillet from the oven. In a small bowl, blend the flour with the water to make a thin paste. Add the paste to the skillet and blend well. Add the peas, carrots, celery, and salt and pepper to taste. Bake, covered, for 30 minutes longer. Serve.

Yield: 1½ quarts

Maximum Storage Times for Frozen Meats

MEAT	CUT OR TYPE	STORAGE TIME IN MONTHS
BEEF	ROASTS	12
	STEAKS OR CHOPS	12
	GROUND	3
LAMB	ROASTS	12
	CHOPS	9
PORK	ROASTS	8
	CHOPS	4
POULTRY	CUT UP	9

Pressure Canning

- METAL BAND
- DOME LID
- DOME LID SEAL
- GLASS THREADING

PARTS OF A JAR

Canning allows you to enjoy your fresh food all year long. Because pressure canners can reach 240 degrees F, they kill off bacteria in food so you can safely preserve all kinds of vegetables, fruits, and even meats. Here's an overview of the steps in pressure canning:

1 Pack your jars tightly. Leave ½ inch of headspace at the top of the jar to allow for food expanding as it gets heated.

2 Slide a plastic spatula up and down inside the jar to let out any air bubbles.

Wipe the lid off well to ensure a tight seal. Place the lid on and screw on the band. Make sure to follow these steps for each jar.

4. Place all jars in the canner rack.

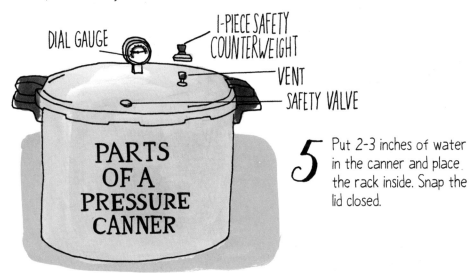

PARTS OF A PRESSURE CANNER

- DIAL GAUGE
- 1-PIECE SAFETY COUNTERWEIGHT
- VENT
- SAFETY VALVE

5. Put 2-3 inches of water in the canner and place the rack inside. Snap the lid closed.

6. At the highest heat, exhaust the air and steam for ten minutes with vent port open.

7. Place the weight on the vent to pressurize the canner.

8 Start timing when the weight starts wiggling or the gauge reads the correct pressure. Regulate the heat until the time is up. Remove from heat.

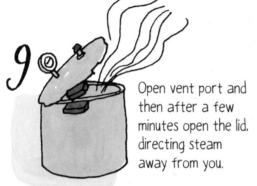

9 Open vent port and then after a few minutes open the lid, directing steam away from you.

10 Use a jar lifter to get the jars out. Put them on a towel in a place that isn't drafty. Once they fully cool down, don't forget to label them.

Root Cellaring

Root cellars are used for the long-term storage of certain vegetables and fruits, and all types of preserved foods. Some crops that keep well if properly stored are beets, turnips, onions, potatoes, carrots, winter squash, and apples. Ways to store crops include layering them in straw or damp sand, wrapping them in paper, and hanging them in net bags to allow air circulation.

A root cellar can be created in a cool basement, built into the side of hill, or dug underground. It should be positioned on the north side of a hill or house to shelter it from the sun. The important thing is a constant cool temperature (between 32° and 40°F) and high humidity to protect food from spoiling in the summer and freezing in the winter. A vent allows warm air to escape and a dirt floor helps maintain humidity.

Making Maple Syrup

SUGAR MAPLE

BIT AND BRACE

All maple trees produce sap, but the sugar maple produces the most and its sap has the highest sugar content. The sap starts to run when the days become longer and is most abundant during periods with warm days and chilly nights. Making maple syrup isn't difficult, but it is very time-consuming. It takes 9-10 gallons of sap to make just one pint of syrup.

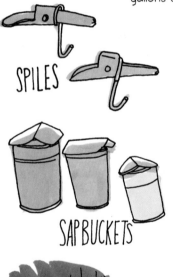

SPILES

SAP BUCKETS

The first step is tapping the trees by drilling holes about 2 inches deep and 2 feet from the ground. The size of the tree determines the number of taps; a tree should be at least 10 inches in diameter before being tapped. Push a spout (spile) into the hole. Most spiles have a hook to hold the bucket to collect the sap.

When you have enough sap, pour it into a large pot or shallow pan to boil it down. As the water boils off, the sap decreases in volume considerably and becomes darker and thicker. When it sheets off a spoon instead of dripping, it is ready. After it cools, filter the syrup through a coffee filter to remove any sediment. Bottle and enjoy!

TAPPING

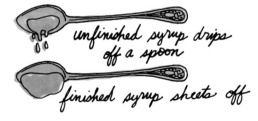

unfinished syrup drips off a spoon

finished syrup sheets off

Maple Fudge

2 CUPS GRANULATED SUGAR
1 CUP PURE MAPLE SYRUP
½ CUP LIGHT CREAM
2 TABLESPOONS BUTTER

1. Grease well an 8-inch-square pan. Combine all ingredients in a medium saucepan. Cook, stirring, over medium-high heat until boiling.
2. Clip a candy thermometer to the side of the pan and continue cooking and stirring until the mixture reaches 238°F, 10 to 15 minutes. Remove from heat and cool without stirring until lukewarm (110°F), about 1 hour.
3. Remove the candy thermometer and beat the mixture with a wooden spoon until the color lightens, the mixture loses its gloss, and the fudge begins to set.
4. Quickly press into the prepared pan; score into squares while warm. When the fudge is firm cut into squares. Store tightly covered.

Yield: 24 pieces

MAKING YARN

Carding

Carding is the process of straightening the wool fibers so they are parallel, preparing them for spinning. Using the traditional method of hand carding, the wool is transferred back and forth between two wooden paddles with wire teeth. This essentially combs the wool. When the fibers are sufficiently separated, they get rolled up into what's called a rolag.

A drum carder is a small machine that can card much more fiber at once than doing it by hand. By feeding the wool into the machine and cranking the handle, the fibers get fed into a wire-tooth roller and then a wire-tooth main drum where they're separated and straightened.

DRUM CARDER

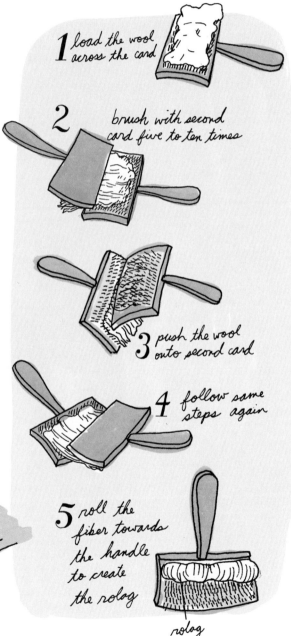
1. load the wool across the card
2. brush with second card five to ten times
3. push the wool onto second card
4. follow same steps again
5. roll the fiber towards the handle to create the rolag

rolag

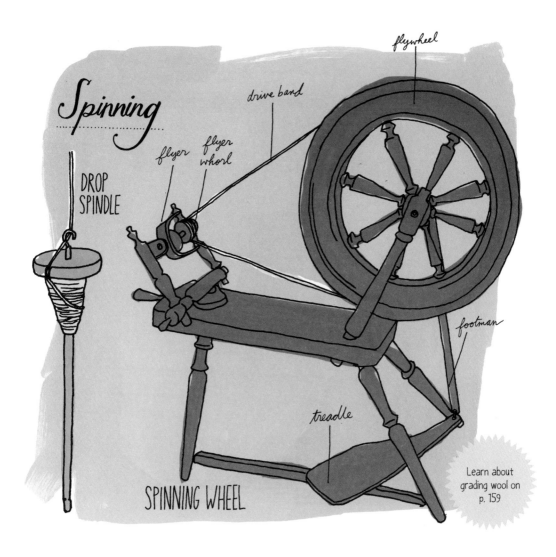

After carding the fiber, spinning is the next step in making it into yarn. There are simple tools like a drop spindle to assist in the process. For doing larger amounts, a spinning wheel is used.

Spinning wheels come in a few different styles. The Saxony style seen above is one of the most popular. It is powered by pumping the treadle, which turns the flywheel. The spinner's hands are free to draft the fibers (pull small amounts).

Natural Dye

Wool can be dyed using natural sources like plant leaves, flowers, roots, or nuts. Some of these plant materials you can find in your own backyard:

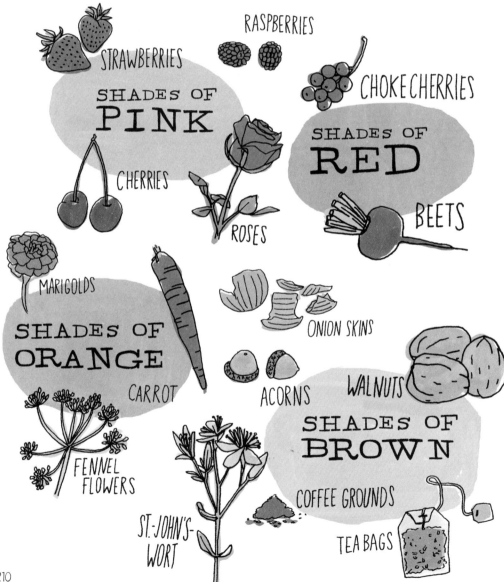

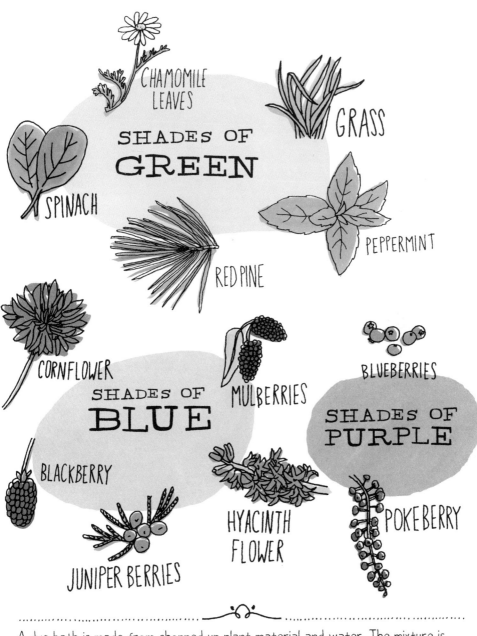

A dye bath is made from chopped-up plant material and water. The mixture is brought to a boil and then simmered. The wool should simmer in the dye bath for 30 minutes to an hour depending on the dye and the intensity of color desired.

How to Make a Flower Press

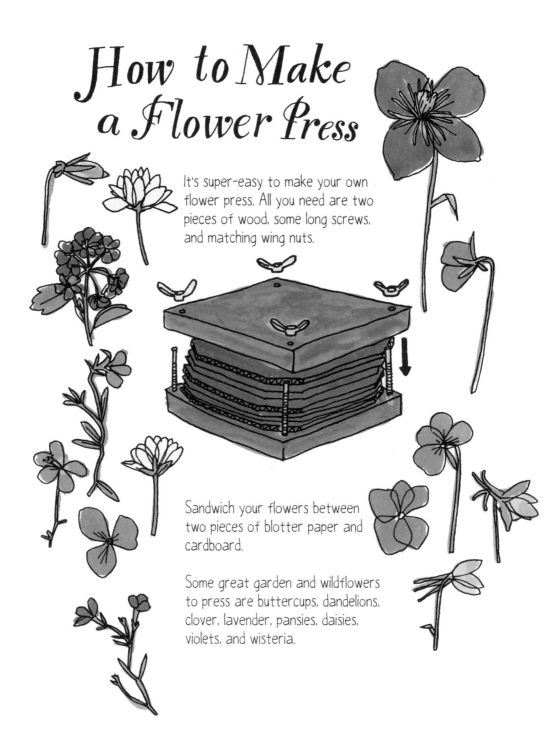

It's super-easy to make your own flower press. All you need are two pieces of wood, some long screws, and matching wing nuts.

Sandwich your flowers between two pieces of blotter paper and cardboard.

Some great garden and wildflowers to press are buttercups, dandelions, clover, lavender, pansies, daisies, violets, and wisteria.

How to Make a Corn Husk Doll

to see a corn plant, turn to p. 83

1 Soak about a half dozen cornhusks in water to soften them.

2 Hold together the ends of 3 husks.

3 Wrap a fourth husk around the ends to hold them together.

4 Fold the husks over the wrapped part.

5 Tie them with string to make a head.

6 Split a new husk in thirds lengthwise.

7 Tie them together and braid, then tie the end.

8 Place between the husks from the head. This makes the arms.

9 Split another new husk in two parts lengthwise.

10 Drape these over each shoulder.

11 Tie string around the middle to make a waist and you're done!

213

Making a Rag Rug

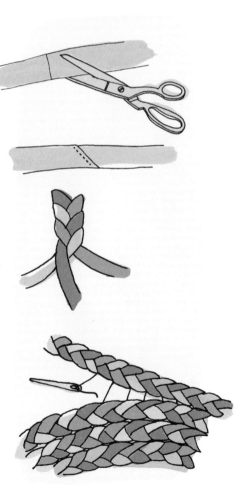

Use old clothes and other worn fabric to make something new: a braided rug! Making rag rugs requires only simple sewing skills.

1. Cut strips of material 2-3 inches wide and as long as possible, with the ends cut diagonally on the bias.

2. Sew the strips at the narrow ends until you have three strands several feet long (longer than that is hard to braid).

3. Knot the strips together at one end and braid them the same way you braid hair.

4. Coil the first braided strip around itself, keeping it flat and sewing it with heavy thread. Make more braided strips to make a bigger rug.

Making Candles

1. Use double the length of wick for the size candle you want to make. Hang the wick over a frame or stick so there is an equal length on both sides. Tie a washer or nut on both ends to weigh them down.

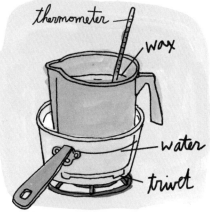

2. Heat the wax in a double boiler to about 155 to 165 degrees. Add color and scent.

3. Dip the wick in the wax for a few seconds, then let it cool. Keep repeating until you get the desired thickness.

4. Cut off the weights and cut the wick to separate the candles.

QUILTS

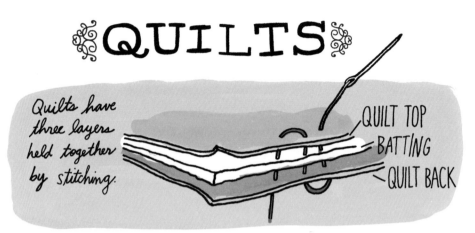

Quilts have three layers held together by stitching.
- QUILT TOP
- BATTING
- QUILT BACK

BORDER Here's a simple way to create a border to frame your design.

Popular Quilt Patterns

JACOB'S LADDER

BASKET

DOUBLE WEDDING RING

LOG CABIN

For our wedding, my mother and Matt's mother made us a beautiful log cabin quilt. Every other block was a photograph of one of us as a child that had been printed on fabric.

BIBLIOGRAPHY

STOREY BOOKS

Bubel, Mike and Nancy Bubel. Root Cellaring. Storey Publishing, 1991

Burch, Monte. Building Small Barns, Sheds & Shelters. Storey Publishing, 1983.

Carroll, Ricki. Home Cheese Making, 3rd ed. Storey Publishing, 2002.

Chesman, Andrea and Fran Raboff. 250 Treasured Country Desserts. Storey Publishing, 2009.

Chioffi, Nancy and Gretchen Mead. Keeping the Harvest. Storey Publishing, 1991.

Damerow, Gail, ed. Barnyard in your Backyard. Storey Publishing, 2002.

———. Fences for Pasture & Garden. Storey Publishing, 1992.

———. Storey's Guide to Raising Chickens, 3rd ed. Storey Publishing, 2010.

Damerow, Gail and Alina Rice. Draft Horses and Mules. Storey Publishing, 2008.

Dutson, Judith. Storey's Illustrated Guide to 96 Horse Breeds of North America. Storey Publishing, 2005.

Eastman, Wilbur F. A Guide to Canning, Freezing, Curing & Smoking Meat, Fish & Game, rev ed. Storey Publishing, 2002.

Ekarius, Carol. How to Build Animal Housing. Storey Publishing, 2004

———. Pocketful of Poultry. Storey Publishing, 2007.

———. Storey's Illustrated Breed Guide to Sheep, Goats, Cattle and Pigs. Storey Publishing, 2008.

Haedrich, Ken. Maple Syrup Cookbook. Storey Publishing, 2001

Hansen, Ann Larkin. The Organic Farming Manual. Storey Publishing, 2010.

Herd, Tim. Maple Sugar. Storey Publishing, 2010

Klober, Kelly. Storey's Guide to Raising Pigs, 3rd ed. Storey Publishing, 2009.

Macher, Ron. Making Your Small Farm Profitable. Storey Publishing, 1999.

Madigan, Carleen, ed. The Backyard Homestead. Storey Publishing, 2009.

Mettler, John J. Jr. Basic Butchering of Livestock & Game. Storey Publishing, 1986. Revised and updated by Martin J. Marchello, 2003.

Philbrick, Frank and Stephen Philbrick. The Backyard Lumberjack. Storey Publishing, 2006.

Ruechel, Julius. Grass-Fed Cattle. Storey Publishing, 2006.

Sanford, Malcolm T., and Richard E. Bonney. Storey's Guide to Keeping Honey Bees. Storey Publishing, 2010.

Schwenke, Karl. Successful Small-Scale Farming. Storey Publishing, 1991.

Simmons, Paula and Carol Ekarius. Storey's Guide to Raising Sheep. 4th ed. Storey Publishing, 2009.

Smith, Edward C. The Vegetable Gardeners Bible. 10th Anniversary ed. Storey Publishing, 2009.

Sobon, Jack and Roger Schroeder. Timber Frame Construction. Storey Publishing, 1984.

Storey, Martha. 500 Treasured Country Recipes. Storey Publishing, 2000.

Thomas, Heather Smith. Getting Started with Beef & Dairy Cattle. Storey Publishing, 2005.

Weaver, Sue. The Donkey Companion. Storey Publishing, 2008.

STOREY BULLETINS

Bubel, Nancy. Braiding Rugs. A Storey Country Wisdom Bulletin A-3. Storey Publishing, 1977.

Heinrichs, Jay. Woodlot Management. A Storey Country Wisdom Bulletin A-70. Storey Publishing, 1981.

Hobson, Phyllis. Making Cheese, Butter & Yogurt. A Storey Country Wisdom Bulletin A-57. Storey Publishing, 1980.

Oppenheimer, Betty. Making Hand-Dipped Candles. A Storey Country Wisdom Bulletin A-192. Storey Publishing, 1999.

Perrin, Noel. Making Maple Syrup. A Storey Country Wisdom Bulletin A-51. Storey Publishing, 1980.

Stephens, Rockwell. Axes & Chainsaws: Use and Maintenance. A Storey Country Wisdom Bulletin A-13. Storey Publishing, 1977.

OTHER BOOKS

Blackwood, Alan. Spotlight on Grain. Rourke Enterprises, 1987.

Dunne, Niall, ed. Healthy Soils for Sustainable Gardens. Brooklyn Botanic Gardens, 2009.

Editors of Storey Books. Country Wisdom & Know-How. Black Dog & Leventhal, 2004.

Henshaw, Peter. Illustrated Dictionary of Tractors. MBI Publishing, 2002.

May, Chris. The Horse Care Manual. Barron's, 1987.

Pellman, Rachel T. Amish Quilt Patterns. rev ed. Good Books, 1998.

Scott, Nicky. Composting: An Easy Household Guide. Chelsea Green, 2007.

Sellens, Alvin, ed. Dictionary of American Hand Tools. Schiffer Books, 1990.

WEBSITES

Biology 205: General Botany
The College of William & Mary
www.resnet.wm.edu/~mcmath/bio205/diagrams/botun08c.gif
"Germination and development of the seedling in garden bean (Phaselus vulgaris), a dicot" a digital copy of a transparency that accompanies Peter H. Raven, Ray F. Evert, and Susan E. Eichhorn's, Biology of Plants, 5th ed. Worth Publishers, 1992.

Crops
Vegetable Research and Extension
Washington State University
http://agsyst.wsu.edu/vegtble.html
Information on dry bean varieties for niche markets in the USA

Draft Horse Harness & Harness Parts
Horse Lovers Headquarters
www.horseloversheadquarters.com/site/570970/page/590504

"Essential Tools and Equipment for the Small Farm," by Carol Ekarius
Hobby Farms
www.hobbyfarms.com/farm-equipment-and-tools/tools-equipment-14995.aspx

Extension Publications
University of Tennessee
http://bioengr.ag.utk.edu/extension/extpubs
Source of the "Agricultural Building and Equipment Plan List (PB 1590)"

"Making Natural Dyes from Plants," by Pioneerthinking.com
Pioneer Thinking
http://pioneerthinking.com/naturaldyes.html

Transport and Machinery
Merriam-Webster Visual Dictionary Online
http://visual.merriam-webster.com/transport-machinery/heavy-machinery.php

"Water Pumping Windmills," by Dorothy Ainsworth
Backwoods Home Magazine
www.backwoodshome.com/articles2/ainsworth90.html
From issue 90, November/December 2004

THANK YOU

I am very grateful for getting the chance to work on this project, which has taught me so much.

Special thanks to everyone at Storey Publishing, especially Lisa Hiley, Deborah Balmuth, Alethea Morrison, and Pam Art for being so patient, for all your ideas, and incredible knowledge. Also to Carol Ekarius for her superb expertise.

Thanks to Jenny Volvovski and Matt Lamothe who are the very best second set of eyes to everything I do.

I would have never finished the book without the help of my assistant painter, the talented Leah Goren! Plus it was so much fun painting together in my kitchen.

Thanks to my Mom, Dad, Jess, Russ, Grandma Betty and Rudy for their continued support. Also to my friends, especially Grace Bonney, Amy Azzarito, Lauren Nassef and Ana Benaroya for their help.

And most of all thanks to my husband, Mathew Curtis Longacre, who provided the inspiration and gave meaning to this project.

Most of the type in this book was handwritten with the exception of this font, which I created from my handwriting. The lettering for titles was based off typefaces Palatino, Archive Antique Extended, Bellevue, and Nelly Script.